# Telepresence & Bio Art

## Studies in Literature and Science
*pubished in association with the*
*Society for Literature and Science*

### Editorial Board
Co-Chairs: N. Katherine Hayles, University of California,
  Los Angeles, and Stephanie A. Smith, University of Florida
James J. Bono, State University of New York at Buffalo
Clifford Geertz, Institute for Advanced Study
Mark L. Greenberg, Drexel University
Evelyn Fox Keller, Massachusetts Institute of Technology
Bruno Latour, Ecole Nationale Supérieur des Mines, Paris
Stephen J. Weininger, Worcester Polytechnic Institute

### Titles in the series
*Transgressive Readings: The Texts of Franz Kafka and Max Planck*
  by Valerie D. Greenberg
*A Blessed Rage for Order: Deconstruction, Evolution, and Chaos*
  by Alexander J. Argyros
*Of Two Minds: Hypertext Pedagogy and Poetics*
  by Michael Joyce
*The Artificial Paradise: Science Fiction and American Reality*
  by Sharona Ben-Tov
*Conversations on Science, Culture, and Time*
  by Michel Serres with Bruno Latour
*Genesis*
  by Michel Serres
*The Natural Contract*
  by Michel Serres
*Dora Marsden and Early Modernism: Gender, Individualism, Science*
  by Bruce Clarke
*The Meaning of Consciousness*
  by Andrew Lohrey
*The Troubadour of Knowledge*
  by Michel Serres
*Simplicity and Complexity: Pondering Literature, Science, and Painting*
  by Floyd Merrell
*Othermindedness: The Emergence of Network Culture*
  by Michael Joyce
*Embodying Technesis: Technology Beyond Writing*
  by Mark Hansen
*Dripping Dry: Literature, Politics, and Water in the Desert Southwest*
  by David N. Cassuto
*Networking: Communicating with Bodies and Machines in the
  Nineteenth Century* by Laura Otis
*Rethinking Reality: Lucretius and the Textualization of Nature*
  by Duncan F. Kennedy
*The Knowable and the Unknowable: Modern Science, Nonclassical
  Thought, and the "Two Cultures"* by David N. Cassuto
*Telepresence and Bio Art: Networking Humans, Rabbits, and Robots*
  by Eduardo Kac

# Telepresence & Bio Art

Networking
Humans,
Rabbits,
& Robots

## Eduardo Kac

**The University of Michigan Press**
*Ann Arbor*

For Ruth & Miriam

Copyright © by the University of Michigan 2005
All rights reserved
Published in the United States of America by
The University of Michigan Press
Manufactured in the United States of America
♾ Printed on acid-free paper

2008   2007   2006   2005     4   3   2   1

No part of this publication may be reproduced, stored in a retrieval system,
or transmitted in any form or by any means, electronic, mechanical, or otherwise,
without the written permission of the publisher.

*A CIP catalog record for this book is available from the British Library.*

Library of Congress Cataloging-in-Publication Data

Kac, Eduardo.
   Telepresence and bio art : networking humans, rabbits, and robots /
Eduardo Kac.
     p.    cm. — (Studies in literature and science)
   Includes bibliographical references and index.
   ISBN 0-472-09810-1 (cloth : alk. paper) — ISBN 0-472-06810-5
(pbk. : alk. paper)   1. Telecommunication in art.   2. Technology in art.
3. Biology in art.   4. Kac, Eduardo.   I. Title.   II. Series.
N74.T45K33 2005
701'.05—dc22                                                                      2004015061

# Foreword

James Elkins

A reviewer once said that Eduardo Kac's work is six degrees of separation from every important issue of our time. It is an accurate remark. I imagine some readers will have picked up this book because they know Kac's work, and others will be hoping to learn something about bioart or telepresence, but there will also be readers for whom this book's subtitle is a red flag, a warning that indicates the book is meant for people with a special interest in technology. Wariness of new media is a traditional accompaniment of modernism, and in some respects it's even a necessary element of modernism. Now, at the beginning of the twenty-first century, modernist wariness about new media has largely evaporated (which is not the same as saying it leaves no unsolved problems in its wake or that it's been done away with once and for all), and yet suspicion about technology remains. Those who are convinced of the importance of film, video, performance, and conceptual art may still resist work that depends on code, pixels, or genes. I suspect the current slight but pervasive mistrust of digital media is a ghostly aftereffect of modernism's dislike of technology. If you find yourself agreeing with Heidegger's critique of technology, then this book may indeed have little to say to you. If you feel, like Heidegger, that technology masks fuller senses of experience, then the subjects covered in this book may seem like attempts to conceal, or escape from, life and art in a broader sense. But I wonder how many people who avoid electronic arts exhibitions actually read Heidegger and how many people have managed to keep the digital portions of their life sequestered from the artistic parts. I think, in other words, that the mis-

---

James Elkins, an art historian, is the author of *The Object Stares Back: On the Nature of Seeing* (Simon & Schuster, 1996), *The Domain of Images* (Cornell University Press, 1999), *What Painting Is* (Routledge, 2000), *What Happened to Art Criticism?* (Prickly Paradigm Press/University of Chicago Press, 2003), and *Six Stories from the End of Representation* (Stanford University Press, 2005).

trust of digital arts is sometimes—not always—a matter of old and unexamined habits.

Given all that, I'd like to use this foreword to address readers who might have some lingering skepticism about the potential relevance of technologically oriented media. Readers who already accept such art may find something of use here as well, especially those who feel that the question of relevance is asked and answered and there are effectively no divides between the digital and the rest of art—what the digital calls the analog.

I'll mention three fields of crucial interest to contemporary theorizing on fine art that apply just as well—and in most cases better—to the work Kac discusses than they do to the media with which they are normally associated. These are three reasons why mainstream art theory, criticism, and history should take notice of the developments in this book *as if* they did not require a separate book of their own—*as if* they were simply and immediately examples of art.

### History

This is an unusual book, because Kac has participated in the movements he discusses. He is an artist and also, at times, a historian. The combination is rare. A comparison might be made to Robert Motherwell, except that as a historian he was more concerned with surrealism than the art of his own generation: he separated documentation from creation in a way that Kac does not. Eugène Fromentin might be another example, and among near contemporaries there are Meyer Schapiro, Leo Steinberg, and David Summers. It's a short list. The closest comparisons may be to László Moholy-Nagy; or to Paul Signac, who wrote a history of French painting up to and including his own generation; or—though he's not much of a historian—Frank Stella. (I thank Margaret MacNamidhe for suggesting Fromentin and Signac.)

Kac does not consider himself a historian, but it might be more accurate to say that his practice includes the making of art as well as its discussion: research into what other people do and have done is part of his working process. At the same time, Kac has a perspective on this material that isn't quite what scholars might have. Rachel Greene's book on Internet art, for example, is oriented partly to politicals and partly to formal innovation. Similar emphases can be found in books by Julian Stallabrass, Oliver Grau, Christiane Paul, Noah Wardrip-Fruin, Nick Montfort, and Stephen Wilson. This book has an *interest*, too: a theory, a common thread that binds the narrative. That interest is, in one word, communication. Kac is concerned to find new forms

of communication, and that takes him into semiotics; linguistics; communication theory; and, especially, what he calls dialogism.

## Dialogism

In his art and writing, Kac is singularly uninterested in one-way communication of the sort in which the work "speaks" to the silent viewer. (I imagine he is also disapproving of the classical music scene, where nothing more articulate than clapping is required of an audience.) The works described in this book share its author's concern with the elaboration of new communities, new kinds of collaboration, new dialogical interactions. Those interests become radical when the thing being communicated with is not another person but a software code, a robot, or something that's alive but isn't human. For Kac the theorist (of his own work and that of others) there is a necessary progression from one-directional work like academic painting (in which meaning seems to flow to a silent viewer), through bidirectional work like some performance, telepresence, and telerobotics (where the audience becomes a participant and the performers can become the audience), to bidirectional work that reaches outside the human. It's a genealogy whose sturdiness has yet to be tested: the link between the second and third is a historical hypothesis, a proposal for a genealogy of art. The three parts of this book rehearse the genealogy, and it will be up to each reader to decide if the theme of dialogism finds its logical end in works that explore the boundaries of the living and nonliving or incorporate "dialogic" animals like the dog.

One question, then, is whether the investigation of new forms of dialogical understanding inevitably leads toward the investigation of new forms of life. Another is the link between dialogism, as Kac explores it, and similar concepts used outside telepresence, telerobotics, and bioart. In the 1990s, for example, Jean-Luc Nancy's work on community became increasingly important, not least for critics and artists involved in the creation of new artistic communities. Queer theorists such as John Rico have used work like Nancy's to rethink the role of communities in the art world. In psychoanalysis, Lacan's theories of vision, elaborated from Sartre's and Heidegger's, provide a basis for thinking of visual communication as inherently dialogic. The dialogic nature of artworks could also be theorized through Derrida's critique of logocentrism and writing; alternates to logocentrism were elaborated in the 1990s by a number of writers, including Eduardo Cadava and Whitney Davis. The lack of dialogism in older art has also been critiqued by artists such as Barbara Kruger, and the emergence of collaborations has been theorized

by artist-historians like Charles Green and historians such as Renée Hubert. Originally, dialogism entered the critical dialogue through Mikhail Bakhtin and—less frequently cited but just as important—Martin Buber. Perhaps it will seem best, in the future, to think of the works documented in this book as exemplifications of broader ideas of dialogue, but it is also possible that Kac's model, which is theorized principally from Baudrillard, Virilio, semiotics, and communication theory, will prove the most fundamental approach.

**Aesthetics**

You won't find much discussion in this book about aesthetics, because the communication model of art is preeminent. What matters is the form and novelty of the communication itself, rather than its affective value. Kac doesn't make works in order to communicate qualities such as beauty, ugliness, revulsion, or attraction. He makes them, I take it, to explore new configurations of speaker and listener, language, message, and symbolic system. He is, to coin an expression, an experimental semiotician. For a number of years now I have had a running discussion with him about this. I point out that some of his works, *Genesis*, for example, could be seen as having an element of cruelty or at least unpleasantness. After a performance of *A-positive*, all that remained was a blood-spotted cloth. His *Time Capsule* involved injecting a small object into his leg using a very large needle. Those projects exude a negative feeling: they are more or less unpleasant, violent, or dark. Other works, like *GFP Bunny* and *GFP K-9*, are potentially sweet and optimistic. The *GFP Bunny* project, although it has become very complex, is potentially pleasurable because it involves the animal's socialization. (Kac mentions, but doesn't critique, the reanimated, partly robotic corpse of a rabbit used in the Survival Research Laboratories' piece *Rabot*.) My disagreement with Kac is over the relevance of affect. For much of the art world, one of the purposes of an artwork is to produce a certain feeling, an affect, in the viewer. Kac leaves that to each participant and concentrates on producing interesting new configurations of communication, code, and language. Now, this may seem to be a critique of Kac, and in part it is, but it is also evidence that he takes a very clear and strong stand in a debate that is central to much of postmodernism. That debate concerns the rise of politically and conceptually motivated art since the 1960s. Lucy Lippard broke with Clement Greenberg, to take a paradigmatic example, precisely over the issue of the relevance of aesthetics. (Lippard confronted Greenberg about his insistence on *quality* in art, which Greenberg took as the be-

all and end-all of art.) Since the 1960s there have been many attempts to create theories of contemporary art that are free from aesthetics. There are several permutations: for Benjamin Buchloh, the supposition that a work generates aesthetic pleasure calls for an institutional critique to determine how and why particular aesthetic values and qualities are taken to be true or valuable. Aesthetics, under the microscope of institutional critique, becomes an artifact or a construction of a certain configuration of institutions and readings. I could go on: I think there are a half dozen different strains in contemporary theorizing on art that treat aesthetics, and the traditional significance given to affect and emotion, as irrelevant, misguided, unhelpful, intellectually bankrupt, ideologically overdetermined, or otherwise beside the point. The debate, as I call it, continues because art that is made *exclusively* for some political purpose—for example, Andrea Fraser's performances—may need to evade the question of quality altogether. To make a politically and socially effective video on AIDS, for instance, or an effective film on war, it will often be necessary to concentrate on the content and let the quality sort itself out. I know some politically committed, activist artists for whom questions of quality are epiphenomenal on their project—that is, quality is considered as an asked-and-answered problem that is more applicable to art of the past. Kac is not especially interested in institutional critique, political action, or identity politics, but his work entails just as strong a rejection or deferral of aesthetic questions.

And yet the artist does use the word *aesthetics*. Telepresence art, he says, expresses on an aesthetic level what mass culture brings us in the form of remote control and remote vision. Each reader will have to decide what *aesthetics* means in these contexts. What distinguishes Kac's approach in this book is the lucidity and purity of his argument: media and their messages are absolutely the point, and aesthetic responses are epiphenomenal. Lippard's argument with Greenberg was over his use of the word *quality*, as in *aesthetic quality*. A Greenbergian—luckily there aren't many of them around anymore—wouldn't be happy with this book. Gilbertto Prado's *Connect*, which Kac describes, is a wonderful example of a circulating dialogic artwork using new modes of communication; it was an endless fax, circulated between machines. But how interesting was the fax itself? Peter Schjeldahl once criticized Kac's *Genesis* because the sentence "edited" by the bacteria wasn't interesting. That comment missed part of Kac's point—the work called *Encryption Stones* focuses on new languages, new kinds of translation—but it also shows how an approach based in aesthetics can find itself at sea in the new art.

The place of aesthetics isn't an easy question, any more than it's easy to theorize dialogism or to consider technological media side by side with painting and other art forms. Kac's work raises all three issues with exemplary clarity, making this book the best introduction to these issues and to the new art.

# Preface

This collection brings together texts on electronic and bio art that I have published over the past twelve years. *Telepresence and Bio Art* is the chronicle of a journey, articulated from the point of view of an artist immersed in his metier. In the course of developing my work with telepresence, biotelematics, biorobotics, and transgenic art, I have always sought to extend the work through reflection and writing. I have also investigated lesser-known aspects of media art and considered the contributions made by other contemporary artists. The book weaves my own trajectory with that of other artists through discussions of some of the most relevant strategies in electronic art. Uniting the topics is my commitment to the practical and theoretical investigation, in art, of the complex phenomenon generally referred to as "communication."

The book is organized in three sections, but the boundaries between them are fluid. Within each section the texts appear in chronological order according to their original publication dates.

The first section, entitled "Telecommunications, Dialogism, and Internet Art," covers works created with telecommunications media, interactive systems, and the Internet. Here I defend the notion that telecommunications media enable the creation of truly dialogical art, which I define as art based on interactions among subjects. In this section I discuss historical examples of pioneering telecommunications work and bridge them with contemporary Internet strategies. The Internet is examined in the larger context of the history of telecommunications art.

The second section, "Telepresence Art and Robotics," consists of texts that document my development of an aesthetics of telepresence based on the coupling of telematics and robotics. I define telepresence art as enabling the participant to have a sense of his or her own presence in a remote environment. A study of the origins and development of robotic art is also included in this section.

Finally, the third section, "Bio Art," is composed of six pieces that address points of contact between electronic art and biotechnology.

The first two chapters discuss works and concepts that I propose and explain: "biotelematics," "biorobotics," and "transgenic art." The first two concepts signal the integration of biology with telematics and robotics, respectively. The third chapter, "*Genesis,*" articulates the question of the creation of (and responsibility for) new life forms in art, discussing a series of works based on the creation of a real gene that encodes a biblical passage and its subsequent mutation through the Internet. "*GFP Bunny*" offers a reflection on the multiple implications of creating a new animal and integrating it into society. "*The Eighth Day*" summarizes an Internet installation that presents a transgenic ecology and offers participants the opportunity to experience and affect it from within. The last chapter of this section, "*Move 36,*" explains a transgenic work that reveals the tenuous border between humanity, inanimate objects endowed with lifelike qualities, and living organisms that encode digital information.

## Acknowledgments

I wish to thank N. Katherine Hayles and Stephanie Smith for their interest in seeing this book materialize back in 1998, when the idea first arose in the context of the Society for Literature and Science conference. Special thanks to Martin Rosenberg for inviting me to give a lecture at the conference. LeAnn Fields of the University of Michigan Press continuously and patiently expressed her support, for which I'm grateful. N. Katherine Hayles also provided additional feedback that improved the overall structure and content of the book.

I appreciate the patient cooperation of the artists and organizations with whom I corresponded and conversed and who generously shared information about their work or from their archives.

I also wish to thank friends and colleagues who, throughout the years, read previous versions of the manuscript or helped in making the works discussed herein a reality. Ed Bennett, my collaborator through much of the early development of telepresence art, offered his pragmatic and thoughtful insights in the heat of the moment. In the late 1980s and early 1990s, when telepresence art was a strange concept for most (but not for the two young lost souls who never seemed to leave the Electronics and Kinetics Lab at The School of The Art Institute of Chicago), his feedback on my writings on telepresence art complemented well our ongoing dialogue and debate. Special thanks to Steve Waldeck, who welcomed and nurtured this work at its earliest stage. Anna Yu participated and contributed in essential ways throughout the years. Thanks are also due to Marlene Przytyk and Nelson Pataro, whose help is much appreciated. I'm also indebted to friends

and colleagues who have offered their support, engaged in productive conversation, or assisted in multiple ways, in particular Annick Bureaud, Carol Becker, Alec Boyd-Peshkin, Kristine Stiles, Edward Shanken, Simone Osthoff, Jon Fisher, David Juros, Mike Rodemer, George Gessert, Ikuo Nakamura, Peter Dobrila, Alexandra Kostic, Carlos Fadon, Mario Ramiro, Carol Gigliotti, Paulo Flavio de Macedo Gouveia, José Roberto Aguilar, Richard Cooper, Roger Malina, Jason Sachs, Bill Seaman, Rachel Weiss, Stephen Collins, Joan Truckenbrod, Saverio Truglia, Lou Hawthorne, Murray Robinson, and Matthew Metz. Thanks to Regina Harders for her editorial assistance and patience with my revisions and corrections. In the course of my research on robotic art, others helped identify sources, obtain documents, or provided specific feedback: Jasia Reichardt, Carl Solway, Barbara Moore, Anita Duquette, Ken Goldberg, Johanna Drucker, George Hirose, Eléonore Schöffer, and Olga Ihnatowicz. Between 1998 and 2001 my work and writing were carried out in conjunction with my research fellowship at the Centre for Advanced Inquiry in Interactive Arts (CAiiA), at the University of Wales, Newport, United Kingdom. Special thanks to Roy Ascott for his support.

For their invaluable assistance with *GFP Bunny* I will be forever thankful to Louis Bec and Louis-Marie Houdebine. Klaus Ammann, Gunalan Nadarajan, and Irina Aristarkhova opened new horizons of hope against all odds. Charles Strom and Peter Gena were instrumental in making *Genesis* a reality. *Genesis* also benefited from a grant from the Langlois Foundation, Montreal, and from the support of the Institute for Studies in the Arts, Arizona State University, Tempe. *The Eighth Day* owes its implementation to the visionary embrace of Richard Loveless and the nurturing provided by the extremely talented team at the Institute for Studies in the Arts. Special thanks to Sheilah Britton, Dan Collins, and Thanassis Rikakis, whose coordination efforts saw *The Eighth Day* from sketch to finished installation. A very special thanks to Alan Rawls and Jeanne Wilson Rawls. Without their biological expertise, interdisciplinary vision, and perseverance, as well as wit and improvisational ability, *The Eighth Day* simply would not have been possible. The assistance provided by the Greenwall Foundation, New York, is also appreciated. I thank the Sacatar Foundation, Ilha de Itaparica, Brazil, for a memorable residency and the Creative Capital Foundation, New York, for its support of *Move 36*. Pam Winfrey, head of the Exploratorium's artist-in-residence program, patiently guided me and was instrumental in facilitating my work at the museum.

I also owe a debt of gratitude to Julia Friedman, who throughout the years provided invaluable feedback on many levels, managed many of the works discussed in the following pages, and otherwise assisted

with countless tasks. Her perseverance and high spirits in the face of adversity have transformed daunting tasks into attainable goals. Additional thanks to Laura Marsiaj, in Rio de Janeiro, and Caroline and Jacqueline Rabouan Moussion, in Paris.

Thanks also go to all the photographers who have documented my work: Carlos Fadon, Belisario Franca, Anna Yu, Erik Lesser, Rod LaFleur, David Yox, Rob Veenendaal, Eduardo Castanho, Craig Smith, Otto Saxinger, Axel Heise, Saverio Truglia, CameraWerks, Jacob Melchi, and Chrystelle Fontaine.

I thank Craig S. Brandist, Bakhtin Centre, Department of Russian and Slavonic Studies, University of Sheffield, Great Britain, and Hege Charlotte Faber, Trondheim Academy of Fine Art, Norwegian University of Science and Technology, Norway, for their feedback on Buber and Bakhtin. Our exchanges helped me express my position more clearly.

Most of my insights about dialogical art spring primarily from lived experience and only secondarily from my studies of philosophy. I owe my understanding that the world can be a different place, and that alternatives are possible, entirely to Perla Przytyk. It was her love, guidance, and dialogical openness, particularly when there seemed to be no escape from oppressive monological discourses, that first revealed to me the power of dialogicality. Perec Przytyk fostered my discovery of the pleasure of the text through countless hours of reading together, an endless stream of books, translations to and from several languages, and making possible the first publications.

Above all, no acknowledgment can express how grateful I am to my wife, friend, and soul mate, Ruth Kafensztok, whose intelligence, companionship, and support are my lifeblood. Our daughter, Miriam—playing with me or near me as many of these pages were written; asking questions about art, poetry, comics, and clones; or trying to usurp my main work computer to explore the Internet—has kept me in check and in tune with the future.

# Contents

**I. Telecommunications, Dialogism, and Internet Art**    1

  1. The Aesthetics of Telecommunications (1992)    3
  2. The Internet and the Future of Art (1997)    59
  3. Beyond the Screen: Interactive Art (1998)    88
  4. Negotiating Meaning: The Dialogic Imagination in Electronic Art (1999)    103

**II. Telepresence Art and Robotics**    125

  5. Toward Telepresence Art (1992)    127
  6. Telepresence Art (1993)    136
  7. Telepresence Art on the Internet (1996)    155
  8. The Origin and Development of Robotic Art (1997)    168
  9. Live from Mars (1997)    187
  10. Dialogic Telepresence Art and Net Ecology (2000)    191

**III. Bio Art**    215

  11. The Emergence of Biotelematics and Biorobotics: Integrating Biology, Information Processing, Networking, and Robotics (1997)    217
  12. Transgenic Art (1998)    236
  13. *Genesis* (1999)    249
  14. *GFP Bunny* (2000)    264
  15. *The Eighth Day* (2001)    286
  16. *Move 36* (2002)    295

Biographical Note    299
Index    301

I. Telecommunications, Dialogism, & Internet Art

# 1. The Aesthetics of Telecommunications

Since the beginning of the twentieth century, but particularly since the early 1980s, increasing numbers of artists around the world have worked in collaborative mode with telecommunications. In their "works," which we shall refer to as "events," images and graphics are not created as the ultimate goal or the final product, as is common in the fine arts. Employing computers, video, modems, and other devices, these artists use visuals as part of a much larger, interactive, bi-directional communication context. Images and graphics are created not simply to be transmitted by an artist from one point to another but to spark a multidirectional visual dialogue with other artists and participants in remote locations. This visual dialogue assumes that images will be changed and transformed throughout the process as much as speech gets interrupted, complemented, altered, and reconfigured in a spontaneous face-to-face conversation. Once an event is over, images and graphics stand not as the "result" but as documentation of the process of visual dialogue promoted by the participants.

This unique ongoing experimentation with images and graphics develops and expands the notion of visual thinking by relying primarily on the exchange and manipulation of visual materials as a means of communication. The art events created by telematic or telecommunications artists take place as a movement that animates and sets off balance networks structured with relatively accessible interactive media such as telephone, facsimile (fax), personal computers, modems, and slow-scan television (SSTV). More rarely, radio, live television, videophones, satellites, and other less accessible means of communication come into play. But to identify the media employed in these "events" is not enough. Instead, one must do away with prejudices that cast off these media from the realm of "legitimate" artistic media and investigate these events as equally legitimate artistic enterprises.

Originally appeared as "Aspects of the Aesthetics of Telecommunications," in *Siggraph '92 Visual Proceedings*, ed. J. Grimes and G. Lorig (New York: Association for Computing Machinery, 1992).

This chapter partially surveys the history of the field and discusses art events that were either motivated by or conceived especially for telecommunications media, attempting to show the transition from the early stages, when the telephone and radio provided writers and artists with a new spatiotemporal paradigm, to a second stage, in which new telecommunications media, including computer networks, became more accessible to individuals and artists started to create events, sometimes of global proportions, in which the communication process itself became the work.

Telecommunications art on the whole is, perhaps, a culmination of the reduction of the role of the art object in the aesthetic experience epitomized by Duchamp and pursued worldwide by artists associated with the conceptual art movement who embraced mass media. If the object is totally eliminated and the artists are absent as well, the aesthetic debate finds itself beyond action as form, beyond idea as art. It founds itself in the relationships and interactions between members of a network.

## Art and Telecommunications

One must try to understand the cultural dimensions of new forms of communication as they emerge in innovative artworks that are not experienced or enjoyed as unidirectional messages. The complexity of the contemporary social scene permeated by electronic media, where the flux of information becomes the very fabric of reality, calls for a reevaluation of traditional aesthetics and opens the field for new developments. In other words, to address the aesthetics of telecommunications is to see how it affected and affects more traditional arts. It is also to investigate to what extent the context for a new art is created by the merger of computers and telecommunications. The new media that artists will be working with more and more must be identified, then, in the intersection between the new electronic processes of visual and linguistic virtualization brought irreversibly by telecommunications and the personal computer (word processing, graphic programs, animation programs, fax/modems, satellites, teleconferencing, etc.) and the residual forms that resulted from the process of dematerialization of the art object, from Duchamp to conceptual art (language, video, electronic displays, printing techniques, happenings, mail art, etc.).

This new immaterial art is collaborative and interactive and abolishes the state of unidirectionality traditionally characteristic of literature and art. Its elements are text, sound, image, and eventually virtual touch based on force-feedback devices. These elements are out of balance; they are signs that are already shifting as gestures, as eye contact,

# The Aesthetics of Telecommunications

as transfigurations of perpetually unfulfilled meaning. What is commuted is changed, rechanged, exchanged. One must explore this new art in its own terms, that is, understanding its proper context (the information society) and the theories (poststructuralism, chaos theory, culture studies) that inform its questioning of notions such as subject, object, space, time, culture, and human communication. The forum where this new art operates is not the materially stable pictorial space of painting nor the Euclidean space of sculptural form; it is the electronic virtual space of telematics where signs are afloat, where interactivity destroys the contemplative notion of beholder or connoisseur to replace it with the experiential notion of user or participant. The aesthetics of telecommunications operates the necessary move from pictorial representation to communicational experience.

Two of the most interesting forms of communication that seem to do away with the old addresser-addressee model proposed by Shannon and Weaver[1] and reinforced by Jakobson[2] are on-line message boards and conference calling. With on-line message boards a user can post up a message and leave it adrift in electronic space, without necessarily sending it to a specific addressee. Then another user, or several other users at the same time, can access this message and answer it, or change it, or add a comment, or incorporate this message into a larger and new context—in a process that has no end. The closed message as identity of the subject is potentially dissolved and lost in the signifying vortex of the network. If real time is not crucial for posting messages, the same cannot be said about conference calling, where three or more people engage in exchanges that don't have to be limited to voice.[3] If the linear model goes as far as allowing for addresser to become addressee when the poles are reverted, this multidirectional and interconnected model melts the boundaries that used to separate sender and receiver. It configures a space with no linear poles in which multilateral discussion replaces alternate monologues, a space with nodes that point in several directions where everybody is simultaneously (and not alternately) both addresser and addressee. This is not a pictorial or volumetric space, but an aporetic space of information in flux, a disseminated hyperspace that does away with the topological rigidity of the linear model. It shares the properties of nonlinear systems, such as found in hypermedia or in the statistical self-similarity of fractals, as opposed to the linear surfaces of painting. It is here, possibly, that artists can intervene critically and suggest a redefinition of the framework and the role of telematics, exhibiting that antagonistic forces mutually constitute each other. What we used to call true and real is and has always been reciprocally and dynamically, in its play of differences, constituted by what we used to call false and unreal. Cul-

tural values are also questioned, since the structures that privileged one culture over the others are conceptually challenged, bringing cultural differences to the forefront. Artists can also show, by working with new media, what role the new media play in forming or preserving stable structures that form the self, that model communication, and that ultimately create social relations (including relations of authority and power).

In like manner, artist and audience are also constructed in this play of differences. If the mass-produced printed book would generate both the notions of author and audience, associating control over the distribution of printed information with power, the disseminated play of meaning of telematic networks potentially dissolves both without fully establishing the integrated, harmonized, aural global village dreamed of by McLuhan. If telecommunications is that which brings people closer, it also is that which keeps them apart. If telematics is that which makes information accessible to everyone at any moment regardless of geographic frontiers, it also is that which makes certain kinds of data generated by particular groups in certain formats accessible to people involved with specific institutions. That which brings people closer is also what keeps them away; that which asks is also what affirms certain values implicit in the framing of the question. If there is no end to this play, to this motion, there must be awareness of its context—but then again awareness is not removed from this motion through which it is also configured.

To the linear model of communication, which privileges the artist as the codifier of messages (paintings, sculptures, texts, photographs), telematics opposes a multidirectional model of communication, one where the artist is creator of contexts, facilitator of interactions. If in the first case messages have physical and semiological integrity and are open only to the extent they allow for different interpretations, in the second case it is not mere semantical ambivalence that characterizes the significational openness. The openness of the second case is that which strives to neutralize closed systems of meaning and provide the former viewer (now transformed into user, participant, or network member) with the same manipulation tools and codes at the artist's disposal so that the meaning can be negotiated between both. This is not a simple inversion of poles, as proposed by Enzensberger,[4] but an attempt to acknowledge and operate within a signification process that is dynamic, destabilized, and multivocal; within a signification process based not on the opposition artist/audience but on the differences and identities they share. Messages are not "works" but a part of larger communicational contexts and can be changed, altered, and manipulated virtually by anybody.

One of the problematic issues here is that the dissolution of the artist in the user and vice versa would take away from artists their privileged position as senders or addressers, because there is no more message or work of art as such. It is clear that most artists are not prepared to or interested in giving up this hierarchy because it undermines the practice of art as a profitable activity and the social distinction associated with notions such as skill, craft, individuality, artistic genius, inspiration, and personality. The artist, after all, is someone who sees himself or herself as somebody who should be heard, as somebody who has something important to say, something important to transmit to society.[5] On the other hand, one can ask to what extent artists who create telecommunications events don't restore the same hierarchy they seem to negate by presenting themselves as the organizers or directors or creators of the events they promote—in other words, as the central figures from which meaning irradiates. As it seems, while a television director works in collaborative fashion with tens or hundreds of people without ever giving up the responsibility for the outcome of the work, the artist (context-creator) who produces telecommunications events sets a network without fully controlling the flux of signs through it. The artist working with telecommunications media gives up his or her responsibility for the "work," to present the event as that which restores or tries to restore the responsibility (in Baudrillard's sense) of the media.[6]

I must observe that a commitment to this change in the processes and issues of art is identifiable not only in the present chapter and in other texts of mine on the subject[7] but also in the writings of other artists who address the aesthetics of communications at large and of telecommunications or telematics in particular, including Roy Ascott,[8] Bruce Breland,[9] Karen O'Rourke,[10] Eric Gidney,[11] and Fred Forest.[12] Artists are endowed with instruments with which they reflect on contemporary issues, such as cultural relativism, scientific indeterminacy, the political economy of the information age, literary deconstruction, and the decentralization of knowledge; artists are able to respond to these issues with the same material (hardware) and immaterial (software) means that other social spheres employ in their activities, in their communion and isolation. If actual walls are falling (the Berlin Wall, the Iron Curtain), and so are metaphorical walls (telematic space, virtual reality, telepresence), one cannot simply overlook or overestimate these historical and technical achievements. It is not with sheer enthusiasm for new tools that the artist will work with communication technologies, but with a critical, skeptical approach concerning the logic of mediation they entail. This means not ignoring that utopias of ubiquitous electronically mediated communication necessarily exclude those cultures and countries that, usually for political and economic reasons,

don't have the same or compatible technologies and therefore cannot participate in any global exchange.[13]

Let us suppose that in a not so distant future Jaron Lanier's dream of "post-symbolic" communication[14] becomes possible. This hypothetical situation could be a viable approach to the problem of linguistic barriers (including language impairment), but it would be no different from other cases of economic segregation, given that even basic telephone technology is full of serious problems in most developing countries. If telecommunications art will not simply neglect the contradictions inherent in the media and in other technological monopolies present in late capitalist societies, I still like to think that perhaps freer forms of communication can emerge out of new interactive artistic practices that make the process of symbolic exchange the very realm of its experience.

**Disembodied Voices**

An assessment of the parallel development of telecommunications media and new art forms throughout the twentieth century reveals an interesting transition: one first sees the impact of new media on much older forms, such as radio influencing theater; later, it is possible to detect more experimental uses of these media. At last, artists master the new electronic media and explore their interactive and communicational potential. In this perspective, radio is the first electronic mass communications medium used by artists.

In the late 1920s commercialization of the airwaves was in its infancy. Radio was a new medium that captured the imagination of listeners with an auditory space capable of evoking mental images with no spatiotemporal limits. A remote and undetected source of sound dissociated from optical images, radio opened listeners to their own mindscapes, enveloping them in an acoustic space that could provide both socialization and private experiences. Radio was also the first true electronic mass medium, capable of remotely addressing millions at once, as opposed to newspapers and cinema, for example, which were only available to a local audience.

In 1928 German filmmaker Walter Ruttmann (1887–1941) was invited by the Berlin Broadcasting System to create a piece for radio. Ruttmann had already achieved international recognition for his abstract animated films, such as *Opus I, II, III,* and *IV,* which pioneered the genre and anticipated computer animation by half a century. His experimental documentary *Berlin, Symphony of a Great City* (1927) also was acclaimed worldwide and, together with the forerunner "Rien que les heures" (1926), by Alberto Cavalcanti, inspired a whole gen-

eration of filmmakers who then created filmic "city symphonies." In addition to his contribution to filmmaking, Ruttmann's innovative work for radio would open the airwaves to the aesthetics of the avant-garde, challenging the standardization of programming imposed by commercial imperatives.

In order to create the commissioned piece, Ruttmann was given access to what was one of the best recording systems for film in the world, the "Triergon" process. Coming from the world of cinema, Ruttmann decided to create *Weekend,* a movie without images, a discontinuous narrative based on the mental images projected by the sounds alone. He employed the sound track in the reel as he would have employed the frame to record images. *Weekend* lasts about fifteen minutes and creates an aural atmosphere that portrays workers leaving the city and going to the countryside after a working day. At first sounds produced by saws, cars, and trains are predominant, but later sounds of birds chirping and children speaking appear more often. As he had done with *Symphony of a Great City,* Ruttmann edited this pictureless film in experimental fashion: splicing the reel and with it the sound track, repeating certain sounds, reorganizing the sequence and duration of sounds. He edited sound like one edits film.

*Weekend* as a sound montage, conceived for a recording medium and for radio transmission, opened new venues and anticipated the aesthetics of movements such as Concrete Music and of artists such as John Cage and Karlheinz Stockhausen. If Ruttmann defined his abstract films as "optical music," one would not hesitate to describe *Weekend* as the first "acoustic film" created for radio. During the rise of Germany's National Socialism (Nazism), while other members of the German avant-garde left the country (e.g., Oskar Fischinger) or stayed in Germany but did not collaborate with the regime (e.g., Hannah Höch), Ruttmann placed his talents at the service of Hitler's minister of propaganda, Joseph Goebbels, for whom he made films such as *Deutsche Panzer* (German Tanks, 1940). In 1935 he also contributed to Leni Riefenstahl's *Triumph of the Will*. Ruttmann died in 1941 in Berlin from an injury suffered at the Russian front while filming combat and war activities.

As it became more popular throughout the 1920s, radio inspired and attracted professionals from different backgrounds, including artists, performers, and writers. German playwright Bertolt Brecht (1898–1956) found in radio a means for expanding the aesthetics and the audience of theater. Between 1928 and 1929, Brecht wrote the first of his didactic plays (Lehrstücke), *Der Lindberghflug* (*Lindbergh's Flight*) (fig. 1), based on Charles Lindbergh's first flight over the Atlantic in 1927. The play was first presented in 1929, at the Baden-

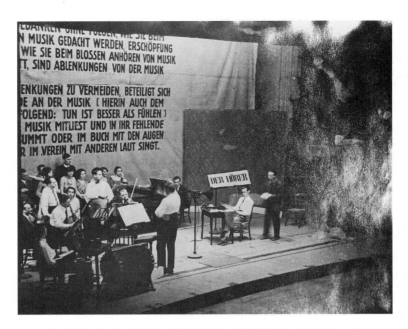

1. Bertolt Brecht, *Der Lindberghflug* (Lindbergh's Flight), participatory radio play, 1929. Brecht proposed to transform radio from a one-way to a two-way medium and to transform listeners into producers. (Courtesy of Bertolt-Brecht-Archiv.)

Baden music festival, in Germany. Lindbergh had made history when he took off in New York and flew for over thirty-three hours without sleep and with little food in a small lightweight plane of his own design, *The Spirit of St. Louis,* before landing in Paris to the astonishment of the whole world. In 1938, Lindbergh accepted a German medal of honor from none other than Hermann Goering, commander in chief of the Luftwaffe, president of the Reichstag, prime minister of Prussia, and Hitler's designated successor. When Brecht became aware of Lindbergh's sympathy for Nazism, he changed the name of the play to *Der Ozeanflug* (*Ocean Flight*).

In a Germany struck by economical and political crisis, Brecht became more and more sympathetic to socialist ideas in hope for a solution. His pedagogic plays did not aim to entertain the audience but to educate it, to raise its members' awareness of the social and economic conditions in which they lived. *Lindbergh's Flight* is, in Brecht's words, "an object of instruction."[15] For Brecht, participation in a play or broadcast was the best way to learn political and moral lessons. Brecht's Marxist aesthetics is clear in his attempt to portray the pilot's feat not as the result of the heroism of an individual but as the consequence of a collective effort. Instead of a single male actor, Brecht employed a chorus to interpret the pilot's character. Attempting to communicate more directly with the audience, Brecht's style became devoid

# The Aesthetics of Telecommunications

of any excessive ornament, turning to a more factual language. The chorus introduces itself in an economic way emptied of any glamour:

> My name is Charles Lindbergh
> I am twenty-five years old
> My grandmother was Swedish
> I am American.
> I have picked my aircraft myself
> Its name is "Spirit of St. Louis"
> The Ryan Aircraft works in San Diego
> Have built it in sixty days. . . .[16]

Brecht wanted to change the social role of theater and the structure of radio, converting theater into an educational tool and transforming radio from a medium of transmission of information to a medium of communication. Perhaps the most significant contribution of *Lindbergh's Flight* is its proposal of interaction between listener and apparatus, giving the listener the opportunity to answer the apparatus. Brecht described this interactivity:

> The first part (songs of the elements, choruses, sounds of water and motors, etc.) is meant to help the exercise, i.e., introduce it and interrupt it—which is best done by an apparatus. The other, pedagogical part (the Flier's part) is the text for the exercise: the participant listens to the one part and speaks the other. In this way a collaboration develops between participant and apparatus, in which expression is more important than accuracy. The text is to be spoken and sung mechanically; a break must be made at the end of each line of verse; the part listened to is to be mechanically followed. . . .
>
> *Der Lindberghflug* is not intended to be of use to the present-day radio but to alter it. The increasing concentration of mechanical means and the increasingly specialized training—tendencies that should be accelerated—call for a kind of resistance by the listener, and for his mobilization and redrafting as a producer. . . .
>
> On the left of the platform the radio orchestra was placed with its apparatus and singers, on the right the listener, who performed the Flier's part, i.e., the pedagogical part, with a score in front of him. He read the sections to be spoken without identifying his own feelings with those contained in the text, pausing at the end of each line; in other words, in the spirit of an *exercise*.[17]

Brecht's demonstration was not realized as an actual remote link via radio. Instead, his staged performance functioned as a suggestion that radio could be different from its unidirectional standard. Even though

the "listener" who sang the part of Lindbergh in this first performance was Josef Witt,[18] Brecht actually meant it as an educational exercise for boys and girls. In theatrical performances, deemed "false" by the playwright because they were not realized on radio as intended,[19] in order to preserve the collective aspect of the experience, Brecht thought that "at least the part of the aviator must be sung by a chorus in order that the spirit of the whole should not be completely destroyed."[20] The play was staged several times but received only one radio production,[21] that of Berlin Radio in 1930. The Berlin Radio broadcast of March 18, 1930, was followed by a retransmission by the BBC on May 7, 1930.[22]

Clearly, Brecht's play was meant not to simply serve radio in its contemporary form but to change it, to provide a new model for interaction in which the listener becomes a participant, a producer. The listener should resist the unidirectional flow of messages, because it is equated with the unidirectional persuasive messages sent constantly by the state to the citizens. The listeners, instead of being passively entertained, should respond to the state and make their voices heard as well. As Brecht saw it, the performance of *Lindbergh's Flight* was an exercise in freedom and discipline, and for him it would only serve the individual if it would also serve the state—a revolutionary state, that is. With the ascension of the Nazi Party, it became ever more difficult for Brecht to work. He left Germany in 1933 to return to Europe only in 1947.

If the strengthening of Fascism prevented left-wing artists like Brecht from working in Europe, it facilitated the work of other artists who publicly associated themselves with it, such as the Italian Futurists. Since the very beginning of Futurism, in 1909, Filippo Marinetti and his supporters had promoted the surpassing of traditional forms and the invention of new ones at the same time that they celebrated technological militarization and war. Abandoning the anarchist leanings that originally influenced Futurism, Marinetti became a Fascist and collaborated closely with Mussolini's regime. In 1929 Marinetti became a member of the Italian Academy, founded by Mussolini, and in 1939 he served in a commission organized by the Fascist regime to censor undesired books, including those written by Jewish authors. In 1935 he went as a volunteer to the war in Ethiopia, and in 1942 he went, again as a volunteer, to the Russian front.

The Futurists' last cry for a new art form came in September–October of 1933, with the *Manifesto della radio,* or *La radia,* signed by Marinetti and Pino Masnata and published both in *Gazzetta del Popolo* (Torino, September 22) and in their own periodical, entitled *Futurismo* (Rome, October 1)—although in *Futurismo* only Marinetti's

name appears.²³ The manifesto was drafted two years after Masnata wrote the libretto for the radio opera *Tum Tum Lullaby (or Wanda's Heart)*.

In the manifesto, they proposed that radio be freed from artistic and literary tradition and that the art of radio begins where theater and movies stop. Clearly, their project for an art of sounds and silences evolved from Luigi Russolo's art of noises, and like Russolo, they tried to expand the spectrum of sources the artist can use in radio. Marinetti and Masnata proposed the reception, amplification, and transfiguration of vibrations emitted by living beings and matter. This proposal was furthered by the mixture of concrete and abstract noises and "the singing" of inanimate objects such as flowers and diamonds. They claimed that the radio artist ("radiasta") would create words-in-freedom ("parole in libertà"), making a phonetic transposition of the absolute typographic liberty explored by Futurist writers in the visual composition of their poems. But even if the radio artist would not air words-in-freedom, his broadcasts still must be "in the parolibero style (derived from our words-in-freedom) that already circulates in avant-garde novels and in the newspapers; a style typically fast, dashing, simultaneous and synthetic."

Futurist radio could employ isolated words and repeat verbs in the infinitive. It could explore the "music" of gastronomy, gymnastics, and lovemaking, as well as use simultaneously sounds, noises, harmonies, clusters, and silences to compose gradations of crescendo and diminuendo. It could make the interference between stations a part of the work or create "geometric" constructions of silence. At last, Futurist radio, by addressing the masses, would eliminate the concept and the prestige of the specialized public, which always had "a deforming and denigrating influence." On November 24, 1933, Fortunato Depero and Marinetti made the first Futurist transmissions over Radio Milano.²⁴

In 1941, Marinetti published an anthology of Futurist theater with a long title—"The Futurist Theater Synthetic (Dynamic-Illogical-Autonomous-Simultaneous-Visionistic) Surprising Aeroradiotelevisual Music-Hall Radiophonic (without Criticisms but with Misurazioni)"²⁵ –in which he compiled nine of Masnata's and five of his own radio works ("radiophonic synthesis").

Although Marinetti has been credited as the author of these pieces, it seems reasonable to believe that they were written by Masnata. In "La poésie Futuriste Italiene,"²⁶ Noëmi Blumenkranz-Onimus points out that in Marinetti's posthumous autobiography, entitled *La grande Milano tradizionale e futurista,* published in Milan (1969, 176), he clearly indicates that these pieces were Masnata's. Marinetti wrote:

"Masnata, at home, offers us radio pieces entitled Drama of distances, silences talk among themselves, a landscape heard, and The construction of a silence."

Regardless of who the real author of these pieces is, they are a document of a pioneer effort toward the invention of an authentic art of radio. In this regard, as "*Weekend*" before them, they anticipate future experimental music forms (e.g., Concrete Music) as well as the work of innovative composers such as John Cage.

Throughout the 1930s radio became not only technically reliable but tunable, allowing the listener to choose among several programming options. Radio could now receive short, medium, and long waves from considerable distances. Whether enjoyed for entertainment or hailed as a tool for political propaganda, radio became a domestic convergence point. Listening to radio became a generalized habit in the 1930s, when the world was on the verge of another global conflict.

On October 30, 1938, the Sunday program *The Mercury Theater on the Air,* directed by the twenty-three-year-old Orson Welles and aired by the Columbia Broadcasting System in New Jersey, presented another adaptation of a literary text, this time to celebrate Halloween. Writer Howard Koch had adapted the novel chosen by Orson Welles, *The War of The Worlds* (1898), by H. G. Wells (1866–1946), updating the story and transposing the action to a virtually unknown but real place, Grovers Mill, in New Jersey. This adaptation was done collaboratively, with active contributions by Welles and producer John Houseman, as was customary. The choice of Grovers Mill was accidental but convenient, since it was close to the Princeton Observatory, where Koch placed the fictitious astronomy authority, Professor Pierson. More important, Koch structured the story, following Welles's specific instructions, by intercalating news bulletins, so that it seemed as if the music were being interrupted every now and then because of strange events and news flashes that reported them live.[27]

Through Orson Welles's dramatic voice (fig. 2), listeners became aware, little by little, that the initial explosions observed on the surface of Mars turned out to be disturbances caused by unidentified flying objects that had landed in Grovers Mill. Next, the monstrous Martian invaders started to use their "heat ray" and project its "parallel beam" against everything surrounding them, burning people alive and destroying cars, houses, cities. Despite several announcements during the program that it was fictitious, the news format of the broadcast caught casual listeners by surprise. At the end, when Professor Pierson read his diary and revealed that the Martians had been defeated by terrestrial microorganisms, it was too late.

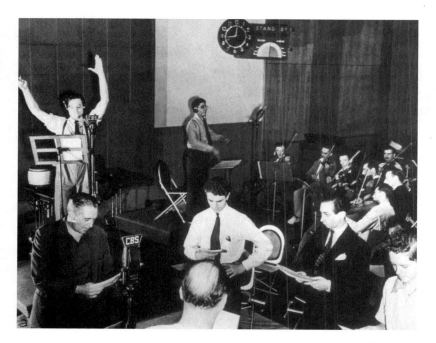

2. Orson Welles, *The War of the Worlds,* radio play, 1938. Millions of Americans tuned in to a popular radio program to find out that Martians were invading the Earth. Welles's broadcast breached the boundaries between fact and fiction. © Archive Photos/Archive Films.

With nervous voices, *Mercury Theater* actors and actresses depicted the landing of Martian war machines, the fire ignited by the deadly rays, and the panic of witnesses. The public reacted with anguish and despair. Nobody died, but several people were injured, miscarriages occurred, houses were left behind without a second thought, roads were caught in huge traffic jams, and policemen and firemen were mobilized against the invisible menace. In New York City, many residents loaded their cars and drove away from New Jersey. Calls from the East overloaded the telephone lines in the Southwestern United States, and in Newark, New Jersey, hundreds of doctors and nurses called hospitals to volunteer their services. In Concrete, Washington, an accidental blackout happened exactly at the point in the transmission when the Martians were taking control over the country's power system. In the South, people sought refuge in local churches, and in Pennsylvania a woman was saved from suicide by the timely return home of her husband. Angry listeners filed lawsuits against Welles and CBS, without major consequences. Welles's contract made him not responsible for consequences of any of the program's broadcasts, and CBS could not

be severely penalized since there was no previous similar case on which to base an evaluation of the incident.

Welles's simulated Martian invasion revealed, for the first time, the true power of radio. It exhibited the unique ability of radio to play with the breath of speech and the plastic sonority of its special effects to excite the imagination of the listener. It showed how the technical reliability of the medium built its credibility, giving veracity to news transmitted through it. It explored unique temporal rhythms, mixing real time (the transmission lasted about one hour) and dramatized time (Professor Pierson tells us at the end that the whole event happened in a few days). The silence between the cuts (from music to news and vice versa) was not simply an absence of sound, as in a musical pause; it was presented to the listener as the actual waiting time to link the reporter at the scene of the landing to the crew in the studio. Even more significant was the fact that during the transmission the panic felt by thousands of listeners was very real. The invasion was an event that happened in the medium of radio, and this medium was already so much a part of the lives of the listeners—it was so transparent and unquestionably reliable—that the transmission was not experienced as a representation or enactment. It was "hyperreal" in Baudrillard's sense of the word, an experience in which signs not grounded in reality are so real that they become more real than the real.[28] Welles made explicit the pseudotransparency of the mass media by unveiling the mechanisms by which the media tries to make itself a clear window to truth, the way it pretends to ignore its own mediation, and the influence it has on the collective unconscious. No doubt, Welles attracted the rage of lawmakers with a propensity to censorship. Radio and electronic media would never be the same after the simulated invasion from Mars.

## Telephone Pictures, Spatialist TV, Conceptual Telex

The telegraph, the telephone, the automobile, the airplane, and of course radio were for the avant-garde artists of the first decades of the twentieth century a symbol of modern life, in which technology could extend human perception and capabilities. The Dadaists, however, deviated from the general enthusiasm for scientific rationalism and criticized technology's destructive power. In 1920, in *The Dada Almanac,* edited in Berlin by Richard Huelsenbeck, they published the irreverent proposal that a painter could now order pictures by telephone and have them made by a cabinetmaker.[29] This idea appeared in the *Almanac* as a pun and a provocation. Constructivist Hungarian artist Laszlo Mo-

# The Aesthetics of Telecommunications

holy-Nagy (1895–1946) arrived in Berlin in January 1921, but it is highly unlikely that he read it or heard about it. What is certain is that the soon-to-be member of the Bauhaus believed that intellectual motivations were as valid as emotional ones in creating art and decided to prove it to himself. Years later, the artist wrote:

> In 1922 I ordered by telephone from a sign factory five paintings in porcelain enamel. I had the factory's color chart before me and I sketched my paintings on graph paper. At the other end of the telephone the factory supervisor had the same kind of paper, divided into squares. He took down the dictated shapes in the correct position. (It was like playing chess by correspondence.) One of the pictures was delivered in three different sizes, so that I could study the subtle differences in the color relations caused by the enlargement and reduction.[30]

With the three telephone pictures (fig. 3) described here, which were shown in his first one-man show, in 1924, at the gallery Der Sturm in Berlin (fig. 4), the artist was taking his Constructivist ideas several steps further. First, he had to determine precisely the position of forms in the picture plane, with the minute squares in the graph paper as the grid through which the pictorial elements structured themselves. This process of pixellation in a sense anticipated the methods of digital art. In order to explain the composition over the phone, Moholy-Nagy had to convert the artwork from a physical entity to a description of the object, establishing a relationship of semiotic equivalence. This procedure antedates concerns set forth by conceptual art in the 1960s. Next, Moholy-Nagy transmitted the pictorial data, making the process of transmission a significant part of the overall experience. The transmission dramatized the idea that the modern artist can be subjectively distant; he or she can be personally removed from the work. It expanded the notion that the art object does not have to be the direct result of the hand or the craft of the artist. Moholy-Nagy's decision to call a sign factory, capable of providing industrial finishing and scientific precision, instead of, say, an amateur painter, attests to his motive. Furthermore, the multiplication of the final object in three variations destroyed the notion of the "original" work, pointing toward the new art forms that would emerge in the age of mechanical reproduction. Unlike Monet's sequential paintings, the three similar telephone pictures are not a series. They are copies without an original. Another interesting aspect of the work is that scale, a fundamental aspect of any art piece, becomes relative and secondary. The work becomes volatized, being able to be embodied in different sizes. Needless to say, relative

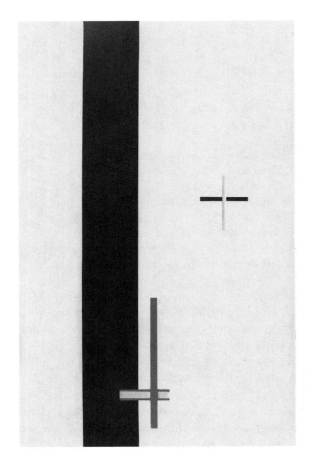

3. Laszlo Moholy-Nagy, *Telephonbild* (Telephone Picture EM 2), porcelain enamel on steel, 18 3/4 × 11 7/8 in (47.5 × 30.1 cm), 1922. In 1922 Moholy-Nagy dictated a composition over the phone to the foreman of a sign factory, who took down the shapes. The form was executed in three different sizes. (Museum of Modern Art, New York.)

scale is a characteristic of digital art, where the work exists in the virtual space of the screen and can be embodied in a small print and in a mural of gigantic proportions.

Despite all the interesting ideas it announces, the case of the telephone pictures is controversial. Moholy-Nagy's first wife, Lucia, with whom he was living at the time, states that in fact he ordered them in person. In her account of the experience, she recalls that he was so enthusiastic when the enamel paintings were delivered that he exclaimed, "I might even have done it over the phone!"[31] The third personal record of the event—and to the best of my knowledge there are only three—comes from Sibyl Moholy-Nagy, the artist's second wife:

> He had to prove to himself the supra-individualism of the Constructivist concept, the existence of objective visual values, independent of the artist's inspiration and his specific *peinture*. He dictated his paintings to the foreman of a sign factory, using a

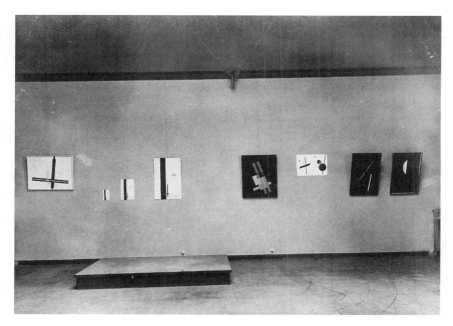

4. Laszlo Moholy-Nagy, *Telephone Pictures*, at the gallery Der Sturm, Berlin, 1924. (Courtesy of Hattula Moholy-Nagy.)

color chart and an order blank of graph paper to specify the location of form elements and their exact hue. The transmitted sketch was executed in three different sizes to demonstrate through modifications of density and space relations the importance of structure and its varying emotional impact.[32]

We are left with the question, usually set aside by commentators, of whether Moholy-Nagy actually employed the telephone or not. Although apparently irrelevant, since the three works were actually painted by an employee of a sign factory according to the artist's specifications and were named *Telephone Pictures* by Moholy-Nagy himself, this question cannot be totally disregarded or answered. It is possible, for example, that Moholy-Nagy delivered partial sketches and offered additional instructions over the phone. Lucia seems to remember the event clearly, but her book has several documented errors, which also put in question her assertions about *Telephone Pictures*. In the absence of proofs that state otherwise, the artist's account would have to be preponderant.

One tends to assume they could in fact have been ordered over the phone because Moholy-Nagy was an enthusiast of new technologies in general and of telecommunications in particular. It was precisely in

1922 that the first transatlantic facsimile service was established by RCA, faxing a photo across the Atlantic in six minutes. Also in 1922, German researcher Arthur Korn's facsimile system was used to transmit, by radio, a photograph of Pope Pius XI from Rome to Maine. The picture was published the same day in the *New York World*. This was a breakthrough, since at the time news pictures crossed the ocean by ship. In the book *Painting, Photography, Film*,[33] originally published in 1925, Moholy-Nagy reproduced two "wireless telegraphed photographs" and a sequence of two images he described as examples of "telegraphed cinema"—all by Arthur Korn. Still, in *Painting, Photography, Film,* Moholy-Nagy issued an early call for new art forms to emerge out of the age of telecommunications:

> Men still kill one another, they have not yet understood how they live, why they live; politicians fail to observe that the earth is an entity, yet television has been invented: the "Far Seer"—tomorrow we shall be able to look into the heart of our fellowman, be everywhere and yet be alone. . . . With the development of photo-telegraphy, which enables reproductions and accurate illustrations to be made instantaneously, even philosophical works will presumably use the same means—though on a higher plane—as the present day American magazines.[34]

From the perspective of the development of electronic art, Moholy-Nagy is the most important artist of the avant-garde of the first half of the twentieth century. His contribution is as relevant for electronic art as Picasso's is for the new figure, Duchamp's is for conceptualism, and Kandinsky's is for nonreferential art. Articulating with astonishing clarity in his works, articles, and books that new technologies are contemporary art-making media, Moholy-Nagy produced a body of work that forms an outstanding legacy for electronic, media, and digital art. Moholy-Nagy's conviction that telecommunications media could open a new field of artistic experimentation remained strong throughout his life. In 1930 he finished the construction of his groundbreaking kinetic sculpture *Light-Space Modulator* after eight years of development. In an article discussing *Light-Space Modulator,* published in the same year of its completion, the artist wrote:

> It may even be predicted that such light displays will be relayed by the radio, partly as tele-projection and partly as real light shows, when radio receivers have their own illuminating device with regulatable electric color filters to be controlled from the center at long distance.[35]

Moholy-Nagy was absolutely current in his understanding of state-of-the-art television research. In 1923, the same year that he joined the Bauhaus, the Hungarian Dénes von Mihály, working in Berlin, filed a patent for his Phototelegraphic Apparatus and published the first book about television, entitled *Das elektrische Fernsehen und das Telehor* (The Electric Television). This nascent technology experienced enormous growth throughout the 1920s and into the early 1930s, with occasional public demonstrations such as the landmark 1925 "First Public Display of Television," realized by John Logie Baird at Selfridge's department store in London. In the United States, in 1928, Francis Jenkins started regular broadcasts of his "Radiomovies." Viewers could purchase or build themselves the "Radiovisor" receiver and see animated silhouettes transmitted by Jenkins via radio. This successful pioneering effort—which Jenkins dubbed "Pantomime Pictures by Radio for Home Entertainment"—jump-started the incipient American television industry.[36] Moholy-Nagy concluded that such developments would lead to experimental art with the moving image transmitted at a distance and that this image stream "relayed by the radio" would be combined with "real light shows" taking place locally in a physical environment. This hybrid of the virtual and remote with the physical and local imagined by Moholy-Nagy anticipated possibilities that would only start to materialize decades later. In 1952 Lucio Fontana, founder of the Spatialist art movement, realized a pioneering live television broadcast in Milan (fig. 5) that was the true beginning of video art. In this broadcast he used his perforated paintings to create dynamic light and shadow patterns on the air.[37] More concretely, Moholy-Nagy's vision would start to be systematically investigated in the 1960s and afterward, when new generations of artists embraced video recorders, video synthesizers, satellites, cable TV, and video installations.

Moholy-Nagy proposed that an art to emerge out of television must reject reproduction of reality and favor the production of new realities based on the unique possibilities of the medium. Realizing that electronics would afford an experimental program not circumscribed by the optical limits of cinema, Moholy-Nagy stated that this new art must reject the conventions of film and invent its own possibilities. Thus in 1930 he criticized Leon Theremin for "imitating the old orchestral music by his new ether wave instrument" instead of fostering a new music. Paving the way for a future art form, Moholy-Nagy asserted:

> The more the technical equipment of the film and of other related forms of communication and expression (wireless and television with all their manifold possibilities) is perfected, the greater will

5. Lucio Fontana, Spatialist live television broadcast, Milan, May 17, 1952. In this broadcast Fontana used light and his perforated paintings (*a*) to create dynamic light and shadow patterns on the air (*b*). (Courtesy of Fondazione Lucio Fontana.)

be the responsibility for elaborating a rational program of work. ... A new program of research would lead to the discovery of an entirely new, so far unprecedented form of expression and entirely new possibilities of artistic creation.[38]

As technology becomes ever more pervasive, the importance of Moholy-Nagy's work and ideas for contemporary art will become more clear. This modernist giant stands side by side with Picasso, Kandinsky, and Duchamp in terms of how profoundly his oeuvre changed art in the twentieth century.

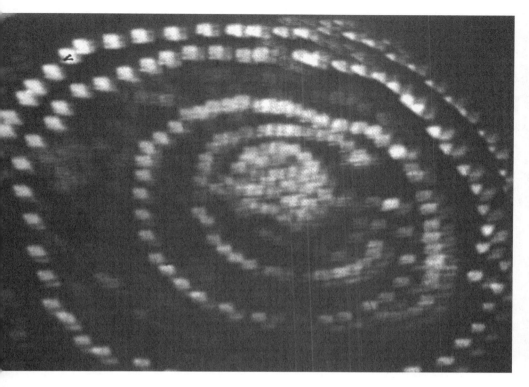

(b)

With Moholy-Nagy's three telephone pictures we see the artist acknowledging the conceptualizing power of the telephone exchange. Throughout the 1960s, the telephone—or more precisely, the telephone call—became a common art medium, particulary in the work of artists associated with Fluxus. George Brecht, Ken Friedman, Davi Det Hompson, and Ben Vautier, among others, wrote several "event scores" that centrally employed the telephone as a signifying agent and that were actually performed by the authors or others. These scores were often short lists of suggested actions to be interpreted and enacted by a performer. Most events were exquisite in their prescriptive ordinariness. Some went beyond the aesthetics of surprise to actually create dialogical situations that enabled performer and participants to engage in live exchanges. A 1961 score by George Brecht[39] combined both possibilities:

**Three Telephone Events**
When the telephone rings, it is allowed to continue ringing until it stops.
When the telephone rings, the receiver is lifted, then replaced.
When the telephone rings, it is answered.

Moholy's pioneering work was recognized by the Museum of Contemporary Art, in Chicago, as a forerunner of the conceptual art of the 1960s with the November 1–December 14, 1969, exhibit Art by Telephone. Thirty-six artists were asked to place a phone call to the museum, or to answer the museum's call, and then to instruct museum staff about what their contribution to the show would be. The museum then produced the pieces and displayed them. A record catalog was produced with recordings of the phone engagements between artists and museum. The director of the museum, Jan van der Marck, maintained that no group exhibition had tested the aesthetic possibilities of remote-control creation:

> Making the telephone ancillary to creation and employing it as a link between mind and hand has never been attempted in any formal fashion.[40]

Art by Telephone was not meant as a telecommunications art event. It was a group exhibition of works produced by an unusual method: telephone descriptions followed by curators' implementations. The artist was to be, as in the case of Moholy-Nagy, physically absent from the process. Marck saw this as an expansion of the syncretism among language, performance, and visual arts characteristic of the decade. Conceptual art set the framework for the emergence of telecommunications art by emphasizing that *cosa mentale* that Duchamp had already defended against the purely visual result of retinal painting. Marck wrote that the participants

> want to get away from the interpretation of art as specific, handcrafted, precious object. They value process over product and experience over possession. They are more concerned about time and place than about space and form. They are fascinated with the object quality of words and the literary connotation of images. They reject illusion, subjectivity, formalist treatment and a hierarchy of values in art.[41]

This exhibit's pioneering status in the development of the aesthetics of telecommunications was counterbalanced by many artists' rather shy response to the challenge of making creative use of the telephone.

## The Aesthetics of Telecommunications

The majority of the participants had never worked with communications or telecommunications before, but what is noticeable is that their response to this unique opportunity was still bound by the notion that the work of art is embodied in tangible matter—even if matter without durable substance. Most artists used the telephone in an ordinary way, providing instructions for the making of objects and installations; only a few dared to transform an actual communication experience into the work itself. The most notable exceptions were Iain Baxter, Stan VanDerBeek, Joseph Kosuth, James Lee Byars, and Robert Huot.

Iain Baxter had founded the N. E. Thing Company (NETCO), a conceptual art group active from 1966 to 1978 that was registered as a business and functioned like one in a parodic and critical mode. Operating out of Vancouver like a real company also enabled Iain Baxter to gain access to telecommunications equipment otherwise unavailable for private use. He started to work with telecommunications media in 1968, when he had telecopier and telex equipment installed in his home (fig. 6). "Telecopier" is the early name of the fax machine. "Telex" is an acronym for TELegraph EXchange—that is, teletypewriters (teletype) linked via the telegraph network. Already in 1968 Baxter used the telex network to send irreverent "messages" to members of the network, which was composed exclusively of businesses and corporations, and cultural organizations as well. Occasionally office personnel responded to the unsolicited telexes in playful ways. Upon installation, Baxter was able to send telexes for free for twenty-four hours, so the artist "advertised" the N. E. Thing Company to network members. Baxter often telegraphed or telexed conceptual art propositions and visual poems, such as *TransVSI Number 12* (1970), a patterned rectangular form (eight inches across and five inches down) organized in three vertical blocks, each composed respectively of the letters *S*, *K*, and *Y,* and sent to the exhibition Information, realized at the Museum of Modern Art, in New York, in 1970 (fig. 7). All NETCO works were received and instantly hung on MOMA's walls. For the Art by Telephone exhibition, Baxter faxed the museum images of worldwide objects, persons, and events that received the N. E. Thing Company "seal of approval."

At the time of the exhibition, Stan VanDerBeek had produced theatrical multimedia pieces and pioneering computer animations. In 1966 he completed the Movie-Drome, in Stony Point, New York, near his house. In this dome-shaped environment audiences lay down while still and moving images were projected on all surfaces above them. VanDerBeek had also experimented with the transmission of pictures from one source to several distant cities. For Art by Telephone he devised a closed-circuit version of his current work, allowing visitors at

6. Iain Baxter sending art telexes from his home in Vancouver, 1968. (Courtesy of Catriona Jeffries Gallery, Vancouver.)

one end of the galleries to feed a fax machine with some of the artist's collages and have them reappear at the other end.

Joseph Kosuth used the context of the show to give continuity to his project of "data dispersion through the mass media," as Jan van der Marck wrote in the exhibition's record catalog. At that point Kosuth was working on an exhibition that was to take place in fifteen cities

```
MODERNART NYK
N E THING VCR

N E THING CO LTD
CTMMUNICATIONS DEPT
1419 RIVE
        SIDE DRIVE N VA COUVER BC CANADA

TRANS-VSI NUMBER    12    @1970
```

(telex image of repeating S, K, and Y letter blocks)

```
N E THING VCR
MODERNART NYK
```

7. Iain Baxter, *Trans VSI Number 12*, telex, 5 × 8 in, 1970. This telex artwork was organized in three vertical blocks, each composed respectively of the letters S, K, and Y, and transmitted to the exhibition Information, realized at the Museum of Modern Art, New York, in 1972. (Courtesy of Catriona Jeffries Gallery, Vancouver.)

around the world and that would require museums or galleries to place ads in local newspapers. The Chicago contribution to the project was an ad in the Panorama section of the *Chicago Daily News* on November 1. In the exhibition space, visitors saw nothing but labels indicating the cities involved in the project.

Only James Lee Byars and Robert Huot used the telephone to generate a communication experience. Byars's piece contradicted the idea of the show at the same time that it took it literally, in that the artist was scheduled to appear on November 13 in the museum and engage in a short silent phone call with French writer Alain Robbe-Grillet (fig. 8). Byars informed the museum that it would be their first meeting. "To me this is an incredible dramatization of a first meeting," said the artist. But perhaps even more dramatic, if not more literal, was Huot's interactive proposal. It potentially involved all visitors to the museum and attempted to generate unexpected first meetings by employing chance and anonymity. Twenty-six cities in America were chosen, each starting with a different letter of the alphabet, and twenty-six men named Arthur were selected, one in each city. Each Arthur's last name was the first listing under the initial letter of the city (Arthur Bacon in Baltimore, for instance). The museum displayed a list of all cities and names and invited visitors to call and ask for "Art." The work was the unexpected conversation between "Art" and the visitor, and its development was totally up to them. Huot's piece, no matter if intended as a pun on the title of the show, presents the artist as the creator of an active context—not a passive experience. It disregards pictorial representation, gives up control over the work, and takes advantage of the real-time and interactive qualities of the telephone. The piece was meant to spark relationships and by doing so anticipated much of the telecommunications work of the next two decades.

If Baxter was among the first to employ telegraphy as an art medium in the context of conceptual art in the 1960s, it must be noted that one of the earliest telegrams by artists on record was a Dada telegram sent in 1919 by Richard Huelsenbeck, Johannes Baader, and George Grosz from Berlin to Milan. The telegram, addressed to the Italian writer and soldier Gabriele D'Annunzio, and sent to the Italian newspaper *Corriere della sera*, was in response to an unexpected and isolated military move by D'Annunzio who, in the company of volunteers (including Futurism activists), invaded and annexed the city of Fiume, today Rijeka (Croatia). D'Annunzio's illegal occupation and dictatorial government, which was opposed by Italy and the rest of Europe, lasted until January of 1921. The telegram is reproduced in *The Dada Almanac* and reads: "Please phone the Club Dada, Berlin, if the allies protest. Conquest a great Dadaist action, and will employ all means to ensure its recognition. The Dadaist world atlas Dadaco already recognises Fiume as an Italian city."

Another Dada telegram was sent by Duchamp in 1921. That year, Tristan Tzara was organizing a "Dada Salon" at the Galerie Montaigne, in Paris. He asked Jean Crotti and his wife, Suzanne Duchamp,

8. James Lee Byars, *Art by Telephone,* Museum of Contemporary Art, Chicago, 1969. On November 13, 1969, Byars (at the museum) engaged in a short silent phone call with French writer Alain Robbe-Grillet, who was in France. (Museum of Contemporary Art, Chicago.)

to contact Suzanne's brother in New York and solicit a piece for the show. After Duchamp declined, Tzara got Crotti to send Duchamp a telegram with an urgent request for his participation. Duchamp replied by sending Tzara a telegram with two words plus his signature, which read "PODE BAL—DUCHAMP."[42] This *calembour* was a play on "peau de balle" (literally, "skin of ball"), an assertion of refusal, meaning "nothing" or "not at all" or, in French vernacular, "balls to you." In any case, all possible readings of the telegram imply a nonacceptance on Duchamp's part. Instead of displaying the telegram itself, which would have been the ultimate Dada gesture, Tzara hung blank signboards in the space reserved for Duchamp.

Telegraphy progressively found its way into contemporary art practice, with interest increasing from the late 1960s to the mid-1980s. In 1962, as his contribution to a portrait show of Paris dealer Iris Clert, Robert Rauschenberg sent a telegram saying, "THIS IS A PORTRAIT OF IRIS CLERT IF I SAY SO."[43] In 1970 the Japanese artist On Kawara started his "I am still Alive" series of telegrams. From 1970 to 1977 he routinely sent telegrams to art world personalities with the statement "I am still Alive." In Brazil, Paulo Bruscky started sending telexes as works of art in 1973. Known for his work in xerography, fax, and mail art, Bruscky was awarded a Guggenheim fellowship in 1981. In a telex sent in collaboration with Daniel Santiago (fig. 9) to the thirtieth Salão Paranaense de Arte, in Curitiba, Brazil, in 1973, Bruscky described three exhibition proposals: "First proposal: Pile in a corner all crates sent to the exhibition. Title: Art is packed as one pleases. Second proposal: In a room, hang a feather duster from the ceiling, one meter off the floor. Place nearby a bucket with water, a broom, a rag, and additional materials used to clean the museum. Title: A clean museum is a developed museum. Third proposal: On a chair, two meters away from the walls, place nails, hammer, stapler, and a roll of adhesive tape. Material used in setting up the exhibition. Title: Do not touch; This is in exhibition." Undoubtedly, the telegram itself (and its transmission) must be seen as an artwork. Moreover, the text it contained elucidates Bruscky's strategies of intervention and critique. While the first and third proposals challenge ordinary categories seen in official art salons, such as painting and sculpture, the second proposal is a direct and acid critique of the military dictatorship's public health campaign, represented by the slogan "Povo limpo é povo desenvolvido" (A clean people is a developed people). In another telex sent in 1983 to an exhibition realized at the Núcleo de Arte e Cultura da UFRN/Universi-

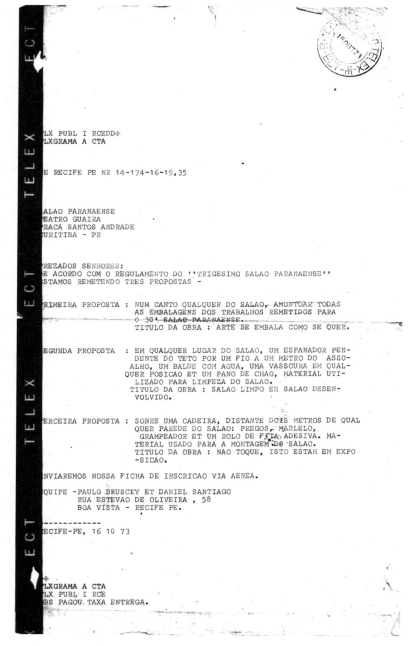

9. Paulo Bruscky (in collaboration with Daniel Santiago), telex sent as artwork to the thirtieth Salão Paranaense de Arte, Curitiba, Brazil, 1973. The telex described three exhibition proposals, one of which was a direct critique of the military dictatorship: "In a room, hang a feather duster from the ceiling, one meter off the floor. Place nearby a bucket with water, a broom, a rag, and additional materials used to clean the museum. Title: A clean museum is a developed museum." (Courtesy of Paulo Bruscky.)

dade Federal do Rio Grande do Norte (Center of Art and Culture, Federal University of Rio Grande do Norte), in Natal, Brazil, Bruscky transmitted: "Art of my time. I'm in a hurry." Also in 1983, Guy Bleus organized a telegraphy exhibition at the Provincial Museum, in Hasselt, Belgium, that included the participation of Paulo Bruscky, Eugenio Dittborn, Carl Andre, Les Levine, Daniel Graham, Achille Cavellini, myself, and many others. This exhibition can be seen as providing a sense of closure to the telegram as an art medium, at a time when the use of telegraphy started to decline due to the rise of digital networks.

## From Visual Telephonics to Media Art

For all the social, political, and cultural implications of the telephone, or more precisely, the dialogic structuring of the telephone, one is compelled to observe that little critical attention has been paid to it. Historical, technical, and quantitative sociological studies can shed little light on the deeper problematics of the telephone, which is adjacent to linguistics, semiology, philosophy, and art. Avital Ronell has brought to the fore a long-distance philosophical call that is as unprecedented as it is welcome. Letting her own discourse oscillate between orality and writing in the connections and reroutings of a metaphorical switchboard, Ronell's book[44] has provided a new philosophical insight, a multiparty line among Martin Heidegger, Sigmund Freud, Jacques Derrida, and of course Alexander Graham Bell. Ronell's gesture, albeit on another plane, is similar to that of those artists who since the late 1970s have found in the telephone an incomparable source for experimentation. Why the telephone?

> In some ways it [the telephone] was the cleanest way to reach the regime of any number of metaphysical certitudes. It destabilizes the identity of self and other, subject and thing, it abolishes the originariness of site; it undermines the authority of the Book and constantly menaces the existence of literature. It is itself unsure of its identity as object, thing, piece of equipment, perlocutionary intensity or artwork (the beginnings of telephony argue for its place as artwork); it offers itself as instrument of the destinal alarm, and the disconnecting force of the telephone enables us to establish something like the maternal superego.[45]

The beginnings of telephony argued for the artistic merits of the telephone based on its capacity of transmitting sound over long distances, that is, based on its resemblance to what we know as radio. It would be possible, Antonio Meucci, Bell, and other pioneers hoped, to listen

to operas, news, concerts, and plays over the phone. In Bell's earliest lectures and performances, when the two-way-ness of the medium was still a technical obstacle, Thomas Watson would play the organ and sing over the phone to entertain the audience and demonstrate the possibilities of the new device. Several decades later, if business over the telephone multiplied transactions, its use in the coziness of the household provoked mixed reactions. John Brooks points out[46] that H. G. Wells, in his "Experiment in Autobiography" (1934), complained about the invasion of privacy spawned by the telephone. Wells expressed his desire for

> a one-way telephone, so that when we wanted news we could ask for it, and when we were not in a state to receive and digest news, we should not have it forced upon us.[47]

Wells was conjuring an image of a future all-news radio station, the creation of which, as McLuhan has noticed, would later result from television's impact on radio. More important, Wells was reacting to the intrusion of that "destinal alarm" that Ronell refers to, to that "disconnecting force" of the telephone that is so disturbing and attractive, so unsettling and arresting. When Wells stresses that the telephone provides news even when he does not desire it, he promotes notice of that projective trait of the telephone, which is the launching of speech—and speech alone—in the direction of the other in constant demand for immediate readiness. This demand takes place in the linguistic domain and is properly answered by a question that is at the same time a dubious answer: "yes?" Or, more commonly, a mixture of compliment and demand: "hello?"

Perhaps what is unique about ordinary telephony is that in its circuitry only spoken language circulates. As Robert Hopper has suggested,[48] the telephone emphasizes the linearity of signs by splitting sound off from all other senses, by isolating the vocal element of communication from its natural congruity with the facial and the gestural. By cutting the audile out of its interrelation with the visual and the tactile, and by separating interlocutors from the speech community, the telephone abstracts communication processes and reinforces Western phonocentrism,[49] now translated into an outreaching telephonocentrism. It is to destabilize this phonocentrism, and subsequently to contribute to undoing hierarchies and centralization of meaning, knowledge, and experience, that theorists like Ronell and telecommunications artists invest their calls. In the twentieth century, what Derrida calls phonocentrism can be traced back to Saussure, and Hopper cau-

tiously finds Saussure bound to the telephone. Hopper supports his argument with evidence that Saussure lived in Paris when the city saw the boom of telephony. But more than that, he reminds us that the telephone was developed by a speech teacher of the deaf (Bell), and he stresses the acute resemblance of Saussure's speaking circuit to telephonic communication.[50] In the almost scientific vocal isolation of telephony and in the presence of absent speakers, speech speaks loudly of its linear structure and offers itself for theoretical (and artistic) investigation.

Being this entity that excludes all that is different from vocal immediacy, the telephone speaks volumes of its platonic metaphysical framework. But when zeroing in on several particulars of telematic experience, one instantiates new insights on the telephonic structure that contribute to a possible deconstruction of that framework. Perhaps the most relevant aspect of the new telephonic syntax is its technical absorption of the graphic element. It is technically possible not only to talk but to write over the phone (chat, email, mobile phone messaging); to print over the phone (fax, remote printing); to produce and record sound and video (answering machine, SSTV, videophone) over the phone. As we have seen, it is also very likely that in the future, fiber optics will give us access to telecyberspace. The telephone is becoming the medium par excellence of that "enlarged and radicalized" writing that signals Derrida, but contrary to what one would otherwise hypothesize, the more the telephone becomes speechless, the more central its role becomes in our lives. It is clear that the telephone is slowly but continuously ceasing to owe its existence exclusively to orality, but the cultural implications of this new aspect of contemporary life remain to be further elaborated as an aesthetic experience.

If the artist can have a unique encounter with technology because he or she is an expert aware of changes in sense perception, as McLuhan purported,[51] then it is the artist who will instigate the discovery of new realms of experience beyond ordinary cognition. A radical departure toward telecommunications art took place worldwide in the 1960s, when artists privileged action over aura and process over product. I mentioned earlier the exhibition Art by Telephone as one example of this break with tradition, but there are other equally significant examples. In synchrony with (if not in anticipation of) the international movement toward the dematerialization of the art object,[52] between 1966 and 1968 Argentinean artists such as Eduardo Costa, Marta Minujin, and Roberto Jacoby created in Buenos Aires communications and mass media works. In her collaborative *Simultaneidad en simultaneidad* (Simultaneity in Simultaneity), from 1966, Minujin proposed to collapse time by integrating media such as telephone, radio, television, and telegraphy.[53] Also in 1966 Eduardo Costa, Roberto

Jacoby, and Raúl Escari published the manifesto "Un arte de los medios de comunicación" (A Media Art).[54] In this manifesto they proposed to

> take on the ultimate characteristic of the media: the de-realization of objects. In this way the moment of transmission of the work of art is more privileged than its production.

Their 1966 piece *Primera obra de un arte de los medios de comunicación* (First Work of Media Art) consisted of distributing to the media (and getting published in them) precise verbal and visual information (press release, photographs) about an event that did not take place—without telling the media the information was false (fig. 10). They were successful: one newspaper and six magazines published articles and pictures based on the fake press release. Writing at the time, the sociologist Eliseo Verón noted that the work created "the unusual image of communications media operating in a void" and that he believed that "the art of the future postindustrial society will be more similar to this experience by Costa, Escari, and Jacoby than to a Picasso painting: an art of objects that we might not be able to imagine, the material of which is social and not physical, and the form of which is constituted of systematic transformations of communications structures."[55]

Also in 1966, giving continuity to the Media Art program, Eduardo Costa started his Fashion Fiction series, which he would intermittently develop until the late 1980s.[56] *Fashion Fiction I* was first published in *Vogue* in 1968, in New York (fig. 11), and then again in the magazine *Caballero,* in Mexico City, in 1969. For this work Costa produced one-of-a-kind objects that were photographed and published as if they were mass-produced fashion accessories. The objects included gold fingers, gold toes, gold hair strands, and gold ears. Worn by models and photographed professionally, these props yielded lush images that, through their seductive power, led readers to think they were widely available in the world at large. However, these objects and their photographs were the vehicle through which the artist investigated how the mass media creates—rather than reproduces—reality.

In 1968, also giving continuity to the Media Art concept, Jacoby presented at the Instituto Di Tella, in Buenos Aires, the installation *Mensage* (Message). The work consisted of three elements: a photograph of an African American man holding a sign that read "I Am A Man,"[57] a teletype[58] machine from the France-Press Agency constantly transmitting daily news, and a poster displaying a text written by Jacoby in which he stated that "all phenomena from social life have been converted into mass media" (fig. 12). By presenting three different kinds of political messages, the artist revealed the material reality

10. Eduardo Costa, Roberto Jacoby, and Raúl Escari, *Primera obra de un arte de los medios de comunicación* (First Work of Media Art), 1966. This work consisted of distributing to the media (and getting published) precise verbal and visual information (press release, photographs) about an event that did not take place. (Courtesy of Eduardo Costa.)

of concepts and stories circulated by communications media. He also pointed out that, just as artists could work with traditional media, it was also possible to work with "ideological content, with social communications structures."[59]

These pioneering works found resonance in the telecommunications art created in the 1980s and 1990s. A small number of artists motivated by a spirit of genuine artistic inquiry turned their back on accepted conventions and committed themselves to creating events in the placeless place of networking, where digital processing meets telecommunications.

### Networking and Telematics

One of the earliest telematic events of global proportions was Roy Ascott's *Terminal Art* (fig. 13), realized in 1980 with Jacque Vallee's Infomedia Notepad computer conferencing system. Ascott described the experience:

11. Eduardo Costa, *Fashion Fiction I*, published in *Vogue* (3.5 million copies), New York, 1968. Costa produced one-of-a-kind objects that were photographed and published as if they were mass-produced fashion accessories. (Courtesy of Eduardo Costa.)

12. Roberto Jacoby, *Mensage* (Message), as seen at the Instituto Di Tella, Buenos Aires, 1968. The work consisted of three elements: a photograph of an African American man holding a sign that read "I Am A Man," a teletype machine from the France-Press Agency constantly transmitting daily news, and a poster displaying a text written by Jacoby in which he stated that "all phenomena from social life have been converted into mass media." (Courtesy of Roberto Jacoby.)

I set up my first international networking project, mailing portable terminals to a group of artists in California, New York and Wales to participate in collectively generating ideas from their studios. One of the group, Don Burgy, chose to take his terminal wherever he was visiting and log-on from there. . . . The possibilities of the medium began to unfold.[60]

Ascott's next telematic work was *La Plissure du Texte* (The Pleating of the Text), realized in the context of the 1983 exhibition Electra, organized by Frank Popper for the Museum of Modern Art, in Paris (fig. 14). The title of the work alludes to Roland Barthes's book *Le plaisir du texte* (The Pleasure of the Text). Ascott's project was an asynchronous fairy tale, created by multiple participants around the world through the I. P. Sharp time-sharing system: participants logged on with portable terminals and posted their contributions, made from the perspective of the role or identity they selected from a repertoire of fairy tales. These were later assembled in the order they were received by some of the remote participants. Although different versions exist, together the messages form an experimental book worthy of publication as an important document of the period.[61] Ascott published a statement in the Electra catalog in which he asserted:

13. Roy Ascott, *Terminal Art*, international telematic event linking California, New York, and Wales, 1980. Artists participated in collectively generating ideas from their studios. (Courtesy of Roy Ascott.)

```
PPPPPPPP      OOOOO         OOOOO       FFFFFFFFFFFF
P       PP   OO   OO       OO   OO      F
P        P   O     O       O     O      F
P        P   O     O       O     O      F
P       PP   O     O       O     O      FFFFF
PPPPPPPP     O     O       O     O      F
P            O     O       O     O      F
P            O     O       O     O      F
P             OO   OO       OO   OO     F
P              OOOOO         OOOOO      F
```

?:Y

NO.406
FROM ASCOT TO NEXUS SENT 19.52 13/12/1983
FROM TRICKSTER
THE RAVENS (4) CIRCLING OVER THIS DESOLATE LAND
OF UNRECEIVED SIGNAL;S AND SOILED SCRAPS OF PAPER
LODGED WITHIN THE PLETHORA OF THEIR OWN STOOLING
ROLL RESTLESSLY.
WITHOUT THE MONUMENTAL INDIFFERENCE OF THE
TRICKS(Y)TER WHIM THEY REPRESENT THEY CANNOT
SUFFERE THE WINTERY INACTIVITY WITH THE SAME
WHITE COMPOSURE.
THROUGH LA NEIGE (THAT BLIX SENDS) THEY GLIMPS
E LA GLACE (283 FRONT). THEY ARE HIGH (ON THEIR
ENNUI) AND IN ANYCASE THESE MESSAGES TAKE A WHILE
TO TRAVEL.
MIRROR WHO IS THE FAIREST IN THE LAND? AND THE
DARK RAVENS (4) SEE THEIR CHANCE FOR REPLY.
GYHVBTJK
YHUOGBNN
UYHIJOP
T6UYBIV
LA GLISSURE DU TEXTE

?:Y

NO.407
FROM FRONT TO NEXUS SENT 19.48 13/12/1983

14. Roy Ascott, *La Plissure du Texte* (The Pleating of the Text), international telematic event, Museum of Modern Art, Paris, 1983. The work was an asynchronous fairy tale, created by on-line participants around the world. Detail of exchange. (Courtesy of Roy Ascott.)

Telecommunications and computer systems when they converge create an electronic space which presents radically new possibilities for the artist. It is an interactive space in which the locations of the participants are irrelevant. The message system is not simply "send-receive"; meaning is generated out of the negotiations between participants in the system who, because of computer mediation, can access this new information space asynchronically—that is, without constraints of time or space such that times of access, of input and retrieval need not be linear.[62]

Roy Ascott also organized, with Tom Sherman and Don Foresta, the Ubiqua telecommunications lab at the forty-second Biennale de Venezia (1986), which enabled participation with multiple media, including text (I. P. Sharp network), SSTV, and fax.[63] Among the many international groups that participated in Ubiqua was the Pittsburgh-based Dax (Digital Art Exchange) group, originally formed by Bruce Breland in 1982 and now based in Bellingham, Washington. One of the first activities of the Dax group was participation in *The World in 24 Hours* (1982) (fig. 15), a global network organized by Robert Adrian for Ars Eletronica, in Linz, Austria, which linked artists and groups in Vienna, Frankfurt, Amsterdam, Bath, Wellfleet, Pittsburgh, Toronto, San Francisco, Vancouver, Honolulu, Tokyo, Sydney, Istanbul, and Athens. Artists participated with SSTV, fax, computer mailbox (email), or telephone sound. Three years later, Dax stretched the notion of worldwide interaction with *The Ultimate Contact,* an SSTV piece created over FM radio in collaboration with the space shuttle *Challenger,* in orbit around the earth. In 1990 they collaborated with African artists in a telecommunications event. In July of that year they created *Dax Dakar d'Accord,* an SSTV exchange with artists in Pittsburgh and Dakar, Senegal, as part of a Senegalese five-year commemoration of the African diaspora, the Goree-Almadies Memorial.[64] Participants from Dakar included Bruce Breland; Matt Wrbican; Bruce Taylor; Mor Gueye (glass paintings); Serigne Saliou Mbacke (sand paintings); Les Ambassadeurs (dance and music); Le Ballet Unité Africaine (dance and music); and Fanta Mbacke Kouyate, performing "Goree Song," which makes reference to Goree Island in Dakar Harbour, a holding and embarkation place for the slave trade that took place over a four-hundred-year period.

In Brazil—or perhaps I should say in and out of Brazil—artists such as Mario Ramiro, Carlos Fadon, Otávio Donasci, and Gilbertto Prado (a member of the French Art Reseaux group) have worked with telecommunications since the early or mid-1980s. All four artists live and work in São Paulo. The events created by these artists, some of

15. Robert Adrian, *The World in 24 Hours,* international telematic event, Ars Electronica, 1982. The work linked artists in sixteen cities on three continents for a day and a night. Artists at work in Linz (*a*); fax sent from Vancouver to Linz (*b*). (Courtesy of Robert Adrian.)

# The Aesthetics of Telecommunications 43

whom have occasionally worked together, encompass exchanges on both a national and international scale.

Mario Ramiro is also a sculptor who works with zero gravity and infrared radiation. He has initiated and participated in a number of telecommunications events with fax, SSTV, videotext, live television broadcasts, and radio.[65] *Altamira,* for example, was an installation-performance (fig. 16) created for a connection via telephone and SSTV between São Paulo and Cambridge, Massachusetts, in 1986. Behind a large projection screen, dancer Laly Krotoszynski performed, illuminated by spots and flashes, to the sound of electronic percussion. Her movements were reminiscent of a ritual dance around a bonfire. The images were captured with a video camera and transmitted live to Cambridge via SSTV. Ramiro has also written extensively on the subject of telecommunications art.

Carlos Fadon is a photographer and artist whose work is part of several international collections. One of his most original SSTV pieces[66] is *Natureza Morta/ao Vivo* (Still Life/Alive), from 1988 (fig. 17). This work proposes that once one artist (A) sends an image to another (B), the image received becomes the background for a still life created live. The artist (B) places objects in front of the electronic image, and the combination of both object and image is captured as a video still that is now sent back to the artist (A). This artist now uses this new image as the background for a new composition with new objects and sends it to the artist (B). This process is repeated with no terminus, so that the generation of a still life remains a work in progress through which a visual dialogue takes place. The piece was first realized in 1988, in a live exchange between São Paulo and Pittsburgh that included other artists and different projects.

Otávio Donasci also participated in this São Paulo/Pittsburgh event. Since 1980 Donasci has been creating what he calls "videotheater," a new kind of performance art based on the "replacement" of the head of the performer with electronic imaging devices (mostly screens of different sorts) that can expand the expressive possibilities of the human face.[67] The performer wears a structure supporting a screen above the shoulder or directly on the head. The viewer does not see the structure, which creates the impression of a seamless hybrid, a cyborg with electronic head and human body. Donasci calls this hybrid a "videocreature." The artist has employed his videocreatures in telecommunications projects of different kinds. For the São Paulo/Pittsburgh event, he instructed his remote collaborators to send images of a human head from Pittsburgh via SSTV. He embodied these images in São Paulo as a videocreature, improvising a performance as the images arrived. The result was a being, constructed in real time, with a local body and a

16. Mario Ramiro, *Altamira,* SSTV transmission from São Paulo to Cambridge, Massachusetts, 1986. The work was a performance reminiscent of a ritual dance around a bonfire. (Courtesy of Mario Ramiro.)

head transmitted from thousands of miles away. Donasci's performance was transmitted back, completing the cycle.

In another dramatic instance in 1990, Donasci invited a São Paulo television host to interview people on the street in real time without leaving the TV station (fig. 18). The program *Matéria Prima* (Raw Material), broadcast by TV Cultura in São Paulo, was hosted by Sergio Groissman. Groissman donned a special helmet designed by Donasci and transmitted his face, as he hosted the program, via a microwave link to Donasci's body in the center of São Paulo. Donasci performed his videocreature live on television, hosting Groissman's head in real time on his body. The result was that it seemed that Groissman was physically present both in the center of São Paulo and back at the TV station. Donasci improvised his bodily expression in space as Groissman interacted with passersby through Donasci's body. Television viewers at home could see both sites (the TV studio and the São Paulo downtown) alternately, as the program cut from one to the other in real time. This experimental interactive broadcast created by Donasci enabled an improvisational approach to television that is highly unusual. The freeplay between

17. Carlos Fadon, *Natureza Morta/ao Vivo* (Still Life/Alive), SSTV exchange between São Paulo and Pittsburgh, 1988. The work calls for artists to use a received still-life image as the background for the transmission of another, forming an endless on-line loop. (Courtesy of Carlos Fadon.)

18. Otávio Donasci, live interactive television broadcast using Donasci's "videocreature," 1990. Donasci invited a São Paulo television host to interview people on the street in real time without leaving the TV station. (Courtesy of Otávio Donasci.)

all involved (host, performer, interviewees) and the unexpected and uncontrollable development of the interaction are evocative of the very early days of television, when all broadcasts were live improvisations. However, the dialogical nature of Donasci's experience, in which participants engaged in an intersubjective encounter in real time, imbued the event with an intimate quality hardly conceivable in standard broadcasts.

In Paris, France, the Art Reseaux group, formed in 1988 by Karen O'Rourke, Gilbertto Prado, Isabelle Millet, Christophe Le François, and others, developed elaborate projects such as O'Rourke's *City Portraits*,[68] which called for participants in a global network to travel in real or imaginary cities by means of exchange of fax images (fig. 19). The project, which was realized several times between 1988 and 1991, involved the initial creation of a pair of images, the departure and the arrival. Artists created departures and arrivals using images of the cities they lived in or by manipulating other images to form synthetic landscapes, blending aspects of direct and imagined experiences of the urban environment. These images were taken by remote artists as the extremes of the route they explored. Artists who received departure and arrival faxes improvised routes between these images and transmitted the new images back to the originating city. Through the metamorphosis and fusion of images exchanged over the telephone line artists from France, Brazil, Spain, the United States, and other countries developed a strong sense of proximity. They collaboratively reimagined their local environments as part of a new global space.

Gilbertto Prado created *Connect* (1991), an interactive fax piece (fig. 20) that involves at least two sites and two fax machines at each

# The Aesthetics of Telecommunications

site. The first exchange was between Paris (Art-Réseaux/Université de Paris I–Centre Saint Charles) and Pittsburgh (Carnegie Mellon University–Studio for Creative Inquiry). Artists at each site are asked not to cut the roll of thermal paper in the machine when fax images start to appear. Instead, they are asked to feed that roll into another fax machine and interfere with the images in the process. A loop is then formed, connecting not only the artists but the machines themselves. This new configuration forms a circle in electronic space, linking in an imaginary topology cities that could be as far apart as Paris and Pittsburgh. As an example of possible systems of interaction beyond linear models, Prado designed a circular diagram in which the hands (and not the mouths or the ears of the interlocutors) are the organs used for communication. The diagram places particular emphasis on graphic communication over the telephone.

In Le François's project *Infest* (1992), artists are invited to investigate aesthetically that aspect of contemporary life that is the deterioration of images and documents due to contamination and infection by computer viruses. During the exchanges, images suffer manipulations that attempt to destroy and reconstruct them (infection/disinfection), pointing to the condition of electronic decay in the world of digital epidemiology.

As the metaphors of human existence continue to intermingle with those of cybernetic existence, designers are learning how to cope with issues of interfacing and artists are comparing remote communication to face-to-face interaction. Acknowledging the place of telephony in art, Karen O'Rourke reflected on the nature of fax exchanges as an artistic practice:

> Most of us today have taken not painting (nor even photography) as a starting point for our images, but the telephone itself. We use it not only to send images but to receive them as well. This nearly instantaneous feedback transforms the nature of the messages we send, just as the presence of a live audience inflects the way in which actors interpret their roles or musicians their scores.[69]

Stephen Wilson explored a different realm of telephone interaction by merging telephony with the premise of the Turing test (named after scientist Alan Turing, who in 1950 predicted that computers would eventually imitate humans in conversation with other humans). In a 1992 piece entitled *Is Anyone There?* Wilson had a telemarketing device call pay telephones in San Francisco. When passersby answered the phone, a remote computer engaged the respondent in a conversa-

(a)

(b)

19. Karen O'Rourke, *City Portraits*, series of international fax exchanges, 1988–91. Isabelle Millet's fax (1989) shows a panoramic view of the Place Léon Blum, Paris. The fax (here segmented in four) contains both departure and arrival images. Artists in other countries created routes between these images and transmitted them back to Paris. (Courtesy of Isabelle Millet.)

(c)

(d)

tion about life in the city and recorded the conversation. Wilson wrote: "The drama of their dialogue with the computer system is an essential aesthetic focus."[70] Wilson recorded video showing life near the selected pay phones and produced a database with the audio recordings of the conversations and the video clips. This database was experienced months later as an interactive installation. Periodically, when viewers accessed the database in a gallery, the system placed a call to a local public telephone, engaging the viewer in a live conversation with a stranger.

20. Gilbertto Prado, *Connect,* fax exchange between Paris and Pittsburgh, 1991. Artists fed the paper roll of one fax machine into another and interfered in the images as they were transmitted and received. Prado during the exchange in Paris (*a*); fax detail (*b*). (Courtesy of Gilbertto Prado.)

Traditionally, as in the sign/idea relationship, representation (painting, sculpture) is that which takes place as absence (the sign is that which evokes the object in its absence). Likewise, experience (happening, performance) is that which takes place as presence (one only experiences something when this something is present in the field of perception). In telecommunications art, presence and absence are engaged in a long-distance call that upsets the poles of representation and experience. The telephone is in constant displacement; it is logocentric, but its phonetic space, now in congruity with inscription systems (fax, email), signifies in the absence more typically associated with writing (absence of sender, absence of receiver). The telephone momentarily displaces presence and absence to instantiate experience not as pure presence but, as Derrida wrote, as "chains of differential marks."[71]

## Conclusion

The new aesthetics outlined in the previous pages certainly escapes from the problematic rubric of *fine arts*. The roles of artists and audience become intertwined; the exhibition qua forum where physical objects engage the perception of the viewer loses its central position; the very notion of meaning and representation in the visual arts—associated with the presence of the artist and stable semio-linguistic conven-

tions—is revised and neutralized by the experiential setting of communications. Or, as Roy Ascott wrote:

> The aesthetics in this transformative [interactive] work lies in the behavior of the observer. The artist sets the initial conditions, establishes the larger context, provides the requisite variety, the necessary and sufficient complexity, and then constructs points of entry into the system he has created which will give the observer access to this transformative field.[72]

Our traditional notions about symbolic exchanges have been relativized by new technologies, from answering machines to cellular telephony, from cash stations to voice-interface computers, from surveillance systems to satellites, from radio to wireless modems, from broadcast networks to email networks, from telegraphy to free-space communications. Nothing in these promoters of social intercourse authorizes either sheer optimism or bleak neglect; they call for a disengagement from the concept of communication as transmission of a message, as expression of one's consciousness, as correspondent of a predefined meaning.

The experimental use of telecommunications by artists points to a new cultural problematics and to a new art. How to describe, for example, the encounter between two or more people in the space of the image in a videophone call? If two people can talk at the same time on the phone, if their voices can meet and overlap, what to say about the experience of telemeeting in the reciprocal space of the image? What to say about all the telecommunications models[73] that don't account for the multiparty interwoven fabric of planetary networks? After minimal and conceptual art, does it suffice to return to the decorative elements of parody and pastiche in painting? And the hybridization of media, which compress maximum information-processing capabilities in minimum space? How to deal with the hypermedia that will unite in one apparatus telephone, television, answering machine, video recording and playback, sound recorder, computer, fax/email, videophone, word processing, and much more? How can there be a receiver or a transmitter as positive values if it is only in the connecting act, if it is only in the crisscrossings of telephonic exchanges, that such positions temporarily constitute themselves? Traditionally art has demanded the copresence of the viewer and the artwork. However, new models have emerged that enable interaction from afar and that propose that elements of the work remain out of sight. Contemporary artists must dare to work with the immaterial means of our time and address the pervasive influence of new technologies in every aspect of our lives.

Appendix

**Three Futurist Radio Syntheses from 1933**
Translated by E. Kac

F. T. Marinetti and Pino Masnata

### Drama of Distance

11 seconds of a military march in Rome
11 seconds of a tango danced in Santos
11 seconds of Japanese religious music played in Tokyo
11 seconds of lively folk dance in the countryside of Varese
11 seconds of a boxing match in New York
11 seconds of road noises in Milan
11 seconds of a Neapolitan aria sung in the Hotel Copacabana in Rio de Janeiro

### The Construction of a Silence

1° Construct a left wall with a drum roll (half minute)
2° Construct a right wall with the horning-shouting of a crash between a streetcar and an automobile (half minute)
3° Construct a floor with the spurt of water through pipes (half minute)
4° Construct a ceiling terrace with cip cip srsrcip of sparrows and swallows (20 seconds)

### Battle of Rhythms

A cautious and patient slowness expressed with the tac tac tac of water drops cut to
A flying and elastic arpeggio from a pianoforte cut to
A ring of an electric bell cut to
A silence of three minutes cut to
A sound of a key laboring in a lock ta trum ta trac followed by
A silence of one minute

### Notes

1. C. E. Shannon and W. Weaver, *The Mathematical Theory of Communication* (1949; repr., Urbana: University of Illinois Press, 1963). Shannon's theory seeks to answer the question of how rapidly or reliably information from a source can be transmitted over a channel to a receiver. As a result, the semantic meaning of information plays no role in the theory.

2. The linguist Roman Jakobson employed Shannon's addresser-channel-addressee structure in his analysis of the functions of language but acknowledged the role of the context and the (cultural or linguistic) codes at play. See Roman Jakob-

son, "Linguistics and Poetics," in *Style in Language,* ed. T. Sebeok (Cambridge: MIT Press, 1960), 353–56.

3. Two examples based on personal experience: (a) In 1989, Carlos Fadon and I (Chicago), Bruce Breland and Matt Wrbican (Pittsburgh), and Dana Moser (Boston) collaborated on *Three-City Link,* a slow-scan exchange operated through three-way calling. (b) In 1990, Fadon and I suggested to Bruce Breland the creation of an international telecommunications event to be called *Impromptu,* in which artists would try to engage in conversations with telemedia (fax, telephone, SSTV, videophone) the same improvised way they do when talking face-to-face. Earth Day was going to be celebrated soon, and Bruce suggested we expand the idea to encompass the ecological context and make it *Earth Day Impromptu.* Fadon and I agreed, and we started to work with Bruce and the Dax group, and with Irene Faiguenboim, in organizing it. Later, Bruce's experience with large networks proved crucial: working with other Dax members, he made possible a very large SSTV conference call with several artists in different countries, which was, together with the fax and videophone network, part of the *Earth Day Impromptu.*

4. H. M. Enzensberger, "Constituents of a Theory of the Media," in *Video Culture,* ed. John Hanhardt (New York: Visual Studies Workshop Press, 1986), 104. Enzensberger proposes that "the manipulation of media cannot be countered . . . by old or new forms of censorship, but only by direct social control, that is to say, by the mass of the people."

5. In his "Artists' Use of Interactive Telephone-Based Communication Systems from 1977–1984" (master's thesis, City Art Institute, Sidney College of Advanced Education, 1986), Eric Gidney gives an account of pioneer artist Bill Bartlett's telecommunications events and also of his disappointment with other artists' response: "Bartlett was dismayed at the rapacity of many North American artists, who were willing to collaborate only insofar as it furthered their own careers. He found that some artists would simply refuse to correspond after a project was completed. He felt let down, exploited and 'burned out.' Assaulted by serious doubts, he decided to withdraw from any involvement in telecommunications work" (18). Gidney also summarizes the telecommunications work of pioneer artist Liza Bear and quotes her as saying: "A hierarchical structure is not conceptually well-suited and does not create the best ambiance for communication by artists. This [medium] is only successful in regions where artists and video people already have a good track record of working together, sharing ideas and preparing material" (21).

6. Jean Baudrillard, "Requiem for the Media," in *Video Culture,* ed. John Hanhardt (New York: Visual Studies Workshop Press, 1986), 129. Baudrillard formulates the problem of lack of response (or *irresponsibility*) of the media with clarity: "The totality of the existing architecture of the media founds itself on this latter definition: *they are what always prevents response,* making all processes of exchange impossible (except in the various forms of response *simulation,* themselves integrated in the transmission process, thus leaving the unilateral nature of the communication intact). This is the real abstraction of the media. And the system of social control and power is rooted in it." In order to restore the possibility of response (or *responsibility*) in telecommunications media it would be necessary to provoke the destruction of the existing structure of the media. And this seems to be, as Baudrillard rushes to point out, the only possible strategy, at least on a theoretical level, because to take power over media or to replace its content with another content is to preserve the monopoly of speech.

7. See Eduardo Kac, "Arte pelo telefone," *O Globo* (Rio de Janeiro), Sept. 15, 1987; "O arco-íris de Paik," *O Globo,* July 10, 1988; "Parallels between Telematics and Holography as Art Forms," in "Navigating in the Telematic Sea," ed. Bruce

Breland, *New Observations* 76 (May–June 1990): 7; "On the Notion of Art as a Visual Dialogue," in *Art-Reseaux,* ed. Karen O'Rourke (Paris: Université de Paris I, 1992), 20–23.

8. Roy Ascott, "Art and Telematics," in *Art + Telecommunication,* ed. Heidi Grundmann, (Vancouver, Western Front, and Vienna: Blix, 1984), 25–58; "Is There Love in the Telematic Embrace?" in "Computers and Art: Issues of Content," ed. Terry Gips, special issue, *Art Journal* 49, no. 3 (1990): 241–47.

9. Tim Anderson and Wendy Plesniak, eds., *Art Com* 10, no. 40 (1990). *Art Com* is an on-line magazine forum; this issue was dedicated to the Dax group.

10. Karen O'Rourke, "Notes on Fax-Art," in "Navigating in the Telematic Sea," ed. Bruce Breland, special issue, *New Observations* 76 (May–June 1990): 24–25.

11. Eric Gidney, "The Artist's Use of Telecommunications: A Review," *Leonardo* 16, no. 4 (1983): 311–15.

12. In English, see Fred Forest, "For an Aesthetics of Communication," *Plus Moins Zéro,* N. 43 (Oct. 1985): 17–24; "Communication Esthetics, Interactive Participation and Artistic Systems of Communication and Expression," in "Designing the Immaterial Society," ed. Marco Diana, special issue, *Design Issues* 4, nos. 1–2 (1988): 97–115. For a discussion of Forest's early work with video, mass media, and interventions in social space, see Fred Forest, *Art sociologique* (Paris: Union Générale d'Éditions, 1977). For a discussion of Forest's works from 1967 to 1992, including telecommunications events, see Fred Forest, *100 Actions* (Nice: Z'Editions, 1995). Since 1983 Forest has continuously collaborated with the Italian critic Mario Costa in developing theoretical contributions to an aesthetics of communications. For more on this collaboration, see Mario Costa, *L'estetica della comunicazione* (Salerno: Palladio, 1987).

13. Robert Adrian X addresses this issue when he observes, "Nobody in eastern Europe can get access to telefacsimile equipment or computer timesharing equipment . . . and the situation is much grimmer in Africa and most of Asia and Latin America. If these parts of the world are to be considered for inclusion in artists' telecommunications projects it has to be at the level of ACCESSIBLE electronic technology . . . the telephone or short wave radio." See "Communicating," in *Art + Telecommunication,* ed. Heidi Grundmann (Vancouver, Western Front, and Vienna: Blix, 1984), 80.

14. On Oct. 28, 1991, Jaron Lanier lectured at The School of The Art Institute of Chicago. On that occasion I asked him what he meant by this often-quoted and seldom-explained phrase ("post-symbolic communication"). Lanier explained that one direction he envisions for virtual reality is for it to be taken over by telephone companies, so that time-sharing in cyberspace becomes possible. In this setting, it would be possible for people in distant locations, wearing datasuits, to meet in cyberspace. These people would be able to exercise visual thinking on a regular basis and communicate by other means different from spoken words; they would be able to express an idea by simply making that idea visible in cyberspace or by manipulating their own avatar or their interlocutor's avatar. This kind of communication, achieved by a still symbolic but perhaps more direct use of visual signs, is what Lanier calls "post-symbolic communication." His *Reality Built for Two,* or *RB2,* was a step in that direction.

15. Bertolt Brecht, "An Example of Pedagogics (Notes to *Der Lindberghflug*)," in *Brecht on Theatre: The Development of an Aesthetic,* ed. and trans. John Willett (New York: Hill and Wang, 1964), 31.

16. Martin Esslin, *Brecht: The Man and His Work* (New York: Anchor, 1971), 119.

17. Bertolt Brecht, "An Example of Pedagogics," 31—32.

18. Josef Heinzelmann, "Kurt Weill's Compositions for Radio," brochure accompanying the CD *Der Lindberghflug: First Digital Recording and Historical Recording of 1930*, by Bertolt Brecht and Kurt Weill (Königsdorf: Capriccio, 1990), 20. Produced Mar. 18, 1930, by Berlin Radio, *Lindbergh's Flight* was recorded (probably on steel tape) for later relay to Radio Paris and the BBC. The original eighteen-minute German-language broadcast is the surviving version.

19. John Willett, ed. and trans., *Brecht on Theatre: The Development of an Aesthetic* (New York: Hill and Wang, 1964), 32.

20. Willett, *Brecht on Theatre*, 32.

21. Claude Hill, *Bertolt Brecht* (Boston: Twayne, 1975), 62.

22. Heinzelmann, "Kurt Weill's Compositions for Radio," 22.

23. Luciano Caruso, *Manifesti Futuristi* (Firenzi: Spes-Salimbeni, 1980), 255–56.

24. Pontus Hulten, org., *Futurism and Futurisms* (Venice and New York: Palazzo Grassi and Abbeville Press, 1986), 546.

25. Filippo Marinetti, *Il teatro futurista sintetico (dinamico-alogico-autonomo-simultaneo-visionico) a sorpresa aeroradiotelevisivo caffé concerto radiofonico (senza critiche ma con Misurazioni)* (Naples: Clet, 1941). Some words in this title are neologisms coined by Marinetti and allow for multiple interpretations. My choices in the translation of the title are but some of the possible solutions.

26. Noëmi Blumenkranz-Onimus, *La poésie Futuriste Italiene: Essai d'analyse esthétique* (Paris: Klincksieck, 1984), 178.

27. Frank Brady, *Citizen Welles* (New York: Doubleday, 1989), 164.

28. Jean Baudrillard, *Simulations* (New York: Semiotext(e), 1983), 54. Telecommunications media efface the distinction between themselves and what used to be perceived as something apart, totally different from and independent of themselves, something we used to call the "real." Baudrillard calls this situation "hyperreal" or "hyperreality." This lack of distinction between sign (or form or medium) and referent (or content or real) as stable entities is by the same token a step further away from McLuhan and a step closer to the new literary criticism as epitomized by Derrida. In what is likely to be his most celebrated essay, "The Precession of Simulacra," Baudrillard once again acknowledges McLuhan's perception that in the electronic age the media are no longer identifiable as opposed to their content. But Baudrillard goes further, saying, "There is no longer any medium in the literal sense: it is now intangible, diffuse and diffracted in the real, and it can no longer even be said that the latter is distorted by it."

29. The Dadaist *boutade* was part of an article entitled "Dada Art," signed by Alexander Partens, a pseudonym for Tristan Tzara, Walter Serner, and Hans Arp. The article stated: "Abstract painters were thus among the first to side directly with Dadaism, being strongly attracted by the movement's individualism. But more important than this was its dislike of handicraft, its disdain for schools and its ridicule of doctrines. In principle no difference was made between painting and ironing handkerchiefs. Painting was treated as a functional task and the good painter was recognised, for instance, by the fact that he ordered his works from a carpenter, giving his specifications on the phone. It was no longer a question of things which are intended to be seen, but rather how they could become of direct functional use to people." See *The Dada Almanac*, ed. Richard Huelsenbeck (Berlin: N.p., 1920); English edition, presented by Malcolm Green (London: Atlas Press, 1993), 95.

30. Laszlo Moholy-Nagy, *The New Vision and Abstract of an Artist* (New York: Wittenborn, 1947), 79.

31. Kisztina Passuth, *Moholy-Nagy* (New York: Thames and Hudson, 1985), 33.

32. Sybil Moholy-Nagy, *Moholy-Nagy: Experiment in Totality* (Cambridge: MIT Press, 1969), xv.

33. Laszlo Moholy-Nagy, *Painting, Photography, Film* (Cambridge: MIT Press, 1987).

34. Moholy-Nagy, *Painting, Photography, Film*, 38–39.

35. Laszlo Moholy-Nagy, "Light-Space Modulator for an Electric Stage," *Die Form* 5, nos. 11–12 (1930); reproduced in Kisztina Passuth, *Moholy-Nagy* (New York: Thames and Hudson, 1985), 310.

36. David E. Fisher and Marshall Fisher, *Tube: The Invention of Television* (San Diego: Harcourt Brace, 1997), 89–90.

37. Luigi Moretti, "Arte e televisione," *Spazio* 7 (Dec. 1952–Apr. 1953): 74, 108. See also Matteo Chini, "Fontana e la TV: Prove techniche di Spazialismo," *Art e Dossier*, no. 145 (1999): 13–16. An English translation of the "Manifesto of the Spatial Movement for Television" (1952) can be found in Enrico Crispolti and Rosella Siligato, *Lucio Fontana* (Milan: Electa, 1998), 176.

38. Laszlo Moholy-Nagy, "Problems of the Modern Film," *Korunk*, no. 10 (1930): 712–19; reproduced in Passuth, *Moholy-Nagy*, 311.

39. George Brecht, *Water Yam* (New York: Fluxus, 1963). See also Ken Friedman, *Fluxus Performance Workbook* (Trondheim, Norway: G. Nordø, 1990).

40. *Art by Telephone*, record catalog of the show (Chicago: Museum of Contemporary Art, Chicago, 1969).

41. *Art by Telephone*.

42. Calvin Tomkins, *Duchamp: A Biography* (New York: Henry Holt, 1996), 236.

43. Lucy R. Lippard, *Pop Art* (New York: Praeger, 1966), 23.

44. Avital Ronell, *The Telephone Book: Technology, Schizophrenia, Electric Speech* (Lincoln: University of Nebraska Press, 1989).

45. Ronell, *The Telephone Book*, 9.

46. John Brooks, "The First and Only Century of Telephone Literature," in *The Social Impact of the Telephone*, ed. Ithiel de Sola Pool (Cambridge: MIT Press, 1977), 220.

47. Quoted by Brooks, "The First and Only Century," 220.

48. Robert Hopper, "Telephone Speaking and the Rediscovery of Conversation," in *Communication and the Culture of Technology*, ed. Martin J. Medhurst, Alberto Gonzalez, and Tarla Rai Peterson (Pullman: Washington State University, 1990), 221.

49. The history of Western civilization, the history of our philosophy, is a history of what Derrida calls the "metaphysics of presence." It is a history of the privilege of the spoken word, which is thought of as the immediate, direct expression of consciousness, as the presence or manifestation of consciousness to itself. In a communication event, for example, the signifier seems to become transparent, as if allowing the concept to make itself present as what it is. Derrida shows that this reasoning is present not only in Plato (only spoken language delivers truth) and Aristotle (spoken words act as symbols of mental experience) but in Descartes (to be is to think, or to pronounce this proposition in one self's mind), Rousseau (the condemnation of writing as destruction of presence and disease of speech), Hegel (the ear perceiving the manifestation of the ideal activity of the soul), Husserl (meaning as present to consciousness at the instant of speaking), Heidegger (the ambiguity of the "voice of being," which is not heard), and virtually any instance of the development of the philosophy of the West. The rationale and implications of this logocentrism/phonocentrism are not obvious, and one must research its functioning. Derrida explains that language is impregnated by and with these notions; therefore, in every proposition or system of semiotic investigation, metaphysical as-

sumptions coexist with their own criticism; all affirmations of logocentrism also show another side that undermines them. See Jacques Derrida, *Of Grammatology* (Baltimore and London: Johns Hopkins University Press, 1976); *Positions* (Chicago: University of Chicago Press, 1981).

50. What Hopper does not account for is the fact that, in his discussion of linguistic intercourse, Saussure only employs examples of face-to-face exchanges, eliminating telephonic intercourse. See Saussure, *Course in General Linguistics* (New York: McGraw-Hill, 1966), 206: "Whereas provincialism makes men sedentary, intercourse obliges them to move about. Intercourse brings passers-by from other localities into a village, displaces a part of the population whenever there is a festival or fair, unites men from different provinces in the army, etc."

51. Marshall McLuhan, *Understanding Media: The Extensions of Man* (New York: McGraw-Hill, 1964), 18. In *The Gutenberg Galaxy: The Making of Typographic Man* (Toronto: University of Toronto Press, 1962) McLuhan seeks to demonstrate how the phonetic alphabet and the technology of printing changed perception from an oral and multisensory experience to a sequential, predominantly visual method. In *Understanding Media* McLuhan states that technologies are extensions of human senses and that new technologies alter what he calls the "ratio of the senses," profoundly changing how we perceive the world. Global electronic communications technology, he states, altered the linear sense-ratio developed by typographic printing and reintroduced the multisensory experience that constituted the world of tribal men, thus creating what he called "the global village" (a term already introduced in *The Gutenberg Galaxy* [31]).

52. The process of dematerialization of art in the 1960s was first noted by the Argentinean critic Oscar Masotta in his lecture "Despues del Pop: Nosotros desmaterializamos" (After Pop: Dematerialization), presented at the Instituto Di Tella on July 21, 1967. The lecture was first published in Oscar Masotta, *Conciencia y estructura* (Buenos Aires: Editorial J. Alvarez, 1968), 218–44. Masotta derived the word "dematerialization" from El Lissitzky's essay "The Future of the Book," in which the Constructivist artist states that, as a consequence of media such as the telephone and radio, "dematerialization was the characteristic of the period" and that as matter diminishes, "dematerialization increases ever more." Masotta's chief insight in the lecture-article is the recognition that a new (immaterial) art had emerged based on the creative use of communications and mass media. This insight came, in part, in response to the practical and theoretical work of the Argentinean artists Roberto Jacoby and Eduardo Costa (see notes 55–57). The American critic Lucy Lippard was in Buenos Aires in the fall of 1968 and met Masotta on that occasion. The concept of "dematerialization" was also proposed by Lippard (with John Chandler) in an article published in *Art International* (Feb. 1968) and in her book *Six Years: The Dematerialization of the Art Object from 1966 to 1972* (1973; repr., Berkeley and London: University of California Press, 1997). Lippard's book mentions several events and works from Argentina but makes no reference to Masotta.

53. See J. Glusberg, *Arte en la Argentina* (Buenos Aires: Gaglianone, 1985), 330–31. *Simultaneidad en simultaneidad* was a collaboration between Marta Minujin, Wolf Vostell, and Allan Kaprow realized in New York, Berlin, and Buenos Aires.

54. Preceded by a discussion of the context that led to its creation, the manifesto was originally published in Oscar Masotta, ed., *Happenings* (Buenos Aires: Jorge Alvarez, 1967), 119–22. It is available in English in Blake Stimson and Alexander Alberro, eds., *Conceptual Art: A Critical Anthology* (Cambridge and London: MIT Press, 1999), 2–4. See also Patricia Rizzo, *Instituto Di Tella: Experiencia '68* (Buenos Aires: Fundación Proa, 1998), 42–46. For more information on

the experimental work carried out at the Instituto Di Tella, see John King, *El Di Tella y el desarrollo cultural argentino en la década del sesenta* (Buenos Aires: Ediciones de Arte Gaglianone, 1985); Jorge Romero Brest, *Arte visual en el Di Tella: Aventura memorable en los años 60* (Buenos Aires: Emecé, 1992).

55. Quoted in Glusberg, *Arte en la Argentina*, 81.

56. See Jane Farver, Luis Camnitzer, and Rachel Weiss, eds., *Global Conceptualism: Points of Origin 1950s–1980s* (New York: Queens Museum of Art, 2000), 192; *Heterotopías: Medio siglo sin-lugar: 1918–1968* (Madrid: Museo Nacional Centro de Arte Reina Sofía, 2000), 410–11.

57. In the spring of 1968 more than thirteen hundred striking Memphis sanitation workers—nearly all African American—demonstrated against racism and poor working conditions, many with the sign "I Am A Man." The photo used by Jacoby was appropriated from a publication reporting on the protest.

58. A teletype machine was a terminal that printed text slowly in capital letters on rolls of paper. Teletypes were made by the Teletype Corporation.

59. Rizzo, *Instituto Di Tella*, 56.

60. Ascott, "Art and Telematics," 27.

61. In photocopy format, the book can be consulted in the Flaxman Library, The School of The Art Institute of Chicago, as an appendix to Gidney's "The Artist's Use of Telecommunications." On the Web, it can be seen at <http://www.normill.com/Text/plissure.txt>. The two versions are different.

62. See *Electra: Electricity and Electronics in the Art of the Twentieth Century* (Paris: Musée d'art moderne de la ville de Paris, 1983), 398.

63. Giorgio Celli et al., *Arte e biologia: Tecnologia e informatica* (Venice: Edizioni La Biennale, 1986), 33–45, 65–74.

64. For a complete list, see *Art Com* 10, no. 40 (1990).

65. Mario Ramiro, "Between Form and Force: Connecting Architectonic, Telematic, and Thermal Spaces," *Leonardo* 31, no. 4 (1998): 247–60.

66. Carlos Fadon, "Still Life/Alive," in "Connectivity: Art and Interactive Telecommunications," ed. Roy Ascott and Carl Eugene Loeffler, special issue, *Leonardo* 24, no. 2 (1991): 235. See also Carlos Fadon, "Evanescent Realities: Works and Ideas on Electronic Art," *Leonardo* 30, no. 3 (1997): 195–205.

67. Eduardo Kac, "O Videoteatro de Otávio Donasci," *O Globo*, Sept. 14, 1988, 8.

68. See "Connectivity: Art and Interactive Telecommunications," ed. Roy Ascott and Carl Eugene Loeffler, special issue, *Leonardo* 24, no. 2 (1991): 233.

69. O'Rourke, "Notes on Fax-Art," 24.

70. Stephen Wilson, "Is Anyone There?" in *Der Prix Ars Electronica 1993*, ed. Hannes Leopoldseder (Linz: Veritas-Verlag, 1993), 106. See also J. Grimes and G. Lorig, eds., *Siggraph '92 Visual Proceedings* (New York: Association for Computing Machinery, 1992), 40.

71. Jacques Derrida, *Limited Inc.* (Evanston: Northwestern University Press, 1988), 10.

72. Roy Ascott, "The Art of Intelligent Systems," in *Der Prix Ars Electronica: International Compendium of the Computer Arts*, ed. H. Leopoldseder (Linz: Veritas, 1991), 26.

73. For a summary of communication models, see Denis McQuail and Sven Windahl, *Communication Models for the Study of Mass Communications* (London and New York: Longman, 1981).

## 2. The Internet and the Future of Art

This chapter is a discussion of the first three years of Internet art (1994–96) as it emerged following the announcement of the pioneering Web browser Mosaic, released in 1993 by the University of Illinois in Urbana-Champaign. The Internet has been used by artists worldwide in many different ways. This chapter will highlight art that explores Net-specific characteristics. Following an introduction to the emergence of the Web as a new environment, I will start by locating sources of contemporary networking art practices within mail art in the 1960s and 1970s. Expanding from mail art, I will then consider aspects of digital networking in art with the videotext medium in the 1980s. Next I will examine works that made radical use of some of the Internet's unique features between 1994 and 1996. I will conclude with remarks on hybrid projects produced in the same period that could not have existed as such if not experienced through the Internet.

### The Internet as a New Social Space

Between 1994 and 1996, the first three years of the Internet explosion, new worlds of aesthetic, social, and cultural possibilities were discovered on-line daily with great excitement. The appearance of a new site was a novel event. For the most part, these discoveries were made at speeds of 14.4 Kbps or 28.8 Kbps, which gave them irreducible aesthetic qualities. A comparison with the first days of cinema is helpful. Roughly speaking, one can think of the frame rate of early silent cinema (which was variable, but let us consider sixteen frames per second [fps] as an example), compared to the twenty-four fps of the sound era. To give us a sense of what audiences saw before the 1920s, silent films must be projected, on average, between sixteen fps and eighteen fps. Likewise, the

---

Originally appeared in German as "Das Internet die Zukunft der Kunst," in *Mythos Internet*, ed. Stefan Muenker and Alexander Roesler (Frankfurt: Suhrkamp Verlag, 1997).

work discussed here must be imagined as accessed between 14.4 and 28.8 Kbps, which were not the fastest speeds available but were the most widespread. This chapter is structured exclusively with reference to material that can be immediately accessed on the Internet.

For artists the Internet is not simply a network, a means of storing, distributing, and accessing digital information. For artists the Internet is a social space, a conflation of medium and exhibition venue. While since 1996 we have witnessed the conversion of the Internet into a global mall, in parallel we have also seen Internet artworks establishing an ever-increasing presence in contemporary art exhibitions. This relatively quick acceptance may be explained in part by the fact that Internet art has made itself attractive in many ways. It usually does not compete for space with material art, since exhibitions are held primarily in cyberspace. (As we shall see, the problem with this approach is the perpetuation of the erroneous perception that all Internet art is contained in cyberspace.) Its implementation calls for minimum cost, since most works shown are digital files hosted remotely or added to servers already in place. With digital literacy among the population at large increasing exponentially, perhaps more significant still is the fact that the Internet has become an effective cultural force, affecting in tangible ways reality outside cyberspace. Examples include, on the one hand, the very commercialization of goods and, on the other, campaigns staged on-line to mobilize public opinion or special interest groups to act publicly on a given issue.

From the questioning of the white cube to street action, from environmental propositions to radio, video, videophones, television, and satellites, artists throughout the twentieth century consistently sought to work in alternative spaces. Public spaces, in the form of urban settings, electronic media, or natural landscapes, have offered artists new challenges and possibilities. The public actions of Flavio de Carvalho or Allan Kaprow, the interactive videophone events of Liza Bear and Bob Adrian, the broadcasts of Jean-Christophe Avery or Nam June Paik, the environmental projects of Krzysztof Wodiczko or Christo, are but a few examples.

One of the key elements that made the work created by these artists so relevant is that their work did not conform to received expectations and standard formats. In challenging themselves to push beyond what social and industrial conventions dictated was acceptable behaviorally or possible technically, these artists expanded the public's imagination and revealed unprecedented possibilities. By contrast, at the beginning of the twenty-first century, the Web has quickly emerged as a conservative force, channeling the potentially free and creative on-line experience to ordinary transactions. While for the general public the emer-

gence of standard interfaces and communication protocols is productive (they facilitate accomplishing tasks), in art conformation to standards runs the risk of imposing unwanted restrictions.

It was in 1995 that the general public started to think of the Internet as "the Web," due to the wide dissemination and ease of use of Web browsers. In 1995 *Newsweek* celebrated "The Year of the Internet" in the cover story of its year-end issue, and in its December issue *Art in America* featured "Art On Line" on its cover. It is clear that most users and many artists consider the Internet and the Web one and the same thing. They are not. The Web is one among many protocols available on-line (to be accurate, the name of the protocol that makes the Web so user-friendly is "http," or "hypertext transfer protocol"). In other words, the Web is a subset of the Internet. While several protocols are compatible with Web browsers, some standard and experimental protocols are not. Examples include CU-SeeMe and MBone, both used for real-time videoconferencing, and Napster and LimeWire, used for file sharing. If on the one hand the market constantly pushes for media convergence, leading us to believe that in the future more protocols will be integrated into common browsers, on the other media research continuously develops new protocols that expand the reach of human agency on-line. Awareness that the Internet is not reducible to the Web is very important because it helps us understand the complexity of this network and its potential beyond the familiar Web browser.

The wide acceptance of the Web as a standard format since 1996 has led to a proliferation of self-contained hypermedia works that employ the Internet as a dissemination medium. (Exceptions developed before 1996 will be discussed later in the chapter.) However, resisting convergence toward a single mode of on-line experience, several artists created works that deviate from standard browsers and Webcentric approaches. Clearly, even projects designed exclusively for the Web can go beyond the usual hypermedia structure, as when an experimental browser is itself the work, for example.[1]

The ordinary use of interactive features of the Internet, such as chat and email, might suggest that it is akin to the telephone and the postal system, which basically enable the exchange of messages synchronically (telephone) and asynchronically (mail) between distant interactors. The Internet does incorporate aspects of television and radio by making possible the broadcast of video, audio, and text messages to small and large groups alike. At times the Internet is a virtual catalog or gallery, resembling a database. While some explore the Internet as a bidirectional medium, others integrate interactivity with hybrid contexts that incorporate physical spaces. Perhaps the most exciting feature of the Internet is that it is simultaneously all of the above and more.

The Internet continues to grow and transform itself as we read our email today.

The Internet can be thought of as a public space, with millions of people experiencing it simultaneously, as if walking in a square or park (one important difference being the lack of awareness one usually has of the on-line presence of others). Art on the Internet can be considered "public art," since the majority of available works are easily accessible from public computers located in libraries and civic centers. This challenges the local specificity of "public art" (i.e., of public art as geographically circumscribed), since on-line works can reach audiences anywhere in the world where the Internet is available.

### Analogue Networking: Mail Art

Long before the Internet, the question of networking in art was explored by artists such as Ray Johnson,[2] who started the *New York Correspondence School*. Johnson created radical experimental media works (fig. 21) that helped lay the foundation of network art. Johnson's "school" became the seed of the international mail art movement. This postal network developed by artists explored nontraditional media; promoted an aesthetics of surprise and collaboration; challenged the boundaries of (postal) communications regulations; and bypassed the official system of art with its curatorial practices, commodification of the artwork, and judgment value. In 1962 Edward Plunkett (an artist who also used the postal system to send his works) coined the phrase *New York Correspondence School* to name Johnson's relentless postal activity. The phrase mocked both the "New York School" of abstract expressionist artists and commercial art schools that teach art by correspondence.

The actual use of the postal system (or some of its characteristics, such as stamps and postcards) as a medium has a few historical antecedents, including Dada telegraphy; Futurist correspondence; and Duchamp's *Rendez-vous du dimanche 6 fevrier 1916*, a set of four postcards with a text in French in which the artist deliberately and playfully avoids referential meaning. The philatelic interventions of Flávio de Carvalho and Yves Klein must also be mentioned. In 1932 the Brazilian artist Flávio de Carvalho created three postage stamps for which he tried, unsuccessfully, to obtain official approval by the Brazilian postal system. One of the stamps shows an expressionist nude with a stylized structure (a modernist building?) in the background; another includes the critical sentence "A people without vision will perish." In 1957 Yves Klein created postage stamps with his unique "Klein Blue" color. He then attached them to invitations to his simultaneous Paris

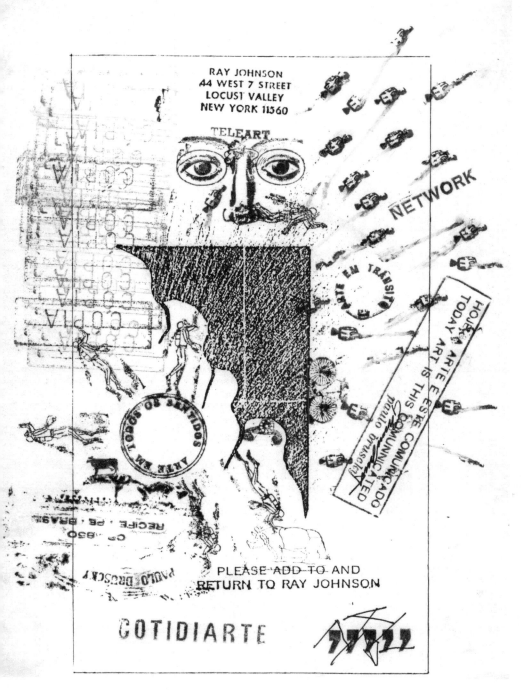

21. Ray Johnson (with intervention by Paulo Bruscky), *Please add to and return to Ray Johnson*, n.d. (late 1970s). (Courtesy of Paulo Bruscky.)

exhibitions at the Iris Clert and Collette Allendy galleries. The painted stamps were then cancelled, and the invitations were delivered by the French post office. Klein continued to use these stamps to mail announcements within France at least through 1959.[3] Mail art[4] was also embraced by the international neo-Dada movement Fluxus in the 1960s[5] and became a truly international postal network, with hundreds of artists feverishly exchanging, transforming, and re-exchanging written and audiovisual messages in multiple media, including faux stamps, invented envelopes, photographs, artist's books, collages, photocopies, postcards, audiotapes, rubber stamps, and fax machines.

From its inception, mail art was noncommercial, voluntary, open, uncensored, and unrestricted. Still practiced via the postal system, but also in cyberspace, mail art shows never have juries, and all entries are always exhibited. Between the late 1960s and early 1980s, in countries with oppressive regimes that silenced dissident voices by torturing and killing their own citizens, and where new technologies were inaccessible to individuals, mail art often became the only form of artistic anti-establishment intervention. Uruguayan mail and performance artist Clemente Padin,[6] for example, was incarcerated in 1975 for the crime of "vilification and mocking of the armed forces." Released from prison in 1977, he was forbidden to leave Montevideo and forbidden correspondence until February 1984. Since 1984, Chilean artist Eugenio Dittborn has been creating what he calls airmail paintings. Using silkscreen, stitching photocopied images onto cheap fabric, and then writing and making painterly marks on it, he borrows from the aesthetics of immediacy and precariousness of mail art. Dittborn folds and mails the paintings to international exhibitions from his home in Santiago, Chile. The envelopes are of his own design. He always exhibits the envelope that transports the painting next to it, revealing its global trajectory and additional information about the work.

A different mail art strategy was developed by Italian artist Guglielmo Cavellini.[7] In 1971, Cavellini—a collector turned postal activist—started a process of "self-historification" through which he relentlessly celebrated his importance to art history. One strategy employed by Cavellini was the promotion of (fictitious) exhibitions of his work at prestigious venues. Cavellini often worked with ephemeral materials in his critique of the idolatry through which museums and the market canonize individuals. I corresponded with Cavellini in the early 1980s, and from 1989 to 1992 was surprised to see one of his round stickers (celebrating his fictitious "centennial exhibition" at the Palazzo Ducale, Venice, Italy) survive Chicago's weather, stuck on a public sign on the same block as the Art Institute. Echoing Klein's self-validating gesture through the blue stamps, which mimicked government-issued

22. Guglielmo Cavellini, untitled artist's stamp, 1975. Cavellini's work was a process of self-historification. He often distributed promotional materials about exhibitions at prestigious venues that in fact did not take place. These stamps, for example, promote Cavellini's "centennial exhibition" at the Palazzo Ducale, Venice, Italy. (Courtesy of The Cavellini Archive Foundation and Piero Cavellini.)

stamps commemorating nationally significant cultural events or works, Cavellini also produced self-glorifying stamps (fig. 22). Cavellini and Johnson never worked with the Web: the first died in 1990 and the second in 1994. Their deaths might be taken to symbolize the end of the print era of artists' networks, coinciding with the first efforts at visual exploration of the Internet.

## Digital Networking: Videotext

Throughout the 1980s, when the Internet was limited to the American Standard Code for Information Interchange (ASCII), complex digital visual artworks were experienced on-line through the national videotext networks installed in countries such as France and Brazil. In the early 1980s artists created stills, animations, literary texts, and interactive works. The videotext system, a precursor to the Internet, enabled users to exchange messages and to access remote databases via the telephone line using a special terminal. A computer with a special card could also be used. Beyond Benjamin's lost "aura" of the unique object and the dematerialization of the work of art, the rise of the digital network signaled the birth of a truly immaterial art.

In France the system was known as Teletel, and the terminal was known as Minitel. The general public used the word "Minitel" in reference to both the terminal and the system. In Brazil the system was called Videotexto (videotext; a term also used in the United States). The system was still in use in France and Brazil in 2002,[8] albeit on a much smaller scale than when introduced in the early 1980s. With the advent of the Internet, interest declined substantially, but a free program that gives access to the Minitel through the Net does exist and is used in France.[9]

Fred Forest and Orlan were among the many artists who worked with the Minitel in France. Forest created *La Bourse de l'Imaginaire* (The Stock Exchange of the Imagination), a multimedia installation (fig. 23) that included the Minitel and was shown in 1982 at the Centre Georges Pompidou, in Paris. Forest invited the French public to create and transmit "fait divers" (news in brief; general news) via the telephone and the postal system. All news was organized in categories and formed an on-line database accessed through the Minitel system. Working with Frédéric Develay and Frédéric Martin, Orlan presented *Art-Accès* on-line in March 1985, in the context of the monumental exhibition Les Immatériaux, also realized at the Centre Georges Pompidou. This virtual gallery included works by Ben, Jean-François Bory, Orlan, Aldo Spinelli, and Edouard Nono, among others.

Brazil licensed the Minitel in 1981 and implemented it in 1982. Throughout the 1980s many artists in the country experimented with it. In 1985 I showed on the network the videotext piece *Reabracadabra* (fig. 24) through a São Paulo virtual gallery called Arte On Line, hosted by Livraria Nobel. This animated digital poem evolved from a sequence of two-dimensional geometric forms to a three-dimensional letter *A* floating in space. The letter was surrounded by blinking stars, which changed into the letters *B, C, D,* and *R.* In 1986 I set up a virtual gallery

23. Fred Forest, *La Bourse de L'Imaginaire* (Stock Exchange of the Imagination), multimedia installation, Centre Georges Pompidou, Paris, 1982. Forest invited the French public to create and transmit real or imaginary "fait divers" (news in brief; news items) via the telephone and the postal system. All news was organized into categories and formed an on-line database accessed via the Minitel (videotext) system. (Courtesy of Fred Forest.)

in Rio with works by several artists, which were accessed with the code RJ*ARTE from public terminals around the country. This virtual gallery included works by Eduardo Kac, Flávio Ferraz, Rose Zangirolami, and Nelson das Neves, among others. I presented several works, including *Tesão* (1985–86), *Recaos* (1986), and *D/e/u/s* (1986). The first was an elaborate sequence of animated lines and color fields that oscillated between forms and words, spelling an erotic-lyrical statement. The second was an animated poem that used color change and movement orientation on the screen (from bottom to top, from right to left) to create meaning and ambiguously evoke both the infinity symbol and the shape of an hourglass. The third piece was an animation that slowly placed a white rectangle in the center of the screen, filling it with interspersed black vertical lines. At the bottom there were letters and numbers: 19D6E U4S86. The viewer soon perceived that this was a Universal Product Code label. Upon close scrutiny, it became clear that the code was the word God (DEUS), with an isolated I (EU) in the center. The numbers represented the date of the composition: April 6, 1986. Ferraz presented *Vira e Mexe* (Turn Around and Swing), a

24. Eduardo Kac, *Reabracadabra*, videotext artwork, 1985. This animated digital poem was shown on-line on the videotext network. It evolved from a sequence of two-dimensional geometric forms to a three-dimensional letter *A* floating in space. The letter was surrounded by blinking stars, which changed into the letters *B, C, D*, and *R*, and vice-versa. (Photograph by Belisario Franca.)

gender-bending two-frame animation (fig. 25) created in 1985. The first frame showed a person's frontal torso. The second frame changed only a few pixels to reveal the back torso. Ferraz's design intentionally made it impossible to discern if the figure was male or female. Ferraz also presented *Babel* (1986), an interactive visual narrative that evolved as on-line participants navigated through an ever-changing sequence of forms. Rose Zangirolami presented works from the Mulheres (Women) series (fig. 26), which she had initiated in 1982. The series was composed of animated portraits of women. Created in different styles, the portraits often presented women in active scenes. Nelson das Neves presented a lyrical animated geometric work. In his piece, horizontal and diagonal lines suggested a static three-dimensional form. Then, a vertical band of color delicately moved from top to bottom on the right side of the screen and disappeared.

25. Flávio Ferraz, *Vira e Mexe* (Turn around and Swing), videotext artwork, 1985. In this gender-bending two-frame animation, it was impossible to discern if the figure was male or female. (Courtesy of Flávio Ferraz.)

Clearly, early artistic networking evolved from the use of postal and electronic telecommunications systems, including but not limited to the videotext network (see chap. 1). These early works made inroads into issues that have contemporary relevance, such as the need to work collaboratively and asynchronously to exchange and manipulate audiovisual materials at a distance; the development of communicative models for the remote integration of text, image, and sound into a coherent form; and the understanding that the conception of network topologies is a creative practice.

## The Emergence of Net Art

The Internet produces a dense information landscape that shapes a particular sensibility. On the Net one becomes capable of inhabiting multiple contexts at once and of absorbing large amounts of sensory stimuli simultaneously. On the Net one evolves strategies to manipulate large amounts of data and to move through fields of information. The Internet configures an absolutely new cultural situation, enabling

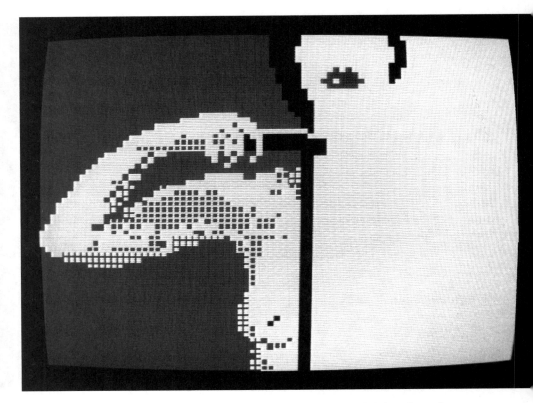

26. Rose Zangirolami, *Untitled* (from the Mulheres series), videotext artwork, 1982. In the early 1980s Zangirolami developed a series of animated portraits of women using the videotext medium. (Courtesy of Rose Zangirolami.)

artists to help define a social process and prompting reflection on its impact and potential.

The alternative cultures and communities on the Internet are evidence that this global network is a new kind of public space. On the Internet artists can show their works to a large public with the same seductive screen glow with which they were created. Without the Internet, artists who make immaterial works (e.g., digital images, multimedia and interactive works) would have to present their work on a CD-ROM, with limited circulation, or in a gallery context, to a relatively small number of viewers. For gallery viewing, images would have to be printed or projected, and multimedia and interactive works would take the form of an installation. It is clear that artworks that require specific network topologies could not adapt to these Netless environments without severe compromise to their meaning.

In the period covered here, from 1994 to 1996, the work that epitomized the use of the Web itself as a medium, sensu stricto, was

jodi.org (fig. 27), a site created by Joan Heemskerk and Dirk Paesmans.[10] It first went on-line in August of 1995, and it is regularly changed by the duo. First-time visitors are often startled by (and fearful of) the apparent visual and verbal randomness of the site, because it might give them the impression that something is wrong with their computer. If the operating system freezes at the moment that the viewer accesses the site—as happened to me once, for example—one's suspicions might become reality. It is a truism that computer programs are constituted of lines of code, which resemble gibberish to the uninitiated. Programming syntax and computer jargon are firmly beyond the reach of most computer users. The sheer amount of lines of code adds another layer of complexity—in some cases a single program can have seven million lines of code. In the context of jodi.org, gibberish becomes art for the initiated. This "gibberish" is, in fact, the result of free association and the appropriation of and witty commentary on the very elements that constitute the environment in which the site resides, that is, the Web itself. When the home page presents a sequence of characters in no apparent order, blinking in a green hue reminiscent of old computer terminals, the page source reveals a long and elaborate ASCII art piece. In jodi.org programming is not hidden as invisible layers of information buried within an application, as is usually the case. Instead of serving a clear purpose, HTML tags, ASCII characters, JPEG or GIF images, Javascripts, and other elements are removed from the standard syntax of the programming environment they belong to and recontextualized as the objects of interest, as the very subject of the work. Heemskerk and Paesmans's work points to the overwhelming saturation of information we ordinarily live with. In daily life, as in their work, this information surplus can lead to great frustration. They make it a point to capture the irrational side of the clean, productive, and functional network that the Internet is evolving into. In a world in which digital technology is virtually omnipresent, who does not enjoy being reminded of the absurdness of it all?

In 1996, searching for a visual language unique to the Internet, Alexei Shulgin, Vuk Cosic, and Andreas Broeckmann created *Refresh* (fig. 28).[11] This collective multinodal artwork asked participants to build a Web page; all pages were then incorporated into a "refresh loop"—that is, each page was activated from the main site and after a few seconds automatically replaced by the next page, creating a digital cascading effect. The original sites often resided in remote servers. *Refresh* offered a dynamic metaphor of an emergent digital culture, one in which information is unstable and every element is connected to another in an endless loop of references.

27. Joan Heemskerk and Dirk Paesmans, jodi.org, Web site, 1995. Home page (*a*); source code of home page (*b*). In jodi.org, HTML tags, ASCII characters, JPEG or GIF images, Javascripts, and other elements are removed from the standard syntax of the programming environment they belong to and recontextualized as the very subject of the work. (Courtesy of Joan Heemskerk and Dirk Paesmans.)

28. Alexei Shulgin, Vuk Cosic, and Andreas Broeckmann, *Refresh*, Web site, 1996. In this collaborative work, after a few seconds each participating Web site was automatically replaced by another, creating a digital cascading effect. This image shows a page from absurd.org featured in *Refresh*. (Courtesy of absurd.org.)

Another vector contributing to changing the Internet is the development of shared three-dimensional environments, that is, volumetric spaces visualized on the screen in which several individuals can be active participants through their avatars (stylized representations of each participant). Many of these worlds have used a standard called VRML, which stands for Virtual Reality Modeling Language, a specification for displaying three-dimensional objects on the Web. VRML was first proposed in the spring of 1994 with the initial 1.0 version available a year later. The more complex version 2.0 became available in 1996, but lack of commercial interest stalled further development while other three-dimensional formats appeared. As the concept of shared virtual worlds evolved with the new tools that made them possible, artists progressively experimented with their many features.

Marcos Novak,[12] for example, started creating three-dimensional virtual worlds in 1991 and in 1995 presented some VRML pieces at the Tidsvag Noll v2.0 (Timewave Zero) art and technology exhibition in Götheborg, Sweden. Entitled *TransTerraFirma*, these worlds "took on the names of cities of disaster—Sarajevo, Kobe, Kikwit, Carthage . . . the idea being to move into virtual space without escapism from this one."[13] In Novak's *AlienSpace* (fig. 29), a virtual world presented on-line in 1996, the viewer navigates a seemingly infinite environment composed of lines, numbers, geometric objects, and words. As the navigation takes place, the lines and the geometric objects spin, and the words and numbers change, giving rise to new meanings.

*Chimerium* was an on-line VRML artwork created by Perry Hoberman and Scott Fisher in 1995.[14] *Chimerium* enabled participants to as-

29. Marcos Novak, *AlienSpace,* virtual world, 1996. The viewer navigates a seemingly infinite environment composed of lines, numbers, geometric objects, and words. As the navigation takes place, the lines and the geometric objects spin, and the words and numbers change, giving rise to new meanings. (Courtesy of Marcos Novak.)

semble their virtual bodies themselves (by connecting headless bodies on the ground with floating heads in the sky) and to navigate in an interactive, three-dimensional virtual world with their new bodies. The creatures included a cow, a dog, an ant, a chimpanzee, a duck, and a turtle. Each body/head combination provided the viewer with a different perspective of the same space.

In 1990 I created *IO* ("I" in Italian), a three-dimensional navigational digital poem (fig. 30) that I first translated to VRML in 1995. In this piece the letters/numbers *I* and *O* form an imaginary landscape suggesting the dispersion of the self. The reader is invited to explore the space created by the stylized letters and experience it both as an abstract environment and as a visual text.[15] My VRML poem *Secret,*[16] created in 1996, is comprised of small bright points dispersed in a dark space. As the viewer navigates the environment, he or she approaches these points and realizes that they are words made of three-dimensional lines (cylinders) and circles (spheres), representing ones and zeros. As the viewer gets close to a particular word, the other words slide away, producing fleeting meanings that resist simultaneous visual apprehension.

VRML is a standard that will disappear, but new formats will emerge in the future. The prospect of teleimmersion suggests that three-dimensional navigation of information landscapes and real-time interaction in three-dimensional spaces will be an important component of the Internet in the future.

As artists explored the Web, some institutions were quick to respond. At the beginning of 1995 the Dia Center for the Arts, in New York, started to promote works created for their Web site.[17] Also in 1995, the international festival Ars Electronica, realized annually in

30. Eduardo Kac, *IO*, virtual world, 1990. Translated to VRML, this work was also experienced on-line. In *IO* the letters/numbers *I* and *O* appear as elements of an imaginary landscape. *IO* means "I" in Italian. In this piece it also stands for reconciled differences (one/zero, line/circle, etc.). The reader is invited to explore the space created by the stylized letters and experience it both as an environment and as a visual text.

Linz, Austria, introduced Web sites as an artistic category in its competition.[18] The proliferation of art on the Net has been followed by a proliferation of critical discourse on network art and related issues, often found on the Net itself. The Nettime discussion list,[19] for example, was founded in 1995 and has brought together writers, artists, and critics from all over the world around many interconnected cyberculture topics. Other on-line publications that emerged between 1994 and 1996, and that contributed early on to documenting and discussing art on the Internet, include *C-Theory*,[20] *Rhizome*,[21] and *Leonardo Electronic Almanac*.[22] Published in the Web edition of the *New York Times* from 1995 to 2000, Matt Mirapaul's "Arts@Large" column was widely read and offered informed insights on digital culture.

Webworks such as those described here make evident that the Internet is not just a publishing medium nor an extension of broadcast television. Existing paradigms of broadcast and publishing are to the Internet what theater and literature were to cinema and radio at the be-

ginning of the twentieth century. Television, as we know it, simply cannot create communitary experiences, but this is the most prominent civic aspect of the Net. Large broadcast and publishing companies continue to muscle their traditional and regulatory views onto the Net, sure that the use of increased technological sophistication and an "army of programmers," as industry jargon has it, will force users away from self-generated content.

In the meantime, most Internet users thrive in the exchange of chat and email messages, in their participation in on-line communities, in the newly accessible body of knowledge they discover daily, and in the wealth of multimedia and interactive experiences available on-line. Further expanding the interest and reach of the Internet are systems that provide high-speed access from home and work, IP telephony (the use of the Net as a phone network), mobile wireless connectivity via palmtops and cell phones, microchip implants, and satellite delivery of Net traffic to remote geographic locations. These and other developments open up new opportunities for artists as well.

### Internet Hybrid Events

Emerging new technologies are constantly reshaping the information landscape. Artists experimenting with interactive concepts on-line are expanding and hybridizing the Internet with other spaces, media, systems, and processes; forging new mediascapes; questioning standards; exploring relationships between protocols and communications infrastructures; and developing new directions for interactive art.

Internet hybrid events expose the limitations of unidirectional and highly centralized forms of distribution, such as painting or television, and contribute to expanding the communicative possibilities in art. Hybrids also allow artists to go beyond the creation of on-line pieces that conform to the design and conceptual standards of the Internet, such as the Web (i.e., http). Often working in collaboration, a new international generation of media artists promotes change by creating immaterial, telematic works on and for the Net, stimulating radical innovation and prompting media criticism.

Two examples are the groups Ponton European Media Art Lab[23] and Van Gogh TV.[24] Ponton was founded in 1986, and in 1995 Karel Dudesek, one of Ponton's founding members, left the group and continued with Van Gogh TV as a separate and independent project. Ponton's interactive television event *Piazza Virtuale* (Virtual Square) was presented for one hundred days as part of Documenta IX in Kassel, in 1993. This event was produced by Van Gogh TV, formerly Ponton's television-production unit.

*Piazza Virtuale* created an unprecedented communication hybrid of live television (based on two satellite feeds) and four lines for each of the following: ISDN (a system that enabled connectivity at a speed of 128 Kbps), telephone voice, modem, touch-tone phone, videophone, and fax. There was no unidirectional transmission of programs as in ordinary television. With no preset rules or moderators, up to twenty viewers called, logged on, or dialed up simultaneously and started to interact with one another in the public space of television, occasionally controlling remote video cameras that moved linearly on a track in the studio's ceiling. All of the incoming activity from several countries was rebroadcast live from Ponton's Van Gogh TV site in Kassel to all of Europe and occasionally to Japan and North America. In an article entitled "Ponton Media Lab Plans to Drive a Stake through the Scleric Heart of that 50 Year Old Bloodsucker, Television,"[25] Jules Marshall, an editor of *Mediamatic*,[26] an Amsterdam-based techno-culture magazine, quoted Dudesek: "We had no intention of dealing with information, post-production, or reality TV. Our major goal was live interaction; to break through the barrier of the screen; to downgrade TV from a master medium into just one window onto a space." Another Dudesek quote from the same article further illustrates the goal of the project: "TV is too linked to power and systems of control. We have more and more free time, but what are we using it for? Do we want to keep everyone at home simply watching and consuming? Piazza was about saying 'Here, if you use this, things can be different, your life can be enriched and enriching to others.' Thought models and games can lead to new social architectures."

This kind of work is deeply rooted in the idea that art has a social responsibility. The artists act directly in the domain of mediascape and reality. Among other implications, this project takes away the monologic voice of television and converts it into another form of public space for interaction, analogous to the Internet. Corporate-hyped ideas of entertainment and shopping via Web TV fall short of the global interactivity enabled by the Internet. In a statement posted on August 30, 1993, in the newsgroup comp.multimedia, Ponton's interface designer Ole Lütjens stated: "The *Piazza Virtuale* is a step forward for the media art of the future, in which interactive television and international networks can be an important collective form of expression."

The emphasis here is on the word "collective." Artists explore the mediascape by creating new arenas for democratic interaction, opposing regulatory models and homogenizing standards. New technologies that aim at Net/TV convergence try to absorb the public space of the Internet and convert it into something akin to the privately controlled

broadcast world. They have failed in the past and will continue to fail in the future because they refuse to recognize that the public does not want the Internet to become another broadcast medium or an extension of the broadcast media. Artists working in electronic media cannot ignore the constantly changing conditions of the mediascape. They are in a unique position to propose alternative communications models from within.

One such alternative was opened up by telepresence (i.e., telecommunications coupled with telerobotics), and in 1994 two telepresence works were presented on the Internet: *Ornitorrinco in Eden*,[27] by Ed Bennett and myself, and the *Mercury Project*,[28] a collaboration between codirectors Ken Goldberg and Michael Mascha, and a team formed by Steven Gentner, Nick Rothenberg, Carl Sutter, and Jeff Wiegley.

*Ornitorrinco in Eden* (fig. 31) hybridized the Internet with wireless telerobotics, remote-controlled mobility in physical (architectural) spaces, the traditional and cellular telephone systems, videoconferencing (CU-SeeMe), and a literal digital "tele-vision." This enabled participants to decide for themselves where they went and what they saw in a remote environment via the Internet. The interface was any regular telephone. Anonymous participants shared the body of the telerobot, controlling it and looking through its eye simultaneously. (For more see chap. 7.)

The *Mercury Project* combined the Web with a remote-controlled robotic arm connected to a video camera. With a built-in compressed-air jet, remote viewers could activate the air jet to reveal buried artifacts. The system used the Mosaic browser to provide access to the Web. The interface consisted of a window that explained the project, showed a schematic map of the area the robot arm traversed, and gave basic operating information about the system. Operators could also see still video images of the scene.

The *Mercury Project* was based on a fictional story created by the collaborators. Thus, it explored the narrative potential of telepresence. It enabled anybody on the Internet to blow air into a remote sandbox to reveal buried artifacts, such as matchbooks, a watch, and dollhouse miniatures. Goldberg said that "the installation encourages a collaborative exploration, with each user posting his discoveries in the log, so that the common threads emerge gradually. The artifacts have been chosen so that they tell a story as multiple users uncover them."[29]

Another fascinating area of investigation is the connection among the human body, the environment, and the Internet. In a pioneering performance entitled *Thundervolt* (1994), Gene Cooper, an American installation and performance artist, linked the electrical system of his

31. Eduardo Kac and Ed Bennett, *Ornitorrinco in Eden,* telepresence work realized on the Internet, 1994. *Ornitorrinco in Eden* hybridized the Internet with wireless telerobotics, the traditional and cellular telephone systems, videoconferencing, and a literal digital "tele-vision." This enabled participants to decide for themselves where they went and what they saw in a remote environment via the Internet.

body to that of the earth.[30] Real-time data sensing lightning strikes around the United States were relayed to his computer in Telluride, Colorado, via the National Lightning Detection Network. The strikes registered on-screen were translated into electrical signals, involuntarily stimulating muscles to twitch in Cooper's body through a series of neuromuscular stimulators called TENS (Transcutaneous Electro Neuro Stimulators).

Exploring the hybridization of radio and the Internet, Austrian artist Gerfried Stocker[31] created *Horizontal Radio* (fig. 32) in collaboration with Heidi Grundmann and many other artists, producers, and technicians in several countries.[32] The project ran live for twenty-four hours (June 22–23, 1995) during the Ars Electronica Festival in Linz, Austria, on the frequencies of many radio stations in Australia, Canada, Europe, Scandinavia, Russia, and Israel; on the Internet; and at the network intersections in Athens, Belgrade, Berlin, Bologna, Bolzano, Budapest, Edmonton, Helsinki, Hobart, Innsbruck, Jerusalem, Linz, London, Madrid, Montreal, Moscow, Munich, Naples, Quebec, Rome, San Marino, Sarajevo, Sydney, Stockholm, and Vancouver. The project was loosely based on the theme of migration and intentionally challenged the standardized forms of communications promoted by large broadcasting institutions and entertainment corporations.

*Horizontal Radio* created a new form of media experience, in which self-regulated groups dispersed worldwide collaborated on a single piece, integrating diverse communications systems such as real-time transmissions typical of broadcast radio and the asynchronous nature of Internet audio. Participants merged several old and new technologies to transform radio into a space for the exchange of audio messages. This new audio environment combined multiple forms of sound art

32. Gerfried Stocker and Heidi Grundmann, *Horizontal Radio,* experimental radio artwork, 1995. Participants merged several old and new technologies to transform radio into a space for the exchange of audio messages. This new audio environment combined multiple forms of sound art such as tape compositions, live concerts, telematic simultaneous events between some of the participating stations, sound sculptures, and texts and sound collages triggered by the Internet. (Courtesy of Bob Adrian.)

such as tape compositions, live concerts, telematic simultaneous events between some of the participating stations, sound sculptures, and texts and sound collages triggered by the Internet. *Horizontal Radio* emphasized dialogic distribution and created a sense of equidistance that transcended the limited spatial range of radio transmitters. A double CD published by Ars Electronica in 1996 documents samples from more than one hundred hours of this global interactive radio event.

Artists such as Fred Forest, Stelarc, Richard Kriesche, Shu Lea Cheang, and Masaki Fujihata contributed other hybrid topologies to this oscillating field between public and private spaces. Merging television, radio, telephones, and the Internet, French artist Fred Forest[33] created *From Casablanca to Locarno: Love Reviewed by the Internet and Other Electronic Media,*[34] realized on September 2, 1995, in Locarno, Switzerland. In this piece, the artist broadcast the film *Casablanca,* with Humphrey Bogart and Ingrid Bergman, without sound and with text on-screen informing the public about the possibility of interactive participation. The public used the Internet and called participating radio stations to fill in with creative and improvised dialogues. Fred Forest also controlled the images viewed on the screen from a theater in Locarno, open to the local public and transformed into a radio and television studio especially for this piece.

Unlike virtual galleries, multimedia projects, and hyperlink-based pieces, hybrid artworks that bridge the Internet with physical environments and other telecommunications media are not seen frequently on-

line. Stelarc, Kriesche, Cheang, and Fujihata proposed such contact between tangible objects and virtual spaces in events and installations. Stelarc's performance *Fractal Flesh*,[35] from 1995, enabled remote collaborators, with point-to-point direct links via the PictureTel teleconferencing system and ISDN connections from three European cities, to manipulate his arms and one leg through muscle-stimulation circuitry while receiving visual feedback on a video monitor (fig. 33). Electrodes attached to his limbs relayed the remote-triggered voltage to cause his arms and leg to jerk involuntarily. Images of the performance were uploaded to the Web site dedicated to the event. Kriesche's installation, entitled *Telematic Sculpture 4*,[36] also from 1995, was comprised of a conveyor belt with a railway track on it that moved in the Austrian pavilion at the Venice Biennale according to Internet data flow (fig. 34), eventually hitting and breaking through a wall. What caused the sculpture to move was an equation comparing data flow in computer newsgroups to that in art newsgroups. A newsgroup is an on-line discussion board that one may read or post to. Internet participants could slow down the movement of the sculpture by sending email to the project's address, accessing its Web site, or discussing the work in the aforementioned newsgroups. Shu Lea Cheang's *Bowling Alley* installation (1995)[37] spanned not only the Web but two "real-world" sites. A gallery in the Walker Art Center, Minneapolis, and a bowling alley several miles away were linked via ISDN lines and sensors. The actions of participating bowlers at the alley controlled an enormous video display in the museum on which were projected pictures of the bowlers (friends of the artist) and text from their earlier email correspondence with her. The images changed according to the velocity of the ball and its course down the lane. In Masaki Fujihata's *Light on the Net* (1996), Web-viewers see a grid depicting forty-nine tiny lightbulbs. They can click on the bulbs to turn their real counterparts on and off in the lobby of a Japanese office building.[38] This whimsical work conflates object (bulbs) and information (light data) and gives you credit for your work—switch on a light and your computer's ID appears under "Recent 10 Accesses."

Works like these render tangible the connection among body, physical space, and the network, a much-needed antidote to the metaphysical suggestion—pervasive since the Internet boom in 1994—that the "consensual hallucination" of cyberspace, as Gibson wrote in *Neuromancer*, suppresses the physical body.

## Multicasting

Undoubtedly, the Internet presents a new challenge for art. The digital revolution foregrounded immaterial works and underscored interac-

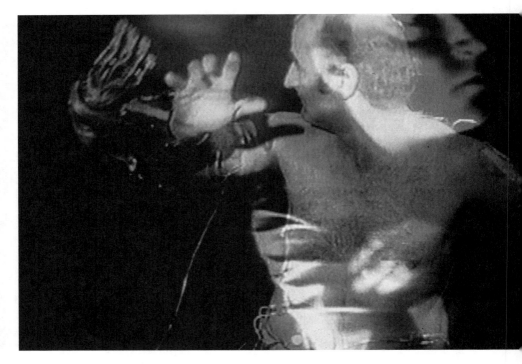

33. Stelarc, *Fractal Flesh*, performance, 1995. This performance enabled remote collaborators, with point-to-point direct links via the PictureTel teleconferencing system and ISDN connections from three European cities, to manipulate Stelarc's arms and one leg through muscle-stimulation circuitry while receiving visual feedback on a video monitor. (Courtesy of Stelarc.)

tive propositions. The Net offers a practical model of decentralized knowledge and power structures, beyond the unidirectionality that shapes the mediascape. The broadband Internet of the future will enable mobile multimedia computing. Fiber-optic infrastructure, wireless access, and small portable devices will connect individuals through the integration of voice, text, graphics, videoconferencing, telepresence, and multiuser three-dimensional worlds.

With an increase in broadband capabilities, conservative forces will also attempt to impose restrictive standards, trying to stifle individual freedom and creativity. The issue of bandwidth is not simply a technical matter; it is important because it will dramatically change the nature of the Internet as a public space and the very experience of being on-line. As I point out at the beginning of this chapter, speed and bandwidth are determining factors in network art, as canvas size and color palette are in painting. Hints of Internet 2 were offered by events realized on the "Multicast Backbone," or MBone, a virtual network first established in 1992 and layered on top of the physical Internet to sup-

34. Richard Kriesche, *Telematic Sculpture 4*, telematic installation, 1995. A conveyor belt with a railway track on it moved according to Internet data flow, eventually hitting and breaking through a wall. (Courtesy of Richard Kriesche.)

port real-time two-way transmission of audio and video data among multiple sites.[39]

Although the MBone is mainly used by scientists worldwide to interactively attend videoconferences, some cultural manifestations occasionally employ the system. Mexican artist Guillermo Gómez-Peña created the satellite/MBone telecast *El Naftazteca: Cyber TV for 2000 A.D.* (fig. 35), broadcast on November 22, 1994.[40] The character El Naftazteca was "a renegade high-tech Aztec who commandeers a commercial television signal and broadcasts a demonstration of his Chicano Virtual Reality machine from the techno-altar setting of his underground bunker. The Chicano Virtual Reality machine enables El Naftazteca to retrieve instantly any moment from his or his people's history, and then display the moment in video images," explains Gómez-Peña on the Web site that documents the event. Also a participant in the international mail art movement of the 1970s, Gómez-Peña addresses issues of multiculturalism in his work with media, including film, video, radio, performance, and installation art. "What will tele-

vision, and performance art, look like in ten years? It will have to be multilingual and it will marginalize everyone," states Gómez-Peña. An interactive component to the production encouraged viewers to phone the iEAR Studios of Rensselaer Polytechnic Institute and examine the basic cultural assumptions they maintain about U.S.–Latino relations. Via the MBone, computer users could communicate directly with El Naftazteca for the ninety minutes of the performance.

I worked with the MBone in 1996 in my networked telepresence installation entitled *Rara Avis*,[41] which was presented simultaneously in

35. Guillermo Gómez-Peña, *El Naftazteca: Cyber TV for 2000 A.D.*, interactive broadcast via cable and the Internet, 1994. Gómez-Peña's character El Naftazteca was a high-tech rebel who hijacked a commercial television signal to broadcast his improvisational virtual reality machine. (Courtesy of Guillermo Gómez-Peña.)

the physical space of the Nexus Contemporary Arts Center, in Atlanta, and on the Internet (via interactive conferencing both in color and in black and white), the Web (with GIF uploads captured from the live video feed), and the MBone (with color video) (fig. 36). Gallery visitors "transported" themselves to the body of a telerobotic macaw inside an aviary with thirty small birds. Visitors could wear a virtual reality headset and take control of the vision system of the robotic bird in real time. They shared the body of the telerobot with Internet participants, who activated the robot's vocal system. What the local viewer saw was seen live on the Internet, the Web, and the MBone. What was heard in the gallery was a combination of the voices of anonymous participants who happened to be on the body at the moment. This piece was first experienced in Atlanta and on the network from June 27 to August 24, 1996.

Growing exponentially since its initial phase discussed here, from 1994 to 1996, Internet art has become a formidable cultural force. It is clear that the future of art and the future of the Internet will be intertwined. As electronic devices with embedded Web browsers and servers become pervasive, we will have access to the network in many

(a)

36. Eduardo Kac, *Rara Avis*, on-line telepresence work, 1996. As a commentary on the problematic notion of exoticism, in this work local and remote participants experienced a large aviary from the point of view of a telerobotic macaw. The work was experienced interactively and simultaneously via Net-based videoconferencing (*a*), on the Web (*b*), and through the MBone (*c*).

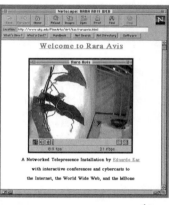

(b)

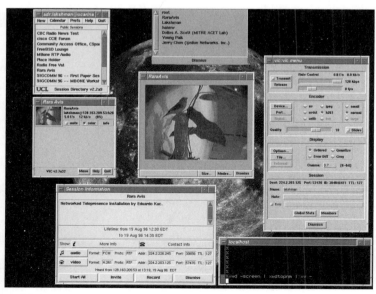

(c)

new ways. For example, it will be common to browse and serve from cars and airplanes. Telephones and photo and video cameras will have IP addresses, numbers that enable them to be directly connected to the Internet without a desktop computer. This newly gained mobility, coupled with broadband access and future protocols, will open new possibilities for network art. It is conceivable that the human body will host embedded miniature servers in the future. As more people gain access to the Internet, with faster land and wireless connections, art created on and for the Internet can reach new audiences. On-line the computer screen is much more than a trading outpost; it is a portal into myriad minds, a vehicle for interaction, a bridge to other worlds waiting to be discovered, invented.

### Notes

URLS were validated on June 5, 2004.

1. The first examples were developed after 1996 and include "WebStalker" (1997), by Mathew Fuller (<http://www.backspace.org/iod/>); "Shredder" (1998), by Mark Napier (<http://www.potatoland.org/shredder/>); and "Netomat" (1999), by Maciej Wisniewski (<http://www.netomat.net/>). While "Shredder" works within contemporary browsers, "Netomat" and "WebStalker" require you to download the browser itself. These are browsers that offer a very unusual view of the Internet. Instead of presenting information in a clear and linear manner, following the original design of accessed Web sites, they reconfigure text and pictures from these sites, in a kaleidoscopic self-assembling display of visual information.
2. See <http://www.artpool.hu/Ray/RJ_onlinetext.html>.
3. See <http://www.geocities.com/johnheldjr/YvesKlein.html>.
4. See <http://www.actlab.utexas.edu/emma/>.
5. See <http://www.fluxus.org/> and <http://www.nutscape.com/fluxus/homepage>.
6. See <http://www.thing.net/~grist/l&d/padin/lcptitle.htm>.
7. See <http://www.cavellini.org/auto/index.html>.
8. See <http://www.pic.fr/site/f_minitel.html>.
9. See <http://www.minitel.tm.fr/multione.cgi/V230/> and <http://iml.jou.ufl.edu/carlson/professional/new_media/History/TELETEL.HTM>.
10. See <http://www.jodi.org>.
11. See <http://www.ljudmila.org/fresh.htm> and <http://www.absurd.org/de-A/fresh.html>.
12. See <http://www.centrifuge.org/marcos/>.
13. Private email from Marcos Novak (Mar. 24, 2002).
14. See <http://www.rvi.com/fisherhob.html>.
15. See <http://www.ekac.org/multimedia.html>.
16. See <http://www.ekac.org/multimedia.html>.
17. See <http://www.diacenter.org/webproj/index.html>.
18. See <http://www.aec.at/>.
19. See <http://www.nettime.org>.
20. See <http://www.ctheory.com>.
21. See <http://www.rhizome.org/fresh/>.
22. See <http://mitpress.mit.edu/e-journals/LEA/>.

23. See <http://www.ponton.de>.
24. See <http://www.vgtv.com>.
25. See <http://www.wired.com/wired/archive/1.05/medium.mission.html>.
26. See <http://www.mediamatic.nl/index_e.html>.
27. See <http://www.ekac.org/ornitorrincoM.html>.
28. See <http://www.usc.edu/dept/raiders/>.
29. See <http://www.usc.edu/dept/raiders/story/press-release.html>.
30. See <http//www.fourchambers.org/artown_gc_thundervolt.asp>.
31. See <http://gewi.kfunigraz.ac.at/x-space/bio/stocker2.html>.
32. See <http://gewi.kfunigraz.ac.at/~gerfried/horrad/>.
33. See <http://www.fredforest.com>.
34. See <http://www.tinet.ch/videoart/va16/multimedia.html>.
35. See <http://www.stelarc.va.com.au/>.
36. See <http://iis.joanneum.ac.at/kriesche/biennale95.html>.
37. See <http://bowlingalley.walkerart.org>.
38. See <http://www.softopia.or.jp/research/report/H08/01_E.html>.
39. As of Mar. 1997, there were more than three thousand MBone servers on the Internet; see <http://webopedia.internet.com/TERM/M/Mbone.html>. The MBone will become obsolete when Internet 2 (see <http://www.internet2.edu./html>) becomes fully operational in the public realm, installing what was dubbed quality of service (QoS) technology. The QBone ("Quality Backbone") (see <http://qbone.internet2.edu>) was first launched in Oct. 1998 by the Internet 2 project as an academic testbed, that is, as a high-speed fiber-optic cable network promoting media integration, interactivity, and real-time collaboration. Temporarily restricted to participating educational and research institutions, this broadband technology will one day be made available to the general public. The QBone is a model for the Internet of the future, which will have bandwidth wide enough to fully enable real-time voice, video, and teleimmersion on-line.
40. See <http://www.vdb.org/smackn.acgi$tapedetail?ELNAFTAZTE>.
41. See <http://www.ekac.org/raraavis.html>.

## 3. Beyond the Screen: Interactive Art

From the room-size computers of the 1940s to desktop, laptop, palmtop, and wristwatch computers, human interaction with this powerful and pervasive calculating machine has changed. When in the 1960s computers started to become capable of producing and manipulating images, computer graphics became a prominent research topic among engineers. Likewise, computers started to attract the attention of experimental visual artists all over the world.

This is exemplified by the Japanese team Computer Technique Group, founded in 1966 by Masao Kohmura and Masanori Tsuchiya in Tokyo. Between late 1967 and early 1968 they produced classics such as *Running Cola Is Africa* (1968), a black and white graphic sequence showing the transformation of a runner into a Coca-Cola bottle that then morphed into the map of Africa.[1] They employed the visual trope of "morphing" as a means of conveying social criticism.

Working against the background of conceptualism, kinetics, and Pop in the 1960s, many artists abandoned the tactile appeal of the analog realm and ventured into the unknown domain of computer graphics. Examples include the work of the Americans John Whitney[2] and Charles Csuri,[3] the Brazilian Waldemar Cordeiro,[4] the Hungarian Vera Molnar,[5] and the German Manfred Mohr.[6] Many artists working with computers at the time explored algorithms that generated multiple forms of abstract or Constructivist art. Others created figurative images that were charged poetically through specific graphic procedures (e.g., warping, morphing, zooming). Cordeiro's work is particularly distinct in this context because the artist, living under the worst phase of the Brazilian military dictatorship, produced computer images that were rich in personal, emotional, or subtle political content.

Computer graphics in art continued to flourish in the 1970s and 1980s, as new algorithms were developed and digital images started to acquire color, rich shading, and photographic qualities.[7] Computers were gradually becoming incorporated in interactive art installations, as exemplified by historical exhibitions such as *Software*, curated by

Jack Burnham in 1970 for the Jewish Museum in New York.[8] Computer graphics were prominent in videos and films in the 1980s, and even television commercials started to feature digital animation regularly. The launch of the Macintosh computer in 1984 and the graphic software industry that followed made computer imaging accessible to a larger number of artists. Consequently, the creation of still images presented new challenges to a younger generation of artists, who enjoyed unprecedented creative freedom. As the new frontier of computer graphics became a stable industry and an established artistic practice, experimental artists in the 1990s started to push the digital image into new areas of imagination and experience. The works discussed in this chapter reveal some of the most fascinating approaches to the areas of virtual reality (VR), interactive performance, avatars, telepresence, and artificial life. In these works digital images are always present, but they are not conceived as static, self-contained pictures. They are spaces, interfaces, remote database inputs, ephemeral real-time creations, and evolving forms.

### Inside the Image

Since the late 1980s the term *virtual reality* has been used in scholarly journals and popular magazines alike, often taken to mean different things for different purposes. When first developed by Ivan Sutherland in the late 1960s, the technology of virtual reality was intended to enable scientific visualization of three-dimensional data in real time through the use of head-mounted stereoscopic electronic displays. Because the technology has grown less expensive since the early 1990s, it has catapulted from research labs into myriad applications, such as education, military training, medicine, and gaming. True to its origins, the concept refers to a visual space that can be seen as such by the viewer and in which this viewer can navigate in three dimensions in real time. If the viewer perceives the space through a stereoscopic device, he or she has the sensation of being immersed in the space. For the viewer to have a seamless experience, the computer must be powerful enough to calculate every subtle change in point of view in real time.

In 1995 the Canadian artist Char Davies, working with designers and programmers, created *Osmose*,[9] a virtual reality immersive artwork (fig. 37) that invited viewers to move through synthetic infinite worlds. In this work Davies presented a unique interface to what she calls the "immersant" (the person immersed in the virtual world). In the form of a vest, this interface provided real-time motion tracking based on breathing and balance. This meant that viewers could inhale to rise and exhale to descend and could move forward or backward in

(a)

37. Char Davies, *Osmose*, virtual reality installation, 1995. In this virtual world viewers navigated an environment made of natural forms and synthetic elements. This shows a view of the forest sector of *Osmose* (*a*). The interface was a vest that allowed participants to move in the virtual world using their breath and balance, resembling scuba diving (*b*). (Courtesy of Char Davies.)

the virtual space by leaning forward or backward in the physical world. Viewers navigated a complex world made of natural forms, such as trees, and synthetic elements, such as three-dimensional Cartesian wireframe grids filled with diaphanous substances.

"The public installation of Osmose," explained Davies, "included large-scale stereoscopic video and audio projection of imagery and interactive sound transmitted in real-time from the point-of-view of the 'immersant.' This projection enabled an audience, wearing polarizing glasses, to witness each immersive journey as it unfolded. Although immersion took place in a private area, a translucent screen equal in size to the video screen enabled the audience to observe the body gestures of the immersant as a poetic shadow-silhouette."

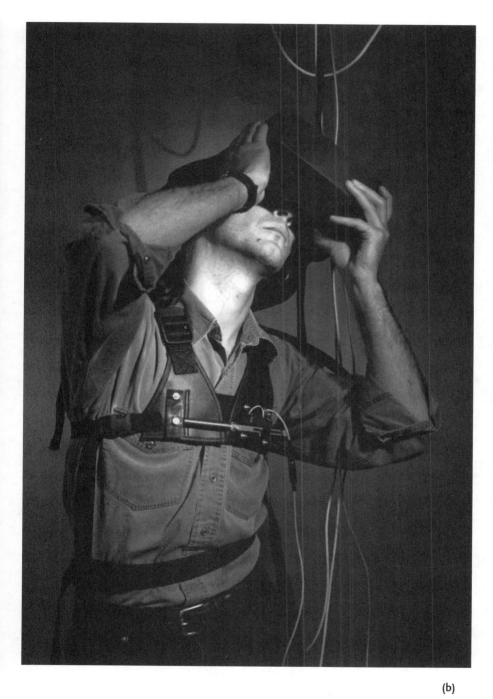
(b)

Her second VR work, entitled *Éphémère* (Ephemeral), was also created with a team of designers and programmers and premiered in 1998 at the National Gallery of Canada in Ottawa.[10] Whereas in *Osmose* the immersant could move through a forested glade populated by static objects, in *Éphémère* every object was in a state of flux. Organized in three levels, this work also made use of organic and natural metaphors, except that this time an analogy was suggested between nature and the human body. Like *Osmose*, *Éphémère* used the breathing and balance vest interface to propel the viewer in space, made creative use of three-dimensional sound, and could only be fully experienced with a virtual reality headset. As viewers tried to make the most of the allotted fifteen-minute time slots, their sense of time might have gotten warped. The digital image became a navigational space, inviting endless exploration.

### Graphics as Body Interface

With the intention of neutralizing the metaphysics of virtual reality through flesh, sweat, and flames, the Barcelona artist Marcel.lí Antúnez Roca created an interactive performance that is at once delirious and frightening. Entitled *Epizoo* (fig. 38), it was first presented in Mexico in 1994.[11] I saw the piece in a small theater in Helsinki in 1996, sitting on the stage in a circle of approximately fifty people. As the audience waited for the artist's entrance, I started to notice the apparatus up front: an exoskeleton of sorts, a small camera attached to a glove, speakers, and a large projection screen raised above the performer's small designated area of action. I also noticed some computer equipment on one side of the room.

Marcel.lí solemnly entered the stage wearing a robe. He positioned himself up front, at the center of the designated area, and disrobed. With the help of an assistant he donned the pneumatic exoskeleton, creating on stage the image of a cyborg, mixture of man and machine. This apparatus pressed metal components against several parts of the artist's body, such as his chest, ears, mouth, nose, and buttocks. At the top of his head, a large Bunsen burner suggested that a flame was also going to be part of the show. The large amount of plastic tubing (necessary for the functioning of the pneumatic exoskeleton) that surrounded the artist suggested that his movements would be hindered.

As soon as the music started, one of Marcel.lí's assistants sat at the computer and started to click on images, which danced about on the large screen above the artist's head. When the assistant clicked on the images, we noticed that the hinged metal parts of the exoskeleton also started to move, and the clicking sounds were very noticeable. The metal components moved the artist's selected body parts in funny, if

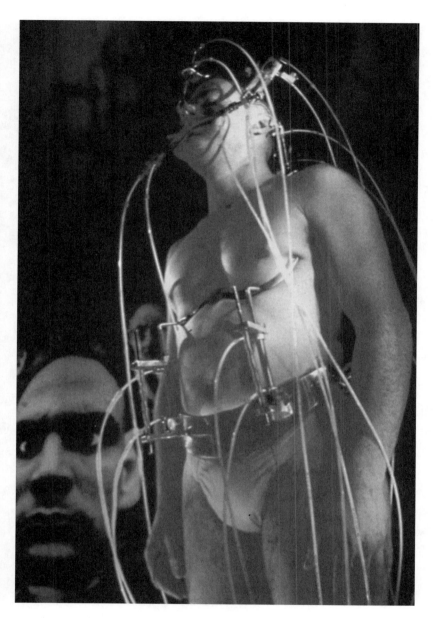

38. Marcel.lí Antúnez Roca, *Epizoo*, interactive performance, 1994. In this work the artist donned a kinetic exoskeleton. Using an exquisite and witty graphic interface, the audience was able to manipulate the artist's body on the stage. (Courtesy of Marcel.lí Antúnez Roca.)

not scary, ways. As the person at the computer activated the artist's body, moving its parts in a peculiar choreography, it also became clear that the limited mobility of the artist was significant in evoking the dangers of technologies of control. His body was besieged.

The digital images seen on the screen, a mixture of stills and animations often including the artist's own likeness, functioned perfectly as an interface to his body. At once humorous in their cartoonish treatment and terrifying in their content, they portrayed scenes of torture and violence, transforming body parts into combinatory and disposable elements. The artist stood under the screen and turned around regularly to reveal all possible viewing angles. With his glovecam, he added a few additional points of view by raising and swinging his hand. Real-time editing enabled the audience to see a combination of the digital interface and the live video.

As the artist's body was manipulated through the interface, the audience saw his mouth and nose being stretched open, his ears flopped forward and backward, his chest and buttocks being raised up and down. Midway through the performance, the audience was invited to experiment with the multimedia interface and assume control of Marcel.lí's body. Many did, and the spectacle of cold and detached manipulation of hot and sweaty human flesh through a clean and dry digital interface continued. The whole performance lasted for about thirty minutes. It culminated with a large flame shooting up from the artist's head, successfully evoking a conclusive dystopian view of the man-machine interface.

### Avatars and Databases

While the body in question in *Epizoo* is made up of flesh and bones, the virtual bodies in *Bodies© INCorporated* (fig. 39) are built of pixels, wireframes, and textures.[12] *Bodies© INCorporated* is a Web-based piece by the California artist Victoria Vesna, developed in collaboration with artists, musicians, companies, and programmers. The basic premise of the site, which first went on-line in 1996, is that Webviewers become active in a mock corporate structure, and as they acquire shares, they can order digital bodies of their choice. The project employs VRML to create a three-dimensional representation of the new body in a database, which can be seen by other participants. VRML transforms the Web from a two-dimensional space similar to print into a three-dimensional navigable environment. While avatars can exist in a two-dimensional space, as evidenced by the once popular multiuser visual chat room "Palace," three-dimensionality quite literally opens up new worlds for the avatar experience. While many participants

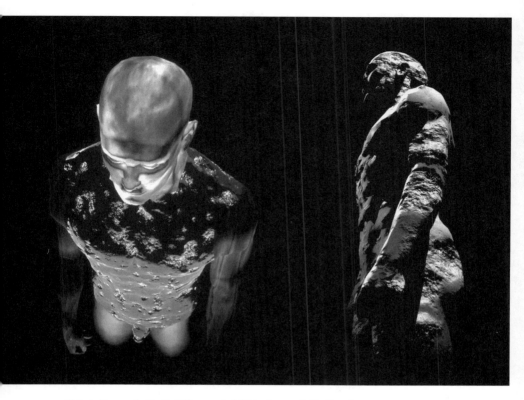

39. Victoria Vesna, *Bodies© INCorporated,* Web site, 1996. On-line viewers participate in a mock corporate structure acquiring shares and ordering digital bodies of their choice. All bodies become part of a database from which they can be retrieved. (Courtesy of Victoria Vesna.)

emailed Vesna and asked her to create an area with live avatar-based chat rooms, to enable these bodies to be displayed in an active social environment, the author explained that this is not her intention. She is exploring what she refers to as "database aesthetics,"[13] enabling Web users to create, access, and modify a complex database that critiques the conversion of the Internet from a social space to a marketplace.

Many denizens of chat rooms and other social areas of the Net often assume multiple identities in their exchanges with other anonymous participants, concealing or forging distinct traits such as gender, age, and race. Exploring the nuances of interaction on the Net, Victoria sees *Bodies© INCorporated* as an investigation into social psychology and group dynamics in a corporate context. After announcing the creation of the site and the availability of digital bodies to be created on demand, Victoria was overwhelmed with responses. Orders

came in for males, females, and hermaphrodites, with sexual preferences ranging from heterosexual to transsexual, from homosexual to bi- and asexual. Most requests were for bodies that represented alter egos, followed by desired sexual partners and, in smaller numbers, significant others. To shift the focus from an exclusively sexual context, textures were added to the bodies to add symbolic value to the otherwise smooth surface of their digital skin. While the majority of requests were for bodies without any texture, many selected from a menu of texture maps that included black rubber, blue plastic, bronze, chocolate, clay, clouds, concrete, glass, lava, pumice, and water.

"Initially, the participant is invited to construct a virtual body out of pre-defined body-parts, textures, and sounds, and gain membership to the larger body-owner community," Victoria explains. "The main elements of the online site are three constructed environments (subsidiaries of Bodies© INCorporated), within which different sets of activities occur: LIMBO ©INCorporated, a gray, rather nondescript zone, where information about inert bodies that have been put on hold—bodies whose owners have abandoned or neglected them—is accessed; NECROPOLIS© INCorporated, a richly textured, baroque atmosphere, where owners can either look at or choose how they wish their bodies to die; and SHOWPLACE!!!© INCorporated, where members can participate in discussion forums, view featured bodies of the week, bet in the deadpools, and enter 'dead' or 'alive' chat sessions."

The creation of digital bodies that can be used to actively represent an individual in a digital world may sound like the exclusive domain of science fiction, but in fact it is a real, growing business. Good examples are companies like Viewpoint Data Labs, which sells three-dimensional body models and which sponsored Victoria's project, and Cyberware, which pioneered the market for three-dimensional detailed scans of people and objects. Cyberware's technology, including a whole-body scanner, was used to make popular films like *Star Trek 4*, *The Abyss*, *Robocop 2*, *Nightmare on Elm Street*, *Terminator 2*, *Batman 2*, and *Jurassic Park*. With the realization of *Toy Story* in 1995, the first completely computer-animated feature film in the history of motion pictures, it becomes conceivable that an actor or actress whose body is scanned could star in a movie long after his or her death. Victoria Vesna knows that a culture obsessed with fitness and shapely bodies finds an acute reflection of itself in the detached and calculated digital incorporations her site provides. Viewers become emotionally attached to their avatars and projected idealized "significant others," further complicating social interaction in cyberspace through the identity, storage, and retrieval of virtual bodies from a database.

## Servers in the Shade

While avatars form dynamic representations of discrete entities in the network, it is also possible to use the Internet and other telematic networks to create a direct link to a real physical space. The California artist and scientist Ken Goldberg is one of the few who have been consistently exploring the unique aesthetic possibilities of telepresence art (the combination of telecommunications and remote action). Some of his previous Web-based telepresence works include the *Mercury Project* (1994) and the *TeleGarden* (1995). The first presented viewers with objects buried in the sand. These objects were introduced as archaeologically significant within a fictitious narrative context. The viewer could control an industrial robotic arm to activate an air jet and reveal the buried artifacts. The viewer could also retrieve updated stills to see the results of his or her action. The second was a small garden with an industrial robotic arm at the center. The arm was controlled via the Web and allowed remote participants to plant seeds and water plants. Viewers could also see live pictures of the garden.

In both cases, the digital image was an important component of the work and performed a specific function: it created a visual bridge between viewers on the Web and the actual physical space where the apparatuses were located. With *ShadowServer* (1997) (fig. 40), in addition to preserving the bridgelike status of the digital image, Goldberg gave it a new role. Rather than observing an image that represents an action, the Web participant is given the opportunity to create the image him- or herself.[14] In other words, the gap between action and image is decreased, because the action is itself the remote creation of the picture.

Goldberg describes his work: "The apparatus is housed in a light-proof box that contains physical objects, some of which move of their own accord within the apparatus. Viewers can interact with these objects via buttons. Viewers can select any combination of five buttons and then click on the button 'Cast a Shadow' which activates a combination of lighting devices and returns a digital snapshot of the resulting shadow. Each combination of buttons produces different lighting conditions. Certain random combinations will provide clues which lead to a mysterious Sixth button. The Sixth button illuminates hidden secrets in an alcove of the apparatus."

The images created by the viewer through the *ShadowServer* interface are invariably evocative of Moholy-Nagy's beautiful and mysterious photograms and even more so of Nathan Lerner's Light Box photograms. A member of the Bauhaus, the historic German art school that profoundly influenced art and design in the twentieth century, Moholy-Nagy coined the term *photogram* to designate his cameraless photo-

40. Ken Goldberg, *ShadowServer*, 1997. On-line participants activate remote lights to create light and shade patterns. (Courtesy of Ken Goldberg.)

graphs produced directly through the contact of objects with photographic paper. Between his first experiments with the photogram in 1922 and his premature death in 1946, the Constructivist master produced approximately five hundred photograms that effectively demonstrated his belief that light is an art medium in its own right. Seeking refuge from the rise of totalitarianism in Europe in the 1930s, Moholy-Nagy immigrated to the United States to found the New Bauhaus in Chicago in 1937. Among his students was the American photographer Nathan Lerner, who in 1938 invented the Light Box. This was a perforated box inside which objects were suspended to create exquisite photograms. Lights were positioned outside. Lerner wrote at the time: "I felt that if I could create a virtual world of darkness, which I could then develop into a disciplined world of light, I would be approaching the solution of the problem of controlled selection [of light]."[15] As the light-box experiment acquires a remote and automatic nature in Goldberg's Web work, we perceive a distinct historical resonance between the light-modulation adventure of the avant-garde photographers and the democratizing gesture of network art. Moholy-Nagy's pedagogy was based on trying to bring out what he believed to be the creativity inherent in everyone. As anonymous viewers create countless digital photograms on the Web, the *ShadowServer* is an instance in which this vision comes full circle.

### Living Pictures

The desire to work between real and digital realms is not exclusive to telepresence art. In their interactive installation entitled *A-Volve* (fig.

41), the Austrian Christa Sommerer and the French Laurent Mignonneau created a unique metaphor of artificial life by merging tangible and intangible elements.[16] The work premiered at the international electronic arts festival Ars Electronica, in Linz, Austria, in 1994. In *A-Volve* the Japan-based European duo allowed digital images generated in real time by anonymous viewers to acquire lifelike behaviors and interact among themselves in a 15-centimeter-deep water-filled glass pool measuring 180 by 135 centimeters. Viewers accustomed to traditional computer animation discovered that these animated organisms were unpredictable in their motions and acquired idiosyncratic behavioral patterns in this real-time interactive environment.

As viewers approached the installation, in addition to the water pool they saw a pedestal with an embedded touch-screen monitor. Asked to draw freely on this monitor with their fingers, viewers improvised and sketched both the profile and the top view of an artificial organism. Moments later they saw this creature emerge from the depths of the water pool and start to swim with its own unique behavior and motion pattern. The creature also interacted with other artificial organisms already in the pool in complex ways, following survival rules that included mating and predatory patterns. Viewers could look into the pool and observe the creatures "in the water" because a projection screen formed the floor of the water pool, and the real-time images were projected upward from a video projector embedded in the base

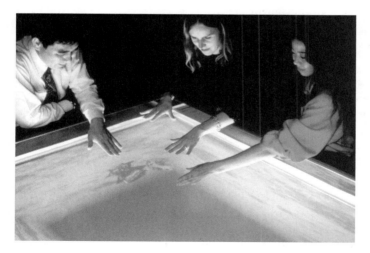

41. Christa Sommerer and Laurent Mignonneau, *A-Volve*, 1994. Participants design their own virtual creatures on a touch screen and introduce them into a virtual world, where they mate, compete, and die. The world is seen projected below a water pool, giving the impression that all creatures swim in the water. (Courtesy of Christa Sommerer and Laurent Mignonneau.)

of the water pool. The sensation was further enhanced by the fact that the digital environment in which these creatures dwelled was created with single-point perspective and a dark, fuzzy bottom, which gave the visual impression of a deep lagoon.

The title of the piece clearly evokes the idea of artificial evolution, because instead of the expected letter *E* in "evolve" we find the *A* that also prefixes the scientific discipline of a-life, or artifical life. One of the key ideas of this scientific field is that what we know about life is, of course, based on life on Earth and that life could conceivably take countless other forms. What we know is carbon-based life, but the field of "astrobiology" studies "extremophile" organisms that seem to shatter the comfortable assumptions that so far have served as pillars of the biological sciences. A good example is the discovery of thriving colonies of microorganisms living in inhospitable environments, such as inside rocks and the bottom of the sea, where temperatures and toxicity are incredibly high. To explore alternatives to the concept of life as we know it, scientists create algorithms that emulate basic life patterns, such as birth, growth, reproduction, and death, and allow them to interact with one another. This often results in unpredictable emerging behaviors that even more closely resemble complex interactions typical of living carbon-based creatures. Surprises may occur and thus further the inquiry into an artificial biology.

*A-Volve* brings this concept out of the removed domain of scientific laboratories and gives it a tangible expression. The piece allows viewers to become participants when they assume responsibility for the creation of these organisms and when they interact with them by moving their hands in the water. If viewers "grab" one of the creatures, they can bring it closer to another one and make them mate. This results in an offspring that soon afterward can be seen wiggling in the water. This situation allows viewers to interfere even more with the evolutionary path of this digital microcosm and to discover how tenuous the boundaries between real and artificial can be.

### Interactive Art in Exhibition

The works examined earlier reveal directions for interactive art that go beyond the limits of the screen. Undermining the role of the individual image and giving greater emphasis to the dynamic quality of the experience, these pieces challenge the notion that the artwork must be centered on the "author" and that it must be materially stable. Essentially immaterial, with varying degrees of emotional, intellectual, and technical complexity, these electronic artworks are finding alternative presentation venues. In some circumstances, as in the case of Victoria Vesna and Ken

Goldberg, the Internet is the "natural" digital space to show the work, which can simultaneously reach multiple audiences worldwide. Char Davies, and Sommerer and Mignonneau, often show their work in museums, and Marcel.lí Antúnez Roca has shown his performance in more than fifty cities in seventeen countries. Electronic art is seen regularly in many different venues, in several countries, and in multiple forms.

Institutions such as ZKM, in Karlsruhe, Germany; the Ars Electronica Center, in Linz, Austria; the Institute for Studies in the Arts, at Arizona State University, Tempe; the InterCommunications Center, in Tokyo; and V2 Organisation, in Rotterdam, are primarily dedicated to producing and promoting media art. Other institutions also invest regularly in electronic art exhibitions, conferences, and documentation, such as the Itaú Cultural Center, in São Paulo, Brazil; the Walker Hill Art Center, in Seoul, Korea; and the Langlois Foundation, in Montreal. In addition to the focused effort of these institutions, electronic art has increasingly been exhibited at traditional art museums. A good example is the four exhibitions realized in 2001 in the United States: 010101: Art in Technological Times (curated by Benjamin Weil et al., the San Francisco Museum of Modern Art); Telematic Connections: The Virtual Embrace (curated by Steve Dietz for Independent Curators International, New York); and the shows Bitstreams and Data Dynamics (curated by Larry Rinder and Christiane Paul, respectively, the Whitney Museum of American Art). This international interest is a clear indication that electronic art has become an integral part of the multivocal and multimedia realm that is contemporary art.

## Notes

1. Jasia Reichardt, *Cybernetic Serendipity: The Computer and the Arts* (New York: Praeger, 1968), 75–77.
2. John Whitney, *Digital Harmony: On the Complementarity of Music and Visual Art* (Peterborough, N.H.: McGraw-Hill, 1980).
3. Charles Csuri, "Computer Graphics and Art," in *Tutorial: Computer Graphics*, ed. J. Beatty and K. Booth (Silver Spring: IEEE, 1982), 558–70; originally published in 1974 in *Proceedings of the IEEE*.
4. Waldemar Cordeiro, *Arteônica* (São Paulo: Editora das Américas, 1972); Annateresa Fabris, "Waldemar Cordeiro: Computer Art Pioneer," *Leonardo* 30, no. 1 (1997): 27–31; Eduardo Kac, "Waldemar Cordeiro's Oeuvre and Its Context: A Biographical Note," *Leonardo* 30, no. 1 (1997): 23–25.
5. Vera Molnar, "Towards Aesthetic Guidelines for Painting with the Aid of a Computer," *Leonardo* 8, no. 3 (1975): 185; "My Mother's Letters: Simulation by Computer," *Leonardo* 28, no. 3 (1995): 167–70.
6. Ruth Leavitt, *Artist and Computer* (New York: Harmony, 1976), 92–96.
7. See Herbert Franke, *Computer Graphics, Computer Art* (London: Phaidon, 1971); Annabel Jankel and Rocky Morton, *Creative Computer Graphics* (Cambridge: Cambridge University Press, 1984).

8. Judith B. Burnham, coord., *SOFTWARE—Information Technology: Its New Meaning for Art* (New York: Jewish Museum, 1970).

9. See Char Davies, "Osmose: Notes on Being in Immersive Virtual Space," in *Sixth International Symposium on Electronic Arts Conference Proceedings* (Montreal: ISEA '95, 1995), 51–56; Ken Goldberg, "Virtual Reality in the Age of Telepresence," *Convergence* 4, no. 1 (1998): 33–37.

10. See Jean Gagnon, "Dionysus and Reverie: Immersion in Char Davies' Environments," in *Char Davies: Éphémère,* exhibition catalog (Ottawa: National Gallery of Canada, 1998), n.p.; Mathew Mirapaul, "An Intense Dose of Virtual Reality," *New York Times Online,* July 9, 1998; Char Davies, "*Éphémère,* Landscape: Earth, Body and Time in Immersive Virtual Space," in *Reframing Consciousness: Art, Mind and Technology,* ed. Roy Ascott (Exeter: Intellect, 1999), 196–201.

11. Marcel.lí Antúnez Roca, "*Epizoo,*" *Leonardo* 29, no. 1 (1996): 11; Teresa Macrì, *Il corpo postorganico: Sconfinamento della performance* (Genova: Costa and Nolan, 1996), 32–52; Claudia Giannetti, ed., *Marcel.lí Antúnez Roca: Performances, objetos y dibujos* (Barcelona: MECAD, 1998).

12. Victoria Vesna, *Bodies© INCorporated,* in *Siggraph '96 Visual Proceedings,* ed. Jean Ippolito et al. (New York: ACM, 1996), 16; Victoria Vesna, "Under Reconstruction: Architectures of Bodies INCorporated," in *Veiled Histories: The Body, Place and Public Art,* ed. Anna Novakov (New York: Critical Press, 1998), 87–117. See also <http://www.bodiesinc.ucla.edu/>.

13. "Database Aesthetics," ed. Victoria Vesna and David Smith, special issue, *AI & Society* 14, no. 2 (2000). On database aesthetics, see also Karen O'Rourke, ed., *L'archivage comme activité artistique/Archiving as Art,* exhibition catalog (Paris: Université Paris 1, 2000).

14. Annick Bureaud, "Review of Shadowserver," *Leonardo Electronic Almanac* 5, no. 11 (1997); Mathew Mirapaul, "Made in the Shade," *New York Times Online,* Oct. 30, 1997. See also <http://taylor.ieor.berkeley.edu/shadowserver/index.html>.

15. Laszlo Moholy-Nagy, *Vision in Motion* (Chicago: Paul Theobald, 1947), 200.

16. Christa Sommerer and Laurent Mignonneau, "Art as a Living System," in *Art @ Science,* ed. Christa Sommerer and Laurent Mignonneau (Vienna and New York: Springer, 1998), 148–61.

# 4. Negotiating Meaning: The Dialogic Imagination in Electronic Art

The words *dialogical* and *dialogism* appear often in literary criticism and philosophy, but further research is necessary regarding the meaning of these terms in the visual arts. When applied to visual arts, these terms usually become tropes similar to their counterparts in literary theory, that is, metaphors to support the analysis of cultural products that are materially self-contained (e.g., books, paintings) and therefore incapable of creating the living experience of dialogues. It is clear that one can engage in a dialogue *about* a book, but the book itself is not a dialogical medium.[1] The understanding of art as intercommunication moves us away from the issue of what it is that art or the artist communicates to question the very structure of the communication process itself. It is not so much what is being communicated in a particular situation that is at stake, but the very possibility of verbivocovisual interlocution that ultimately characterizes symbolic exchanges. Works of art created with telematic media are communication events in which information flows in multiple directions. These events aim not to represent a transformation in the structure of communication but to create the experience of it. I propose that new insights can be gained by examining artworks that are themselves real dialogues, that is, active forms of communication between two living entities. These works can often be found among artists who pursue the aesthetics of telecommunications media. To name these works, I propose a literal use of the term *dialogism*. I will present four main ideas. First, it is important to identify and articulate the significance of the field of practice that I refer to as "dialogical art." Second, there is a clear difference between dialogical art and interactive art (all dialogical works are interactive; not all "interactive" works are dialogical). Third, dialogical aesthetics is

---

Originally appeared in *Proceedings of Computers in Art and Design Education Conference 1999* (University of Teesside, U.K.).

intersubjective and stands in stark contrast with monological art, which is largely based on the concept of individual expression. Last, because it employs media that enable real dialogues, electronic art is uniquely suited to explore and develop a radical (i.e., literal) dialogical aesthetics. Seen collectively, these notions will inform the identification and study of what can be properly called "dialogical electronic art."

### Introduction

One of the most important contributions of electronic art in the second half of the twentieth century was the introduction of what I call the "dialogic principle in the visual arts." This means that dialogic electronic art undermines emphasis on visuality to give precedence instead to interrelationship and connectivity. These two terms do not designate purely theoretical concepts. Interrelationship and connectivity refer to tangible processes that enable the emergence of dialogic artworks. While dialogism in art is not exclusive to media-based propositions, as Lygia Clark's relational works[2] and some of Suzanne Lacy's social projects[3] so clearly demonstrate, the creation of media-based dialogic art is particularly significant. It finds a model in the unpredictable loop of ideas, gestures, words, gazes, sounds, and reactions interlocutors perform in real time according to one's feedback to the other's utterances.

Naturally, dialogic electronic art is interactive, but dialogism in electronic art must not be confused with interactivity. Many interactive electronic artworks are monologic, for example, a CD-ROM or a self-contained Web site. Some interactive electronic artworks are dialogic without employing telecommunications media, as exemplified by Piero Gilardi's *Shared Dolor* (2000), in which two participants recline opposite one another and together navigate a virtual world as they touch each other's hands (fig. 42). As much as local dialogical interaction is relevant and deserves to be further discussed, my focus is on telecommunications-based dialogicality, as it overcomes local boundaries and enables intersubjective experiences through the network on a global scale.

Dialogic electronic art has exhibited the collapse of the sender/receiver bipolarity of Jakobson's schematic communication model and is inventing the multilogue of networking as a collaborative art form. Positioning itself against monologic ideologies that structure the mediascape, as exemplified by one-way television broadcasting, dialogic electronic art remains open to differentiated levels of contingency and indeterminacy. Media-based dialogic artworks are important not only because they enable new kinds of dialogues to emerge in art but also

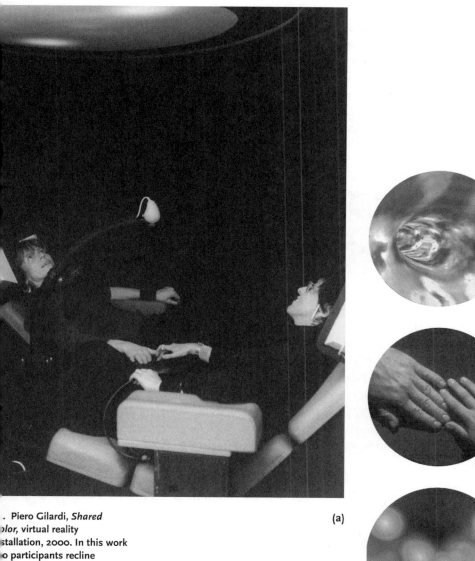
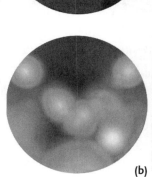

Piero Gilardi, *Shared
[Co]lor,* virtual reality
[in]stallation, 2000. In this work
[tw]o participants recline
[op]posite one another (*a*) and
[na]vigate together through a
[vir]tual world as they touch
[ea]ch other's hands (*b*).
[(Co]urtesy of Piero Gilardi.)

because they remind us that it is possible (and desirable) to stimulate dialogue. Works that make open and emancipative use of telecommunications media, in association with the Internet or not, are representative of the dialogic adventure in electronic art. Also significant are works that do not exist as independent entities and in a direct way depend on what interactants bring to the experience. My intention here is to propose a literal interpretation of dialogicality in art. I wish to assert the importance of artworks in which actual dialogical experiences (i.e., dialogues of various kinds) take place. I hope that, by acknowledging the differences between monologic and dialogic modalities of art, we can recognize the unique contribution of the latter as a promoter of new aesthetic values such as real-time remote interaction, intersubjectivity, and negotiation of meaning through manipulation of visual elements. To that end, I will discuss some key concepts of dialogism and provide examples that illustrate the emergence of dialogical electronic art since the 1960s.

## Dialogic Philosophy and Collaborative Art

A major manifestation of the digital revolution is the Web, the most popular of Internet protocols. While the Internet is made up of several different protocols, many of which enable intersubjective linking among participants, the Web itself has not privileged synchronous two-way social interaction. Likewise, most of what we see on the Web under the rubric of art is as monological as painting or television. It is useful to remember that the initial impulse behind the Web was to produce a publishing instrument, not a dialogic medium. The monological models that prevail on-line show, I believe, that electronic art has more to learn from Martin Buber's philosophy and from interactional sociolinguistics than from computer science.

Dialogic philosophy was elaborated by Buber in regard to interpersonal relationships.[4] Mikhail Bakhtin's concept of dialogics was a platform for the study of the literary genre of the novel. In both cases, the intellectual achievement of these thinkers can be (and has been) expanded and extended not only to philosophy and literature but to several other areas of study. Bakhtin clearly recognized the dynamic and intersubjective nature of language beyond what he understood to be Saussure's rigid model. For Bakhtin, human consciousness is the semiotic intercourse of one subject with another; that is, consciousness is at once inside and outside the subject. The novel, by its very nature as print, freezes speech rather than promotes its flow. The novel preserves imagined interactions on paper; it does not enable, nor could it, the

truly dialogic and unpredictable nature of language as experienced in interlocutive reciprocity. This can only be accomplished via face-to-face interactions or with two-way media works. Acknowledging the conceptual gap between the novel (print) and other genres (media), Bakhtin wrote: "It seems to us that one could speak directly of a special *polyphonic artistic thinking* extending beyond the bounds of the novel as a genre. This mode of thinking makes available those sides of a human being, and above all the *thinking human consciousness and the dialogical sphere of its existence,* which are not subject to artistic assimilation from *monologic positions.*"[5]

For Bakhtin, language is not an abstract system but a material means of production. In a very concrete way the body of the sign is negotiated, altered, and exchanged via a process of contention and dialogue. Meaning arises along the way. Bakhtin is very clear: "*the thinking human consciousness and the dialogic sphere in which this consciousness exists,* in all its depth and specificity, cannot be reached through a monologic artistic approach."[6] If taken literally, as I believe it should be, Bakhtin's approach reveals the possibility of articulating artworks that give no prerogative to visuality and that reinstate the dialogic in the aesthetic experience. In this scenario, images (and objects) become one among many elements in the elaboration of dialogic situations. Visual dialogues, for example, imply the exchange and manipulation of images in real time. In this case, we no longer speak of space as form but instead concentrate on the time of formation and transformation of the image—as in speech. This, of course, demands a revision of the most entrenched convictions of what art is, from its material base and predominant ocularcentrism to its unilateral reception, semiological negotiation, distribution logic, and social meaning.

When applying Bakhtin's ideas to the visual arts, commentators, despite their enthusiasm for his work, have been unable to show that dialogism always had the potential to be more than a literary trope.[7] Because the dialogic principle is deeply rooted in the social reality of consciousness, thought, and communication, it is precisely there that it ought to be explored aesthetically. Allusions to dialogism in reference to wall hangings and other objects miss the opportunity to contribute a theoretical viewpoint to the actual embodiment of dialogical principles in art. The dialogic principle changes our conception of art; it offers a new way of thinking that requires the use of bidirectional or multidirectional media and the creation of situations that can actually promote intersubjective experiences that engage two or more individuals in real dialogic exchanges. Through creative network topologies, artists can enable the realization of experiences that I call "multilogic

interactions." Multilogic interactions are complex real-time contexts in which the process of dialogue is extended to three or more persons in an ongoing open exchange. What one says or does directly affects and is affected by what the others say or do.[8]

The dialogic imagination has the potential to push art even beyond advanced notions of collaboration and participation. In the modern sense of the term, collaboration in the visual arts has been pursued since the first decades of the twentieth century. The playfulness of strategies such as the exquisite corpse enraptured writers and artists such as Tristan Tzara, André Breton, Yves Tanguy, and Man Ray. Breton wrote that the collective production of a sentence or drawing "bore the mark of something that could not be created by one brain alone" and that it "provoked a vigorous play of often extreme discordances, but also supported the idea of communication between the participants."[9] There are significant parallels between the shared authorship of the exquisite corpse and the collaborative procedures typical of telecommunications art. One significant difference is that in the copresence of the participants communication is partially influenced by the local behavior of the participants. Artists working through telematic networks can operate between synchronous and asynchronous time. They can also limit the exchange to specific channels (thus exploring a focused mode of communication); incorporate network noise into the experience; work the visual, audio, or verbal material simultaneously; convert one into the other (since through the network they are data); or explore the nondeductive response enabled by geographic distance (i.e., response in the absence of the source of sound or image).

### The Dialogic Imagination

Another important early sign of reaction against monologic ideologies in art is Brecht's call in 1926 for radio to cease being unidirectional and to enable dialogue and response. Brecht stated that radio should be bidirectional and that it should stop forming passive consumers and allow them to become producers. In other words, he proposed to change radio from a distribution medium to a communication medium. Brecht argued that radio should know "how to receive as well as to transmit, how to let the listener speak as well as hear, how to bring him into a relationship instead of isolating him."[10] Brecht is among the first artists to understand the importance of undoing the monologism of media and to propose dialogic alternatives to them. In his 1929 radio work *Lindbergh's Flight,* still available in an original recording from 1930,[11] he proposed that a radio broadcast be complemented with readings by members of the local audience.

# Negotiating Meaning

Throughout the twentieth century new concerns for dialogicality slowly emerged. In the 1930s and 1940s, while early kinetic art had already moved sculpture beyond fixed form, the few kinetic artworks produced still called for a contemplative viewer. This started to change with the first works that required direct, physical involvement on the part of the viewer. This noncontemplative strategy, which depended on viewer interaction, was a first step toward future dialogicality.

Laszlo Moholy-Nagy created kinesthetically interactive works in 1936, when he lived in London. His *Gyros* was a kinetic sculpture composed of gyrating glass rods filled with mercury. Elegantly suspended over a reflective metallic surface, the two mercury-filled structures had to be spun by hand in order to reveal their performative potentialities. The effect was accentuated by the structure's duplication as a reflected image. His *Light Painting* was constituted by two painted and engraved celluloid sheets spiral-bound to a painted background. The viewer was asked to manipulate the sheets. Sibyl Moholy-Nagy remembered in 1950 that, in creating this work, "the re-creative *action* became his goal, the establishment of an immediate relationship between spectator and object."[12] Moholy-Nagy himself described the effect: "The slight warpage and motion of the hinged celluloid sheets produces a combination of reflections and shadows on the background and the pigmented surfaces of the wings achieving an effective combination."[13] Sibyl Moholy-Nagy pointed out that the experience "depended on the action of the spectator" and that one "could create a variety of light and color combinations of his own choice."[14] The aesthetic parameters in these two works deliberately replaced static form and contemplation with action, immediate relationship, combinatory operations, participation, and choice.

Pushing these premises further, the Buenos Aires–based Madi movement produced works in the 1940s and 1950s with indeterminate mobile structures that were meant to be manipulated by the viewer and that, therefore, had no finite form. These works reflected formal concerns, but they opened up new and unexpected interactive possibilities. The material configuration of these works demanded active participation, ultimately leaving the experience open-ended. Outstanding examples of these early forms of interactive art are *Roÿi* (1944) (fig. 43), an articulated wooden sculpture by Gyula Kosice,[15] and the articulated wall paintings by Diyi Laañ,[16] Arden Quin,[17] and Sandú Darié.[18] These artists proposed that art should reach beyond fixed form to engage the viewer in a transformative process.

I find striking conceptual connections between the ideas embedded in these pioneering works and much of the participatory art of the

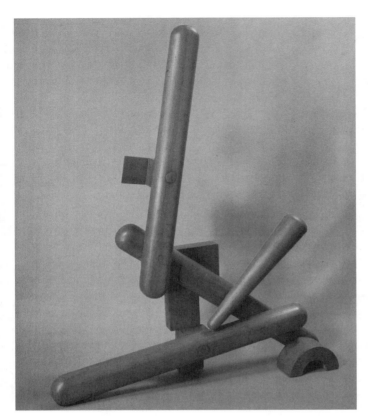

43. Gyula Kosice, *Roÿi*, articulated wood sculpture, 1944. The viewer is invited to interact with the sculpture and change its form. This is one of the earliest examples of interactive art. *Roÿi* (*a*); Kosice changing the configuration of the sculpture at the Movimiento Madí exhibition, Instituto Francés de Estudios Superiores, Buenos Aires, 1946 (*b*). (Courtesy of Gyula Kosice.)

(a)

1960s, when the ornamental qualities of the discrete objet d'art gave way to propositions that privileged challenging concepts and culturally meaningful ideas. This often meant that actions were more important than products, that technological media were more appropriate to the zeitgeist than precious materials, and that lived experiences were more significant than contemplation of pictorial form. This radical change led to the unpredictability that results from the direct involvement of the participant, echoing Bakhtinian concepts such as outsideness, answerability, and unfinalizability. I suggest that the roots of contemporary dialogical art experiences can be traced back to this arc of experimentation briefly summarized here—from modern avant-garde collaborations and interactive propositions to the dematerialized and participatory events of the 1960s and 1970s. This makes evident, I believe, that dialogism is an intrinsic and continuous development in art that results from the increased dissatisfaction with concepts of art centered on the individual and on romantic heroic myths, as elaborated by Clement Greenberg and others.[19]

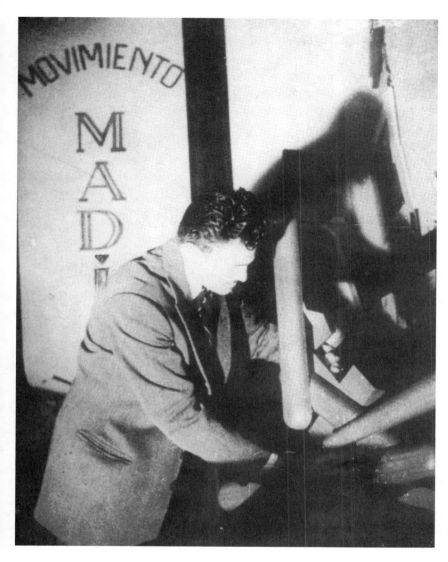

(b)

Crucial in the context of dialogic experimentation in the arts is the understanding that radical works of art cannot be limited by visuality; instead they are lived experiences based on contextual reciprocity (the context of the experience is reciprocal; i.e., it enables one to take the initiative to interfere and alter the experience). The outdated rubric of "visual arts" is unable to express the gamut and complexity of the experiences developed within a truly dialogic framework. We are no longer contemplating the notion of the artist as the individual who

works in isolation and who provides the audience with a personal vision of an idea or emotion as embodied in a rigid material composition in a system of time deferral. This model, which affirms the primacy of individuality, simply does not have the power to suggest alternatives to unidirectional and conventional modes of thinking and perception. It is based on the belief that an individual has the need (and particular skills) to externalize emotions and inner visions. This assumes that the "individual" is a discrete psychological entity and not a dialogical subject in perpetual negotiation with others. This model is too far removed from the reality of a networked world in a global economy. Or, as Suzi Gablik so poignantly put it: "Modernist aesthetics, concerned with itself as the chief source of value, did not inspire creative participation; rather, it encouraged distancing and depreciation of the Other. Its nonrelational, noninteractive, nonparticipatory orientation did not easily accommodate the more feminine values of care and compassion, of seeing and responding to need. The notion of power that is implied by asserting one's individuality and having one's way through being invulnerable leads, finally, to a deadening of empathy."[20]

The dialogic imagination in electronic art enables us to think about notions of alterity in a larger sense, beyond the specific situated conditions of given groups and representation politics. Needless to say, the struggle for acceptance and recognition of outnumbered groups within a given social system is more than a necessity; it is often a matter of physical, intellectual, and emotional survival. However, instead of constituting specific groups as Other, peripheral to a given dominant group, Buber's philosophy of dialogue foregrounds the simple and radical notion that I and Thou relate as subjects through reciprocity and mutuality. Likewise, Bakhtin's dialogic literary theory articulates the idea that meaning only emerges in dialogic relations with the other. Despite the original contexts and impetuses that prompted Buber and Bakhtin to develop their work—that is, Buber's manifest theology and Bakhtin's literary emphasis despite his strong religiosity (developed under a totalitarian regime that suppressed religion)[21]—we must not lose sight of the political statements they make. Buber makes it clear that I-It connections objectify subjects in disproportionate relationships that involve control of passive objects. For Bakhtin, monologic discourse is that which tries to negate the dialogic nature of our very existence—always the case of political discourse. For both men these ideas were not just theoretical exercises. The rise of Nazism forced Buber to leave Germany in 1933. One year later, Martin Heidegger answered a phone call from the Nazis and accepted their order to eliminate Jewish faculty and curricula from his university. Bakhtin was arrested in Stalin's Soviet Union in 1929 (for expressing his spiritual connection with the

Orthodox church) and exiled because of poor health. This most likely saved him from the fate that befell his colleague Pavel Nikolaevich Medvedev (arrested and shot in 1938 in one of Stalin's purges).

The political dimension of dialogism is intrinsically connected to its aesthetic potential. Buber states that the spirit is not in individuals but between them. For Bakhtin the aesthetic event implies the dialogic interaction of two distinct consciousnesses. Taken literally, as I wish to do here, once the premise of a dialogical aesthetics is uttered, it becomes clear that traditional visual arts are monologic, for they offer finite forms in unidirectional systems of meaning. One is often left to marvel at the individual artist's idea, skill, or craft, rather than find oneself in a situation in which one's own active cognitive, perceptual, and motor engagement ignites the discovery of one's creative potential and other relational processes.[22] Vilèm Flusser, who like Buber left Europe fleeing the Nazis, clearly understood the relevance of dialogics not only as aesthetic parameter but as social and ethical philosophy. He stated that "what we call 'I' is a knot of relations,"[23] and in a brilliant summary he gave the following examples to support his position:

> analytic psychology is able to show that what we call an individual psyche is nothing but the tip of an iceberg of what might be called a collective psyche. Ecological studies are able to show that individual organisms must be understood to be functions of a relational context best called an ecosystem. Politological studies can show that "individual man" and "society" are abstract terms (there is no man outside society, and no society without men), and that the concrete fact is intersubjective relations. This relational (topological) vision of our position coincides with the relational vision the physical and biological sciences propose to us with regard to the physical world. The physical objects are now seen to be knots within relational fields, and the living organisms are now seen to be provisional protuberances out from the flow of genetic information. Husserl's phenomenology is possibly the most adequate articulation of this relational vision, and it is becoming ever more adequate as our knowledge advances. It states (to put it in a nutshell) that what is concrete in the world we live in, are relations, and that what we call "subjects" and "objects," are abstract extrapolations from these concrete relations.[24]

Drawing from the collective insights of Buber and Bakhtin, Gablik and Flusser, and many other authors,[25] a rough sketch of a dialogical aesthetics emerges, one that is concerned not with sensory cognition or beauty but with intersubjectivity. A truly dialogic art evolves its own parameters. Just as in the system of broadcast television, in which it is

technically irrelevant if a given spectator is actually watching a program, in the monologic system of art it is irrelevant to an object if anyone is before it. The actual presence of individuals in space and time, remotely or not, is, of course, of great relevance in life, and so it is in dialogic art. In a dialogic context the presence of an individual has a bearing on what kinds of experiences might unfold. Many works that try to break away from the monologic model find in the promise of computer-based interactivity a latent liberating horizon. However, electronic interaction has the danger of promoting instead interpassive experiences that catalog all possibilities within a preestablished and restrictive system of choices. In this case, the interactant has to choose one option after another, being ultimately guided down a multioptional monologic path. No doubt capable of creating works of distinct cultural relevance in the scenario mentioned earlier, interactive art will only fulfill its greater potential, I believe, when it absorbs the dialogic stimulus provided by the actual engagement of two or more individuals in direct dialogic situations or in multilogic interactions.

### Dialogic Electronic Art

The dialogic model in electronic art will not be expressed via arrangements that privilege teleological human-computer interfaces (unless, perhaps, we consider "machine consciousness"). The a priori determination of the behavior of the computer or device prevents true responsiveness, surprise, and synergetic interaction. We have a lot to learn from a preverbal child who grabs a book with the left hand, looks at you, and with the right hand stretches your fingers, only to gently place the book against your palm in anticipation that you will read it for her. We can expand our awareness of the untapped possibilities of electronic art by observing the signals given by a plant to a pollinating bee, and by this bee to the other bees through its accelerated wing beat. The lifelong interaction between a human and her dog is also a precious education for anyone who cares to notice its beauty, complexity, emotional charge, unpredictability, and rich behavioral nuances beyond verbal languages. Rather than reiterating what we already know about point, line, and plane, electronic art can be an art of promoting contact between apparently disparate elements, expanding our awareness by revealing that what may seem distant in fact plays a direct role in our local experience. Nam June Paik points out Jules Henri Poincaré's insight that in his time we witnessed, not new things, but new relationships between things that were already there.[26] In doing so, Paik echoes Moholy-Nagy's assertion: "Creations are valuable only when they produce new, previously unknown *relationships.*"[27] It is impor-

tant for art to foster the cognizance that it ought to bring into dialogic contact entities that may not seem connected. Electronic art ought to become less "clean" and enable the coming together of antithetical ideas, public and private places, artificial and natural forces, organic and inorganic matter, intellect and emotion. This might imply that electronic art cannot be exclusively digital. Technology does not exist in a vacuum, and the world, with its smooth and rough surfaces, is analog. The postbiological metaphor, for example, reflects a mixture of organic analog tissue and inorganic digital components and techniques, perhaps to the point of erasure of distinctions. It is exactly as a negotiating agent between the two, in the interface between analog and digital, that the new electronic art is situated.

Electronic art is particularly well suited to bring about this change (i.e., dialogic awareness) because of the very communicative potentiality of electronic media, digital and analog. Important albeit sporadic experiences in the 1960s created the precedent. It was in the late 1960s and early 1970s, however, that the dialogic principle started to be addressed more directly and systematically. One of the first artworks/exhibitions to employ multiple channels of communication and to explore exchange between remote participants was *Trans V.S.I.* (1969), by Iain Baxter. This event was a Halifax-Vancouver connection realized via telex, telephone, and fax. It took place between September 15 and October 5, 1969, between Vancouver-based Iain Baxter (a member, with Ingrid Baxter, of the N. E. Thing Company, a conceptual art group) and the Nova Scotia College of Art and Design, in Halifax, where a group of art students was coordinated by artist Gerald Ferguson. Starting in 1968, instead of using the word "art" to denominate his activity, Baxter used "V.S.I.," an acronym he coined for Visual Sensitivity Information. *Trans V.S.I.* was, therefore, the transmission of art through remote communication channels. This three-week event unfolded as Baxter transmitted instructions to the art students, who in turn executed them and transmitted back the results. Baxter sent to Halifax instructions such as "live in Vancouver time" and received in exchange a diary with the record of the experience. He also instructed his remote collaborators to "make molds of the word MELT, freeze water, release the frozen letters, put them in the ocean, and let them melt." The young artists followed the instructions, took photographs, and sent them back. Baxter asked the art students to "find a tree, paint the trunk green and paint the bow and branches brown." Perhaps even more significant, Baxter and the Halifax group engaged in a discussion about the overall experience through the phone and the telecopier—arguably the most dramatic moment in this experimental dialogic work, since the discussion was not based on the execution of conceptual tasks but on an intersubjective engagement.[28]

Another early remote and interactive work was Robert Whitman's *Children and Communication,* realized in 1971 in the context of Billy Kluver and Robert Rauschenberg's Experiments in Art and Technology (E.A.T.) Projects outside Art, a series designed to show how E.A.T. could contribute to areas of society beyond the fine arts. *Children and Communication* linked children in two primary schools in New York via telephone, fax, telex, and other devices.[29] Douglas Davis, a New York–based artist, working with live broadcast and cable television, created works such as his three-and-a-half-hour-long *Talk-Out!* in 1972 (fig. 44). This was a live bidirectional telecast in which callers had a conversation with Davis over the phone and on the air about what they were watching. As the program unfolded, and phone calls started to come in, the artist interacted with viewers in real time. The dialogue could be seen by everyone watching the broadcast. A surprising moment occurred when an irate viewer yelled, "You don't know what you're doing!", following this comment with the suggestion that an open experiment such as this would corrupt young minds. Davis and his cohost made an impromptu effort to engage in dialogue with an unidentified viewer who had a gripe with the work, thus creating one of the most fascinating moments in this dialogic project. In instances such as this, when a conversation takes unprecedented turns and participants become emotionally invested in the exchange, the dialogic principle in art manifests itself plainly.[30]

Also in 1972, Aaron Marcus created *An X on America,* a three-thousand-mile-wide letter X produced both as an environmental form and as a signal-flow diagram through the telephone network. This piece engaged passersby in impromptu conversations.[31] While standing at one telephone booth located at Forty-second Street and Fifth Avenue in New York, Marcus arranged for additional telephone booths to ring in Omaha, San Francisco, Los Angeles, and Washington, D.C.: "People walking by answered the phones and found themselves hooked into a conference call with other unknown people. We discussed art, politics, and the weather. If I wanted to draw/write a mark of that scale, where would I find enough ink/paper? The answer lay in global telecom."[32] The X can also be seen as a political statement, since the national elections were taking place at the time and Richard Nixon was about to be reelected president. In this case the X acquires the characteristic of making a mark, crossing it out.

Another artist who has employed the telephone in several bidirectional situations is the French artist Fred Forest. His contribution to the twelfth Bienal de São Paulo (1973), entitled *Animation Presse* (loosely translated as "Press Intervention") (fig. 45), was realized at the height of the repressive military regime's dictatorship. It was a bank of

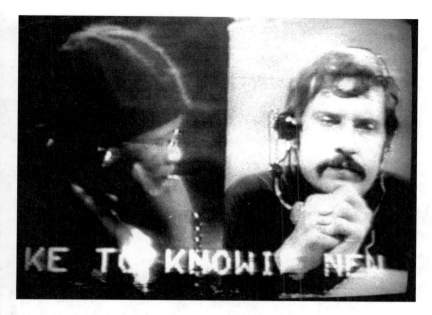

44. Douglas Davis, *Talk-Out!*, live interactive television broadcast, 1972. In this three-and-a-half-hour-long experimental broadcast, Davis fielded questions and interacted with television viewers over the telephone and on the air. (Courtesy of Douglas Davis.)

telephones that enabled citizens to call in, "speak freely," and be heard, at a time when public space and freedom of speech had been obliterated in the country.[33] Forest also enabled the public to mail messages that were posted on the walls of his exhibition area. After a demonstration with blank posters on the street, another of Forest's "actions" (as "happenings" were known in France) that indeed drew the attention of the press, the artist was arrested and interrogated by the political police (DOPS). He was set free after the French embassy and the organizers of the Bienal intervened.

In contrast with Forest's activist approach, Fluxus artist Ken Friedman developed several interpersonal telephone pieces, mostly in 1967. In 1975 he created *In One Year and Out the Other*, a dialogical telephone event meant to evoke the idea that, magically, the interlocutors inhabited distinct zones in chronological time. Here's the integral score for this event:

**In One Year and Out the Other**
On New Year's Eve, make a telephone call from one time zone to another so that you are conducting a conversation between people located in two years.

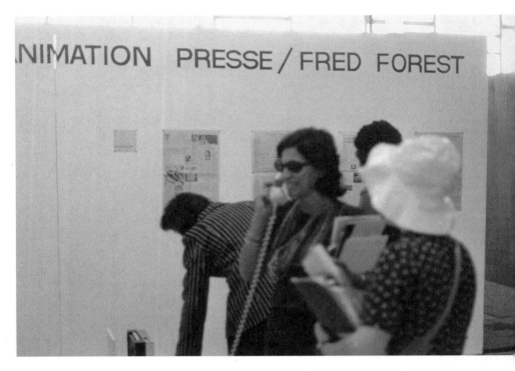

45. Fred Forest, *Animation Presse*, multimedia interactive installation, 1973. Shown at the twelfth Bienal de São Paulo, at the height of the military regime's dictatorship, the piece included public demonstrations with blank signs, newspapers with blank areas in which participants wrote as they wished, and a bank of telephones that enabled citizens to call in and "speak freely." (Courtesy of Fred Forest.)

Friedman first performed *In One Year and Out the Other* on New Year's Eve 1975–76, calling from Springfield, Ohio, forward to Dick Higgins, Christo, and Nam June Paik in New York, then back to Tom Garver and Natasha Nicholson in California. "I have performed this work annually since then," explains the artist.[34]

Liza Bear, Willoughby Sharp, Keith Sonnier, and others collaborated in 1977 to create the first live bidirectional satellite artwork, *Send/Receive* or *Two-Way Demo* (fig. 46), between New York and San Francisco (simulcast via cable in both cities).[35] Absolutely new dialogic possibilities were first explored in this piece, such as the idea of the image as a meeting place in which, for example, two dancers could interact and affect one another remotely. In 1978 Bear started to work with slow-scan television (SSTV) a device to send and receive video stills over the phone. This made communications projects more practical than with expensive live satellite links, and in the following year she

(a)

46. Willoughby Sharp, Liza Bear, Keith Sonnier, and others, *Send/Receive* or *Two-Way Demo*, bidirectional satellite link between New York and San Francisco (simulcast via cable in both cities), 1977. Dancers from New York and San Francisco perform together in electronic space (*a*); setup used in the exchange, New York (*b*). Several artists collaborated to create this event, the first live two-way satellite artwork. (Courtesy of Willoughby Sharp.)

(b)

realized the first SSTV project in Europe, between Milan, Arnhem, and Amsterdam.[36]

Works like these brought Brecht's utterances closer to our ears and elicited responses. Responsibility implies both the aesthetic bidirectionality of the art experience as well as the ethical awareness of the social implications of the work. The 1980s saw the emergence of a truly international telecommunications art movement, with artists worldwide experimenting with two-way systems and network topologies often based on accessible media such as SSTV, telephones, fax, and ham radio. As a result, not only were countless dialogic propositions carried out,[37] but the conception of network topologies was also elevated to a legitimate area of artistic experimentation. This legacy finds its natural expansion on the Internet, with its listservs, MOOs and MUDs, chat sessions, videoconferences, and telepresence (i.e., telerobotic) experiences.

## Conclusion

Telecommunications based on the exchange of audiovisual information offers the reassurance of the remote presence of the other (via voice, video, white board, and chat). Telepresence, as it merges telecommunications media with telerobotics and remote hardware steering, allows one to have a sense of one's own presence in a remote space.

These two aesthetic principles are complementary. Dialogical telepresence events combine self and other in an ongoing interchange, dissolving the rigidity of these positions as projected remote subjects. Art both shares concerns with other disciplines and offers us cognitive models with which to reflect on social, political, emotional, and philosophical aspects of life. The more electronic art learns from the fascinating and unpredictable qualities of conversational interaction—with its reciprocal rhythms, body language, speech patterns, eye contact, touch, hesitations, sudden interruptions, changes of course, and continuing flow—the closer it will get to engaging us in a process of negotiation of meaning. This is the true dialogic calling of art.

### Notes

1. My objective is to propose the creation of art that transforms unidirectional communications systems into dialogical media. Thus, by "dialogical media" I literally mean media that enable the *experience* of dialogical interaction in real time. (Of course, it is possible to create dialogical interaction with asynchronic systems or media, such as mail art, but my emphasis here is on synchronic interaction.) As a result, the meaning I ascribe to the word *dialogical* is different from the meaning assigned to it by Bakhtin, for whom a novel is a complex utterance and

therefore a part of a larger dialogue. Likewise, the way I employ the word *monological* differs from Bakhtin's theory. In his dialogic philosophy of language, speech is monological when it tries to suppress the multitude of voices that characterize culture and when it takes an authoritarian posture toward another discourse. While I find this sense of the word perfectly applicable to the context set by Bakhtin and his circle (that is, society at large), in my own dialogical theory of art it means modes of creation and experience that preclude real-time intersubjective engagement and response. So, for example, in my sense of the word, as usually produced, paintings, drawings, photographs, and sculptures are monologic. This is so because viewers engage objects that, by definition, cannot themselves literally engage the viewer.

2. For a comprehensive survey of Clark's work, see *Lygia Clark*, a catalog of the homonymous exhibition organized by the Fundació Antoni Tàpies, Barcelona, 1997. For an account of the significance of Clark's dialogism for electronic art, see Simone Osthoff, "Lygia Clark and Hélio Oiticica: A Legacy of Interactivity and Participation for a Telematic Future," *Leonardo* 30, no. 4 (1997): 279–89.

3. A good example is her *Crystal Quilt* (1987), in which 430 older women sat down in groups of four to discuss aspects of their personal lives. See Suzanne Lacy, ed., *Mapping the Terrain: New Genre Public Art* (Seattle: Bay Press, 1995).

4. Martin Buber, *I and Thou* (New York: MacMillan, 1987); first published in German in 1923 and in English in 1937. In his excellent article on Buber's dialogical philosophy, John Stewart clarifies ambiguous aspects of Buber's work and offers an overview of Buber's main concerns. See John Stewart, "Martin Buber's Central Insight: Implications for His Philosophy of Dialogue," in *Dialogue: An Interdisciplinary Approach*, ed. Marcelo Dascal and Hubert Cuyckens (Amsterdam and Philadelphia: John Benjamins, 1985), 321–35. See also Robert E. Wood, *Martin Buber's Ontology: An Analysis of* I and Thou (Evanston: Northwestern University Press, 1969); Ronald C. Arnett, *Communication and Community: Implications of Martin Buber's Dialogue* (Carbondale: Southern Illinois University Press, 1986); Samuel Hugo Bergman, *Dialogical Philosophy from Kierkegaard to Buber* (New York: State University of New York Press, 1991); Nina Perlina, "Bakhtin and Buber: Problems of Dialogic Imagination," *Studies in Twentieth Century Literature* 9 (Fall 1984): 13–28.

5. Mikhail Mikhailovich Bakhtin, *Problems of Dostoevsky's Poetics*, trans. Caryl Emerson (Minneapolis: University of Minnesota Press, 1984), 270. It is worth noting that Bakhtin read Buber while a gymnasium student. See Michael Holquist, *Dialogism: Bakhtin and His World* (London and New York: Routledge, 1990), 2.

6. Bakhtin, *Problems of Dostoevsky's Poetics*, 271.

7. In her book *Bakhtin and the Visual Arts*, Deborah Haynes provides a clear and important discussion of Bakhtin's aesthetics, represented by concepts such as outsideness, answerability, and unfinalizability. Haynes applies these concepts to the works of such artists as Carl Andre and Sherrie Levine. The point I wish to make is that, while Bakhtin's ideas can be employed as metaphors in multiple contexts, they are uniquely suited to the analysis of works that actually embody these concepts in material form. My contention is that such works are to be found, not in the genres of painting and sculpture, which, as conventionally practiced, are irreversibly monologic, but in the field of electronic art, particularly in interactive telecommunications works. As Haynes notes, Bakhtin does not focus on the aesthetic object or on the problem of beauty, but on "the phenomenology of self-other relations, relations that are embodied—in actual bodies—in space and time." Reading Bakhtin in the context of the digital culture, one can see that dialogical aesthetics is literally manifested in interactive telecommunications works that explore the phenomenology of self-other relations in dispersed remote spaces and real time.

See *Bakhtin and the Visual Arts* (Cambridge and New York: Cambridge University Press, 1995), 5.

8. Ordinary examples of such interactions in cyberspace are MOOs, MUDs, chat rooms, and avatar-based virtual communities.

9. André Breton, "The Exquisite Corpse" (1948), in *Surrealism*, ed. Patrick Waldberg (New York: McGraw-Hill, 1966), 95.

10. Bertolt Brecht, "The Radio as an Apparatus of Communication," in *Video Culture: A Critical Investigation*, ed. John G. Hanhardt (Salt Lake City: Peregrine Smith Books, 1986), 53–55.

11. Brecht and Weill, *Der Lindberghflug: First Digital Recording and Historical Recording of 1930, CD* (Königsdorf, Germany: Capriccio, 1990).

12. Sibyl Moholy-Nagy, *Experiment in Totality*, 202.

13. Laszlo Moholy-Nagy, *Vision in Motion*, 167.

14. Sibyl Moholy-Nagy, *Experiment in Totality*, 203.

15. Gyula Kosice, *Arte Madi* (Buenos Aires: Ediciones de Arte Gaglianone, 1982), 26–27. In a phone conversation between Chicago and Buenos Aires (Jan. 3, 2002), Kosice stated that *Roÿi* (pronounced roh-gee) was "the first kinetic and participatory artwork in the context of Latin American art."

16. Dawn Ades, *Art in Latin America* (New Haven and London: Yale University Press, 1989), 246.

17. *Arden Quin*, catalog of the artist's retrospective (Madrid: Fundación Telefónica, 1997), 38.

18. Maria Lluïsa Borràs, ed., *Arte Madi* (Madrid: Museo Nacional de Arte Reina Sofia, 1997), 88–89.

19. Suzi Gablik offers a sharp critique of individualism, heroism, and market-driven art and embraces a dialogical aesthetics that privileges relatedness and interactivity. See Suzi Gablik, "Connective Aesthetics: Art after Individualism," in *Mapping the Terrain: New Genre Public Art*, ed. Suzanne Lacy (Seattle: Bay Press, 1995), 74–87; "The Dialogic Perspective: Dismantling Cartesianism," in *The Reenchantment of Art*, ed. Suzi Gablik (London and New York: Thames and Hudson, 1991), 146–66.

20. Gablik, "Connective Aesthetics," 80.

21. In "Author and Hero in Aesthetic Activity," Bakhtin states that his concept of "otherness" is directly connected to the Christian worldview, which stresses that "we must relieve the other of any burdens and take them upon ourselves." See Mikhail M. Bakhtin, *Art and Answerability: Early Philosophical Essays*, ed. Michael Holquist and Vadim Liapunov, trans. Vadim Liapunov (Austin: University of Texas Press, 1990), 38. Discussing autobiographical writings, Bakhtin says that an accounting of oneself is not possible without the existence of another. For Bakhtin, any writing about the self implies an audience of higher authority: "Outside the bounds of trust in absolute otherness, self-consciousness and self-utterance are impossible . . . because trust in God is an immanent constitutive moment of pure self-consciousness and self-expression" (144).

22. The point is that, in a world dominated by monological propositions, dialogical artworks are often perceived as non-art and, as a result, not relevant. Of course, I do not believe that there is any problem with monological art forms. The problem lies in underestimating the significance of dialogical propositions.

23. Vilèm Flusser, "On Memory (Electronic or Otherwise)," in *Art Cognition—Pratiques artistiques et sciences cognitives*, ed. Marc Partouche (Aix-en-Provence: Cypres/Ecole D'Art, 1994).

24. Flusser, "On Memory," 33.

25. Deborah Tannen, *Talking Voices: Repetition, Dialogue, and Imagery in Conversational Discourse*, Studies in Interactional Sociolinguistics 6 (Cambridge:

Cambridge University Press, 1990); Dale M. Bauer and Susan Jaret McKinstry, eds., *Feminism, Bakhtin, and the Dialogic* (New York: State University of New York Press, 1991); S. N. Eisenstadt, ed., *On Intersubjectivity and Cultural Creativity* (Chicago: University of Chicago Press, 1992); Roy Ascott, *Telematic Embrace: Visionary Theories of Art, Technology, and Consciousness,* ed. Edward Shanken (Berkeley: University of California Press, 2003).

26. Nam June Paik, "Satellite Art," in *The Luminous Image,* ed. D. Mignot (Amsterdam: Stedelijk Museum, 1984), 67.

27. Laszlo Moholy-Nagy, *Painting, Photography, Film,* 30.

28. Phone conversation between Chicago and Windsor, Ontario (Feb. 5, 2002). *TransV.S.I.* was documented in a book published in 1970 by the Nova Scotia College of Art and Design. For more on the N. E. Thing Company, see William Wood, "Capital and Subsidiary: The N. E. Thing Company and Conceptual Art," *Parachute* 67 (July–Sept. 1992): 12–16.

29. Private email from Sue Wrbican, from Experiments in Art and Technology, Berkeley Heights, N.J. (Mar. 23, 1998).

30. Douglas Davis, *Art and the Future* (New York: Praeger, 1975), 91. The video documentation of this work is archived at the Flaxman Library, The School of The Art Institute of Chicago.

31. "Soft Where, Inc.," special issue, *West Coast Poetry Review* 1 (1975): 15–18.

32. Private correspondence (May 20, 2003).

33. Catalog of the twelfth Bienal de São Paulo (São Paulo: Fundação Bienal, 1973). Sebastião Gomes Pinto, "Entre na bienal pelo telefone," *Veja,* no. 267 (Oct. 17, 1973): 130. See also: Forest, *100 Actions,* 94–95.

34. Private correspondence (May 19, 2003).

35. Willoughby Sharp, "The Artists TV Network," *Video 80* 1, no. 1 (1980): 18–19.

36. See Ligia Canongia, "Imagens à Distância," *Arte Hoje,* no. 30 (1979): 40–43.

37. Many of these propositions are well documented in Eric Gidney, "Artists' Use of Interactive Telephone-Based Communication Systems from 1977–1984," Master of Arts thesis, City Art Institute, Sidney, Australia, 1986.

II. Telepresence Art and Robotics

# 5. Toward Telepresence Art

Telepresence art is a new art form generated in the intersection among telecommunications, computers, and robotics. My early work with telepresence art was a natural development from my investigation of telecommunications art. After experimenting with mail art in the late 1970s and early 1980s I started to explore networking issues in electronic spaces. My first works in 1985 with videotext (a network that enabled remote retrieval of pictures and text from databases via a special terminal) were stimulating and were followed by pieces created with fax and slow-scan TV (SSTV) (the transmission and reception of video stills over regular phone lines). SSTV allowed the exchange of images immediately after capture among small groups, and videotext enabled the artist to reach multiple audiences simultaneously across a given country. Videotext also allowed viewers to respond by sending written messages back to the artist. As I sought to develop it, telecommunications art deemphasized the picture as the focus of the work and accentuated instead the unique qualities of networking—above all, dialogical possibilities. I did not generate images thinking of space as form but concentrated instead on the time of formation of these images on-line, as in an interpersonal conversation. Real time was paramount to enable the creation of visual dialogues between distant geographic locations: sending, receiving, and transforming texts, sounds, and images. As exciting as these new frontiers were, I also sought to expand telecommunications beyond the screen and to give it a tangible or corporeal sense that comes from spatial contiguity. I wanted to enable the participant to cross the screen and gain a sense of his or her own presence in a remote social milieu.

In 1986 I created my first work with telerobotics, in the context of the exhibition Brasil High Tech, realized at Galeria de Arte do Centro

---

This chapter incorporates portions of an earlier article: "*Ornitorrinco*: Exploring Telepresence and Remote Sensing," *Leonardo* 24, no. 2 (1991). Originally appeared in *Interface* 4, no. 2 (1992).

47. Eduardo Kac, RC Robot, radio-controlled telepresence robot, 1986. The image shows a moment in the dialogical performance staged by Kac in which a remote participant interacted with Otavio Donasci's videocreature (on the floor) through the telepresence robot. The event was realized during the opening of the exhibition Brasil High Tech, Galeria de Arte Centro Empresarial Rio, Rio de Janeiro, 1986.

Empresarial Rio, in Rio de Janeiro. For this show I used a seven-foot-tall wireless anthropomorphic robot (RC Robot) in the role of a host who conversed bidirectionally with exhibition visitors.[1] The robot's voice was that of a real human being transmitted via radio waves. Motion control was also achieved through a radio link. Still in the context of the exhibition, I used the robot in a dialogical performance realized with the Brazilian artist Otavio Donasci (fig. 47), in which the robot interacted with Donasci's videocreature (a performer wearing a costume that hides the human head and replaces it with a video screen). Through the robotic body, a human improvised responses in real time to the videocreature's prerecorded utterances and to the reactions of the audience. It was a dramatic interaction, which culminated with the "suicide" of the videocreature and with a robotic "farewell." This was a telepresence work not because of the remote-control component alone but precisely because the robot became a host to a human being

Eduardo Kac and Bennett, Ornitorrinco, wireless telepresence robot, 1989. *Ornitorrinco* enabled participants to experience a remote environment from a first-person perspective.

and because this human—who was out of sight—conversed with other humans through the robotic body.

After this work, I started to think of other ways in which it might be possible to combine my telecommunications experience with wireless telerobotics. The telerobot Ornitorrinco ("platypus," in Portuguese) came to life in 1989 in Chicago (fig. 48) as a result of my collaboration with hardware designer Ed Bennett. Telepresence art will be characterized by the creation of invented worlds populated by imaginary creatures embodied in electronic parts. Most of all, telepresence art will create the context for the participant to explore these worlds—not from a human scale but from the perspective of their denizens.

*Ornitorrinco* is the name of both a series of telepresence artworks and the telerobot used to realize them. The platypus is an Australian mammal that lays eggs. This noun was chosen early on as the telerobot's name because of the unique nature of the platypus, which is

popularly thought of as a "hybrid" of bird and mammal. The objective was to imply kinship between the organic (animal) and the inorganic (telerobot) and to highlight hybridity as an important evolutionary development. The telerobot Ornitorrinco is a different kind of hybrid: it has an electronic body and the cognitive apparatus of a remote human. *Ornitorrinco* events involve at least two locations geographically remote from each other. One or more members of the public, the participant, navigates through an installation at a remote location by pressing keys on a telephone keypad and receiving visual feedback in the form of still or moving images on a computer or video monitor (fig. 49). Each work is always built to the scale of the telerobot, and not to a human scale.[2]

*Experience 1* was Ornitorrinco's first international telepresence work. It took place on January 11, 1990, in a link between Chicago and Rio de Janeiro. From Rio de Janeiro, I controlled Ornitorrinco in Chicago via a telephone connection. Ornitorrinco was in an environment in the Electronics and Kinetics Area at The School of The Art Institute of Chicago.[3] To dramatize the tangible feeling of remote presence, *Experience 1* focused on promoting collisions between the telerobot's body and objects in the remote space. The telepresence installation *Ornitorrinco in Copacabana* was unveiled at the Siggraph '92 art show (fig. 50) as part of the Siggraph '92 conference held at McCormick Place, in Chicago, from July 26 to July 31, 1992. As one experiences Ornitorrinco, one in a sense "becomes" the telerobot, looking at an invented remote space through its eye. The installation *Ornitorrinco in Copacabana* was realized simultaneously at McCormick Place (Place 1) and in the Kinetics and Electronics Department of The School of The Art Institute of Chicago (Place 2), where I built an environment. Visitors found a telenvironment that was far from the glamour of the famous Brazilian beach evoked in the title. Instead, participants saw dispersed and apparently incongruous elements, such as a skeleton trying to make a phone call, a humorous reference to the time it took to get a line in an antiquated telecommunications infrastructure, and a large mirror, which allowed visitors to "see themselves" as Ornitorrinco. The mirror, which reflected the space behind Ornitorrinco, led many participants to believe that this space was in front of them. As they moved forward in their telerobotic body, some participants collided head-on with the mirror. In telepresence the participant is prompted to exercise new sensorial abilities from the perspective of a remote body: scene and object recognition, selection of spatial cues, identification of spatial relationships, and navigation to a specific position.

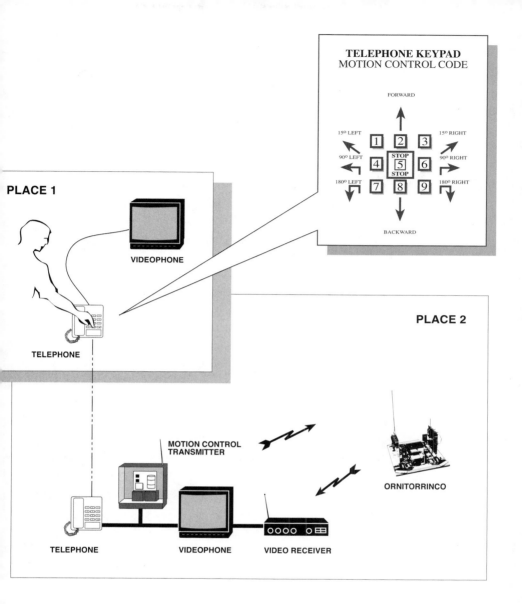

49. Eduardo Kac and Ed Bennett, basic diagram of the *Ornitorrinco* project, 1989. Participants pressed the keys on a regular telephone to control in real time the telerobot Ornitorrinco in a remote place.

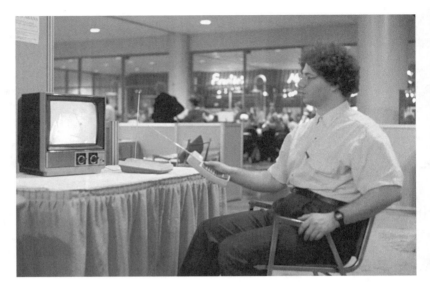

(a)

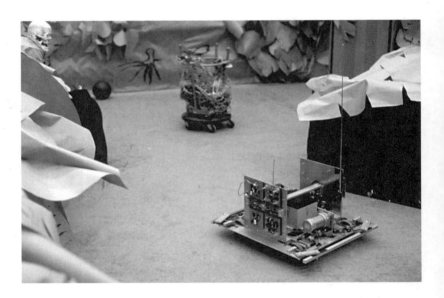

(b)

50. Eduardo Kac and Ed Bennett, *Ornitorrinco in Copacabana,* telepresence work, 1992. *Ornitorrinco in Copacabana* enabled participants (*a*) to navigate in an environment miles away through Ornitorrinco's body (*b*). The participant perceived the remote environment through Ornitorrinco's eyes (*c*).

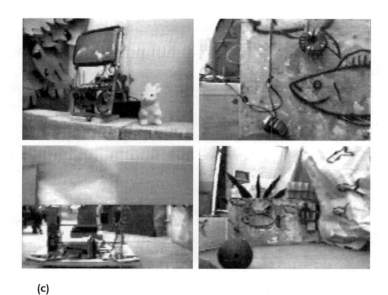

(c)

Siggraph art show visitors, who were physically present at Place 1, pressed the keys on a regular phone to navigate in Place 2. This allowed them to control in real time the telerobot Ornitorrinco. Pressing the keys also let participants see where they were in the environment created at Place 2. Since the environment was built to the scale of Ornitorrinco, and not to a human scale, a sensation of strangeness was produced when participants tried to relate what they saw, as they navigated through Place 2, to their conventional expectations of a space inhabitable by a human. It was not a matter of being successful or frustrated in figuring out the actual physical dimensions and visual characteristics of Place 2. The issue was the subjective construction of an imaginary space in the mind of each participant based on his or her decisions as he or she navigated in space.

*Ornitorrinco* purports to provide a participant (in Place 1) with conditions that allow for a remote experience of presence in an environment of which the participant has no previous knowledge (Place 2). The project allows a person to see through the eye of a telerobot and control its motion in space from a remote location in real time. By employing a regular telephone line of the sort used ubiquitously for private interpersonal communications, this project introduced the notion of "personal telepresence," which makes telepresence a subjective and individualized experience open to creative inquiry. As the participant explores the remote environment and gathers image after image of that environment, he or she constructs a personal mental image of the space. This mental space will vary from person to person. In this sense, each

participant creates in real time a relatively different and personalized imaginary environment.

The numbers on the keypad of a touch-tone phone form a code that the participant uses in a variety of combinations. For example, by simply pressing and releasing the number two, the participant actually moves forward about a foot. Pressing and releasing the number four enables the participant to make a ninety-degree left turn. Pressing the number two and then the number four allows the participant to combine the two commands and navigate around obstacles. Fresh images can be obtained just by pressing and releasing the number five.

The motion control and vision systems of Ornitorrinco are time-multiplexed over a single phone line. This means that the participant uses only one line both to transmit motion-control signals and to request and receive fresh images. Motion control is achieved by pushing a number on the keypad in Place 1 and generating a tone, which travels over the phone line to a telephone in Place 2. The signal is transmitted to Ornitorrinco, decoded, and amplified to drive the motor relays. Ornitorrinco moves at a speed of forty feet per minute over level ground. Skid steering gives it a zero turning radius. Ornitorrinco's vision system transmits a video signal over a 900-MHz carrier to a video modem connected to the phone line. At Place 1 another modem converts the signal back to video for viewing.

The telepresence works created in the context of the *Ornitorrinco* project explore the displacement of geographic references. By attaching the names of existing geographic areas, many of which a large percentage of the participants will never have experienced in person, the work plays on cultural expectations and preconceptions, which are fueled in part by real physical distance, clichés circulated in the media, and participants' own limited understanding of foreign cultures and places.

The remote environment where the participant is telepresent may or may not have elements that make reference to the location it is named after. Clearly, again, the question is not and could never be that of mimicry, resemblance, or duplication of an existing environment. The question is that of the image-that-now-becomes-place. The participant experiences the image not as a sign in the semiotic sense of the word but as a locus. Without direct access to the remote environment, and without prior knowledge of it, the participant structures imaginarily the space he or she experiences according to his or her decision-making process. The work then becomes the ephemeral bridge between real spaces and the mental architecture instantiated by the participant as the navigation takes place.

## Notes

1. The robot was built by Cristovão Batista da Silva.
2. Eduardo Kac, "*Ornitorrinco:* Exploring Telepresence and Remote Sensing," in "Connectivity: Art and Interactive Telecommunications," ed. Roy Ascott and Carl Eugene Loeffler, special issue, *Leonardo* 24, no. 2 (1991): 233.
3. My sketches for this work were published in the Brazilian journal *34 Letras*, no. 7 (1990): 80–81.

# 6. Telepresence Art

This chapter discusses an art based on the integration of telecommunications, robotics, human-machine interfaces, and computers. The "telepresence art" of which I write here can be understood within the wider framework of electronic interactive art. At its best, interactive art implies less stress on form (composition) and more emphasis on behavior (choice, action); negotiation of meanings; and the foregrounding of the public who, transformed into "participants," acquire a prominent and active role in shaping their own field of experiences. The role of the artist in interactive art is not to encode messages unidirectionally but to define the parameters of the open-ended context in which experiences will unfold.

Confusion has resulted from the almost indistinguishable use of the words *cyberspace, virtual reality,* and *telepresence* in electronic art theory and criticism. This chapter focuses on telepresence as a new art medium, but first I wish to clarify the meanings of these three words. Second, I will suggest that telepresence is a new kind of communicative experience. Third, I will point out the primacy of real time over real space as it pertains to telepresence in general and to telepresence art in particular. Fourth, I will comment on some cultural implications of telepresence beyond the narrow field of scientific simulation. Finally, I will conclude with a brief discussion of the telepresence installation *Ornitorrinco on the Moon,* presented by myself and Ed Bennett on May 28, 1993, as part of the international telecommunications art festival Entgrenzte Grenzen II (Beyond Borders II), organized by Richard Kriesche and Peter Hoffman and realized in Graz, Austria, in 1993.

Throughout the chapter I will use the word *media* in reference to all systems that allow transmission of information from one point to another, both one-way and two-way (television, telephone). I will use the

---

Originally appeared as "Telepresence Art," in *Entgrenzte Grenzen II,* ed. R. Kriesche and P. Hoffman (Graz, Austria: Kulturdata and Division of Cultural Affairs of the City of Graz, 1993).

phrase *mass media* more specifically in relation to systems that transmit information unidirectionally from one point to many points (television, radio).

## Cyberspace, Virtual Reality, and Telepresence

The word *cyberspace* was coined by William Gibson in his sci-fi book *Neuromancer*, where it meant "a graphic representation of data abstracted from the banks of every computer in the human system."[1] The prefix *cyber* as used here comes from the science of "cybernetics" (from the Greek "kubernetes," or steersman), first proposed by Norbert Wiener in 1948 to address control and communication in animal and machine. In cybernetics the notion of communication of information joins biological and physical sciences, encompassing under a general science automatic mechanisms and the workings of the brain and the central nervous system. Topics usually understood separately, such as mechanics, biology, and electricity, are brought together in the discussion of self-stabilizing control action and communication, and man and machine are seen in *analogous* fashion. Regardless of its pertinence, the ordinary use of the word *memory* to describe the storage unit of a computer is an example of the pervasive influence of cybernetic theory. It is also an example of its subtle attempt to undermine the implications of traditional philosophic concepts, such as soul, life, choice, and memory, which, writes Jacques Derrida, "until recently served to separate the machine from man."[2] Cyberspace is, therefore, a synthetic space where a human equipped with the proper hardware and software can perform based on visual, acoustic, and sometimes haptic feedback.

The phrase *virtual reality*, coined by Jaron Lanier,[3] is more generic than the term *cyberspace*. "Virtual reality" depicts the field of activity devoted to promoting human performance in synthetic environments. These environments are images representing computer data. The word *virtual*, as used in computer jargon (e.g., "virtual memory"), can be traced back to its earlier use in optics, where a *virtual image* is, for example, the one seen inside a (flat) mirror. Such an image is called *virtual* because it is not optically formed where one sees it (i.e., behind the mirror). *Virtual images* stand in opposition to so-called *real images*, which are in fact formed outside a (concave) mirror. A *real image* is formed at a point through which the rays of light entering the observer's eyes actually pass. In optics, "virtual" stands for what is inside the mirror and beyond reach, while "real" stands for that which is outside and shares our three-dimensional bodily space. If we look at the surface of the mirror as we look at the surface of the screen, as that

boundary that separates two spaces, the corporeal and the representational, we notice that, as opposed to the specular image, the digital image is formed on the screen from within. The digital image on the screen does not require external illumination as does the mirror to form its image. The digital image on the screen projects light on us. It invades our corporeal reality. Virtual reality blends the ideas of tangible corporeality (real) and intangible representation (virtual). To experience virtual reality one must, in a sense, enter the virtual image; that is, one must be immersed in cyberspace. The two concepts are intertwined.

As for *telepresence*, the coupling of robotics and telematics, we must look at both literature and popular culture to locate the origin of the concept. In 1910 the French avant-garde poet Guillaume Apollinaire published in Paris a collection of short stories in which he described a system capable of reproducing touch at a distance.[4] More concretely, the idea of a remote-controlled robotic system appeared in the comic strip *Buck Rogers in the Twenty-fifth Century* A.D. (1929),[5] by writer Philip Francis Nowlan and artist Richard Calkins. Robert Heinlein's 1942 short novel *Waldo* tells the tale of Waldo F. Jones, a genius who suffers from a disabling disease and who builds for himself a zero-gravity home in orbit around Earth. Using his impotent muscles without the constraints of gravity, he develops hardware ("waldoes") that allows him to perform teleoperations on Earth. He builds waldoes with robotic hands of different sizes, from half an inch to several feet across their palms, which respond to the commands of his arms and fingers: "The same change in circuits which brought another size of waldoes under control automatically accomplished the change in sweep of scanning to increase or decrease the magnification so that Waldo always saw before him in his stereo receiver a 'life-size' image of his other hands."[6]

When Marvin Minsky wrote the pioneering article "Telepresence,"[7] he acknowledged Heinlein's vision and proposed the development of a whole economy of mining, nuclear, space, and underwater exploration based on this technology. Minsky wrote: "Think how much more we could have learned with a permanent vehicle on the moon. The Earth-Moon speed-of-light delay is short enough for slow but productive remote control."[8] In the same article Minsky also clarified the origin of the word *telepresence*, which, he writes, "was suggested by my futurist friend Pat Gunkel."[9] Telepresence, which seemed as improbable in 1980 as when Heinlein wrote *Waldo*, has evolved into a new field.

In principle, telepresence and virtual reality coincide only when a person immersed in the digital environment can remotely control an actual telerobot in our tangible space and receive feedback from his or her teleactions. The input may originate in the physical world and affect the

virtual space as well. One can also conceive of immersive virtual reality on-line. This means that several people from different countries could meet on-line and interact through their graphic projections using telecommunications systems, which could be coupled to telerobots.

Telepresence is pursued by scientists as a pragmatic and operational medium that aims at equating robotic and human experience. The goal is for the anthropomorphic features of the robot to match the nuances of human gestures. In this search for an "operational double," to use Baudrillard's term, humans wearing flexible armatures will, scientists believe, have a quantifiable feeling of "being there." While it is clear that actions will be performed by telepresence routinely in the future, I do not think that the ability to execute specific tasks, which captivates scientists, is what will interest artists working with telepresence. It is certainly not what stimulates me. The idea of telepresence as an art medium is not about the technological feat, the amazing sensation of "being there," or any practical application whose success is measured by accomplishing goals. I see telepresence art as a means for questioning the unidirectional communication structures that mark both traditional fine arts (painting, sculpture) and mass media (television, radio). I see telepresence art as a way to express on an aesthetic level the cultural changes brought about by remote control, remote vision, telekinesis, and real-time exchange of audiovisual information. I see telepresence art as challenging the teleological nature of technology. To me, telepresence art creates a unique context in which participants are invited to experience invented remote worlds from perspectives and scales other than the human.

### Telepresence: A New Communicative Experience

It is clear that the old sender/receiver model of semio-linguistic communication is no longer enough to account for the multimodal nature of networked, collaborative, interactive telecommunications events that characterize symbolic exchange in art or in the ordinary intercourse of our daily affairs.[10] As a hybrid of robotics and telematics, telepresence adds to the complexity of this scene. In telepresence links, images and sounds are transmitted, but there are no "senders" attempting to convey particular meanings to "receivers." Telepresence can be either an individualized or an intersubjective bidirectional experience.

We speak of the mass media as being means of *communication,* but if we look carefully at the logistics of the mass media we realize that what they produce is in fact noncommunication. Baudrillard states that mass media are antimediatory because communication is "an ex-

change, ... a reciprocal space of a speech and a response."[11] How is this reciprocal space different from that of the transmission-reception model made reversible through feedback? In other words, when any television spectator phones in and participates in a poll giving his or her opinion, is he or she in a reciprocal space? Baudrillard does not think so: "The totality of the existing architecture of the media founds itself on this latter definition: *they are what always prevents response,* making all processes of exchange impossible (except in the various forms of response *simulation,* themselves integrated in the transmission process, thus leaving the unilateral nature of the communication intact). This is the real abstraction of the media. And the system of social control and power is rooted in it."[12] Whether involving an exchange between two interlocutors or not, telepresence seems to create this *space of reciprocity* absent from mass media. The space created by telepresence is reciprocal because the decisions (motion, vision, sound, operation) made by the "user" or "participant" affect and are affected by the remote environment and/or remote participant.

Baudrillard formulates the problem of lack of response (or *irresponsibility*) with clarity, but to solve the problem, to restore the possibility of response (or *responsibility*) in telecommunications media, would be to provoke the destruction of the existing structure of the media. And this seems to be, as he rushes to point out, the only possible strategy, at least on a theoretical level, because to take power over media or to replace its content with another content is to preserve the monopoly of verbal, visual, and aural discourse. The idea of probing the structure of the mass media and creating parallel structures that defy the persuasive nature of unidirectional transmissions is, I believe, of relevance to artists exploring interactivity.

In a growing tendency observable since the 1960s, when videotape and communication satellites became the major vectors in forming the grammar of television, many important social events (of both a progressive and a conservative nature) have been experienced as media events. Examples include the historic democracy movement in China and the Gulf War. Not that these events became the *content* of special programs; the new phenomenon is that for most of the world these events took place *in* the media. Thus, it comes as no surprise that Chinese crowds were cheering American reporters as heroes and asking "Get our story out!" and that Gulf War missiles transmitted from their own perspective images of their targets as they approached them, until the very moment of the explosion, when all one saw was a noisy screen. What is observed here is that the meaning of actions no longer results purely and simply from the actions themselves, from negotiations between copresent interactors; meaning is now generated *directly* in the

domain of reproducibility, in the realm of the ubiquitous and unidirectional image. Telecommunications media seem to abstract everything, from their own pseudomediation process to the massacre of a population. It all becomes abstract, spectacular, and, in a perverse twist, entertaining, served in minute temporal doses between commercials.

Telecommunications media efface the distinction between themselves and what used to be perceived as something apart, totally different from and independent of themselves, something we used to call reality. Baudrillard calls this lack of absolute distinction between sign (or form or medium) and referent (or content or real) as stable entities "hyperreal" or "hyperreality." In what is likely to be his most celebrated essay, "The Precession of Simulacra," he once again acknowledges McLuhan's perception that in the electronic age the media are no longer identifiable as different from their content. McLuhan knew that it is the new pattern introduced by a new medium or technology that provokes the social consequences of the medium or technology—and not a particular program content. But Baudrillard goes further, saying that "there is no longer any medium in the literal sense: it is now intangible, diffuse and diffracted in the real, and it can no longer even be said that the latter is distorted by it."[13] One could say that the fusion of the medium and the real is especially true in telepresence, since one can actually perform and change things in the real world from far away. Thus, telepresence art dramatizes and draws attention to this significant aspect of contemporary culture.

Television is of particular importance here because it is the mass medium par excellence, the most influential medium worldwide. It is easy to see that television's influence will grow even stronger with HDTV, digital TV, and the popularization and miniaturization of both static and mobile satellite receivers, and once fiber-optic networks become as ordinary as the introspective Walkman. I mention the Walkman because in its private sensorial experience it can be seen as the epiphenomenon of a society that chooses to remove itself from public space. Away from public space, we experience socialization as phone conversations, the shared experience of TV viewership, or interactions through networks such as the Internet. More and more the phenomenon that used to be thought of as "direct" experience becomes mediated experience without us really noticing it. To "get in touch" (touch!) is to make a phone call. People get married after having developed personal relationships over the Internet.[14] From a technological standpoint we are not so far from routinely touching someone remotely through a phone call by means of force-feedback devices. As in Heinlein's *Waldo*, the dream is of being there without ever leaving here. At different levels we subordinate local space to remote action, promoting what Bau-

drillard so succinctly describes as "the satellitization of the real."[15] What we understand by *communication* is changing because physical distances of the public space no longer impose absolute restrictions on certain kinds of bodily experiences (audition, mobility, vision, touch, proprioception—i.e., sense of limb position) as they once did.

In his essay "Signature Event Context," Derrida points out the multivocal nature of the word *communication:* "We also speak of different or remote places communicating with each other by means of a passage or opening. What takes place, in this sense, what is transmitted, communicated, does not involve phenomena of meaning or signification. In such cases we are dealing neither with a semantic or conceptual content, nor with a semiotic operation, and even less with a linguistic exchange."[16] It is this opening, this passage between two spaces, that defines the nature of the particular communication experience created by telepresence art. This opening is not a context for "self-expression" (of the author or of the participant); it is not a channel for communicating semiologically defined messages; it is not a pictorial space where aesthetic formal issues are structurally relevant; it is not an event from which one can clearly extract specific meanings. Baudrillard suggests that to restore the responsibility of the media would imply a reconfiguration of the architecture of the media. This is an area that artists should critically investigate. The structure of the telepresence works I create with Ed Bennett involves one regular phone line through which the participant controls a telerobot in real time. Through the telerobot the participant gathers images and hears the sounds in the environment. In their dispersed organization, our telepresence works provide a reflection on relevant contemporary issues without addressing them as "content," as separate from the materials that constitute the work itself. The communication event created by telepresence art undoes in its own realm the polarizing categories of "transmitter" and "receiver" and restores, in an unprecedented reversal, the primary sense of the word *tele-vision,* enabling the participant to move in a remote space and to decide what he or she wants to see.

## Real Time and the Disappearance of Distance

At a nearly subliminal level we are experiencing a significant change in the way we carry out even our most ordinary affairs. What seems to be at the core of this change is the fact that *real space* and the very notion of *distance* are becoming increasingly irrelevant, giving up their once privileged status to *real time* and the *commuting of sound and images* (including text). I believe that this change cannot be examined only with enthusiasm or reluctance, because technophobia and technomes-

sianism are two sides of the same coin. I'm interested in investigating to what extent these changes will reinforce social and cultural codes already in place and to what extent they will create new and different ones, generating unprecedented contexts where new art forms will emerge.

Paul Virilio addresses such questions as they concern the new social role of the image and the field of telepresence. Suggesting that live transmission of video images over great distances becomes in itself a new kind of place, a "tele-topographic locale," he states that a *telebridge* of sorts, made of sound and image feedback loops, gives origin to telepresence or telereality, of which the notion of real time is the essential expression. This telereality, Virilio continues, supersedes in real time the real space of objects and sites. In other words, we see the continuity of real time overcoming the contiguity of real space. We experience this new condition daily, when we are in the office or studio and activate by remote control our answering machine at home to retrieve recorded messages or when we withdraw money from an automatic teller machine that communicates with a remote computer. The impact of fiber optics, monitors, and video cameras on our vision and our surroundings will go beyond that of electricity in the nineteenth century: "In order to see," Virilio observes, "we will no longer be satisfied in dissipating the night, the exterior darkness. We will also dissipate time lapses and distances, the *exterior itself.*"[17]

In consonance with Baudrillard's perception of the new informational landscape, Virilio advances the notion that we don't inhabit or share a *public space* anymore, as we used to do before the electrification of towns. Our domain of existence or socialization is now the *public image*, with its volatile, functional, and spectacular ubiquity that commands identity, surveillance, relationship, memory, and ultimately life and death. To the notion of a phenomenology of perception as epitomized by Merleau-Ponty, he opposes a *logistics of perception*, the meaning of which becomes more obvious in the piercing gaze of scientific imagery and in satellite surveillance, which will instantaneously map the body of the patient or the enemy territory. The strategy of vision will anticipate the strategy of the assault (against a virus or an army) and will be a powerful weapon in itself. With the use of real-time video in surveillance systems, the introduction of video technology in apartment buildings, and the popularization of the camcorder and the videophone, social behavior is changing. One can expect strategies of vision to develop on a more personal level.

For Virilio, one of the most important aspects of the new technologies of digital imaging and of synthetic vision made possible by optoelectronics is the "fusion/confusion of the factual (or operational) and

the virtual," the predominance of the "effect of the real"[18] over a reality principle. In other words, everything now involves images in one way or another—not necessarily images in the traditional sense of representation but images of light that are part of the contemporary landscape, as electricity invaded towns in the late nineteenth century, an "electronic lighting." Images now are invasive, and they are used by diverse social groups. The role of the image, Virilio says, is "to be everywhere, to be reality."[19]

He distinguishes three kinds of logic of images, according to a clear historical development. For Virilio, the *formal logic* of the image is the one achieved in the eighteenth century with painting, engraving, and architecture. In traditional pictorial representation it is the composition of the figure that has primary importance, and the flow of time is relatively irrelevant. Time is absolute. The age of *dialectical logic* is that of the photograph and of cinematography in the nineteenth century, when the image corresponds to an event in the past, to a differentiated time. At last, the end of the twentieth century, with video, computer, and satellites, marked the age of *paradoxical logic*, when images are created in real time. This new kind of image gives priority to speed over space, to the virtual over the real, and therefore transforms our notion of reality from something given to a construct. Virilio says that to some extent the lesson of the new technologies is that reality has never been given; it has always been acquired or generated. Our images never really duplicated reality; they always gave it shape. The difference is that, before, a functional distinction could still be made on more solid grounds.

A great deal of our social experience takes place through sound and images transmitted throughout the globe via telecommunications: regular and cellular phones, satellite and cable television, teleconference systems, fax, modems, wristwatch telecommunications devices, and so on. In all cases the actual space that disconnects the interlocutors is not an impediment to interaction because what really separates them is the different time zones. At six P.M. in Chicago I cannot call my friend in Dusseldorf because there it is one A.M., and he is asleep.

The shortest distance between two points is no longer a straight line, as it was in the age of the locomotive and the telegraph. In the age of satellites and fiber optics, the shortest distance between two points is *real time*. The ability to commute information instantaneously, to send and receive sound and images immediately (i-mmediately, or with no apparent medium or means?), accounts for the decreasing social relevance of the extensity of space in regard to the intensity of time. As a consequence, speed is no longer expressed only in miles or kilometers per hour but also in bauds or bytes per second. More than ever, when we need to actually dislocate our bodies through

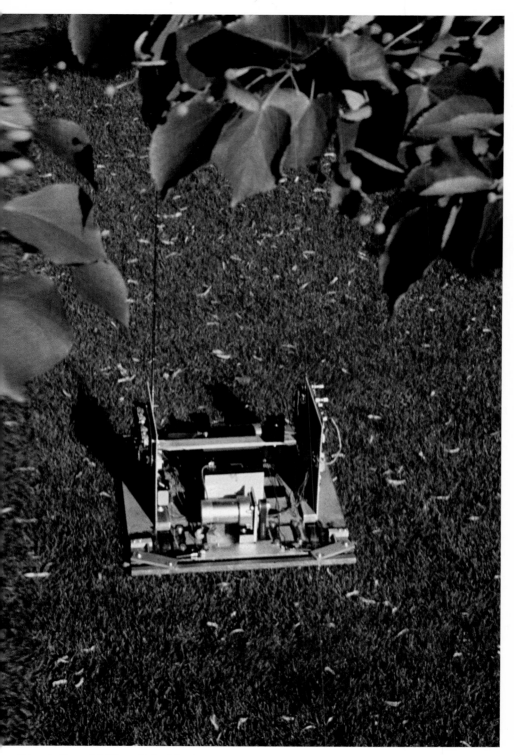

Eduardo Kac and Ed Bennett, the telerobot
Ornitorrinco, 1989. Aluminum, electronic
components, wireless networking.
18 x 24 x 24 in (plus extendible antennae).

Eduardo Kac, *Rara Avis*, 1996. Telerobot, thirty zebra finches, aviary, VR headset, Internet.
Dimensions variable.

Eduardo Kac, *Teleporting an Unknown State*, 1994–96. Plant, video projector, webcams, wood, Internet. Dimensions variable.

Eduardo Kac, *Time Capsule* (top), 1997. Microchip implant simulcast on TV and the Web, remote scanning of the microchip through the Internet, photographs, X-ray. Dimensions variable.

Eduardo Kac, *Time Capsule* (bottom), 1997. One of seven sepia-toned photographs that are part of *Time Capsule*. 2.5 x 3.5 in.

ardo Kac, *Telepresence Garment*, 1995–96. Semielastic
, leather, CCD, video board, wireless transmitters and
ivers. Dimensions variable.

Eduardo Kac, *Genesis* (top), 1999. Net installation with live video, light box, microvideo camera, petri dish with *Genesis* gene, Web site. Dimensions variable.

Eduardo Kac, *Transcription Jewels* (bottom), 2001. Glass, purified *Genesis* DNA, gold, wood. Dimensions variable.

Eduardo Kac, *Free Alba! (Le Monde)*, 2001. Color photograph mounted on aluminum with Plexiglas.

Eduardo Kac, *The Eighth Day*, 2001. Net installation with live video, blue lights, sound, biological robot, water, GFP organisms (plants, mice, fish, amoeba), Web site. Dimensions variable.

the environment we express the contiguity of space by means of a temporal deferral or delay.

Discussing the cultural and aesthetic conditions of a society that increasingly manipulates more information than objects, Abraham A. Moles states that the human spirit has to adjust to this new situation in which images and reality become more and more identified with one another. I find this to be nowhere more patent, in terms of applied technology, than in virtual reality systems under development by NASA[20] that allow a person immersed in cyberspace to mediate force at a distance. In this case, the operator or user acts or performs at the level of reality and virtuality simultaneously. "As we enter the age of telepresence," writes Moles, "we seek to establish an equivalence between 'actual presence' and 'vicarial presence.' This vicarial presence is destroying the organizing principle upon which our society has, until now, been constructed. We have called this principle the law of proximity: what is close is more important, true, or concrete than what is far away, smaller, and more difficult to access (all other factors being equal). We are aspiring, henceforth, to a way of life in which the distance between us and objects is becoming irrelevant to our realm of consciousness. In this respect, telepresence also signifies a feeling of equidistance of everyone from everyone else, and from each of us to any world event."[21]

This blending of reality and images, and the "feeling of equidistance," are, like most consumer technologies, the consequence of research originally carried out for strategic and military purposes. Telepresence will leave the laboratories and become more accessible, as happened before with the telephone, radio, television, and computers. We shall not lose sight of this, even if our sight is blurred with images of a new kind, images that themselves illuminate the environment. The equidistance we share is felt as a media phenomenon, if such a distinction can still be made, because of the process of intermediation of real space promoted by real-time telecommunications apparatuses. This equidistance means approximation as much as it means distancing. The subordination of three-dimensional bodily space to real time is a process of abstraction that continuously blurs the distinction between images and reality. It brings to the same sphere of entertainment sitcoms, the most tragic news from Bosnia or Somalia, and talk shows.

Telecommunications systems are used for overt or disguised entertainment and surveillance, for democratic and antidemocratic propaganda, and for new forms of imprisonment. Remote surveillance is found in public areas, such as the subway, or in private environments, such as office and apartment buildings. Remote surveillance systems are also available for the domicile. During the Tien an Men Square bloodshed, in Beijing, the Chinese military warned journalists that they would

be shot if they photographed army units on the streets of the city. CBS news anchorman Dan Rather was forced by Chinese officials to shut down his satellite hookup. CBS in its turn used videophones ("transceivers") to transmit still-video pictures over regular phone lines from Beijing to New York, and from there to the rest of the world. Reporters like Richard Roth in Beijing used cellular phones to speak live on TV from Tien an Men Square over the pictures that galvanized world opinion. During the Gulf War the American government released prerecorded video sequences transmitted in real time by a missile, from its own perspective, until the moment of the explosion. The images were broadcast to show the missile's precision (which one obviously reads as military supremacy). Videophones are also being used to control multiple offenders incarcerated in their own homes. In some states in the United States convicted drunk drivers are prisoners in their own houses under a strict regime of electronic surveillance. A computer at local police headquarters phones the offender at random up to fifteen times every twenty-four hours and orders him or her to transmit a picture after performing a simple task (e.g., "turn your head to the right") to confirm real-time action. The computer also asks the offender to blow into an alcohol tester and send a picture of the resulting numbers.

Virilio reminds us that through telepresence, "the inhabitant of telematic places is in the position of a demiurgue: to the *omnivision* of the trans-appearance of things, is added another divine attribute, i.e., *omnipresence* from afar, a sort of electro-magnetic telekinesis."[22] The use of remote surveillance for social control is already rooted in our public space, and it invades the privacy of the home. This is an important phenomenon, and contemporary art must address it, employing the same tools to criticize its scrutinizing gaze from within.

### Less Simulation, More Stimulation

If we look at the domain of virtuality not only as punishment but as business as usual, going from the police headquarters to the corporate world, we notice that the dream of omnivision resurfaces, this time turning the invisible visible as simulation and visualization. At Siggraph '91, in Las Vegas, I had the opportunity to try several virtual reality systems, all in one room, where the show Tomorrow's Realities took place. This turned out to be quite an interesting experience, since I was able to compare the way my body reacted while I experienced approximately ten systems. One of the systems I tried involved the idea of surrogate tourism and was the one that left me with the most vivid memories: *Mountain Bike with Force Feedback for Indoor Exercise,* from the University of North Carolina at Chapel Hill. It used a ten-

speed bicycle with a resistant device attached to the rear wheel. As the user rides around in a synthetic countryside, he or she can change direction by turning the handlebars. The rider sees the synthetic environment by wearing a head-mounted stereo display, and the pedaling resistance changes according to the type of terrain.

What I found compelling was not so much the technological tour de force but my body's response. My whole body was engaged in the activity of riding this bike, which meant that I was propelled not only by my vision but by the coordination of my body as a whole. I must say that I was not able to disregard the fact that I had two tiny pixelated LCD screens so close to my eyes. The result was a mixture of fascination (at being immersed kinesthetically in cyberspace) and discomfort (since my eyes never quite adapted to the screens and my body felt suspended and groundless). Perhaps most significant of all was the fact that I sustained conversation with the person who was in charge of the demonstration throughout my journey, maintaining through language a link with the exterior reality. Language was the only bridge between the two worlds, the only link that helped me preserve my balance and that kept me from getting completely sick from the experience. Language helped me keep in perspective that there I was, in that room, stationary on an actual bike but moving with a synthetic bike, listening to the sounds of the synthetic world and to this real person's voice at the same time but seeing only a digital landscape.

I tell this story because to me it illustrates the excitement in exploring the bidirectional path between two planes of experience. Language in the case of my virtual bike ride was not so much a means of communication, in the traditional sense of the word, between myself and the gentleman next to me. What was actually said was not relevant. Language, in this specific context, provided me with a means of communication between two spaces, like an open door separating and joining, creating the feeling of equidistance between two rooms. In the *Ornitorrinco* telepresence works I create with Ed Bennett, we use remote vision to bridge two spaces. By creating a context in which the participant experiences the remote environment through the images that he or she gathers at will, our telepresence works use the screen as that which mediates visual perception.

The debate on direct or mediated perception of reality reemerges with renewed interest in light of digital networking and simulation technologies. In "Téléprésence, naissance d'un nouveau milieu d'expérience" (Telepresence, Birth of a New Milieu of Experience),[23] Jean-Louis Weissberg indicates what he sees as the phenomenological predicaments of virtual reality. Despite being one more case in which the word *telepresence* is used erroneously to indicate performance in

cyberspace, with no mention of telerobotics whatsoever, Weissberg's essay rightly points out connections between Merleau-Ponty's discussions of vision and what Weissberg refers to as the "applied phenomenology of NASA's laboratories." In "Eye and Mind" Merleau-Ponty criticizes the operational models of science as a construct; he also mentions Panofsky's reading of Renaissance perspective in order to reveal perspective as another form of construction of the world. In both cases, the constructs are abstracted from that body caught in the fabric of the world that generates them. Science uses instruments that "sense" phenomena that the human body does not respond to. The technique of perspective promotes cyclopean vision, which does not represent stereopsis and other aspects of human vision. If scientific thinking deals with "the most 'worked-out' phenomena, more likely produced by the apparatus than recorded by it,"[24] Renaissance perspective tried to found an "exact construction" but was only "a particular case, a date, a moment in a poetic formation of the world which continues after it."[25] Rejecting Cartesian rationalism, Merleau-Ponty states that one cannot "imagine how a *mind* could paint" and that in fact it is in his or her actual body—not the body as bundle of functions but as an "intertwining of vision and movement"—that the artist changes the world into artworks.[26] Observing the indissociability of vision and motion, he underlines that the body is immersed in the visible, that it sees and is seen, that it sees itself seeing. Changes of place, Merleau-Ponty writes, form a "map of the visible," meaning that what is within the reach of sight, the visible world, is also within the map of motility, "the world of my motor projects." "My movement," he writes, "is not a decision made by the mind, an absolute doing which would decree, from the depths of a subjective retreat, some change of place miraculously executed in extended space. It is the natural consequence and the maturation of my vision."[27]

The very idea of telepresence in art plays on the notion of this "change of place miraculously executed in extended space." This *miracle,* of course, is not achieved by a mental command but by the use of specific instruments (telerobot, modem, telephone, video monitors, computers, network routers, etc.). This equipment, which in science could be used for data collecting and other applications, in art is used as a means to address the complexity of our perception in the age of media. If we once thought of images only in terms of mirror reflections, pictorial representations, or mental recollections, in the contemporary context electronic images command the map of the visual and of the motor projects of humankind. That is why Virilio speaks, as I mentioned before, of a logistics of perception replacing a *phenomenology of perception.* Electronic cameras invade all spaces (including

the limits of the galaxy and the human body, during surgery), and electronic images on screens become indissociable from other elements in our landscape.

The screen, then, acquires a particular significance. In the *Ornitorrinco* telepresence works, the screen is both the bridge to another place and that which makes vision possible. But this vision does not separate what it sees from where it sees it; it does not separate space from objects, since all are brought to the same layer. This layer is a black and white, pixelated image that breaks action into instants, that invites participants to generate "maps of the visible." The low-resolution image that forms the bridge to the low-resolution environment draws attention to itself and makes no effort to disguise itself as that clear window that commercial television strives to be. The screen, then, is as much a part of the process of seeing as the movements made by the participant in consonance with the telerobot. The point here is that we humans don't see just because light shines on objects around us, exciting our retinas, but because of a code or a network of meanings in place prior to our seeing, which allows us to recognize these illuminated objects as meaningful forms. "Between the subject and the world," writes Norman Bryson, "is inserted the entire sum of discourses which make up visuality, that cultural construct, and make visuality different from vision, the notion of unmediated visual experience. Between retina and world is inserted a *screen* of signs, a screen consisting of all the multiple discourses on vision built into the social arena."[28] Bryson's linguistic interpretation of visuality agrees with Merleau-Ponty's, when he says that our eyes are "more than receptors for light rays" and that the gift of the visible "is earned by exercise."[29] This interpretation uses the metaphor of the screen as that which mediates our experience, a screen that catches our vision in a network of meanings agreed upon socially. In this sense, perhaps, all "presence" is somewhat removed, remote, caught in an oscillation between presence and absence. Merleau-Ponty says, "voir c'est avoir à distance" (to see is to have at a distance).[30] The use of the video monitor in the *Ornitorrinco* telepresence works is meant both as a door or passage between two spaces and as a metaphor for our mediated experience of an intelligible world. As an artwork, *Ornitorrinco* is not concerned with scientific *simulation* but with promoting aesthetic *stimulation* of the presence-absence experience.

### Ornitorrinco on the Moon

The moon may not have changed significantly since artists started to express their fascination with it. Painters such as Jan van Eyck and Tintoretto included the moon in some of their paintings, and so did mod-

ern avant-garde artists such as Joan Miró and Max Ernst. However, our relationship to the earth's satellite has certainly changed dramatically since the realization of our ultimate lunar fantasy, that is, walking on its surface and transmitting the feat live on television to the astonishment (and incredulity) of spectators worldwide. In 1969, Joseph Kosuth wrote: "One can fly all over the earth in a matter of hours and days, not months. We have the cinema, and color television, as well as the man-made spectacle of the lights of Las Vegas or the skyscrapers of New York City. The whole world is there to be seen, and the whole world can watch man walk on the moon from their living rooms. Certainly art or objects of painting and sculpture cannot be expected to compete experientially with this."[31] Arguably, the global mobilization around the televised lunar conquest was as significant as the landing itself. It was a confirmation of the remotely transmitted image's influence over the collective consciousness and a clear political message. The age-old muse of poets everywhere was no longer a distant symbol, or a symbol of distance, but a step in our exploration of the firmament.

In a process that started with the development of photography, and that was further accentuated through electronic media, we acquired the ability to visualize ourselves in remote spaces that we did not experience directly. These images are so ingrained in our subconscious that one can dream of being on the moon and evoke accurate lunar images in sleep. Rather than trying to reproduce the inhospitable landscape of the earth's satellite, the telepresence work *Ornitorrinco on the Moon* evokes the process of construction of reality at a distance. In other words, it seeks to examine how the media employed in gaining access to a remote physical locale are critical in determining one's apprehension of what that locale is.

Realized between Chicago and Graz, *Ornitorrinco on the Moon* (fig. 51) employed real-time video stills and sound. The basic structure was similar to previous *Ornitorrinco* installations: when participants in Graz pressed the keys on a regular telephone they controlled in real time the vision and motion of the telerobot Ornitorrinco in Chicago. The numbers on the key pad of the phone were treated as spatial coordinates (press one and turn left, press two and move forward, press three and turn right, and so on). When the participant pressed five he or she stopped Ornitorrinco in Chicago and requested that an image be sent back to him or her in Graz. Ornitorrinco responded to the request in real time, taking approximately six seconds for the image to be formed on the remote participant's screen due to the bandwidth of regular phone lines. This delay was an intrinsic part of the aesthetic experience: one-way telecommunications time delays between Earth and

51. Eduardo Kac and Ed Bennett, *Ornitorrinco on the Moon*, telepresence work linking Chicago and Graz, Austria, 1993. The telerobot was in an environment that used sound spatially. Different sounds came from the speakers, including a looped recording that stated, "I remember the day when . . ."

the moon are on the order of three seconds, and between Earth and Mars are on the order of eleven minutes.

An important component of this work was sound. Speakers were scattered across the space and hung facing down. Different sounds were coming from the speakers, including synthetic sounds, live radio, and a looped recording of my voice saying, "I remember the day when . . ." Each recording or live transmission was heard on at least two speakers positioned away from each other. This way, the sounds, instead of serving as spatial markers, became in fact disorienting. The production of architectural ambiguity was a strategy to undermine literalization of the experience and to provoke participants to explore freely this invented situation.

In art remote communication reflects critical changes in cultural patterns: the subordination of real space to real time. The moon here is not the earth's natural satellite. The moon in this installation is nothing but an image among other images, where the participant moves about at will, encountering here and there elements of surprise (e.g., puppets, a Renoir reproduction, a bowling ball, a looped slide show about evolution), moving them out of their place and rearranging the

space, causing objects to fall, discovering here and there spaces not explored before.

This exploration originates a "subjective cartography." The participant spontaneously tries to map the space based on the samples gathered along the way. The samples are gathered not from a human scale, but from the perspective of the telerobot Ornitorrinco (approximately two feet above the ground). Each "map of the visible" that results from each experience is, therefore, unique in its difference to paths explored by other participants. Each mental map is peculiar to each experience, which is to say that each participant forms a different conception of the actual space. The actual space is therefore vicariously multiplied, corroborating the instability of its factual data.

In *Ornitorrinco* telepresence works, the features of the actual space (geographic location, size, color, materials, etc.) are secondary. The space is what I call a "low-resolution environment," that is, a space created specifically to be seen from a black and white, mobile, pixelated point of view. Again, the remote action is factual, but for the participant it all takes place as an image, the image being the place. The participant only gains access to the space through images he or she gathers as he or she moves telerobotically in real time. The actual space is not conceived to be experienced by humans locally, in body, as an installation in itself. What is at stake is the ephemeral and fleeting remote experience realized through the phone line.

A new art has emerged that addresses the cultural, material, and philosophical conditions of our time. Some key elements of this new art are real-time interactive installations, robotics, and telecommunications events. In telepresence works these three parameters come together, suggesting further developments.

### Notes

1. William Gibson, *Neuromancer* (New York: Ace Books, 1984), 51.
2. Derrida, *Of Grammatology*, 9.
3. Jaron Lanier: "I made up the term 'virtual reality.' Originally the term referred to systems that used head-mounted displays and gloves that were networked together so that people could experience a shared meeting place in the virtual world and have the ability to design the world with simulated tools while they were inside it. I made up the term to contrast this technology with 'virtual environment' systems, where you focus on the external world but not on the human body or the social reality created between people." See Lanier's interview with Tim Druckrey, reproduced in *Digital Dialogues: Photography in the Age of Cyberspace* 2, no. 2 (1991): 114.
4. Guillaume Apollinaire, "L'amphion faux-messie ou histoires et aventures du baron d'Ormesan," in *L'hérésiarque et cie* (Paris: Stock, 1984), 238–54.
5. Philip Francis Nowlan and Richard Calkins, *Buck Rogers au vingt-cinquième siècle* (Paris: Pierre Horay, 1977), 46.

6. Robert A. Heinlein, Waldo *and* Magic, Inc. (New York: Ballantine Books, 1990), 133.
7. Marvin Minsky, "Telepresence," *Omni*, June 1980, 45–52.
8. Minsky, "Telepresence," 48.
9. Minsky, "Telepresence," 47. For more on Pat Gunkel, see David Stipp, "Patrick Gunkel Is an Idea Man Who Thinks in Lists," *Wall Street Journal*, June 1, 1987.
10. Eduardo Kac, "Aspects of the Aesthetics of Telecommunications," *Siggraph '92 Visual Proceedings*, ed. John Grimes and Gray Lorig (New York: ACM, 1992), 47–57.
11. Baudrillard, "Requiem for the Media," 128.
12. Baudrillard, "Requiem for the Media," 129.
13. Baudrillard, *Simulations*, 54.
14. Tracy LaQuey with Jeanne C. Ryer, *The Internet Companion* (Reading, Mass.: Addison-Wesley, 1992), 8.
15. Jean Baudrillard, "The Ecstasy of Communication," in *The Anti-Aesthetic: Essays on Postmodern Culture*, ed. Hal Foster (Seattle: Bay Press, 1983), 128.
16. Jacques Derrida, "Signature Event Context," in *Limited Inc.* (Evanston: Northwestern University Press, 1990), 1.
17. Paul Virilio, *L'inertie polaire* (Paris: Christian Bourgois, 1990), 72.
18. Paul Virilio, *La machine de vision* (Paris: Galilée, 1988), 128.
19. Paul Virilio, interview, in "The Work of Art in the Electronic Age," special issue, *Block*, no. 14 (1988): 7.
20. Scott S. Fischer, "Virtual Environments: Personal Simulations and Telepresence," in *Virtual Reality: Theory, Practice, and Promise*, ed. Sandra K. Helsel and Judith Paris Roth (Westport, Conn., and London: Meckler, 1991), 101–10. Fischer writes: "The VIEW system is currently used to interact with a simulated telerobotic task environment. The system operator can call up multiple images of the remote task environment that represent viewpoints from free-flying or telerobotmounted camera platforms. Three-dimensional sound cues give distance and direction information for proximate objects and events. Switching to telepresence control mode, the operator's wide-angle, stereoscopic display is directly linked to the telerobot 3-D camera system for precise viewpoint control. Using the tactile input glove technology and speech commands, the operator directly controls the robot arm and dexterous end effector which appear to be spatially correspondent with his own arm" (107).
21. Abraham A. Moles, "Design and Immateriality: What of It in a Post-Industrial Society?" in *The Immaterial Society: Design, Culture and Technology in the Postmodern World*, ed. Marco Diani (Englewood Cliffs, N.J.: Prentice-Hall, 1992), 27–28.
22. Virilio, *L'inertie polaire*, 129. Virilio coins the term "trans-appearance" (108) to indicate that in this age of real-time transmission of sensible appearances it is no longer light alone that lets us see, but its speed. Virilio: "Transparency is not only that of the appearance of objects seen at the instant of the gaze. It suddenly becomes that of appearances transmitted instantaneously over distance; therefore I propose the term TRANS-APPEARANCE of 'real time,' and not only the TRANSPARENCY of the 'real space.'"
23. Jean-Louis Weissberg, "Téléprésence, naissance d'un milieu d'expérience," *Art Press Spécial*, H.S., no. 12 (1991): 169–72.
24. Maurice Merleau-Ponty, "Eye and Mind," in *The Primacy of Perception and Other Essays on Phenomenological Psychology, the Philosophy of Art, History and Politics*, ed. James M. Edie (Evanston: Northwestern University Press, 1964), 160.

25. Merleau-Ponty, "Eye and Mind," 174–75.
26. Merleau-Ponty, "Eye and Mind," 162.
27. Merleau-Ponty, "Eye and Mind," 162.
28. Norman Bryson, "The Gaze in the Expanded Field," in *Vision and Visuality*, ed. Hal Foster (Seattle: Bay Press, 1988), 91–92.
29. Merleau-Ponty, "Eye and Mind," 165.
30. Merleau-Ponty, "Eye and Mind," 166.
31. Joseph Kosuth, "Art After Philosophy" (1969), in *Idea Art: A Critical Anthology*, ed. Gregory Battcock (New York: Dutton, 1973), 88.

# 7. Telepresence Art on the Internet:
## *Ornitorrinco in Eden* and *Rara Avis*

Telepresence and virtual reality have opened up new areas of artistic experimentation. Scientific telepresence research focuses on telerobotics and teleoperation. The development of commercial virtual reality technologies has enabled individuals to experience a completely synthetic environment from immersive or second-person perspectives. When used in radical ways to critique aspects of the mediascape and contemporary life, hybrids of these and other technologies have helped electronic artists chart new directions for contemporary art.

In the future telepresence and virtual reality will become more integrated. This integration will enable actions that will take place inside an immersive virtual environment to affect physical reality and vice versa. The same can be said about the use of these technologies in art. However, it is also possible to make an objective distinction between the two. In this sense, I will refer from now on in this chapter to the word *telepresence* in relation to telerobotics, that is, remote control of a nonautonomous robot in a distant physical space. I understand *virtual reality* as related to the creation and experience of purely digital worlds.

The distinction between telepresence and virtual reality can be further clarified by comparing the processes of these two technologies. Virtual reality relies on the power of illusion to give the observer a sense of actually being in a synthetic world. VR makes perceptually "real" what in fact only has virtual (i.e., digital) existence. By contrast, telepresence transports an individual from one physical space to another, often via a telecommunications link. Telecommunications and robotics can bring together the transmission and reception of motion-control signals with audiovisual, haptic, and force feedback. Telepresence virtualizes what in actuality has physical, tangible existence.

Originally appeared in *Leonardo* 29, no. 5 (1996).

In fact, from this point of view, it would almost seem that virtual reality and telepresence technologies are opposite in nature. However, I propose that the rise of these two technologies indicates that the new domain of human agency encompasses with the same intensity electronic space and physical space. Under specific circumstances digital or synthetic worlds may become "equivalent" to tangible realities, since both telepresence and virtual reality technologies can project human performance beyond its ordinary, immediate reach.

### Interaction, Telepresence, and Netlife

The introduction of televirtual technologies in society at large is remapping our domain of action and interaction in all public spheres. The social introduction of new technologies has always affected cultural sensibility, from the mechanical press to photography; from telegraphy to the telephone; from the phonograph to cinema, radio, television, the personal computer, and the Internet. New information technologies generate new contexts for the production, distribution, and reception of cultural works as well as new ways of understanding familiar scenarios. They have the power to modify the social arena through the introduction of new forms of intercourse and negotiation of meaning. Our systems of symbolic exchange are increasingly incorporating new multimedia elements introduced by the merger of telecommunications, real-time computing, and worldwide networking. It is clear that phone calls and email messages will never be the same when full-motion video (30 fps) takes over pervasive broadband digital lines. Conversations will become multimedia and telepresential experiences, incorporating tactile feedback, for example, will become ordinary. Technology will continue to migrate toward the body, reconfiguring, expanding, and transporting it to remote sites.

The new art of telepresence redefines our understanding of human potential by expanding the reach of human presence in real time beyond spatiotemporal barriers. Through events, systems, and ephemeral installations this new art operates in the realms of mediascape and netlife (n-life)[1] and interfaces the human body to computers and other electronic devices. The dominant presence of the local object in the visual arts[2] makes room for the immaterial experience of telepresence. While a few decades ago we spoke about the process of dematerialization of the art object,[3] it is necessary to acknowledge the existence of an immaterial art. Immaterial art does not mean art without any physical substrates; rather, it signifies the exploration of televirtual domains and the foregrounding of the participant's experience.

# Telepresence Art on the Internet

Artists working with the tools of their time merge technologies of the visible and the invisible, configuring synthetic and telepresential environments in which physical boundaries are partially removed in favor of virtual and remote navigation. This results in the synergy of new nonformal elements, such as coexistence in virtual and real spaces, telerobotic navigation, synchronicity of actions, real-time remote control, body-sharing of telerobots, and collaboration through networks. The telepresence installation *Ornitorrinco in Eden* integrated all these elements simultaneously.

### Ornitorrinco in Eden

The networked telepresence installation *Ornitorrinco in Eden* (fig. 52) was experienced publicly worldwide over the Internet on October 23, 1994 (after more than one year of experiments). This piece bridged the placeless space of the Internet with physical spaces in Seattle, Chicago, and Lexington. The piece consisted of these three nodes of active participation and multiple nodes of observation worldwide (fig. 53). Anonymous viewers from several American cities and many countries (including Finland, Canada, Germany, and Ireland), who received information about the event via Listserv groups and word of mouth, came on-line and were able to see the remote installation in Chicago from the point of view of Ornitorrinco. They were also able to see each other as they looked through Ornitorrinco's eye.

The mobile and wireless telerobot Ornitorrinco in Chicago was controlled in real time simultaneously by participants in Lexington and Seattle. The remote participants shared the body of Ornitorrinco. Via the Internet, they saw the remote installation through Ornitorrinco's eye. The participants controlled the telerobot via a regular telephone link (a three-way conference call) in real time.

The space of the installation was divided into three sectors, which were all interconnected. The predominant visual theme was the obsolescence of media once perceived as innovative and the presence of these media in our technological landscape. Obsolete records, magnetic tapes, circuit boards, and other elements were used primarily for their external shape, texture, and scale, rather than function. This worked as a direct comment on the postindustrial environment we live in, made of products that become useless faster than users manage to understand and master their functionality. Theatrical lights were also used to enhance the visual experience and to control the projection of shadows in specific areas of the installation. Small objects were placed in strategic points in the space, including plastic globes that were actually

(a)

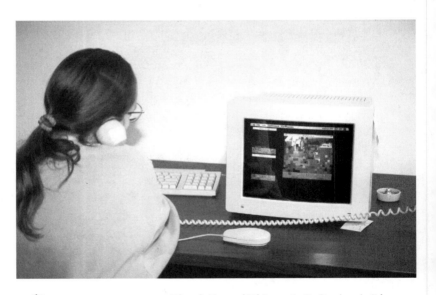

(b)

52. Eduardo Kac and Ed Bennett, *Ornitorrinco in Eden*, telepresence work on the Internet, 1994. On-line participants (*a* and *b*) shared the body of the telerobot (*c*), located in Chicago, and experienced a physical environment built with obsolete media (*d*, detail).

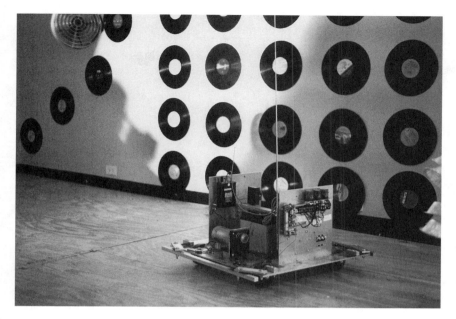

(c)

(d)

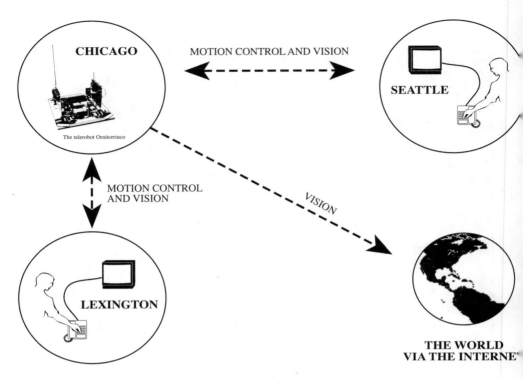

53. Diagram of *Ornitorrinco in Eden*, 1994.

pushed around by the telerobot, a self-propelled circular fan that hung from the ceiling by its power cord and swung in unpredictable ways, a little stationary robot with glowing eyes (which upon close scrutiny revealed itself as a swiveling fan), and a mirror that enabled participants to "see themselves" as the telerobot Ornitorrinco. Objects like these provided viewers with surprise encounters along the path of their exploration of the space and helped convey the atmosphere suggested by this teleparadise of obsolescence.

One of the main issues raised by this piece is the cultural need for the Internet to become more of a shared social space and less of an information-delivery system. As Geert Lovink pointed out during our panel at Ars Electronica, in 1995, as hundreds of viewers/readers log on to Web sites they remain completely unaware of each other's presence in the same server.[4] As a result, technologies that are marketed as promoters of social interaction remain developed and practiced as product-dissemination technologies, as preservers of the same social isolation that characterizes television. The mutual awareness of participants sharing the body of Ornitorrinco already reveals the social significance of such experience. Unable to fully control the body on their own terms, they must cooperate for any navigation to be realized.

## Telepresence: Telecommunications as a Space for Remote Agency

In the interactive and participatory context generated by *Ornitorrinco in Eden,* communicative encounters took place not through verbal or oral exchange but through the rhythms that resulted from the participants' engagement in a shared mediated experience. Viewers and participants were invited to experience together, in the same body, an invented remote space from a perspective other than their own, making temporarily irrelevant individual control, physical presence, and geographic location. As the piece was experienced through the Internet, electronic space was transformed from a representation medium into a medium for remote agency.

By merging telerobotics, remote participation, geographically dispersed spaces, and the traditional telephone system, as well as cellular telephony, real-time motion control, and videoconferencing through the Internet, this networked telepresence installation produced a new form of interactive art—one that does not conform to unidirectional structures that form the mediascape. As the analog mediascape of radio and television becomes digital, mass media's monological discourse (one-to-many) will try to renew its system and its reach through pseudointeractive gadgets, attempting to absorb and domesticate the multilogue (many-to-many) genuinely practiced on the Internet. It is also clear that more and more people will live, interact, and work between the worlds inside and outside the computer. The expansion of communications and telepresence technologies will prompt new forms of interface between humans, plants, animals, and robots.[5] The *Ornitorrinco* project has pursued this strategy while at the same time insisting on undermining trends toward stabilization of standards. The aesthetics of hybridization explored by *Ornitorrinco* calls for alternatives to the hegemonic configuration of the mediascape.

With low Earth orbit satellites, portable satellite dishes, virtual retinal displays, wristphones, holographic video, and a whole plethora of new technological inventions, new media will continue to proliferate, but by no means can this be seen as an assurance of a qualitative leap in interpersonal communications. *Ornitorrinco in Eden* creates a context in which anonymous participants perceive that it is only through their shared experience and nonhierarchical collaboration that little by little, or almost frame by frame, a new reality is constructed. In this new reality, spatiotemporal distances become relative, virtual and real spaces become equivalent, and linguistic barriers may be temporarily dissolved in favor of a common experience.

### Rara Avis

I use telecommunications media to implode their unidirectional logic and to create experiences that give precedence to dialogic exchanges.

In *Rara Avis* (fig. 54) the participant saw a very large aviary as soon as he or she walked into the room.[6] In front of this aviary the participant saw a virtual reality headset. Inside the aviary the viewer noticed a strong contrast between the thirty flying birds (zebra finches, which were very small and mostly gray) and the large, perched tropical macaw. This macaw, like any other, had a long saber-shaped tail, pointed wings, a curved powerful bill, and brilliant plumage. Upon observing the behavior of the birds, the viewer noticed that the macaw—the most commanding bird in the aviary—appeared motionless. Only its head moved. This tropical bird was in fact a telerobot. Macaws see laterally better than forward due to the lateral position of the eyes on the head and little overlap in fields of view. To accommodate human stereoscopic vision, the ocular apparatus of the robot was fused with that of an owl. Since the macaw's eyes were on the front of the head, the telerobot was called a macowl.

The viewer was invited to put on the headset. While wearing the headset, the viewer was transported into the aviary. The viewer now perceived the aviary from the point of view of the macowl and was able to observe himself or herself in this situation from the point of view of the macaw. The tropical bird's eyes were two CCD cameras. When the viewer, now a participant, moved his or her head to left and right, the head of the telerobotic macowl moved accordingly, enabling the participant to see the whole space of the aviary from the macowl's point of view. The real space was immediately transformed into a virtual space. The installation was permanently connected to the Internet (fig. 55). Through the Net, remote participants observed the gallery space from the point of view of the telerobotic macowl. Through the Internet remote participants also used their microphones to trigger the vocal apparatus of the telerobotic macaw, which was heard in the gallery. The body of the telerobotic macowl was shared in real time by local participants and Internet participants worldwide. Sounds in the space, usually a combination of human and bird voices, traveled back to remote participants on the Internet.

The piece can be seen as a critique of the problematic notion of "exoticism," a concept that reveals more about relativity of contexts and the limited awareness of the observer than about the cultural status of the object of observation. This image of "the different," "the other," embodied by the telerobotic macowl, was dramatized by the fact that the participant temporarily adopted the point of view of the rare bird.

By enabling the local participant to be both vicariously inside and physically outside the cage, the installation also addressed issues of identity and alterity, projecting the viewer inside the body of a rare bird that was the only one of its kind in the aviary and was also distinctly different from the other birds (in scale, color, and behavior). Seeing himself or herself behind the cage, as if imprisoned, the participant was both observer and observed, caught in an irresolvable loop between two distinct subject positions. In *Rara Avis*, the spectacular became specular, forcing the viewer to see himself or herself through the eye of the so-called exotic being.

This piece created a self-organizing system of mutual dependence, in which local participants, animals, a telerobot, and remote participants interacted without direct guidance, control, or external intervention. As the piece combined physical and nonphysical entities, it merged immediate perceptual phenomena with a heightened awareness of what affects us but is visually absent, physically remote. Local and on-line participants experienced the space simultaneously. The local ecology of the aviary was affected by Internet ecology and vice versa.

Telepresence art introduces action at a distance into the repertoire of network-based contemporary art. Network topology is an area of artistic creativity. Just as the facture in painting or the rhythm of the line in drawing creates the specific quality of a picture, network topology contributes to produce the specific quality of an on-line piece. The topology of *Rara Avis* was carefully designed to expose how the social hierarchies and inequalities found outside cyberspace are reproduced in the network. As the video feed from the point of view of the macowl went out from the Atlanta space into the Internet, one eye was digitized in grayscale (with the freeware CU-SeeMe), while the other was digitized in color (with the commercial product Enhanced CU-SeeMe). While anyone with Internet access could download the freeware and participate in the interactive component of the work, full participation in color was only accessible to those who had already purchased the commercial version of the freeware. The gray images were subsequently and automatically uploaded to the *Rara Avis* Web site, where they became even more accessible. This was relevant because more people had access to (and felt comfortable with) the Web than to videoconferencing on the Internet.[7] The color feed was rerouted to the MBone, the multicasting zone of the Net, which only a much smaller group of individuals could access. Some experienced the space in Atlanta in grayscale, while others saw it differently, in color and at faster frame rates. Those who logged on in color saw those who logged on in black and white, but not the reverse.[8] In its geographic dispersal, *Rara Avis* was willfully never exactly the same to remote or local participants, revealing that disparities found

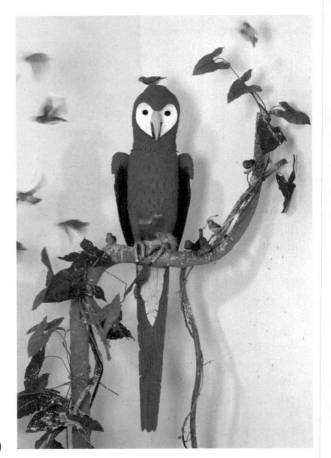

(a)

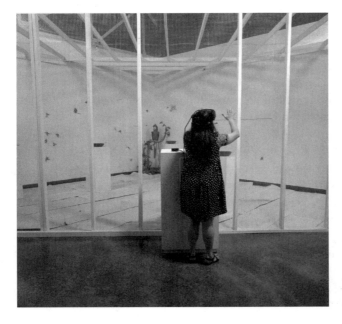

(b)

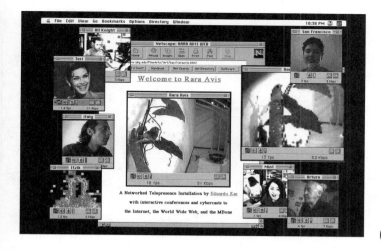

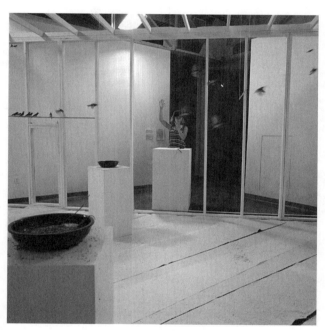

54. Eduardo Kac, *Rara Avis*, telepresence work on the Internet, 1996. A large and colorful telerobotic macaw (*a*) shared an aviary with thirty small birds. Local (*b*) and remote (*c*) participants experienced the space from the perspective of the macaw. The image of "the other" embodied by the telerobot was dramatized by the participant adopting the point of view of the rare bird (*d*).

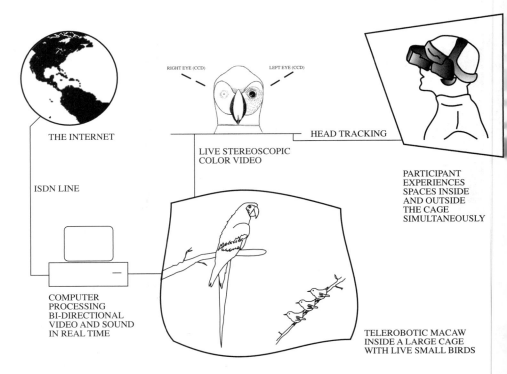

55. Diagram of *Rara Avis*, 1996.

in the physical world are easily duplicated on-line. Blending subject and object, bridging physical and virtual, integrating electronics and living animals, *Rara Avis* created a domain of interaction where reality emerged as negotiation of differences.

### Notes

1. In my telematic interactive installation *Teleporting an Unknown State* (1994–96) the concept of netlife, or life that depends on network activity for its survival, was realized. The piece was shown in The Bridge, the 1996 Siggraph Art Show, at the Contemporary Arts Center in New Orleans, from July 22 to Aug. 9, 1996. See Jean Ippolito et al. (eds.), *Siggraph '96 Visual Proceedings* (New York: ACM, 1996). On the Web, see <http://www.ekac.org/teleporting.html>.

2. M. Fried, "Art and Objecthood," *Artforum* 5, no. 10 (1967): 21; F. Colpitt, *Minimal Art: The Critical Perspective* (Seattle: University of Washington Press, 1990), 67–73.

3. L. Lippard, (ed.), *Six Years: The Dematerialization of the Art Object from 1966 to 1972* (1973; repr. Berkeley and Landon: University of California Press, 1997). See also Oscar Masotta's lecture "Despues del Pop: Nosotros Desmaterializamos" (After Pop: Dematerialization), presented at the Instituto Di Tella on July 21, 1967. The lecture was first published in Oscar Masotta, *Conciencia y estructura* (Buenos Aires: Editorial J. Alvarez, 1968), 218–44.

4. See K. Gerbel and P. Weibel, *Mythos Information—Welcome to the Wired World* (Vienna and New York: Springer-Verlag, 1995).

5. R. Weiss, "New Dancer in the Hive," *Science News* 136, no. 18 (1989): 282–83; P. Fromherz and A. Stett, "A Silicon-Neuron Junction: Capacitive Stimulation of an Individual Neuron on a Silicon Chip," *Physical Review Letter* 75, no. 8 (1995): 1670–73.

6. *Rara Avis* premiered as part of the exhibition Out of Bounds: New Work by Eight Southeast Artists, curated by Annette Carlozzi and Julia Fenton. See K. Maschke, ed., *Out of Bounds: New Work by Eight Southeast Artists* (Atlanta: Nexus Contemporary Art Center, 1996). On the Web, see <http://www.ekac.org/raraavis.html>. *Rara Avis* traveled to three more venues: the Huntington Art Gallery (now the Jack Blanton Museum of Art), Austin, Texas, Jan. 17–Mar. 2, 1997; the Centro Cultural de Belém, Lisbon, Portugal, Apr. 11–May 8, 1997; and the Casa de Cultura Mário Quintana, Porto Alegre, Brazil, Oct. 2–Nov. 30, 1997 (in the context of the exhibition I Bienal de Artes Visuais do Mercosul).

7. This, of course, is bound to change, since videoconferencing on the Web itself will become more popular.

8. The expression of social and technological inequality represented through access to higher or lower color depth and frame rate was suggested by science fiction writer Neal Stephenson in his novel *Snow Crash* (New York: Bantam, 1993). For example, he describes "the avatars of Nipponese businessmen, exquisitely rendered by their fancy equipment" and "black-and-white people—persons who are accessing the Metaverse through cheap public terminals, and who are rendered in jerky, grainy black and white" (41). For a succinct explanation of the MBone, see M. R. Macedonia and D. P. Brutzman, "MBone Provides Audio and Video across the Internet," *IEEE Computer* 27 (Apr. 1994): 30–36. For a detailed discussion of the MBone, see Vinay Kumar, *MBone: Interactive Multimedia on the Internet* (Indianapolis: New Riders, 1996).

# 8. The Origin and Development of Robotic Art

As electronic media become more pervasive in every aspect of culture, the role of robotics in contemporary art, along with video, multimedia, performance, telecommunications, and interactive installations, needs to be considered. In this chapter I propose to define a framework for the understanding and analysis of robotic art. I will discuss three pivotal artworks from the 1960s that outlined the genesis of robotics in art and that formed the basis of the three main directions in which robotic art has developed. I will also elucidate the issues raised by contemporary robotic artworks and clarify their relationship to the main paths defined by those three early works.

## Problems of Definition

One of the most problematic issues of robotics in art is the very definition of what a robot is. Complicating matters, on the one hand, we have mythological traditions of various cultures. These traditions have originated fantastic synthetic creatures, such as the ancient Greek story of Galatea[1]—a statue brought to life by the goddess Aphrodite—or the Jewish legend of the Golem, a speechless anthropoid made of clay by humans.[2] On the other hand, we find more recent literary traditions offering fictional profiles of automata, robots, cyborgs, androids, telerobots, and replicants. Intriguing literary artificial beings have excited the imagination of readers worldwide: Mary Shelley's *Frankenstein* (1818), Villiers de l'Isle-Adam's "Future Eve" (1886), Gustav Meyrink's version of the Golem (1915), Karel Capek's robots in the play *R.U.R.* (which introduced the world in 1922 to the Czech word *robot*), Robert Heinlein's *Waldo* (1940), Isaac Asimov's *Cutie* (1941)—to name a

Originally appeared in *Digital Reflections: The Dialogue of Art and Technology*, ed. Johanna Drucker, special issue, *Art Journal* 56, no. 3 (1997).

few.³ The literary robotic canon is further expanded by the presence of robots in film: Fritz Lang's *Metropolis* (1926), Fred Wilcox's *Forbidden Planet* (1956), George Lucas's *Star Wars* (1977), Ridley Scott's *Blade Runner* (1982). Television contributed to further popularize the image of the computing companion (Irwin Allen's *Lost in Space*, 1965); the cyborg (Harve Bennett's *The Six Million Dollar Man*, 1974); the sophisticated android and the evil mixture of flesh and electronics (*Star Trek: The Next Generation*, 1987; after Gene Rodenberry's *Star Trek*, 1966).

Another aspect of the problem is the operational definition of robots as found in scientific research and industrial applications. The first industrial robots appeared in the early 1960s in the United States and in about twenty years developed a stronghold in industrial facilities around the world.⁴ These reprogrammable manipulators easily handled repetitive tasks. They increased productivity and prompted further research aimed at improving their efficiency in manufacturing plants. It is clear that from this perspective robots are advanced computer-controlled electromechanical appliances.

If artists working with or interested in robotics cannot ignore mythological, literary, or industrial definitions of robots and artificial life forms, it is also true that these definitions do not necessarily apply to any given robotic artwork.⁵ Each artist explores robotics in particular ways, developing strategies that often hybridize robots with other media, systems, contexts, and life forms.

As artists continue to push the very limits of art, they introduce robotics as a new medium at the same time that they challenge our understanding of robots—questioning therefore our premises in conceiving, building, and employing these electronic creatures. The fascination robots exert on the population at large has unexplored social, political, and emotional implications. These implications must be coupled, if they are to be properly understood in the contemporary art context, with the new aesthetic dimension of modeling behavior (the artist creates not only form but the actions and reactions of the robot in response to external or internal stimuli) and developing unprecedented interactive communicative scenarios in physical or telematic spaces (the object "perceives" the viewer and the environment).

The works highlighted here often evade any narrow definition of robotics—except, perhaps, for the principle of giving precedence to behavior over form. Sticking to a narrow definition seems less important than the opportunity to trace parallels between strategies that foreground at times electronic creatures ("robotic art") and at times a combination of organic and electronic ("cybernetic art") or the remote projection of a human subject onto a telerobot ("telepresence art").

Not only do these art forms seem directly related, but they also appear hybridized in several works.

## The Genesis of Robotics in Art

While prototypes of noncommercial robots were developed in the 1940s, notably for entertainment and scientific research,[6] it was not until the 1960s that we saw the first robotic artworks. As developed in the 1950s and 1960s, kinetic art contributed to free sculpture from static form and reintroduced the machine at the heart of the artistic debate.[7] It is important to mention the use of an analogue and tethered remote-control device by Akira Kanayama, in 1957, as a means for the creation of his Gutai painting experiments, but particularly significant in this context is Nicolas Schöffer's *CYSP 1* (Cybernetic Spatiodynamic Sculpture), from 1956 (fig. 56). This pioneering analog electronic interactive work, built with photo-cells, a microphone, and a homeostat (that is, a machine capable of responding to environmental input) produced different kinds of movements in response to the presence of observers.[8] *CYSP 1* was the first artwork to actually move about in the three-dimensional space of a gallery or open-air environment. As it passed from the electro-mechanical domain to the electronic realm, Schöffer's work provided a bridge between kinetics and robotics. The transitional character of this work was well documented in the 1959 television program entitled *Robocybernétique* (Robocybernetics), transmitted live in Paris from Schöffer's studio in the same city. Influenced by this experimental context, and already opening up new directions that privileged complex interactive and behavioral concerns, three artworks created in the mid- and late 1960s stand as landmarks in the development of robotic art: Nam June Paik and Shuya Abe's *Robot K-456* (1964), Tom Shannon's *Squat* (1966), and Edward Ihnatowicz's *The Senster* (1969–70). While these works are very significant in their own right, they acquire a particular meaning when reconsidered together, since they also configure a triangle of new aesthetic issues that has continually informed the main directions in robotic art. With Paik and Abe's *Robot K-456*, a humorous and politically charged piece, the problem of remote control was introduced. With Shannon's *Squat* we see the first interactive artwork that is an organic and inorganic hybrid, raising the question of the creation of biocybernetic entities. In Ihnatowicz's *The Senster,* also an interactive piece, we find the first instance of digitally controlled behavioral autonomy in art, in which a given personality is assigned through software to the robot, which then responds to humans and changing situations on its own.

The Origin and Development of Robotic Art　　171

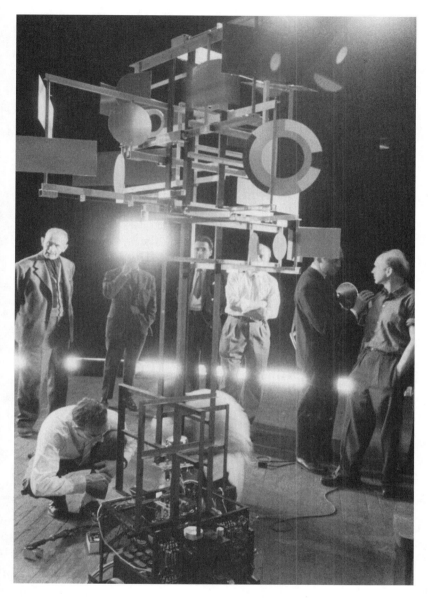

56. Nicolas Schöffer, *CYSP 1*, cybernetic sculpture, 1956. This pioneering interactive work produced different kinds of movements in response to the presence of observers. (Courtesy of Eléonore Schöffer.)

Named after Mozart's piano concerto (Köchel's number 456), Paik and Abe's twenty-channel remote-controlled anthropomorphic robot first performed in a private space (*Robot Opera*, at Judson Hall, in col-

laboration with Charlotte Moorman) and on the streets, both as part of the Second Annual New York Avant-Garde Festival, in 1964. As Paik guided it through the streets, K-456 played through its mouth (a radio speaker) a recording of John F. Kennedy's inaugural address and excreted beans. On video we can clearly see the wondrous dynamism of the robot's eyes (toy airplane propellers), of its legs dragging forward, and of its twirling Styrofoam breasts.[9] Paik approaches robotic art with a peculiar sense of humor, finding in these creatures a caricature of humanity, not a cause of fear (of lost jobs, of erased identity). Reflecting on the role of robotics in the economy, and the differences between robotics in art and industry, he stated: "Now, my robot . . . generally people say that robots are created to decrease people's work . . . but my robot is there to increase the work for people because we need five people to make it move for ten minutes, you see. Ha ha."[10]

K-456 was reactivated once again in 1982, when the Whitney Museum of American Art hosted Paik's retrospective exhibition (fig. 57). On the occasion, the artist staged an accident in which K-456 was hit by a car. For this performance, titled *The First Catastrophe of the Twenty-First Century,* K-456 was removed from its museum pedestal and guided by the artist down the street to the intersection of Seventy-fifth Street and Madison Avenue. When crossing the avenue, the robot was "accidentally" hit by an automobile driven by artist Bill Anastasi. With this performance Paik suggested the potential problems that arise when technologies collide out of human control. After the "collision," K-456 was returned to its pedestal in the museum.[11]

Less traumatic is the kind of contact enabled by Tom Shannon's work. Created only two years after *Robot K-456,* Shannon's *Squat* (fig. 58) was a cybernetic system wiring a live plant to a robotic sculpture.[12] In this early form of cybernetic interactive art, Shannon enabled the electric potential of the human body to trigger an organic switch. When viewers touched the plant, the electricity was amplified and turned on the motors of the robotic sculpture, which then moved. On human-plant contact, *Squat* retracted and extended its three legs as well as its two arms, creating undulating motion and humming and chirping sounds. If the viewer touched the plant again, the piece returned to its resting state.

While tactile participation is crucial to *Squat,* in Ihnatowicz's work it was the voice and the proximity of viewers that prompted responsive behavior. Working in relative isolation in England, after immigrating from his native Poland and studying at the Ruskin School of Drawing and Fine Art at Oxford, Edward Ihnatowicz (1926–88), perhaps the least known of the three pioneers, created between 1969 and 1970 *The Senster* (fig. 59), a biomorphic computer-controlled robotic creature

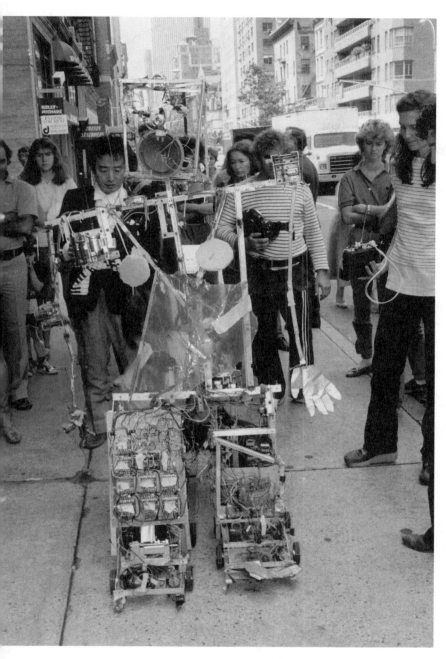

57. Nam June Paik and Shuya Abe, *Robot K-456*, radio-controlled robot, 1964. In 1982, Paik removed the robot from its pedestal at the Whitney Museum of American Art in New York—where it was exhibited as part of Paik's retrospective—and took it outside for a performance (*above*). (Photography by George Hirose.)

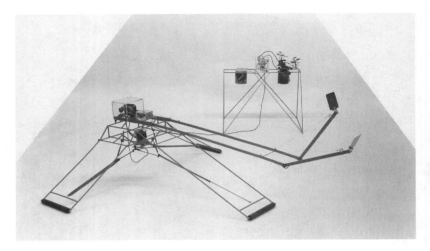

58. Tom Shannon, *Squat,* cybernetic installation, 1966. This work wired a live plant to a kinetic sculpture. When viewers touched the plant, the electricity was amplified and turned on the motors of the kinetic sculpture, causing it to move and produce sounds. (Courtesy of Tom Shannon.)

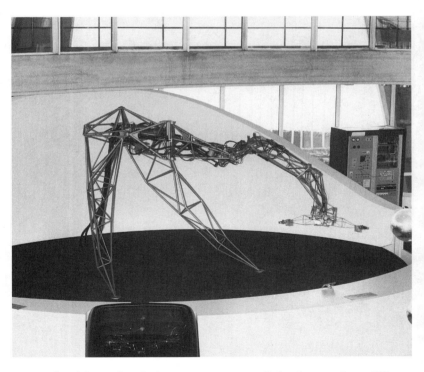

59. Edward Ihnatowicz, *The Senster,* computer-controlled sculpture, 1969–70. This biomorphic robot responded to motions and sounds within one or two seconds and gently moved its head toward persistent sounds below a certain frequency. (Courtesy of Olga Ihnatowicz.)

with shy behavior.[13] This piece was shown at Philips's permanent showplace Evoluon, in Heindhoven, Holland, from 1970 to 1974, when it was dismantled. Built after the articulation of a lobster's claw, *The Senster* was about fifteen feet long by eight feet high and occupied a space of one thousand cubic feet. Its head had sensitive microphones and motion detectors, providing sensorial input that was processed by a digital Philips minicomputer in real time. *The Senster*'s upper body consisted of six independent electro-hydraulic servo-mechanisms with six degrees of freedom. Responding to motions and sounds within one or two seconds, *The Senster* gently moved its head toward persistent sounds below a certain frequency. Vintage film documentation shows children clapping their hands and watching in ecstasy as the robot moves toward them. Loud sounds accompanied by violent gestures saw the creature shy away and protect itself from any harm. In its sensual, and apparently intelligent behavior, the piece was very engaging to a wide audience. While the debate on the use of computers in art at the time revolved around the creation of still or sequential images, and the use of static or mobile plotters to produce such images, Ihnatowicz merged software-based parametric behavior with hardware presence in a real space as he introduced the first computer-controlled robotic artwork. In other words, *The Senster* was the first physical work whose expression in space (its choices, reactions, and movements) was triggered by data processing (instead of sculptural concerns).

### The Emergence of an Art Form

Further contributing to this nascent field, Norman White created *Ménage* (Household, or Family), in 1974, an installation with five light-scanning robots. This installation was comprised of four robots moving back and forth along separate ceiling tracks and a fifth robot positioned on the floor. Each creature had a scanner (which pointed itself toward strong light sources) and a spotlight mounted at its center. As a result of the central position of their own light source, the ceiling robots had the tendency to keep staring at one another. However, despite the apparent simplicity of this arrangement, a more dynamic behavior emerged once their motors pulled them apart and the gaze-locking interplay resumed. If in the three pioneering works seen earlier the artists worked with individual robots, White tried to create a small robotic community that would already exhibit collective behavior. If Paik's, Shannon's, and Ihnatowicz's contributions to robotic art can be said to be circumscribed to the pieces discussed earlier, White is the first artist to have consistently championed robotics as an art form throughout the years,[14] producing a number of different and intriguing pieces,

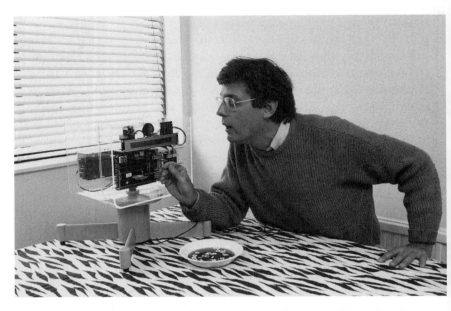

60. Norman White, *Helpless Robot*, interactive robot, in progress since 1985. This work humorously reverses the polarity of robot-human relationships. It converses with viewers and requests their assistance to spin it, changing its behavior in time if it gets more or less help. (Courtesy of Norman White.)

most notably *Helpless Robot* (fig. 60), a robot originally made in 1985 that converses with viewers and requests their assistance to spin it, changing its behavior in time if it gets more or less help. Norman White considers *Helpless Robot* unfinished (possibly unfinishable), and since 1985 he has modified it many times. *Helpless Robot* was shown publicly for the first time in 1988. In 1997 it was controlled by two cooperating computers, both programmed by White. One computer is responsible for tracking the angular position of the rotating section and detecting human presence with an array of infrared motion detectors. The other computer analyzes this information in relation to past events and generates an appropriate speech response. This work humorously reverses the polarity of robot-human relationships, asking humans to help an electronic creature conventionally designed to be a human aid.

Also working with sensors and microcontrollers (i.e., embedded digital controllers)[15] in interactive situations is James Seawright, known for responsive kinetic sculptures[16] such as *Watcher* (1965–66) and *Searcher* (1966) and for early interactive installations (which he termed "reactive environments") such as *Electronic Peristyle* (1968) and *Network III* (1970). The latter must be highlighted as a pioneering interactive computer installation, in which a digital minicomputer (PDP

# The Origin and Development of Robotic Art

8-L) translated the movement of viewers over pressure-sensitive plates into flashing light patterns on the ceiling. In the 1980s Seawright developed computer-controlled robotic works that achieved a sophisticated level of behavior as they interacted with the environment and the public. His *Electronic Garden #2* (1983) is comprised of five computer-controlled robotic flowers. Responding to climate parameters, such as temperature and humidity, these electronic flowers were originally installed in a public space as an indoor garden. Viewers could also alter their behavior by pushing buttons that modified the program installed in the custom-built microprocessor. These electronic flowers suggest the possibility of a harmonious integration among humans, nature, and technology at the same time that they poeticize responsive electronics in analogy with ornamental plants. Taking this concept further, Seawright created in 1984 *House Plants* (fig. 61), two computer-controlled robotic flowers.[17] *House Plants* used a computer (a custom-built microprocessor) to give the electronic plants their environmentally responsive behavior. While the taller plant opened its four petals at night,

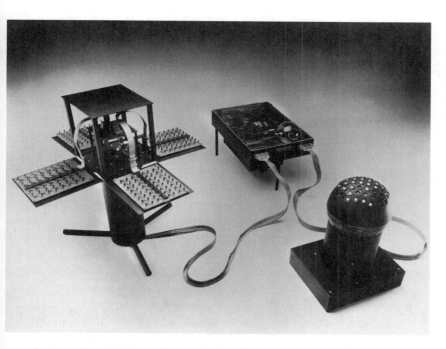

61. James Seawright, *House Plants,* robotic sculpture, 1984. As many plants do, these robotic flowers responded to changing light levels. While the taller plant opened its four petals at night, reacting to changing light levels, the shorter, domed plant produced a peculiar sound pattern as small disks opened and closed. (Courtesy of James Seawright.)

reacting to changing light levels, the shorter, domed plant produced a peculiar sound pattern as small disks opened and closed. Both plants displayed dynamic blinking light patterns: the taller one on the inside of the petals (made visible when opened) and the shorter one on the surface of its spherical top. If placed in a gallery setting, both plants were programmed to exhibit their behavior simultaneously. Cybernetic botany is a theme that has been explored by the artist in multiple pieces and in different versions of single pieces.

### Expanding into the Theatrical and Performative

With its emphasis on behavior, it was only a matter of time until robotic art expanded its realm of possibilities into theatrical and performative events. Two of the most prominent artists of the generation that emerged in the 1970s who work with robotics are Mark Pauline and Stelarc. In 1980 Pauline founded the Survival Research Laboratories, or SRL, a San Francisco–based collaborative team that since then has created multiple-machine performances combining music, explosives, radio-controlled mechanisms, violent and destructive action, fire, liquids, animal parts, and organic materials.[18] Two of the early key collaborators were Matthew Heckert and Eric Werner. Since 1980 SRL has developed machines and robots and staged performances in Europe and the United States, all too numerous and varied to be fully covered here. These works are marked by visceral violence and entropic choreography, often culminating in a cathartic self-destructive extravaganza. These robotic spectacles of discomfort, fear, and actual destruction are meant as commentaries on social issues, particularly in regard to ideological control, abuse of force, and technological domination. In 1981, for example, Pauline mechanically animated dead animals, evoking Frankensteinian fears and suggesting the larger-than-human powers of technology. *Rabot*, for example, was produced by grafting a mechanical exoskeleton to the entire body of a dead rabbit, causing it to walk backward. These and many other large and powerful machines, animal-machine hybrids, and robotic or computer-controlled devices have animated SRL's loud and often controversial pyrotechnic events, such as *Crime Wave* (fig. 62), realized in November 1995 in San Francisco, or *The Unexpected Destruction of Elaborately Engineered Artifacts*, realized in March 1997 in Austin, Texas. More than fifteen years later, Paik's 1982 staged accident can be reconsidered in the context of SRL's work, which gives emphasis to the aesthetic principle of technologies colliding out of human control.

By contrast, Stelarc has focused his work on his own body. He attached a third (robotic) arm to his right arm, only to expand his sus-

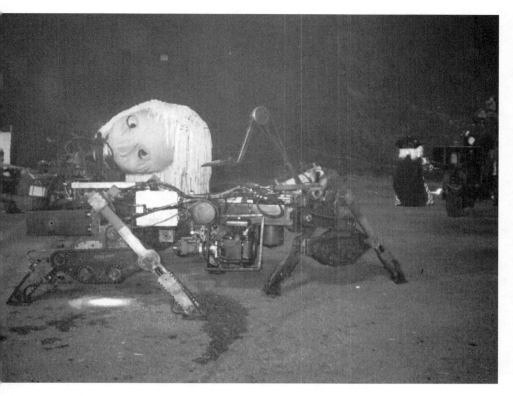

62. Survival Research Laboratories, scene from the *Crime Wave* show, realized in San Francisco, November 28, 1995. The image shows the Running Machine attacking a victim prop. (Courtesy of Mark Pauline.)

pension events[19] into complex performances that have evolved cyborg and posthuman metaphors, raising the issue of evolution and adaptation in our highly technological environment.[20] *The Third Hand* (fig. 63), a five-finger robotic hand activated by abdominal and leg muscles, was built in 1981 with the assistance of Imasen Denki and was based on a prototype by Ichiro Kato. Among Stelarc's first robotic performances in 1981 were *The Third Hand* (Tamura Gallery, Tokyo) and *Deca-Dance* (Komai Gallery, Tokyo). In the performance of *The Third Hand*, the artist held a sheet of paper with his left hand and explored the possibility of writing THE THIRD HAND simultaneously with his right hand and his third hand. In *Deca-Dance*, he experimented with human and robotic choreographic gestures. In *Hands Writing* (1982), Stelarc sought to write EVOLUTION with his three hands. Since 1981 Stelarc has been creating amplified body performances in which he expands the power and reach of the human body by wiring it to electronic

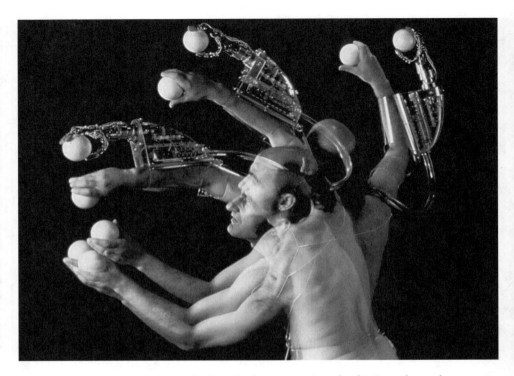

63. Stelarc, *The Third Hand,* robotic arm, 1981. Stelarc has created several performances in which he attaches a third (robotic) arm to his right arm, generating cyborg and posthuman metaphors. (Courtesy of Stelarc.)

devices and telecommunications systems. In these performances he has combined *The Third Hand* with many other technological components, including sensing devices conventionally used in medicine. On occasion Stelarc has also performed in the company of industrial robotic arms. He has also used prosthetic technologies that physically wire his body and enable remote and direct muscle stimulation, which results in involuntary gestures and body motions by the artist.

Also exploring this fertile vein of flesh-machine hybrids in theatrical or performative settings is the Barcelona artist Marcel.lí Antúnez Roca. One of the founders of the polemical performance group La Fura dels Baus, Roca collaborated with Sergi Jorda in 1992 in the creation of *Joan, l'Hombre de Carne* (Joan, Flesh Man), a life-size humanoid robot covered in pigskin and encased in a glass box (fig. 64). Parts of the robot move (head, arms, penis) in response to environmental sounds or the applause of participants. I saw *Joan* in 1996, when it was presented in the robotic art show Metamachines: Where Is the Body?,

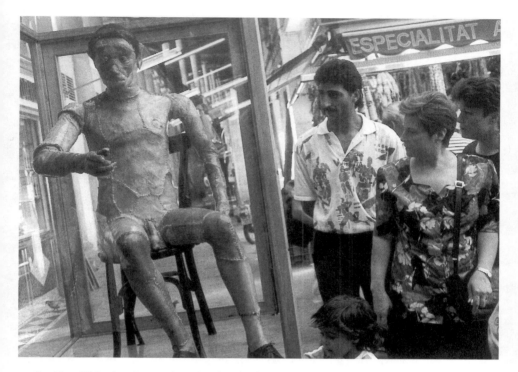

64. Marcel.lí Antúnez Roca and Sergi Jorda, *Joan, l'Hombre de Carne*, 1992. "Joan" is a life-size humanoid robot covered in pigskin and encased in a glass box. Parts of the robot move (head, arms, penis) in response to environmental sounds or the applause of participants. (Courtesy of Marcel.lí Antúnez Roca.)

at Otso Gallery, in Tapiola, near Helsinki.[21] Inspecting the work up close, one is drawn to examine the sutures that unite the pigskin over the polyester carcass into a human form. Details such as the nails at the end of the robotic fingers and the commonplace accessories, such as shoes, contribute to create an otherwordly impression, while the robot rests on an ordinary wooden chair. The facial expression suggests that the creature is bemused. It is when the interactive robot and the public move together, however, that the piece comes to life, adding to the spectacular image a sense of discovery, as humans change their behavior in response to Joan's actions.

## Robotics and Telecommunications

Several artists working with robotics don't circumscribe the experience of the work to one's immediate perceptual field. The absence of the object stimulates a particular kind of experience: it heightens awareness

of the remote in detriment to local vision. Remoteness creates a new situation for performance, robotics, and interactive art. As a consequence of my desire to push telecommunications art into a more physical domain, since 1986 I have been developing what I call *telepresence art*, coupling robotics and telecommunications into new forms of communicative experiences that enable participants to project their presence into a geographically distant place. Other artists have pursued this basic premise with very engaging results.

In 1993 the Austrian group X-Space (Gerfried Stocker and Horst Hörtner, with Arnold Fuchs, Anton Maierhofer, Wolfgang Reinisch, and Jutta Schmiederer) created the interactive robotic installation *Winke Winke*,[22] first shown on top of the only skyscraper in Graz, on the building of Austrian Telecommunications (Posthochhaus in Graz). I saw the piece at the Minneapolis College of Art and Design, on the occasion of the International Symposium on Electronic Art (ISEA), November 3–7, 1993. This project made reference to one of the earliest forms of a telecommunications network: the optical telegraph (1794), precursor to the electric telegraph. In a gallery or other public space, the participant approached a computer terminal connected to a robot placed on the roof of the building. Each message typed on the terminal was translated by the robot into signs of the international marine semaphore system: the robot actually produced these signs by moving the flags attached to its arms. On the roof of another location, in a straight line of sight with the robot, a video camera with a telephoto lens recorded the signs made by *Winke Winke*. The pictures were fed into a computer, which read the position of the flags and converted the signs back into words. Digital telecommunications comes full circle with the optical telegraph, suggesting new beginnings. The expression "winke winke" is Austrian baby talk for "bye-bye."

In 1995, Ken Goldberg, Joseph Santarromana, George Bekey, Steven Gentner, Rosemary Morris, Carl Sutter, and Jeff Wiegley collaborated to create the *TeleGarden*, a Web telepresence installation.[23] The *TeleGarden* (fig. 65) enabled anyone on the Web to plant and water seeds in a real living garden using an industrial robot arm. This garden, six feet in diameter, was soon filled with marigolds, peppers, and petunias. Participants, who became "members" of this virtual cooperative, could also discuss co-op policy via on-line chat. The project explored the evolution of community on the Web, in particular the analogy with the agrarian revolution, which established the conditions for cultural communities.

Also in 1995, Nina Sobell and Emily Hartzell, working in collaboration with New York University Center for Advanced Technology en-

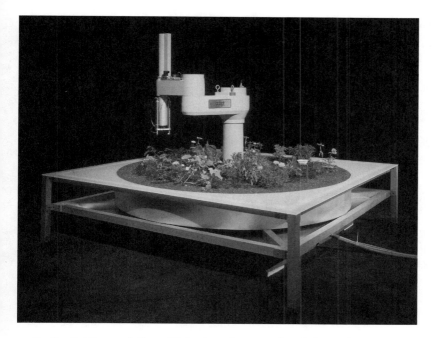

65. Ken Goldberg and others, *TeleGarden,* telepresence installation on the Internet, 1995. This work enabled participants on the Web to plant and water seeds in a garden using an industrial robot arm. (Courtesy of Ken Goldberg.)

gineers and computer scientists, created *Alice Sat Here*. In this piece, a camera-equipped wheelchair was steered by local participants, with sequential uploads to the Web.[24] Sobell and Hartzell worked with New York University engineers and computer scientists to create this telepresence installation, originally shown at the Ricco/Maresca Gallery, in New York. While local participants were able to sit on and steer Alice's Throne (the wheelchair), remote visitors could control camera direction. A monitor in the gallery's front window showed real-time video from the point of view of the wheelchair-mounted wireless camera; the video was then displayed as sequential stills on the Web. Touchpads in the front window surrounded the monitor. Local participants pressing the touchpads were caught in the act of controlling the Throne's camera: their images were captured by the small camera mounted atop the monitor. The small camera mounted on top of the monitor overlayered the local participant's image with the image captured from the point of view of the wheelchair-mounted camera prior to the Web upload. This piece explored the multiple levels of control

(of observation, navigation, and image capture) as participants oscillated between physical space and cyberspace.

## Enduring Concerns

If on the one hand telepresence art places human cognitive processes on remote robotic bodies, on the other we find artists who pursue issues of autonomy of the robotic body in space. Simon Penny, for example, created in 1996 his autonomous robot Petit Mal[25] and exhibited it the same year in the aforementioned Metamachines: Where Is the Body? exhibition. The title of this piece is a medical term that refers to a momentary loss of consciousness. As an autonomous robotic artwork it explores architectural space and pursues and reacts to people. Its behavior is neither anthropomorphic nor zoomorphic, but is unique to its electronic nature. It has three ultrasonic sensors and three body-heat sensors that allow it to realize the presence of humans near it. Petit Mal was designed to be lightweight, durable, and mechanically efficient, which gave it a "laboratory prototype" physiognomy. By covering parts of the robot's body with domestic printed vinyl tablecloth, the artist intended to change its appearance. Petit Mal consists of a pair of bicycle wheels that support a pair of pendulums suspended on a single axis. The top pendulum nests a processor, sensors, and logic power supply. The bottom pendulum houses motors and a motor power supply. The top pendulum keeps the sensors in a vertical position despite the swing that results from acceleration. Petit Mal functions autonomously in a public environment for many hours before battery replacement is needed.

## The Maturation of an Art Form

The works outlined here suggest that at the same time that robotics has matured into an art form, since its first introduction in the 1960s, it has been quickly appropriated and incorporated into other forms, such as performance, installation, dance, earthworks, theater, and telepresence pieces. Artists such as Margot Apostolos, Ted Krueger, Ken Rinaldo, Chico MacMurtrie, Alan Rath, Martin Spanjaard, Ulrike Gabriel, Louis-Philippe Demers, and Bill Vorn, among many others, are developing a complex and fascinating body of work in robotic art.[26] Remote control, cybernetic entities, and autonomous behavior, as first outlined by Paik, Shannon, and Ihnatowicz, define the three key directions that have informed the development of robotics in art. As artistic freedom promotes robotic diversity, the understanding of this tri-

angular framework is essential to enable us to continue to explore the history, the theory, and the creation of robotic art.

## Notes

1. Geoffrey Stephen Kirk, *The Nature of Greek Myths* (London: Penguin, 1990).
2. Moshe Idel, *Golem: Jewish Magical and Mystical Traditions on the Artificial Anthropoid* (Albany: State University of New York Press, 1990).
3. Mary W. Shelley, *Frankenstein; or, The Modern Prometheus: The 1818 Text* (Oxford and New York: Oxford University Press, 1998); Villiers de l'Isle-Adam, *Tomorrow's Eve* (Urbana: University of Illinois Press, 1982); Gustav Meyrink, *Two German Supernatural Novels:* The Golem *and* The Man Who Was Born Again (New York: Dover, 1976); Karel Capek, *R.U.R: Rossum's Universal Robots and the Insect Play* (New York and Oxford: Oxford University Press, 1961); Robert Heinlein, *Waldo* and *Magic, Inc.* (New York: Ballantine Books, 1990); Isaac Asimov, "Reason," in *I, Robot* (New York, Bantam Books: 1991), 56–81.
4. Kuni Sadamoto, ed., *Robots in the Japanese Economy: Facts about Robots and Their Significance* (Tokyo: Survey Japan, 1981); Frederik Schodt, *Inside the Robot Kingdom: Japan, Mechatronics, and the Coming of Robotopia* (New York: Kodansha International, 1988); Daniel Hunt, *Understanding Robotics* (San Diego: Academic Press, 1990).
5. Jack Burnham, *Beyond Modern Sculpture* (1968; repr., New York: George Braziller, 1982); Jasia Reichardt, *Robots: Fact, Fiction, and Prediction* (New York: Penguin Books, 1978), 48–61; Derrick Kerckhove, "L'espace de la robotique en art," in *Esthétiques des arts médiatiques*, ed. Louise Poissant (Montreal: Presse Universitaire du Québec, 1995), 1:271–77.
6. Alfred Chapuis and Edmond Droz, *Automata: A Historical and Technological Study* (New York: Central Book Company, 1958).
7. Frank Popper, *Origins and Development of Kinetic Art* (Greenwich: New York Graphic Society, 1968).
8. Nicolas Schöffer, *Nicolas Schöffer* (Neuchatel: Editions du Griffon, 1963), 50.
9. Nam June Paik, *A Tribute to John Cage* (1973; 60 min.).
10. Willoughby Sharp, "Artificial Metabolism—An Interview with Nam June Paik," *Video 80*, no. 4 (1982): 14.
11. John Hanhardt, "Non-Fatal Strategies: The Art of Nam June Paik in the Age of Postmodernism," in *Nam June Paik: Video Time, Video Space*, ed. Toni Stoos and Thomas Kellein (New York: Abrams, 1993), 79. Capturing Paik's unique sense of humor, Hanhardt quotes the artist as saying in a television interview on the occasion that *K-456* "was twenty years old and had not had its bar mitzvah."
12. *Squat* was first documented in Pontus Hulten, *The Machine as Seen at the End of the Mechanical Age* (New York: Museum of Modern Art, 1968), 193. See also Burnham, *Beyond Modern Sculpture*, 5. For a comprehensive catalog of Shannon's work, see Catherine Monnier, ed., *Thomas Shannon* (Geneva: Galerie Eric Franck, 1991).
13. Jonathan Benthall, *Science and Technology in Art Today* (London: Thames and Hudson, 1972), 78–83; Edward Ihnatowicz, "Towards a Thinking Machine," in *Artist and Computer,* ed. Ruth Leavitt (New York: Harmony, 1976), 32–34.
14. Derrick de Kerckhove, "Les robots de Norman White," *Art Press* 122 (1988): 21–22; Norman White, "A casa dos espelhos," in *A arte no século XXI*, ed. Diana Domingues (São Paulo: Unesp, 1997), 45–48.

15. Microcontrollers are microprocessors with built-in program-storage memory, RAM, and usually some peripheral devices (such as serial communications circuitry and timers).

16. For an account of Seawright's work between 1965 and 1968, see James Seawright, "Phenomenal Art: Form, Idea, and Technique," in *On the Future of Art,* ed. Edward Fry (New York: Viking, 1970), 77–93. See also Douglas Davis, "James Seawright: The Electronic Style," in *Art and the Future,* 153–56.

17. Cynthia Goodman, *Digital Visions: Computers and Art* (New York: Abrams, 1987), 135, 138–43.

18. C. Herman and K. Ludacer, "Rare Animals Trying to Breed: An Interview with SRL," *Lightworks,* no. 17 (1985): 17–21; Alfred Jan, "Survival Research Laboratories," *High Performance* 8, no. 2 (1985): 32–35; Mark Pauline, "Interview with Mark Pauline," *Re/Search,* nos. 6–7 (1991): 20–41. See also the Survival Research Laboratories Web site: <http://www.srl.org>.

19. Stelarc, *Obsolete Body Suspensions* (San Francisco: Contemporary Art Press, 1984).

20. Stelarc, "Prosthetics, Robotics and Remote Existence: Postevolutionary Strategies," *Leonardo* 24, no. 5 (1991): 591–95; "Parasite Visions: Alternate, Intimate and Involuntary Experiences," *Art and Design,* 12, no. 56 (1997): 66–69.

21. On the occasion, Marcel.lí Antúnez Roca and I decided to share our notes and drafted a joint statement, entitled "Robotic Art," which was published in *Leonardo Electronic Almanac* 5, no. 5 (1997). For more on Roca's work, see Giuseppe Savoca, *Arte estrema* (Rome: Castelvecchi, 1999), 117–30. See also Claudia Giannetti, *Arte facto y ciencia* (Madrid: Telefonica, 1999).

22. Jutta Schmiederer, ed., *Cross Compilation* (Graz: X-Space, 1994), n.p. This is a self-published catalog documenting the group's work from 1991 to 1994.

23. Ken Goldberg et al. "The Tele-Garden: An Interactive Art Installation on the World Wide Web," in *Siggraph Visual Proceedings* (New York: ACM, 1995), 135; "Telepistemology on the World Wide Web," in "Telepresence," ed. Eduardo Kac, special issue, *YLEM* 17, no. 9 (1997): 3.

24. Nina Sobell and Emily Hartzell, "ParkBench Public-Access Web Kiosks," *Siggraph Visual Proceedings* (New York: ACM, 1996), 135; Nina Sobell and Emily Hartzell, "VirtuAlice," in "Telepresence," ed. Eduardo Kac, special issue, *YLEM* 17, no. 9 (1997): 5.

25. K. D. Davis, "Dystopic Toys," *World Art,* no. 1 (1996): 30–33.

26. Margot Apostolos, "Robot Choreography: Moving in a New Direction," *Leonardo* 23, no.1 (1990): 25–29; L. Brill, "Art Robots: Artists of the Electronic Palette," *AI Expert,* Jan. 1994, 28–32; Ted Krueger, "Autonomous Architecture," *Digital Creativity* 9, no. 1 (1998): 43–47; Ken Rinaldo and Mark Grossman, "The Flock," in *Siggraph Visual Proceedings* (New York: ACM, 1993), 120; Louis-Philippe Demers and Bill Vorn, "Espace Vectoriel," in *Siggraph Visual Proceedings* (New York: ACM, 1993), 122; Martin Spanjaard, "Adelbrecht," in *Siggraph Visual Proceedings* (New York: ACM, 1993), 166; Mark Dery, *Escape Velocity* (London: Hodder and Stoughton, 1996), 131–36; Laura McGough, "Prosthetic Aesthetics," *Mesh,* nos. 8–9 (1996): 11–13.

# 9. Live from Mars

Today, July 4, 1997, is an exciting day for art. Although the art of telepresence has been consistently explored since the mid-1980s, today the landing of the Mars *Pathfinder* (fig. 66) spacecraft brought telepresence to the masses. This historic event rekindled the drama of distance and the cultural meaning of telepresence in the imagination of the general public, reverting the numbing and soothing effect of habitual televised entertainment and newscasting. In the terrestrial afternoon, *Pathfinder* sent the first images from the surface of Mars ever transmitted live on television. The first images to arrive from the Ares Vallis area were small grayscale pictures, and on television at least, the resolution was rather low. The very first broadcast images appeared on a computer screen, inside a small window that floated among many other windows on the desktop. What was on the air seemed to indicate that a cameraman had pointed his camera at the computer monitor, eagerly awaiting and immediately retransmitting the first picture as it appeared on NASA's computer screen. The CNN announcer was ecstatic and, contrary to journalism protocol, clearly expressed her own excitement with what she was seeing for the first time herself.

While perhaps unimpressive in the eyes of the visually literate public, accustomed to flashy digital special effects on television and in the movies, these stills are profoundly significant, overcoming real space (119 million miles from Earth) with near real-time contiguousness. Their meaning does not arise from cinematic entertainment but from the raised awareness of the universe we have gained by being collectively telepresent on the Martian surface. These pictures were not representations of science fiction scenarios but a de facto window into another world entirely. The feeling of remote presence was intense. "We're there!" shouted NASA mission control personnel.

---

Written on July 4, 1997, date of the historical Mars landing. Originally appeared in *Leonardo Electronic Almanac* 5, no. 7 (1997).

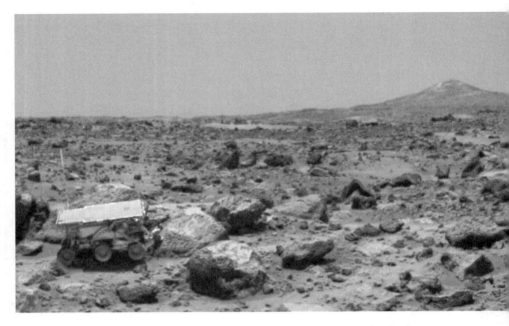

66. *Sojourner* telerobot on Mars, 1997. The photograph, taken by the Mars *Pathfinder* lander, reveals traces of the red planet's warmer, wetter past, showing a flood plain covered with a variety of rock types. The image shows the *Pathfinder* telerobot, *Sojourner* (*lower left*), snuggled against a rock nicknamed Moe. The south peak of two hills, known as Twin Peaks, can be seen on the horizon, about one kilometer (six-tenths of a mile) from the lander. (Courtesy of NASA/JPL.)

As with the moon landing before, what is most remarkable about the *Pathfinder* mission is not the technological tour de force but the fact that millions of people watched simultaneously the first images as they were broadcast (and soon uploaded to NASA's Web site). It took about eleven minutes for each encoded image to arrive. It took the NASA team about thirty minutes to process the data stream into color images. As the first color images were unveiled—again, live on CNN, approximately one hour after arrival—I was struck with the realization that what I was seeing at that very moment, in the privacy of my home, was exactly what the surface of the fourth rock from the sun had looked like one hour ago! Twenty-one years ago *Viking* gave us our first glimpses of the red planet. Today, through this near real-time experience, *Pathfinder* gave us a sense of being telepresent on Mars. While it took the spacecraft seven months to travel to Mars, the near instantaneity—given the relative distance between the planets—of the telecommand, remote response, and image retrieval touched us with a renewed sense of proximity beyond the material limits of physical space.

This is the first time ever that a fully mobile and wireless telerobot (the rover *Sojourner*) has been sent to explore another planet, a true landmark for telepresence and the history of the space program. The pictures of the landing site taken by *Pathfinder* will be used to determine the exploratory path of the rover *Sojourner*, which is two feet by one and a half feet wide and one foot tall. Once deployed, the rover will navigate the environment and negotiate the terrain on its own, at a speed of two feet per minute. A unique kind of human-machine interaction takes place in this mission. The cognitive process of a human being is remotely projected on a distant robot, which in turn has autonomy to sense the surroundings and make decisions that are in its best interest (e.g., to prevent an accidental fall from a cliff).

While the aesthetic dimension of this experience will go unnoticed by most directly involved in the project and telespectators alike, it is precisely this aspect of the media event I witnessed today that I find particularly significant. Some of the aesthetic features unique to this telepresence event are the relativity of space and time (seven months to get there, eleven minutes to transmit a picture); the nature of the human-machine interface (a combination of teleoperation and autonomy); remote space negotiation and navigation (the unpredictability of the terrain, the feeling of remote presence); teleoperation (at-a-distance control of a robot); the capture, transmission, reception, processing, and unveiling of the images; the instantness of the pictures; the realization of all this live on television (the integration between the one-to-one experience of remote control with the public space of television); and the impact of this telepresence event on the collective consciousness. All this, I suggest, has paramount aesthetic value and must be further explored in contemporary art.

It is clear that the aesthetic dimension of this historic event introduces telepresence to the population at large, pointing to a future when personal telepresence will be an integral part of our daily lives. As our presence on the red planet increases via telerobots, and eventually with humans, one can easily foresee webcams enabling us to look at the Martian surface on the Internet with the same ease and regularity as today we see the skyline of several North American cities. Other forms of personal telepresence will be developed in the future in many segments of society. For example, through a telerobot, hand surgery might be performed remotely, or a document located in one city could have the original signature of an individual situated in another city miles away. Artists working today can directly respond to an event of this magnitude by working with the very same means employed in the fantastic exploration of outer space: telepresence, remote operation, and networking. No object can rival the experiential quality of today's event.

The very first images broadcast live on CNN were hard to discern or recognize as a landscape. In science as in art, what you cannot recognize, you cognize. Awareness of the unfamiliar remote terrain, coupled with intermittent visual feedback, guided and will continue to guide the telexploration of the dry flood channel where the spacecraft landed. As *Pathfinder* deploys the small rover *Sojourner* on the inviting crimson terrain, it will be searching the Martian surface (and below) for signs of life, intelligent or not, present or past. I need no further evidence, however, because today I saw, telepresentially, clear signs of intelligent life on the surface of Mars: ours.

# 10. Dialogic Telepresence Art and Net Ecology

A Pakistani cab driver in New York talks to his sister in Islamabad through a videophone parlor in Brooklyn. Native craft stands in La Paz, Bolivia, accept credit cards. People in a small village in Nigeria use a local satellite cellular phone service to talk to relatives in another village in the same country. An English artist in Rotterdam uses the Web to buy a book only found in a secondhand bookstore in Cape Town. These are not fictitious scenarios; they are facts routinely experienced around the globe, often reported by the news media as signs of globalization. Throughout the 1990s the world saw the flourishing of both a global free trade enterprise and the Internet, a network that not only reflects political and economic change but plays a significant role in creating a transnational culture that has English as the universal business language. These are signs of a more complex version of what once was called imperialism.

Increasingly people, ideas, objects, influence, and money move fluidly between two or more places. Acquaintances, colleagues, friends, and family members dispersed around the world routinely employ email, chat, and videoconferencing software to work together, express affection, or simply stay in touch, thus reaffirming social and familial bonds. As a result, we have the notion that a community can exist and thrive as a dispersed but interconnected group in multiple places at once. We have also become acutely aware of the interconnectedness of the world economies and ecologies. Glaring examples are the financial crashes that resonated across Asia, Russia, and Latin America in the 1990s and the dramatic consequences of the geographic displacement

---

Originally appeared in *Metamachines: Where Is the Body?*, exhibition catalog (Finland: Otso Gallery, 1996). This revised and enlarged version appeared in *The Robot in the Garden: Telerobotics and Telepistemology in the Age of the Internet*, ed. Ken Goldberg (Cambridge: MIT Press, 2000).

of viruses and insects around the world as a result of increased travel and commercial shipments.

Physical distance is at once erased and reaffirmed by new technologies. This condition raises the relevant question of how telecommunications technologies—including telepresence, the Internet, and the coupling of both—affect the ways in which we acquire and create knowledge. Ultimately, the question is not how these technologies *mediate* our exploration of the world, local or remote, but how they actually *shape* the very world we inhabit. Any technology embeds cultural and ideological parameters that, in the end, give shape to the sensorial or abstract data obtained through this very technology. Telescopic and telecommunicative technologies are no exception. In science, the selection of a research topic and the extraction, accumulation, and processing of data, as well as the interface through which the data are later explored, are themselves an integral part of the nature of the data. They are not a detached element that causes no interference in what is experienced. Quite the contrary: the knowledge we acquire through instruments and media is always modulated by them. They are not separable. While in science we observe the drive to build instruments capable of ever more "precise" measurements, in art we can freely and critically explore the ways in which these instruments and media help define the nature of the reality thus produced. While in science the elimination of what is not repeatable produces the field where knowledge is possible, in art the irrepeatable is celebrated as the singularity that enables aesthetic knowledge. Clearly, artists working critically with scientific instruments must be aware of how meaning is created in the realm of science.

In interactive telepresence artworks created since 1986, I have been investigating multiple aspects of this phenomenon. My telepresence work has never been about what it would be like if we could be *there* (i.e., at the remote site). Instead, it investigates how the fact that we are experiencing this remote site in a given way (i.e., through a particular telerobotic body, with a given interface, and over a specific network topology) modulates the very notion of reality we conjure up as we navigate the remote space. In what follows I will present some of the key ideas that inform my work in telepresence art. Following a discussion of the relationship between the technology of telepresence and art, I will address the development of my telepresence work in the 1990s.

## Telepresence and Art

As we consider some of the vectors that shape the contemporary experience, an astounding list emerges: global economy, digital culture,

on-line relationships, multiplicity of identities in cyberspace, integration of organic and artificial life, microchip implants, biotelemetry, reading and writing of new genes, plasticity of skin and flesh, DNA computers, satellite telephony, xenotransplantation, astrobiology, wearable technologies, neuroprosthesis, telepresence, piracy, patenting and commerce of foreign genetic material, new algorithmic and real viruses. New cartographies are being created as digital technologies generate world maps that show reconfigured contours based on arbitrarily defined shared systems (e.g., DVD region codes using the zone lock feature) and on special network links (e.g., MBone and Internet 2 topology diagrams based on connectivity of routers). Art can contribute to a larger cultural debate by appropriating tools employed in other social sectors (e.g., business, medicine, military); exposing the fissures within standard approaches to these developments; and proposing new models that foreground alternative ways of thinking.

Telepresence (i.e., the union of telematics and elements of remote physical action) emerges as a significant parameter in this complex environment. Telepresence is being developed both as a law-enforcement and a medical technology, as a tool for both science and entertainment.[1] We are undergoing cultural perceptual shifts due to the remote projection of our corporeal sense of presence. The dynamic, fluctuating interplay between presence and absence on telerobotic bodies creates new aesthetic problems and escapes from rigid formal dichotomies, such as figuration versus abstraction, or physicality versus conceptualism. Expanded through the synergy of organic and cybernetic systems, bodies (human, robotic, zoomorphic, or otherwise) renew their relevance in contemporary art—beyond stylistic pictorial concerns and representation politics. Telepresence art offers dialogical alternatives to the monological system of art and converts telecommunications links into a physical bridge connecting remote spaces. Telerobots and teleoperated humans (which I call "teleborgs") become physical avatars, as they enable single or multiple individuals to actively explore a remote environment or social context.

Telepresence art shows us that from a social, political, and philosophical point of view, what we cannot see immediately around us is equally relevant to what meets the eye. Our satellites probe with equal ease deep space and isolated regions of the earth, revealing unprecedented vistas that shed new light on our presence in the universe. Teleoperated aircrafts fly over inhospitable zones to sense and gather valuable data. Telerobots handle explosive devices, excavate the ocean, and clean nuclear disasters. Speculation on possible extraterrestrial life calls for remote control of telerobots to examine the red planet beneath the surface. Weather systems in the Pacific affect life in the Atlantic. An

African virus could spread and kill in North America. The prospect of nanomachines working in our bloodstreams gives us the notion of our physical bodies as hosts of synthetic agents. Military battles are staged and swiftly won in networked immersive simulators. Hacking, or remote digital attacks through the network, continuously undermine the most secure data-protection systems. Smart bombs seek their targets and show us live video of the trajectory until the aseptic moment of impact. We are affected by the remote as much as we impinge upon the visually or physically absent the consequences of our collective gestures.

Telepresence art undermines the metaphysical propensity of cyberspace through emphasis on the phenomenological condition of actual remote physical environments. By engaging precepts and effects that constitute the remote sensuous, telepresence evolves an aesthetics based on extending action in the absence of the actant. The distributed vision brought by telepresence art is that of integration of the familiar and the unconventional, toward a more harmonious acceptance of the differences that constitute the shifting ground under our feet and the turbulent air above our head. As optical fibers thread the soil like worms, and digitally encoded waves cross the air as flocking birds, a new ecology emerges. This new ecology conciliates carbon and silicon. To survive the imbalances created by increased standardization of interfaces (which promotes uniformization of mental processes) and centralized control achieved by corporate megamergers (which decreases choice), and to thrive emotionally and intellectually in this hostile mediascape, we need to do more than subsist as we adapt. Our synergy with telerobots, transgenics, nanobots, avatars, biobots, clones, digital biota, hybrids, webots, animats, netbots and other material or immaterial intelligent agents will dictate our ability to endure fast-changing environmental conditions in a networked world. Telepresence art can offer new cognitive and perceptual models as well as new possibilities for social agency in the digital network ecology.

## Ornitorrinco Mutated in Finland

After ten years of development of telepresence art, I increasingly sought to expand the context of intersubjective interaction to include life forms other than human. My objective was to use telerobotics to create the experience of consensuality among humans and nonhumans. I also developed works that enabled the teleoperation of humans and that promoted dialogical interaction in a televirtual realm. In what follows I will describe and discuss telepresence works created since 1996.

For the exhibition Metamachines: Where Is the Body?, realized in 1996 at Otso Gallery, near Helsinki, in Finland, the telerobot Orni-

torrinco underwent a mutation: it hosted components of the telerobot Uirapuru (which was still a work in progress), particularly a new chip, a new camera, and a custom-designed board that enabled it to take on new behaviors. The installation, entitled *Ornitorrinco, the Webot, Travels around the World in Eighty Nanoseconds, Going from Turkey to Peru and Back* (fig. 67), was divided between two remote spaces, which were linked to the Web in unexpected ways. The public first encountered the work from Otso Gallery's ground level, while Ornitorrinco navigated in its subterranean nest. Critically examining the blind trust and the expectations we project over information networks, this piece appeared straightforward, but nothing really was as it seemed.

In the space upstairs participants saw a Web interface (the Netscape browser) projected on the wall with embedded live, real-time (30 fps) color video feedback. Anybody familiar with the state of development on the Web in 1996 knew that this was technically impossible because of bandwidth limitations. Still, there it was.[2] Clicking outside the video window (left/right, forward/backward) enabled participants to navigate the nest in real time and interact with turkeys and humans from Ornitorrinco's point of view. The public participated actively, thinking that they were on the Web. They weren't. Every move they made continually resulted in fresh images, and what they did not realize at first was that these images were automatically grabbed and uploaded to a Web site (to which they themselves did not have access from the gallery, only from home). In other words, the public on-line could see what participants were doing off-line in the gallery. The latter remained unaware of the on-line surveillance system in place. The topology of this work was intentionally conceived to reveal that communications media alienate us from our very own utterances and actions.[3]

As participants explored the piece their role changed subtly and significantly. While they were in control on the first floor, they experienced the work as active subjects. They navigated in the remote space, they made choices, they interacted with the turkeys. Descending the staircase that led to the basement of the gallery, they found themselves behind a four-foot-high glass wall. At this point they unwillingly relinquished the role of active subjects and became objects of contemplation—they themselves became the focus of multiple gazes. They were contemplated by incoming participants on the first floor who were now on Ornitorrinco's body, by the turkeys, and by remote Web viewers who logged on from different parts of the world.

The elements that constituted the nest made a metacritical, and at times humorous, commentary on the state of development of the Web at that time. The space was topped by an all-encompassing coarse mesh net suspended halfway between floor and ceiling. Standing local

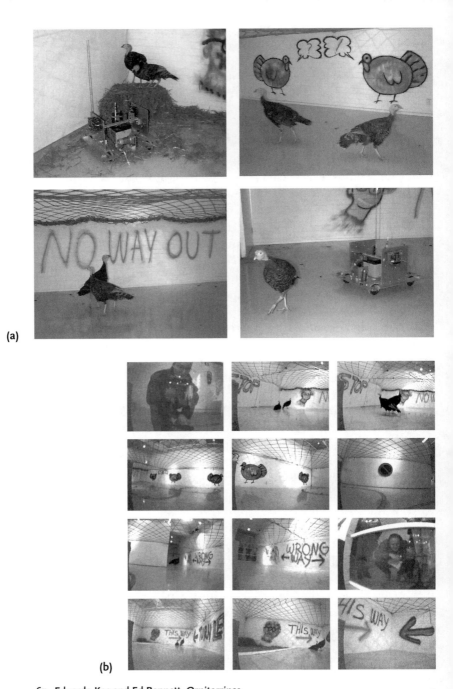

67. Eduardo Kac and Ed Bennett, *Ornitorrinco, the Webot, Travels around the World in Eighty Nanoseconds, Going from Turkey to Peru and Back,* telepresence work on the Internet, 1996. The telerobot Ornitorrinco shared a nest with two turkeys in Finland (*a*). Local and on-line participants (*b*) could experience the environment from the perspective of the telerobot (*c*).

visitors had to look through this net to see the nest. Spread through the space, graffiti resembling traffic signs made humorous commentary on the then-popular "information highway" metaphor. For example, "Turn Left" and "This Way" arrows both pointed to a corner, and "Wrong Way" was flanked by arrows pointing left and right.

Coexisting and interacting with Ornitorrinco in the same space, two real turkeys went about their business in their spacious nest. The turkeys resonated, in a subtle and comical manner, with the words "Turkey" and "Peru" in the title. Both words represent different countries and the same bird, the first in English and the second in Portuguese: the two languages I use the most. The displacement of cultural references and dispersal of subjects that have always informed Ornitorrinco's life was experienced anew in this piece. As Ornitorrinco mutated in Finland, it explored the detachment of the subject from a single body as well as relative and imaginary geographies, accompanied as it was in its hay-filled nest by a large plastic globe. Ornitorrinco qua webot circumnavigated the globe, occasionally moving it by means of direct physical contact.

(c)

One very important aspect of this work was to be sure that the turkeys would be comfortable in the space and feel at home in the nest they shared with the webot. After consultation with the Finnish farmers who bred the turkeys, they stated that since the turkeys live in a very small cage with seventy other turkeys, and with practically no space to move around, they would be very happy with the unprecedented freedom and the unusually large room. An official visit during the show by city and provincial government veterinarians confirmed that both were happy and in excellent health.

The turkeys spent time looking at the pictures on the wall, in a manner somewhat similar to a human being (to everyone's surprise). The graffiti on the wall were both an ironic commentary on the information highway and a means to adorn the nest, although no one expected the turkeys to actually care much about them. On occasion, the turkeys would stop in front of the graffiti (which were all either signs or caricatures I made of the turkeys, Ed Bennett, and myself) and spend some time contemplating them. The emergence of this behavior was as intriguing as the behavior of humans in relation to the turkeys once humans were embodied on the webot.

The turkeys also helped organize the space to their satisfaction by spreading hay anywhere they felt like it. Another clear sign that they felt at home was the abundance and quality of the fecal matter they spread all over the space. This created a peculiar situation, since the telerobot Ornitorrinco had never shared a space with living animals before. While most people thought that this would be a problem, in fact the webot welcomed the excrement. The waste matter made the floor a little more slippery, which made the webot's motions smoother. This decreased the stress on the webot's motors and therefore demanded less from its battery, conserving more energy for a whole day's activity. In this tale of feathers, circuit boards, Web servers, and dung, the moral is that there is more to netlife than meets the eye when the harmony among humans, robots, animals, and the Internet is at stake.

### The *Telepresence Garment*

I conceived the *Telepresence Garment* in 1995 (fig. 68). This work, which I finished in 1996, came out of the necessity to explore ways in which technology envelops the body, suppresses self-control, and shields the body from direct sensorial experience of the environment. Instead of a robot hosting a human, the *Telepresence Garment* presents a roboticized human body converted into the host of another human. Far from utopian or escapist portrayals of the potential of these technologies, the *Telepresence Garment* is a sign of their problems.

A key issue I explore in my work is the chasm between opticality and cognizance, that is, the oscillation between the immediate perceptual field, dominated by the surrounding environment, and what is not physically present but nonetheless still directly affects us in many ways. The *Telepresence Garment* creates a situation in which the person wearing it is not in control of what is seen, because he or she cannot see anything through the completely opaque hood. The person wearing the garment can make sounds but cannot produce intelligible speech because the hood is tied very tightly against the wearer's face. An elastic and synthetic dark material covers the nose, the only portion of flesh that otherwise would be exposed. Breathing is not easy. Walking is impossible, since a knot at the bottom of the garment forces the wearer to be on all fours and to move sluggishly.

The garment is divided into three components. The Transceiver Hood has a CCD attached to a circuit board, both sewn to the leather hood on the left side, and an audio receiver sewn on the right side. The CCD is lined up with the wearer's left eye. Underneath the garment,

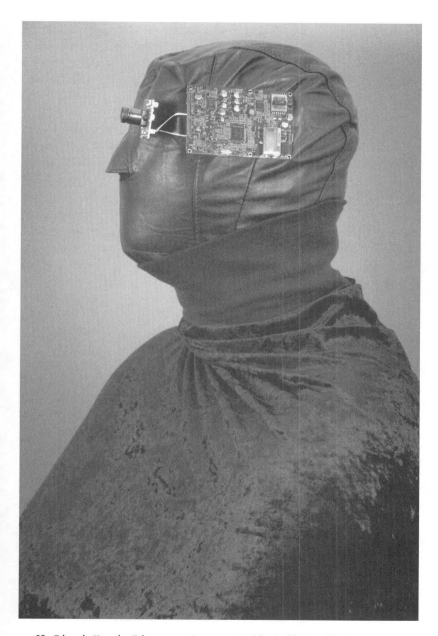

68. Eduardo Kac, the *Telepresence Garment,* semielastic fabric and leather hood with sewn video circuit and audio receiver, 1995–96. The participant wearing the garment becomes a host to a remote human. The remote participant issues commands by whispering in the right ear and sees the world from the perspective of the left eye of the wearer. (Photograph by Anna Yu.)

the wearer dons in direct contact with the skin what I call a Transmitter Vest, which is wired to the hood and enables wireless transmission of 30-fps color video from the point of view of the wearer's left eye. Enveloping the body is an opaque Limbless Suit, so-called because one cannot stand or stretch one's arms, temporarily reducing or eliminating the functionality of the limbs.

Instead of adorning or expanding the body, the *Telepresence Garment* secludes it from the environment, suggesting some of the most serious consequences of technology's migration to the body. Body sensations are heightened once the wearer removes the garment. This prêt-à-porter foregrounds the other meanings of the verb "to wear": to damage, diminish, erode, or consume by long or hard use; to fatigue, weary, or exhaust. The *Telepresence Garment* was experienced publicly for the first time in the context of *Ornitorrinco in the Sahara* (fig. 69), a dialogical telepresence event I presented with Ed Bennett at the Fourth Saint Petersburg Biennale, which took place in Saint Petersburg, Russia, in 1996.[4]

### *Ornitorrinco in the Sahara*

In the case of *Ornitorrinco in the Sahara,* the phrase "dialogical telepresence event" refers to a dialogue between two remote participants who interacted in a third place through two bodies other than their own. Realized in a public area of a downtown building in Chicago, The School of The Art Institute, without any prior announcement to facilities users, the event mentioned earlier consisted basically of three nodes linking the downtown site in real time to the Saint Petersburg History Museum (a Biennale sponsor) and the Aldo Castillo Gallery, in Chicago. Through these telecommunications ports of entry, human remote subjects interacted with one another by projecting their wills and desires onto equally remote and fully mobile, wireless telerobotic and teleborg objects.

One of the Saint Petersburg Biennale directors, Dmitry Shubin, used a black and white videophone to control (from the Saint Petersburg History Museum) the wireless telerobot Ornitorrinco (in Chicago) and receive feedback (in the form of sequential video stills) from the telerobot's point of view. At the same time, my own body was enveloped by the wireless *Telepresence Garment*. The dispossessed human body was controlled, also via a telephone connection, by artist and art historian Simone Osthoff from the Aldo Castillo Gallery. During the event, while both the telerobot and the teleborg were remote controlled, a unique dialogical telepresence situation unfolded.

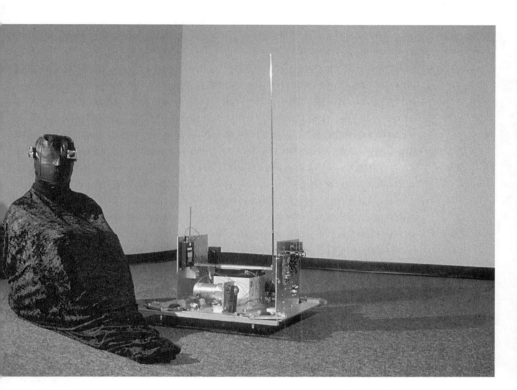

69. Eduardo Kac and Ed Bennett, *Ornitorrinco in the Sahara*, telepresence work between Chicago and Saint Petersburg, Russia, 1996. Through a videophone link, participants in Saint Petersburg were telepresent in Chicago in Ornitorrinco's body. They interacted with another person who was telepresent on the body of a human wearing the *Telepresence Garment*. (Photograph by Anna Yu.)

With the *Telepresence Garment* the human subject was converted into a human object, becoming a direct conduit to a remote operator's commands. The human body could not see anything at all. It could barely hear, and with great difficulty it could emit sounds. Locomotion on all fours was dramatically disabled by the Limbless Suit. With this garment, breathing became an exercise in patience, and as the temperature rose, sweat dripped incessantly, and most senses were either effaced or had their range and power reduced. The human body could only rely on instinct and the concern and cooperation of the remote agent. The feelings that emerged in this dialogical context were a sense of spatial unawareness and fear of getting harmed, an agonizing combination of feeling invisible and fragile simultaneously. Like a corpse revived by an external power, my motions were not proprio motu.

In previous Ornitorrinco telepresence works the concept of geographic displacement was an important element. Without ever leaving Chicago, in the past the telerobot Ornitorrinco had gone to the legendary beach of Copacabana, the inaccessible terrestrial moon, and the mythic Garden of Eden. It had also traveled around the world, from Turkey to Peru and back. This time, it went to the inhospitable Sahara. The title of this event, *Ornitorrinco in the Sahara*, dealt wryly with the contradictions inherent in the oppositions between a mostly barren land visited by few and the public space of a downtown building, very early in the morning on a weekend day, in one of the largest American cities.[5] The sense of isolation, as well as nomadic activity, conveyed by the African desert was translated into the temporary telenomadic experience of the remote subjects.

As Simone Osthoff controlled the behavior of my body, I dreaded the moment I would hit a wall or a pillar, accidentally find myself in the elevator, or collide with passersby or the telerobot (which hosted Dmitry Shubin, from Saint Petersburg). Considerate of my sensorial deprivation, Osthoff spoke slowly and paused intermittently, commanding the body as if via a telempathic sense of touch,[6] as when someone enters a dark space and tries hesitantly to touch surrounding objects, hoping to regain spatial awareness of the environment. At first completely unaware of what he was contemplating, Shubin alternated the behavior of his telerobotic host between propelling himself down the hall to navigate other areas of the space and engaging me (i.e., Osthoff on my body) directly. On occasion, physical contact between the two occurred, reiterating the tangible reality of this vicarious encounter.

### The Impossibility of Knowing: The Life Experience of a Bat

*Darker Than Night* (fig. 70) is a telepresence artwork that explored the human-machine-animal interface and telepresence as a means of mediating relations of empathy. It was realized from June 17 to July 7, 1999, in a bat cave at the Blijdorp Zoological Gardens in Rotterdam. In this interactive piece, participants, a telerobotic bat (batbot), and over three hundred Egyptian fruit bats[7] shared a natural habitat to which humans had no direct access. The cave is dark at all hours and is fifteen meters in diameter and twenty meters in height.

*Darker Than Night* had two separate areas: the first had the telepresence station (through which the local public could be telepresent in the cave); the second was the cave itself, where the batbot continuously swept through the space with its ultrasonic emissions. At the second site the public saw the cave and the batbot behind a glass wall.

The batbot, the central element of the installation, is seventeen inches long. It contains a small sonar unit inside its head, a frequency converter to transform bat echolocation calls into audible sounds, and a motorized neck that enables its head to spin.[8]

The sonar unit scanned the space at 45 kHz and was wired to a computer taking in data and providing video output to the public.[9] The batbot is a telepresence medium through which participants entered the cave via a virtual reality headset. The headset had a temperature sensor, thus activating the batbot in the cave through a reading of the warmth of the participant's body. Through the metaphor of "energy transfer" from participant to batbot, the latter exhibited behavior that, from the point of view of the three hundred bats, was unpredictable.[10] With the headset on, the viewer's sight was transformed into the point of view of the batbot's sonar. Participants wearing the VR headset saw the batbot's ultrasonic display: a semicircle made of white dots represented the walls of the cave. A large white dot at the center represented the position of the batbot. The white dots along the semicircle represented the cave walls from the ultrasonic "perspective" of the batbot. Moving white dots represented obstacles encountered by the batbot's sonar, that is, Egyptian fruit bats that happened to be flying within the batbot's range at the moment. Since bats flew through the space regularly, the white dots changed constantly.

This work brought participants together to foster an interspecies, dialogical experience. The behavior and the biosonar of the Egyptian fruit bats in the cave affected the participants, while the behavior and the telerobotic sonar of the participants on the body of the batbot affected the Egyptian fruit bats. Both groups became aware of their mutual presence and actions, since they were able to hear and track each other.

*Darker Than Night* emphasized the barriers that prohibit each individual from moving beyond insular, self-reflective experience.[11] The bat, a rarely understood, enigmatic, flying mammal, represents the mystery and nuances held within each individual's consciousness.

### *Uirapuru:* Televirtual Eye above the Amazon

The telepresence work *Uirapuru* (fig. 71) was shown from October 15 through November 28, 1999, in the context of the ICC Biennale '99, at the InterCommunication Center, in Tokyo, and on the Web. The word *uirapuru* (musician wren) is the name of both an actual Amazonian bird (*Cyphorhirius arada*) and a legendary creature.[12] In the rain forest the bird Uirapuru sings for about ten days, only in the morning, and only once a year, when it mates and builds its nest. According

(a)

(b)

(c)

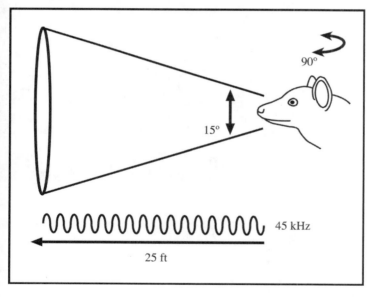

(e)

70. Eduardo Kac, *Darker Than Night*, telepresence work, 1999. Participants (a), a telerobotic bat or batbot (b) and over three hundred Egyptian fruit bats (c) shared a cave (d) and became aware of their mutual presence through sonar emissions and frequency conversions (e). (Photograph by Anna Yu and Rob Veenendaal/Buro Luxor.)

# Uirapuru: Televirtual Eye above the Ama[zon]

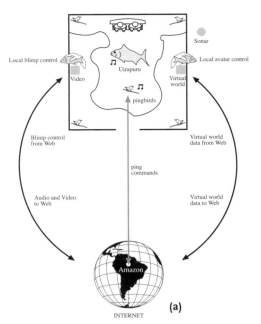

(a)

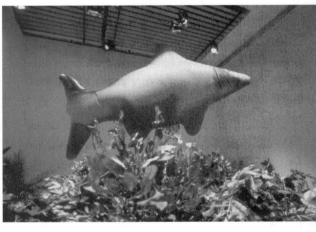

(b)

(c)

(d)

(e)

(f)

71. Eduardo Kac, *Uirapuru*, telepresence work on the Internet, 1996–99. This work unites telepresence, multiuser virtual reality, and networking into a single realm of experience (*a*). A flying fish hovers above a forest in the gallery (*b*), responding to local (*c*) as well as Web-based commands (*d*). Audio and video from its point of view are streamed on the Web. Local and remote participants interact with the avatar of the flying fish in a virtual world (*e*). Six "pingbirds" (robotic birds) sing Amazonian birdsongs in the gallery in response to the rhythm of Internet traffic (*f*). (Photograph by Anna Yu.)

to the legend, of Tupi origin, Uirapuru's song is so beautiful that all other birds stop singing to listen to it. Yet in another account of the legend, a human being is transformed after his death into the enchanted Uirapuru, breathing new life into the silent forest. Another interpretation of the Uirapuru legend states that the figure can bring love or happiness to those who own it as a talisman or those who drink *cauim* (an ancient native brew) mixed with Uirapuru's ashes. The Uirapuru story has many more versions, and composers such as Heitor Villa-Lobos ("Uirapuru, Symphonic Poem," 1917), Olivier Messiaen ("Et exspecto resurrectionem mortuorum," 1964), and Tom Eastwood ("Uirapuru," 1983) have reworked Uirapuru's folklore and melodic line in their own work. Both in legend and in reality, Uirapuru is a symbol of rarefied beauty.

I have always been fascinated by the Uirapuru story and by its dual status as real and legendary. With the interactive telepresence work *Uirapuru* I created my own version of the legend. In my personal mythology Uirapuru is a flying fish that hovers above the forest, singing and giving good fortune to forest inhabitants. My Uirapuru sings when it hosts the spirits of those who are far away. Uirapuru's forest is populated by "pingbirds," fantastic creatures whose melody oscillates according to the rhythm of global network traffic. Uirapuru's own spirit is hosted by a virtual fish, who flies and interacts on-line in virtual space with other virtual fish. Thus, Uirapuru's behavior contributes to increased network traffic and causes the pingbirds to sing more often.

My version of the legend reinvents Uirapuru's dual status as a real animal and a mythical creature through an experience that is at once local and remote, virtual and physical. The flying telerobotic fish is a blimp that can be controlled both through a local interface and through the Web. The local interface is a fish-shaped object that can be handled and moved freely in three-dimensional space. When participants control it, Uirapuru moves accordingly in the gallery.[13] Sensors in the gallery track the movement of the telerobotic fish in three dimensions and send data to the VRML server. As a result, Uirapuru's avatar moves in the virtual space according to the movement of the telerobotic fish in the gallery. Video from the point of view of the telerobotic fish is seen in the gallery and is streamed live on the Web.

There is a direct correspondence between the physical organization of the gallery space and the Web interface in *Uirapuru*. In the gallery, once the participant approached the Uirapuru forest, she had to choose between walking to the left or right. Because of the dense concentration of trees, it was not possible to walk straight into the space. Likewise, once the participant accessed the Uirapuru interface on the Web, she had to choose between clicking on the left or right. There were no

clickable options in the middle. If the participant chose to walk to the left in the gallery, she discovered a reddish, earthy toned pedestal. The top of this pedestal was a flat video display, over which rested the fish-shaped interface. The video on the flat panel (full frame, 30 fps) revealed the top of the canopy from the ever-changing perspective of the flying telerobot Uirapuru. This was the telepresence portal. An identical setup was found when the participant walked to the right side of the gallery. On the right, however, this setup worked as the virtual portal. The image on the flat panel revealed the virtual world from the perspective of an avatar, who was logged on by default to enable gallery participants to fly in the virtual world and to see the other on-line participants navigating in the same world. On the Web, in correspondence with the gallery's spatial organization, clicking on the left opened the telepresence portal; clicking on the right opened the virtual portal.

Uirapuru's on-line telepresence interface was composed of a rectangular window in the middle of the screen, which showed the live video stream coming from the point of view of the telerobot Uirapuru. Slightly to the right of this window there was a vertical bar for dynamic volume control, with which on-line participants could change the volume of the incoming, video-synchronized streaming audio of Amazonian birdsongs heard in the remote gallery. Surrounding this window there were six Java buttons. On-line participants clicked on them to control the flight pattern of the telerobot Uirapuru: up/down, left/right, forward/backward.

Uirapuru's on-line multiuser virtual reality interface was composed of a window with a digital forest. The trees were concentrated on a brown floating square, which corresponded to the six-by-six-meter gallery space. In the lower right corner the participant was asked to choose an avatar from a list of fish (blue, red, green, yellow) or to type an URL with a link to his or her own avatar of choice. Once logged in to the virtual world with the selected avatar, the participant saw below the world a chat window (bottom left) and a list of participants (bottom right). Participants were able to move freely in the world, going in any direction and traversing any objects.

In the gallery participants could only experience one portal at a time, having to walk to the other side of the space to experience the other portal. On the Web participants were able to keep both portals open at once, leaving one in the foreground and the other in the background and toggling between them.

Both the telepresence and the virtual interfaces in the gallery were composed of a pedestal with a flat video display for its top, over which rested the fish-shaped interface. Measuring approximately eight inches, the fish had a three-dimensional tracking device inside, which gave a

local computer information about its position, orientation, and movement. When participants handled the fish interface freely over the telepresence station, the telerobot Uirapuru flew accordingly in real time in the gallery (up/down, left/right, forward/backward). When participants grabbed and moved the fish interface at the multiuser VRML station, they moved their avatar accordingly in the virtual world (also in all directions).

Both local and remote participants were always aware of each other's actions. Since the video from the perspective of the telerobot was constantly streaming, independently of who was controlling the flying telerobot at the moment, Web participants could see local gallery visitors from above (the telerobot's point of view). When the telerobot seemed to move by itself, without local control, gallery visitors became aware that somebody on-line was on Uirapuru's body. Likewise, when a fish with the "ICC Tokyo" tag above it was moving in the virtual world, on-line participants became aware that a local participant was present and active in it. If local participants saw any fish other than Uirapuru in the virtual world, they knew that someone on-line was participating at the moment. A tag of one's choice, typed before logging on, was always seen above one's avatar, clearly showing who was who from the list of participants.

The telerobotic fish hovered above the forest, which was populated by six colorful pingbirds. Pingbirds were telerobotic birds that sang their songs according to ping commands sent to a server geographically located in the Amazon region (where the rain forest is located).[14] The ping command is a regular part of the UNIX system, which is at the core of the Internet. It operates by sending a packet to a designated address and waiting for a response. It is used to monitor round-trip travel time and as such is a direct measurement of Internet activity. In *Uirapuru* greater Internet traffic resulted in the telerobotic birds singing more often.

The pingbirds were placed strategically in the gallery space to create an immersive sound experience. One pingbird was placed in each of the four corners, while the remaining two were placed around the middle of the space. The flying telerobot, which had a speaker onboard, was also part of the pingbird system, providing an additional sound source from above. To reflect the rarity of Uirapuru's song in the rain forest, its song was only available 40 percent of the time when compared with the six pingbirds. This meant that, depending on how much time a visitor spent in the space, she would hear all the other pingbirds but might hear Uirapuru's song only once or not at all.

*Uirapuru* merged virtual reality with telepresence on the Internet. Virtual reality offers participants a purely digital space that can be ex-

perienced visually and in which one can be active, in this case the VRML forest populated by flying fish. Telepresence provides access and a point of entry to a remote physical environment, in this case the "Amazon forest." This forest consisted of over twenty artificial trees, on top of which vividly painted pingbirds were perched. The Internet's information flow was expressed in the gallery through the melodic pattern of the pingbirds. In a direct way, anybody who participated in this work, locally or on-line, increased Internet traffic and as a result contributed to increasing the frequency of the pingbird chorus. At the back of the space, along a pathway, hidden within the forest, a bench awaited local visitors who were invited to rest and enjoy the songs of Uirapuru and the Amazonian pingbirds.

## Conclusion

The works discussed here created dialogical and multilogical telepresential experiences. They suggest the need to nurture a network ecology with humans and other mammals, with plants, insects, artificial beings, and avian creatures, as was the case with the warm-blooded, egg-laying, feathered vertebrates included in Ornitorrinco's Finnish netnest. Network ecology, with its latent expansion of human potentialities, is a motive power of our digital nomadism. It is imperative to assert alternatives that promote digital-analog integration and that lead to unprecedented hypermedia, telematic, and postbiological experiences. Telepresence is one such alternative. Escaping from rubrics that categorize past contributions to contemporary art—such as body art, installations, happenings, video art, performance, and conceptual art—telepresence works have the power to contribute to a relativistic view of contemporary experience and at the same time create a new domain of action, perception, and interaction.

### Notes

1. See "Robo-Shots," *New York Times Magazine,* July 19, 1998, 13; John W. Hill and Joel F. Jensen, "Telepresence Technology in Medicine: Principles and Applications," *Proceedings of the IEEE* 86, no. 3 (1998): 569–80; Samuel Rod and Allan Pardini, "Telepresence and Virtual Environment Applications at Hanford," *Nuclear News* 39 (Jan. 1996): 34–36; "LunaCorp Flies Rover to the Moon," *Washington Post,* Aug. 12, 1997; Michael D. Wheeler, "Robotic 3D Imager to Brave Chernobyl," *Photonics Spectra,* Aug. 1998, 34, 36.

2. On the one hand, this apparently contradictory effect operated a critique of how the social credibility of mass media is derived, in part, from its technical reliability. On the other hand, it pointed to the technical future of the Web, when terabits of bandwidth coming into households will enable the streaming of 30 fps. The effect was achieved by enclosing inside a pedestal three components: a computer, a

dual-input video editor and processor, and a projector. The editor embedded the live input coming from Ornitorrinco inside a multimedia application simulating the Netscape browser. An opening on the pedestal enabled the simulated interface to be projected on the wall. Clicking on the interface sent wireless motion-control signals that were decoded in real time by Ornitorrinco. It was critical to the success of this system that no wires were seen by the public.

3. Two ordinary instances illustrate this point. As we talk on the phone, for example, we do not know if our words go up to a satellite, down to an underwater cable, or just above our heads via a microwave link (or all of the above in a single call). As we slide a credit card to purchase a product, we do not know in what kinds of databases information about the transaction is stored (amount, date, nature of selected products, brand of choice).

4. In addition to an exhibition catalog, the Biennale published a book with critical writings on electronic art. See Eduardo Kac, "*Ornitorrinco* and *Rara Avis*," in *The Visuality of the Unseen*, ed. Dmitry Golinko-Volfson (Saint Petersburg: Borey-Print, 1996), 111–22.

5. The event took place early in the morning because of the Chicago–Saint Petersburg nine-hour time-zone difference.

6. I coined the word *telempathy* to designate the ability to have empathy at a distance.

7. This species was named after a specimen collected in the pyramids of Egypt, hence the name. Egyptian fruit bats are gregarious and cave-dwelling. Colonies of up to thousands occur. They roost in the darkest parts of a cave, closely packed together, usually hanging by one of their hind feet. They are the only fruit bats known to echolocate. Low-frequency clicks produced by the tongue are used in echolocation. The Egyptian fruit bats echolocate mostly with a constant frequency from 30 kHz to 80 kHz. Approximately three hundred Egyptian fruit bats live in the cave at the Blijdorp Zoological Gardens in Rotterdam. The bats are active mostly in the afternoon when they are fed. In the morning the cave is cleaned. The public can see the bats through a glass pane. In front of the glass pane there are two wooden construction beams that the food (bananas, oranges) hangs from. The batbot also hung from one of these beams.

8. Echolocation—the active use of sonar (SOund Navigation And Ranging)—allows bats to "see" with sound. Bats use their biosonar in a sound or frequency range that humans cannot hear. Human hearing spans from about 200 hertz (or 200 cycles per second) to 20,000 hertz (or 20,000 cycles per second). Bats can hear well into the ultrasonic range, or up to roughly 200,000 hertz. The biosonar of most bats operates from about 25,000 to 100,000 hertz, abbreviated as 25 to 100 kilohertz or kHz (thousand hertz). The classic text on bat ultrasonic echolocation is Donald Griffin, *Listening in the Dark: The Acoustic Orientation of Bats and Men* (Ithaca and London: Cornell University Press, 1986). This is a reprint of the 1958 original text, in which Griffin proved that bats emit high-frequency sounds to detect objects in the environment and presented the term *echolocation* to designate "this type of perception of objects at a distance" (77). The term first appeared in Griffin's paper "Echolocation by Blind Men, Bats, and Radar," *Science* 100 (1944): 589–90.

9. When the participant wears the VR headset the batbot produces its echolocation call and its head swivels ninety degrees. It produces a fifteen-degree ultrasonic beam with a twenty-five-foot range. The batbot's emission signal peaks at 45 kHz.

10. By this I mean that instead of sending sonar emissions uninterruptedly (twenty-four hours a day), the batbot only emitted its call when hosting a participant, for as long as the participant wore the headset. The result was dynamic bat-

bot behavior, contingent on human participation. Since the batbot's call was within the hearing range of the Egyptian fruit bats, we can ascertain that the bats heard it. As a result we can say that their experience of the batbot's behavior in the cave was conditional on the participant's remote presence—constantly changing.

11. In his classic essay "What Is It Like to Be a Bat?" Thomas Nagel rejects explanations of consciousness based on "materialism, psychophysical identification, or reduction." For Nagel, the "subjective character of experience" means that there is something that it is to *be* a given organism. In this context, the bat helps elucidate the question of consciousness because bats are closely related to humans but present a range of activity and a sensory apparatus (i.e., biosonar) very different from ours. For Nagel, the connection of experience with a particular point of view is very close. Ultimately, knowledge of observable facts is insufficient: it is impossible for humans to truly know what it is like *for the bat* to be a bat. Nagel concludes his essay with a call for an "objective phenomenology not dependent on empathy or the imagination." This "objective phenomenology" would attempt to describe the subjective quality of experiences to those incapable of having those experiences. Nagel's essay was first published in 1974 and is reproduced in *Mortal Questions* (New York: Cambridge University Press, 1979), 165–80.

12. On the actual bird, see Helmut Sick, *Ornitologia Brasileira, uma introdução*, vol. 1 (Rio de Janeiro: Editora Nova Fronteira, 1997); Johan Dalgas Frisch, *Aves Brasileiras*, vol. 1 (São Paulo: Sabiá; Dalgas-Ecoltec Ecologia Técnica e Comércio, 1980); and Rodolpho von Ihering, *Dicionário dos animais do Brasil* (Brasília: Ed. Universidade, 1968). On the Uirapuru legend, see Luís da Câmara Cascudo, *Dicionário do folclore brasileiro*, 2d ed. (Rio de Janeiro: Ministério da Educação e Cultura/Instituto Nacional do Livro, 1962), 756–57.

13. The telerobot Uirapuru has three propellers: one on each side and one at the bottom. During the exhibition, a forward command activated both side propellers in the same direction (clockwise). A backward command made them both turn counterclockwise. Left and right commands made one propeller turn clockwise and the other counterclockwise, and vice versa. Up and down commands activated the bottom propeller clockwise and counterclockwise, respectively. Sonar in the gallery tracked Uirapuru's movement and instructed the VRML server to move Uirapuru's avatar accordingly. If no instructions were given, because no one was controlling it, Uirapuru's avatar flew in a pattern that took it from above the canopy to the bottom of the forest, and then out in space and back again above the canopy.

14. The server's IP address, which belonged to the Amazon-based company Netium, was 200.241.125.15. The pingbirds sang the songs of real Amazonian birds according to the rhythm of global network traffic. The birds selected to give voice to the pingbirds were the *uirá-trovão* (peruvian wren), *rouxinol* (gray-breasted wren), *sabiá-verdadeiro* (sabian thrush), *fri-frió* (gray screaming piha), *galo-do-mato* (rofous-vented ant thrush), and *japacanim* (black-capped mocking thrush). Each bird call lasted approximately twenty seconds.

III. Bio Art

## 11. The Emergence of Biotelematics and Biorobotics: Integrating Biology, Information Processing, Networking, and Robotics

The passage of biology from a life science to an information science provokes debates on the ethical, psychological, economic, and cultural implications of biotechnology, undoubtedly affecting what we used to call "visual arts." Contrary to expectations, the notion of biotechnology is by no means new. The use of microorganisms to produce chemical compounds goes back to the beginning of recorded history, including the use of fermented juices to produce vinegar and alcoholic beverages. What is different about contemporary biotechnology is the development of genetic engineering and related procedures to exert precise control over living organisms at microscopic levels. Uniquely distinct about molecular biology is the range of goals, ever more ambitious, and the wide assortment of results, at times shocking to the general public, such as the growth of eyes in multiple parts of the bodies of fruit flies, the creation of headless frogs, the successful birth of chicks embodying the behavior of quails, and the growth of a prosthetic human ear on the back of a mouse.[1] At the level of microorganisms we find, for example, bacteria that convert agricultural garbage into fuel alcohol and chips inhabited by bacteria genetically engineered to glow when detecting pollutants.[2] At the mammalian level, a turning point was the cloning of the sheep Dolly, in 1996, followed by the

---

This chapter results from the integration of the following articles: "Essay Concerning Human Understanding," *Leonardo Electronic Almanac* 3, no. 8 (1995); "Teleporting an Unknown State," in Jean Ippolito et al. (eds.), *Siggraph Visual Proceedings*, The Bridge section (New York: ACM, 1966); "A-positive," in *ISEA '97—The Eighth International Symposium on Electronic Art*, September 22–27, 1997 (Chicago: The School of The Art Institute of Chicago, 1977); "Time Capsule," leaflet, Casa da Rosas, São Paulo, Brazil, 1997.

cloning of mice and cows in 1998.[3] These are but a few examples that clearly illustrate the complexity of the biotech culture.

Another aspect of this cultural shift is the transformation of biology into an information science. The understanding of genetic events in light of semiotics and communications theory has fostered the field known as biosemiotics,[4] which studies communication and signification in living systems. Biosemiotics regards communication as the essential characteristic of life. With its emphasis on context and meaning, it serves as a healthy antidote to genetic determinism. Because of its conventionalist nature, traditional semiotics cannot be simply and directly applied to biological systems, however. Peirce[5] stresses the representation of an object in the human mind invoked by the sign vehicle. Sebeok[6] goes beyond the human mind and speech ability in defining zoosemiotics, or the study of visual, acoustic, and chemical signs used by animals. When considering plants, which are believed not to have a mind or be conscious[7] but seem to interpret signs,[8] one has to loosen definitions of interpretation (i.e., make them less humanlike) and widen the scope of communications research to include interspecies interaction, "biotelematics," and "biorobotics" (two terms I coined to designate the integration of biology and telematics, and biology and robotics, respectively).

I believe that these areas of inquiry open up uncharted territory for artistic investigation. To illustrate my work in this area, I will discuss four artworks in which I employ biological processes or interfaces. These works are entitled *Essay Concerning Human Understanding* (1994), *Teleporting an Unknown State* (1994–96), *A-positive* (1997), and *Time Capsule* (1997). The first piece created a situation in which a canary dialogued over a regular phone line with a plant (a philodendron) six hundred miles away. In the second work actual photosynthesis and growth of a living organism took place over the Internet. The third piece proposed a dialogical exchange between a human being and a robot through two intravenous hookups. The fourth approached the problem of wet interfaces and human implantation of a memory microchip. Working with multiple media to create hybrids from the conventional operations of existing communications systems, I hope to engage participants in situations involving biological elements, telerobotics, interspecies interaction, light, language, distant places, time zones, video conferences, and the exchange and transformation of information via networks. Often relying on contingency, indeterminacy, and the intervention of the participant, these works encourage dialogical interaction and confront complex issues concerning identity, agency, responsibility, and the very possibility of communication.

## Remote Interspecies Communication

*Essay Concerning Human Understanding* (fig. 72) was a live, bidirectional, interactive, telematic, interspecies sonic installation I created with Ikuo Nakamura between Lexington, Kentucky, and New York. In this work, a canary dialogues over a regular phone line with a plant (a philodendron) six hundred miles away. The piece was exhibited in the context of my show Dialogues, realized in 1994 simultaneously on the Internet and in museums and galleries. *Essay Concerning Human Understanding* was presented publicly from October 21 to November 11, 1994, simultaneously at the Center for Contemporary Art, the University of Kentucky, Lexington, and the Science Hall, New York.[9]

Placed in the middle of the Center for Contemporary Art, the yellow canary was given a very large and comfortable cylindrical white cage, on top of which circuit boards, a speaker, and a microphone were located. A clear Plexiglas disk separated the canary from this equipment, which was wired to the phone system. In New York, an electrode was placed on the plant's leaf to sense its response to the singing of the bird. The microvoltage fluctuation of the plant was monitored through a Macintosh running software called Interactive Brain-Wave Visual Analyzer (IBVA). Ironically, a program designed to detect human mental activity was employed to inspect the vital activity of an organism generally understood as devoid of consciousness. The information coming from the plant was fed into another Macintosh running MAX, which controlled a MIDI sequencer. The electronic sounds themselves were prerecorded, but the order and the duration were determined in real time by the plant's response to the singing of the bird.

When this work was shown publicly, the bird and the plant interacted for several hours daily. Humans interacted with the bird and the plant as well. Just by standing next to the plant and the bird, humans immediately altered their behavior. When in close proximity, the interaction was further enhanced by the constantly changing behavior of the bird and the plant, which responded by singing more (bird), activating more sounds (plant), or remaining quiet.

By enabling an isolated and caged animal to have a telematic conversation with a member of another species, this installation dramatized the role of communication and telecommunications in human lives. The interspecies communicative experience observed in the gallery reflects our own longing for interaction, our desire to reach out and stay in touch. This interactive installation is as much about creating art for nonhumans as it is about human isolation and loneliness and about the very possibility of communication. As this piece projects

(a)

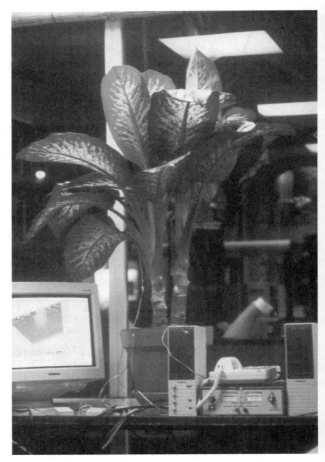

(b)

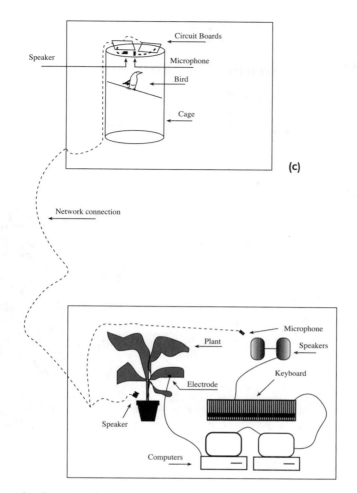

72. Eduardo Kac and Ikuo Nakamura, *Essay Concerning Human Understanding*, biotelematic work connecting Lexington, Kentucky, and New York, 1994. This work explored interspecies communication: a canary (*a*) dialogued with a plant six hundred miles away (*b*) over the network (*c*).

the complexities of electronically mediated human communication over nonhuman organisms, it surprisingly reveals aspects of our own communicative experience. This interaction is as dynamic and unpredictable as a human dialogue.

### Biotelematics Live

*Teleporting an Unknown State* (fig. 73) is the title of my biotelematic installation that linked the Contemporary Art Center, in New Orleans, to the Internet (August 4–August 9, 1996). This piece was part of The Bridge, the Siggraph '96 Art Show. *Teleporting an Unknown State* combined biological growth with Internet (remote) activity. In a very

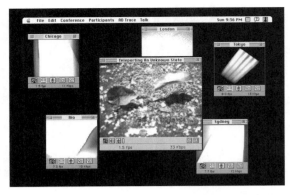

(a)

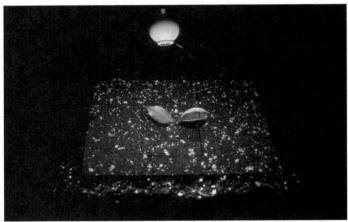

(b)

(c)

73. Eduardo Kac, *Teleporting an Unknown State*, biotelematic work on the Internet, 1994–96. The installation creates the experience of the Internet as a life-supporting system (*a*). In a very dark room a pedestal with earth serves as a nursery for a single seed (*b*). Through a video projector suspended above and facing the pedestal, remote individuals send light via the Internet (*c*) to enable this seed to photosynthesize and grow in total darkness (*d*).

(d)

dark room, a pedestal with earth served as a nursery for a single seed. Remote individuals responded to email announcements and sent light via the Internet to enable this seed to photosynthesize and grow in total darkness. The installation created the experience of the Internet as a life-supporting system.

As local viewers walked in they saw the installation: a video projector hung from the ceiling and faced down, where a single seed lay on a bed of earth. Viewers didn't see the projector itself, only its cone of light projected through a circular hole in the ceiling. The circularity of the hole and the projector's lens flush with it are evocative of the sun breaking through darkness. At remote sites around the world, anonymous individuals pointed their digital cameras to the sky and transmitted sunlight to the gallery. The photons captured by cameras at the remote sites were reemitted through the projector in the gallery. The video images transmitted live from remote countries were stripped of any representational value and used as conveyors of actual wavefronts of light. The slow process of growth of the plant was transmitted live to the world via the Internet as long as the exhibition was up. All participants were able to see the process of growth via the Internet. The computer screen, that is, the graphical interface on which all the activity could be seen, was rendered immaterial and projected directly onto the bed of earth in a dark room, enabling direct physical contact between the seed and the photonic stream.

The poetics of this piece's network topology operated a dramatic reversal of the regulated unidirectional model imposed by broadcasting

standards and the communications industry. Rather than transmitting a specific message from one point to many passive receivers, *Teleporting an Unknown State* created a new situation in which several individuals in remote countries transmitted light to a single point in the Contemporary Art Center, in New Orleans. The ethics of Internet ecology and network community were made evident in a distributed and collaborative effort.

During the show, photosynthesis depended on remote collective action from anonymous participants. Birth, growth, and death on the Internet formed a horizon of possibilities that unfolded as participants dynamically contributed to the work. Collaborative action and responsibility through the network were essential for the survival of the organism. The exhibition ended on August 9, 1996. On that day the plant was eighteen inches tall. After the show, I gently uprooted the plant and replanted it next to a tree by the Contemporary Art Center's front door.

In October of 1998 I created a Web version of *Teleporting an Unknown State* at KIBLA Art Gallery, in Maribor, Slovenia.[10] What the participant saw on the Web was a nine-image grid, comprised of a central image (the plant) and eight surrounding images (live views of the skylines of different cities). The central image showed the plant and the earth in the dark physical space of the gallery, in Maribor, and was updated automatically (to provide feedback to Web participants). The eight surrounding images were activated by Web participants at will and immediately projected onto the earth, where the seed was planted, in the gallery. The position of the images on the grid reflected the real position of their respective places on the globe, as represented by standard maps. I positioned Maribor at the center and the other locations around it: Vancouver (top left); Chicago (left); Cabo Lucia, Mexico (bottom left); Paris (top center); Antartica (bottom center); Moscow (top right); Tokyo (right); and Sydney (bottom right).

The central image was captured and uploaded automatically with a self-contained camera server (a video camera with embedded Web server), which added to it a time stamp showing the day and time in Maribor. When projected over the plant, this central image concentrated the light sent by Web participants. The eight surrounding images were uploaded interactively upon the Web participant's request. The default state of this work was a central image surrounded by black rectangles (which were filled with live images when requested by the participant). If one saw a black image when logging on, either it was dark at the moment at the selected geographic location or the corresponding image had not been selected by the previous Web participant. Once selected by the Web participant, an image remained active (on-line and

in the gallery) for five minutes. After this period it was replaced by a black rectangle, to enable incoming participants to make their own choices. This new version enabled Web participants to seamlessly harness the light of the sky from eight different locations to grow a plant in a dark room in Slovenia and to monitor its progress. A newer Web version traveled in 2001 as part of the exhibition Telematic Connections: The Virtual Embrace, organized by Independent Curators International (ICI), in New York, and curated by Steve Dietz.

### Dialogical Biorobotics

*A-positive* (fig. 74) was an event realized on September 24, 1997, at Gallery 2, in Chicago, in the context of the ISEA '97 art exhibition.[11] This work, created with Ed Bennett, probes the delicate relationship between the human body and hybrid machines that incorporate biological elements and from these elements extract sensorial or metabolic functions. The work created a situation in which a human being and a robot had direct physical contact via an intravenous needle connected to clear tubing and fed one another in a mutually nourishing relationship. I call the new category of hybrid biological robots "biobots" and the field dedicated to their study and construction "biorobotics." With the term "biorobotics" I do not mean the application of biological principles (derived from fields such as ethology and neurobiology) to machine engineering. I mean precisely the creation of robots that incorporate within their body actual, active, and wet biological elements. Because of its use of human red blood cells, the biobot created for *A-positive* is termed a "phlebot."

In *A-positive*, the human body provided the robot with life-sustaining nutrients by actually donating blood to it; the biobot accepted the human blood and from it extracted enough oxygen to support a small and unstable flame, an archetypal symbol of life. In exchange, the biobot donated dextrose to the human body, which accepted it intravenously. The interactive model created by this dialogical work is far from conventional scenarios that portray robots as slaves that perform difficult, repetitive, or humanly impossible tasks; instead, as the event unfolds the human being gives his own blood to the biobot, creating with it a symbiotic exchange. This work is dialogical in the sense that, by presenting a robot with circulating human blood and an apparent will of its own, it speculated on the future lifelike properties of biorobots.

This work uses a biodigital human/machine interface that penetrates the sacred boundaries of the flesh in order to draw attention to the condition of the human body in the context in which biology meets com-

(a)

(b)

74. Eduardo Kac, *A-positive*, biorobotic work, 1997. The work created a situation in which a human being and a biological robot (biobot) had direct physical contact via an intravenous needle and fed one another in a mutually nourishing relationship (*a*). The biobot accepted the human blood and from it extracted enough oxygen to support a small and unstable flame (*b*), an archetypal symbol of life. (Photograph by Carlos Fadon.)

puter science and robotics. We can no longer regard the body as isolated from firm contact with the technoscape; neither can we fail to resist the biological surveillance of biometrics. Disembodied DNA has become a computational tool, while artificial blood circulates in human blood vessels. A DNA computer has been successfully demonstrated by a mathematician turned biologist, opening new possibilities for both computer science and molecular biology.[12] Instead of electrical impulses, it employs deoxyribonucleic acid, or DNA, and uses nucleotides, the basic units of DNA, to replicate the actions of a processor. The technologies that condition our imagination and sensibility, including nanotechnology and genetic engineering, also penetrate our skin—our bloodstream, even—enabling unique forms of therapy. Miniaturized electronic devices (implants) and new chemical compounds are invading (and cohabiting) the physical structure of the organism. Artificial blood is made of compounds that, like red blood cells, can carry oxygen from the lungs to the rest of the body and carry carbon dioxide back. This and other related developments clearly reveal that technology permeates the body in subtle ways. The dialogical situation created in *A-positive* quite literally wires the human being to the robot, with four connection points in a prototypical biological network.[13] Once extracted from the blood and released inside the sealed chamber, the oxygen supports the minuscule glowing mass of burning gas, the symbolic "nanoflame."

The body is one of the most traditional subjects in art, one that continues to fascinate us, albeit for entirely different reasons than it did in the past. However, instead of portraying the body as predominant or privileged (figure) in contrast with the environment (background), we investigate the political and the psychological dimension of our passage into a digital culture. As we realize how close technology is to the body, or how deep it already is inside the body, we must also grasp that the use of the master/slave model in robotic science is more than just a very unfortunate choice of words. It assumes that machines are slaves, with all the connotations of the word, perpetuating the idea that certain kinds of creatures must provide forced labor, only this time the creatures are electronic.[14] While it might be easy to dismiss such considerations on the basis of the fact that machines do not have organic life, humanlike intelligence, or a will of their own, the increased presence of electronic and computational devices inside the human body and the accelerated investigation of biological directions for robotics and computer science suggest that the gaps are being slowly narrowed beyond what we might be willing to admit or perhaps accept. In this sense, one might speak of the "ethics of robotics"[15] and reconsider

many of our assumptions about the nature of machines in the biobotic frontier.

We are no more masters of our machines than we are at their mercy. *A-positive* does away with the metaphor of robotic slavery and suggests a new ecosystem that takes into account the new creatures and organic devices that populate our postnatural pantheon. Such creatures can be biological (mutants), biosynthetic (genetic engineering), inorganic (robots), algorithmic (a-life), or biobotic (machine/organism hybrids).

### Memory and Digital Mnemotechnics: Bioimplant and Telemetry

*Time Capsule* (fig. 75) was realized on November 11, 1997, at Casa das Rosas, a cultural center in São Paulo, Brazil. The piece is a distributed work that links a local event installation, a site-specific intervention in which the site itself is both my body and a remote database, and a live simulcast on TV and the Web. The object that gives the piece its title is a microchip that contains a programmed identification number and is integrated with a coil and a capacitor, all hermetically sealed in biocompatible glass. The temporal scale of the work is stretched between the ephemeral and the permanent, that is, between the few minutes necessary for the completion of the basic procedure, the microchip implantation, and the permanent character of the implant. As with other underground time capsules, it is under the skin that this digital time capsule projects itself into the future.

When the public walked into the gallery where this work took place, what they saw was a horizontal bedstead, seven sepia-toned family photographs shot in Eastern Europe in the 1930s, an on-line computer serving the Web, a telerobotic finger, and additional broadcasting equipment. I started (and concluded) the basic procedure by washing the skin of my ankle with an antiseptic and using a special needle to insert subcutaneously the passive microchip, which is in fact a transponder with no power supply to replace or moving parts to wear out. Scanning the implant remotely via the Net generated a low-energy radio signal (125 kHz) that energized the microchip to transmit its unique and inalterable numerical code (026109532), which was shown on the scanner's sixteen-character liquid crystal display (LCD). Immediately after this data was obtained I registered myself via the Web in a remote database located in the United States. This was the first instance of a human being added to the database, since this registry was originally designed for identification and recovery of lost animals. I registered myself both as animal and owner under my own name. After implan-

tation a small layer of connective tissue formed around the microchip, preventing migration.

The television broadcast was produced by Canal 21, a station based in São Paulo, and the webcast was produced by Casa das Rosas. The TV-Web simulcast, which included interactive scanning of the implanted microchip via the Internet, was not realized as "coverage." Instead, it was deliberately conceived as an integral part of the work, as a disturbance in the predictable horizon of newscasting. The television broadcast was thought of as a way of creating art directly in the realm of mass media, as a means of intervening in a social realm by realizing the event in millions of living rooms simultaneously. The live *Time Capsule* television broadcast reached approximately seventeen million viewers who routinely tuned in to watch the Canal 21 nightly news. The transmission was divided into three parts. During the first segment viewers were introduced to the main ideas that inform the work and were told what was about to happen. The second segment presented the process of implanting the microchip. In the last segment viewers saw the interactive remote scanning of the microchip via the Internet and the subsequent database registration. Additional delayed television broadcasts by other stations (TV Cultura and TV Manchete) extended the audience to more than fifty million. If the microchip was developed to identify and recover lost animals, in *Time Capsule*, before millions of viewers, the human animal was tagged, registered in a database as both domestic animal and its "owner," identified, and "recovered" through the Web.

Not coincidentally, documentation and identification have been one of the main thrusts of technological development, particularly in the area of imaging, from the first photograph to ubiquitous video surveillance. Throughout the nineteenth and twentieth centuries photography and its adjacent imaging tools functioned as a social time capsule, enabling the collective preservation of memory of our social bodies. This process has led to a global inflation of the image and the erasure by digital technologies of the sacred power of photography as *truth*. The representational power of the image is no longer the key agent in the preservation of social or personal memory and identity. We are able to change the configuration of our skin through plastic surgery as easily as we can manipulate its representation through digital imaging. We can embody the image of ourselves that we wish to become. With the ability to change flesh and image also comes the possibility of erasure of their memory.

Memory is a chip. As we call the storage units of computers and robots "memory," we anthropomorphize our machines, making them

(a)

(b)

75. Eduardo Kac, *Time Capsule*, biotelematic work realized live on television and on the Internet, 1997. This work approached the problem of wet interfaces and human hosting of digital memory through the implantation of a microchip (a). The work consisted of a microchip implant (b), seven sepia-toned photographs (c), a live televison broadcast (d), a webcast (e), interative telerobotic webscanning of the implant (f), a remote database intervention (g), and additional display elements, including an X-ray of the implant (h). (Photograph by Carlos Fadon.)

(d)

(e)

(f)

(g)

(h)

look a little bit more like us. In the process, we mimic them as well. The body is traditionally seen as the sacred repository of human-only memories, acquired as the result of genetic inheritance or personal experiences. Memory chips are found inside computers and robots and not ordinarily inside the human body yet. In *Time Capsule,* the presence of the chip (with its recorded retrievable data) inside the body forces us to consider the copresence of lived memories and artificial memories within us. External memories become implants in the body, anticipating future instances in which events of this sort might become common practice and inquiring about the legitimacy and ethical implications of such procedures in the digital culture. Live transmissions on television (during a primetime newscast) and on the Web were an integral part of *Time Capsule* and brought the issue closer to home. Scanning of the implant remotely via the Web revealed how the connective tissue of the global digital network renders obsolete the skin as a protective boundary demarcating the limits of the body.

The contemporary mediascape reveals other clear signs of this change. If one's genetic inheritance is also a unique signature, in order to leave an undeniable authentic mark one does not need to sign one's name in blood. A special pen containing ink infused with one's own DNA, which is available to fight counterfeiting, is all that is needed. Even more ordinary is the standard use of a DNA spray to identify merchandise (e.g., Calvin Klein jeans), such as the kind marketed by the English company Securitrac. The DNA spray, which is invisible under normal light, glows under UV light. Its objective is to track counterfeiting and alleged abuse on the part of distributors. Biotelemetry, or the use of tagging and tracking technology to monitor at a distance the position and behavior of animals as small as a butterfly and as large as a polar bear, is also a case in point. The emergence of biometrics, with its conversion of irrepeatable personal traits—such as iris patterns and fingerprint contours—into digital data, is a clear sign that the closer technology gets to the body, the more it tends to permeate it. The successful use of microchips in spinal-injury surgery already opens up an unprecedented area of inquiry, in which bodily functions are stimulated externally and controlled via microchips. Experimental medical research toward the creation of artificial retinas, using microchips in the eye to enable the blind to see, for example, forces us to accept the liberating effects of intrabody microchips. Another example is the tiny transmitter that can be implanted in a mother's womb to monitor the health of an unborn child. At the same time, the unacceptable seizing and patenting of DNA samples from indigenous cultures by biotech companies, and their subsequent sale through the Internet, show that

not even the most personal of all biological traits is immune to greed and to technology's omnipresence.[16]

Standard interfaces that require us to pound a keyboard and sit behind a desk staring at a screen create a physical trauma that amplifies the psychological shock generated by ever-faster cycles of technological invention, development, and obsolescence. In its most obvious manifestation, this physical trauma takes the shape of carpal tunnel syndrome and backaches. In its less evident form, interface standardization has led to an overall containment of the human body, which is then forced to conform to the boxy shape of the computer setup (monitor and CPU). It is almost as if the body has become an extension of the computer, and not the other way around. This, perhaps, only reflects technology's general outlook, since organic life is indeed becoming an extension of the computer, as vectors in microchip technology clearly point to biological sources as the only way to continue the exponential process of miniaturization, beyond the limits of traditional materials.

### Conclusion

We are as intrigued as we are perhaps fascinated and terrified by the notion that we are embodying technology. We are intrigued because of our innate and insatiable curiosity about our own limits; we are fascinated because of the new possibilities of an expanded body contemplating the notion of extended life; and we are terrified because these technologies, originally developed to aid ill or physically impaired persons, are in fact not desirable for a healthy body and therefore renew our fear of confronting our own mortality.

Albeit for distinct reasons, contemporary art partakes of some of the same concerns shared by fields conventionally seen as extraneous to the "fine arts," such as biology, computer science, digital networking, and robotics. On the one hand, art is free to explore the creative potential of these tools and fields of knowledge unconstrained by their own self-imposed limits. On the other, art can offer a critical and philosophical perspective that is beyond their stated goals. As artist Flávio de Carvalho wrote, "routine is an illusion and can be replaced by the discovery of new phenomena."[17]

The wet hosting of digital memory—as exemplified by *Time Capsule*—points to a traumatic but perhaps freer form of embodiment of alternative interfaces. The subdermal presence of a microchip reveals the drama of this conflict, as we try to develop social models that make explicit undesirable implications of this impulse and that, at the same

time, will allow us to reconcile aspects of our experience generally regarded as antagonistic, such as freedom of movement, data storage and processing, biological interfaces, and networking environments. As art participates in the wider debate and circulation of ideas we witness in the culture at large, it can help us develop new philosophical and political models and influence the new kinds of synergies emerging at the frontier where the organic and the digital meet.

### Notes

1. The multieyed fruit flies (see Halder, Callaerts, and Gehring) and the headless frogs (see Christen and Slack) represent the isolation and control of specific genes that play a role in organ formation. The quail-like chicks are meant to demonstrate the ability to isolate and transplant certain behavioral traits (see Balaban). The mouse (see Paige et al.) shows the technical feasibility of growing organs for surgical cosmetic repair (the ear does not work for hearing). See G. Halder, P. Callaerts, and W. J. Gehring, "Induction of Ectopic Eyes by Targeted Expression of the Eyeless Gene in Drosophila," *Science* 267 (Mar. 24, 1995), 1788; Bea Christen and Jonathan M. W. Slack, "FGF-8 Is Associated with Anteroposterior Patterning Limb Regeneration in Xenopus," *Developmental Biology* 192 (1997): 455; Evan Balaban, "Changes in Multiple Brain Regions Underlie Species Differences in a Complex, Congenital Behavior," *Proceedings of the National Academy of Sciences of the United States of America* 94 (1997): 2001; Keith T. Paige et al., "Tissue Engineered Growth of New Cartilage in the Shape of a Human Ear Using Synthetic Polymers Seeded with Chondrocytes," in *Materials Research Society Symposium Proceedings*, vol. 252, *Tissue-Inducing Biomaterials*, ed. L. G. Cima and E. S. Ron (Pittsburgh: Materials Research Society, 1992), 323–30.

2. Y. Murooka and T. Imanaka, eds., *Recombinant Microbes for Industrial and Agricultural Applications* (New York, Basel, and Hong Kong: Marcel Dekker, 1994). See also Michael L. Simpson et al. "Bioluminescent-Bioreporter Integrated Circuits Form Novel Whole-Cell Biosensors," *Trends in Biotechnology* 16, no. 8 (1998): 332.

3. K. H. S. Campbell et al., "Sheep Cloned by Nuclear Transfer from a Cultured Cell Line," *Nature* 380 (1996): 64–66; T. Wakayama et al., "Full-Term Development of Mice from Enucleated Oocytes Injected with Cumulus Cell Nuclei," *Nature* 394 (1998): 369–74, Letters to Nature; Yoko Kato et al., "Eight Calves Cloned from Somatic Cells of a Single Adult," *Science* 282 (Dec. 11, 1998): 2095–98.

4. T. A. Sebeok and J. Umiker-Sebeok, eds., *Biosemiotics: The Semiotic Web* (Berlin: Mouton de Gruyter, 1991).

5. Charles Sanders Peirce and James Hoopes, eds., *Peirce on Signs: Writings on Semiotics* (Chapel Hill: University of North Carolina Press, 1991).

6. Thomas A. Sebeok, "Communication in Animals and Men," *Language* 39 (1963): 448–66; Thomas A. Sebeok, *Perspectives in Zoosemiotics* (The Hague: Mouton, 1972).

7. Alexandra H. M. Nagel, "Are Plants Conscious?" *Journal of Consciousness Studies* 4, no. 3 (1997): 215–30.

8. Martin Krampen suggests that plants are capable of interpreting signs although they have no nervous system. See Martin Krampen, "Phytosemiotics," *Semiotica* 36, nos. 3–4 (1981): 187–209.

9. Keith Holz, "Eduardo Kac's Dialogues," *Leonardo Electronic Almanac* 2, no. 12 (1994). See also Joyce Probus, "Eduardo Kac: Dialogues," in *Dialogue: Arts in the Midwest,* Jan.–Feb. 1995, 14–16; Margot Lovejoy, *Postmodern Currents: Art and Artists in the Age of Electronic Media* (Englewood Cliffs, N.J.: Prentice Hall, 1997), 229.

10. Peter Tomaz Dobrila and Aleksandra Kostic, eds., *Eduardo Kac: Teleporting an Unknown State* (Maribor, Slovenia: KIBLA, 1998).

11. Eduardo Kac, "A-positive," *ISEA '97 Program Guide* (Chicago: The School of The Art Institute of Chicago, 1997), 62; Mathew Mirapaul, "An Electronic Artist and His Body of Work," *New York Times on the Web,* Oct. 2, 1997; Giselle Beiguelman, "Artista discute o pós-humano," *Folha de São Paulo,* Oct. 10, 1997, 13; Simone Osthoff, "From Stable Object to Participating Subject: Content, Meaning, and Social Context at ISEA 97," *New Art Examiner* 25, no. 5 (1998): 18–19, 23.

12. Leonard M. Adleman, "Molecular Computation of Solutions to Combinatorial Problems," *Science* 266 (Nov. 11, 1994): 1021–24; Richard Lipton, "DNA Solution of Hard Computational Problems," *Science* 268 (Apr. 28, 1995): 542–45. A simplified account of the development of the DNA computer can be found in Leonard M. Adleman, "Computing with DNA," *Scientific American* (Aug. 1998): 54–61.

13. With the concept of "biological network" I wish to suggest the possibility of data exchange or networking through biological media.

14. The term *master/slave* was coined by Ray C. Goertz at the Atomic Energy Commission's Argonne National Laboratory in the late 1940s. See Edwin G. Johnsen and William R. Corliss, "Teleoperators and Human Augmentation," in *The Cyborg Handbook,* ed. Chris Hables Gray (New York and London: Routledge, 1995), 87. The concept of "slavery" in robotic science is particularly awkward in light of the fact that, as startling as this may seem, in the 1990s we still found real human slavery sanctioned or ignored by local governments. The *New York Times* reported that Mauritania, for example, had ninety thousand slaves. See Elionor Burkett, "God Created Me to Be a Slave," *New York Times Magazine,* Oct. 12, 1997, 56–60. The Italian magazine *Panorama* reported that there is active slave traffic on the Togo-Benin border. See Giuseppe Fumagalli, "Le nuove rotte degli schiavi," *Panorama* 37 (Sept. 9, 1999): 95. Sydney Possuelo, the internationally respected Brazilian government's leading authority on isolated Indians, told a *New York Times* reporter, "There are still women with the names of the rubber plantations that enslaved them tattooed on their arms." See Diana Jean Schemo, "The Last Tribal Battle," *New York Times Magazine,* Oct. 31, 1999, 74. See also Samuel Cotton, *Silent Terror: A Journey into Contemporary African Slavery* (New York: Harlem River Press, 1998); Kevin Bales, *Disposable People: New Slavery in the Global Economy* (Berkeley: University of California Press, 1999).

15. James Gips, "Towards the Ethical Robot" (243–52) and A. F. Umar Khan, "The Ethics of Autonomous Learning Systems" (253–65), both in *Android Epistemology,* ed. Kenneth M. Ford et al. (Menlo Park: AAAI Press; Cambridge: MIT Press, 1995).

16. It is imperative to make sure that the indigenous peoples donating samples comprehend what is at stake, authorize their use, and ultimately profit from the outcome of the research. For a discussion of DNA patenting and the rights of indigenous peoples, see Donna J. Haraway. *Modest-Witness, Second-Millennium: Femaleman Meets Oncomouse: Feminism and Technoscience* (New York: Routledge, 1997), 250–53.

17. Flávio de Carvalho, *Experiência N. 2* (São Paulo: Irmãos Ferraz, 1931), 115.

## 12. Transgenic Art

New technologies culturally mutate our perception of the human body from a naturally self-regulated system to an artificially controlled and electronically transformed object. The digital manipulation of the appearance of the body (and not of the body itself) clearly expresses the plasticity of the new identity of the physical body. We observe this phenomenon regularly through media representations of idealized or imaginary bodies, virtual reality incarnations, and network projections of actual bodies (including avatars). Parallel developments in medical technologies, such as plastic surgery and neuroprostheses, have ultimately allowed us to expand this immaterial plasticity to actual bodies. The skin is no longer the immutable barrier that contains and defines the body in space. Instead, it becomes the site of continuous transmutation. While we try to cope with the staggering consequences of this ongoing process, it is equally urgent to address the impact of biotechnologies that operate beneath the skin (or inside skinless bodies, such as bacteria) and therefore out of sight. More than making visible the invisible, art needs to raise our awareness of what firmly remains beyond our visual reach but, nonetheless, affects us directly. Two of the most prominent technologies operating beyond vision are digital implants and genetic engineering. Both will have profound consequences in art as well as in our social, medical, political, and economic life in the future.

Transgenic art, I propose, is a new art form based on the use of genetic engineering techniques to create unique living beings. This can be accomplished by transferring synthetic genes to an organism, by mutating an organism's own genes, or by transferring natural genetic material from one species into another. Molecular genetics allows the artist to engineer the plant and animal genomes and create new life forms.[1] The nature of this new art is defined not only by the birth and growth of a new plant or animal but above all by the nature of the re-

Originally appeared in *Leonardo Electronic Almanac* 6, no. 11 (1998).

lationship among artist, public, and transgenic organism. Organisms created in the context of transgenic art can be taken home by the public to be grown in the backyard or raised as human companions. With at least one endangered species becoming extinct every day,[2] I suggest that artists can contribute to increase global biodiversity by inventing new life forms. There is no transgenic art without a firm commitment to and responsibility for the new life form thus created. Ethical concerns are paramount in any artwork, and they become more crucial than ever in the context of bio art. From the perspective of interspecies communication, transgenic art calls for a dialogical relationship among artist, creature, and those who come in contact with it.

Among the most common domesticated mammals, the dog is a quintessentially dialogical animal; it is not self-centered, it is empathic, and it is often prone to extroverted social interaction.[3] Hence my work in progress: *GFP K-9* (fig. 76). GFP stands for green fluorescent protein, which is isolated from Pacific Northwest jellyfish (*Aequorea victoria*) and emits bright green light when exposed to UV or blue light.[4] Wild-type *Aequorea* GFP absorbs light maximally at 395 nm, and the fluorescence emission spectrum peaks at 510 nm.[5] The protein itself is 238 amino acids in length. The use of the green fluorescent protein in a dog is harmless, since GFP is species independent and requires no additional proteins or substrates for green light emission.[6] GFP has been successfully expressed in several host organisms and cells such as *E. coli,* yeast, and mammalian, insect, fish, and plant cells.[7] A GFP variant, GFPuv, is eighteen times brighter than regular GFP and can be easily detected by the naked eye when excited with standard, long-wave UV light. The dog born in the context of the *GFP K-9* project will be a welcome member of my family. Its creation may be years or decades away,[8] because it faces several obstacles, among them the developing of canine in vitro fertilization (IVF). To facilitate visualization, hairless dogs are the best candidates for the *GFP K-9* project, particularly the albino hairless dog. This animal, considered "faulty" by professional breeders due to its lack of pigmentation, in the context of the *GFP K-9* project is considered the "standard." The project subverts the logic of purebreeding by crossing species lines and by electing a rejected animal as the standard-bearer. The hairless is an ancient breed. Evidence of its existence has been found in the ruins that remain from the pre-Columbian societies of Mexico and the countries of Central and South America. Breeds of hairless dogs include the Mexican xoloitzcuintli, the Peruvian Inca orchid, the American hairless terrier, and the Argentinian pila. The Mexican xoloitzcuintli (or xolo) is a likely *GFP K-9* breed (fig. 77). "Xoloitzcuintli" (pronounced "Sho-low-eets-queen-tlee") means "rare dog" in Nahuatl, the language of the Aztecs.

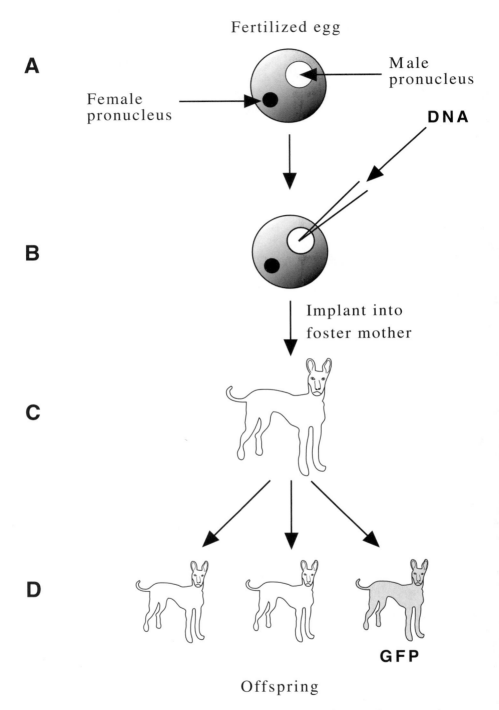

76. Eduardo Kac, *GFP K-9* (diagram), transgenic dog, 1998–in progress. The diagram shows the steps that will lead to the creation of *GFP K-9*. Fertilized eggs are removed from a female (*a*), and the DNA carrying the GFP gene is injected into the male pronucleus (*b*). The eggs are then implanted into a carrier (*c*), and some of the pups express the GFP gene (*d*).

77. Eduardo Kac, *GFP K-9*, transgenic dog, 1998–in progress. The pre-Columbian hairless dog known as the Mexican xoloitzcuintli (or xolo), seen above, is the *GFP K-9* breed of choice. "Xoloitzcuintli" (pronounced "Sho-low-eets-queen-tlee") means "rare dog" in Nahuatl, the language of the Aztecs. (Photograph by Kaarina Naaralainen.)

The sequencing of the dog genome will also contribute to the process of creating *GFP K-9*. Collaborative research is under way to map the canine genome, the results of which will eventually enable precision work at the level of canine morphology and behavior. Independent of the subtle phenotypic alteration, that is, the delicate coat-color change, *GFP K-9* will eat, sleep, mate, play, and interact with other dogs and humans normally. It will also be the founder of a new transgenic lineage.

While at first the *GFP K-9* project may seem completely unprecedented, there is archaeological evidence that the direct influence of humans on dog evolution goes back at least fifteen thousand years.[9] Genetic evidence pushes the date back to approximately sixty thousand years and confirms that the dog was developed after human breeding of wolves.[10] The dog had a prominent role in ancient societies (fig. 78). The very existence of the domesticated dog, with approximately 150 recognized breeds, is due to very early human-induced selective breed-

78. Taking the dog for a walk in ancient Egypt. This painted detail appears on an outer face of the wooden coffin of Khuw. The deceased leads his dog on a leash. From the tomb of Khuw at Asyut, Egypt, Twelfth Dynasty (1991–1783 B.C.). (Courtesy of Patrick Francis Houlihan.)

ing of adult wolves that retained immature characteristics (a process known as "neoteny"). In other words, there are no poodles, chihuahuas, and bulldogs in the wild. The similarities of physiognomy and behavior between the immature wolf and the adult dog are remarkable. Barking, for example, is typical of adult dogs, but not adult wolves. The dog's head is smaller than the wolf's and more closely resembles that of an immature wolf. There are many other examples, including the very significant fact that dogs are also interfertile with wolves. After centuries of natural selective breeding, a turning point in human breeding of dogs took place in 1859, when the first exhibition of dogs prompted appreciation for their unique visual appearance. The search for visual consistency and for new breeds led to the concept of the purebred and to the formation of different groups of founding dogs. The practice is responsible for many of the dogs we see in homes everywhere (fig. 79). The results of indirect genetic control of dogs by breeders are proudly expressed on the pages of the canine trade press. A quick look at the marketplace reveals ads for bulldogs "engineered for protection," mastiffs with a "careful genetic breeding program," dogs

79. The dog is the species with the greatest variety of all. Due to their common ancestry in the wolf, all dog breeds share certain characteristics. Evolving from wolves that adapted to human settlements and were no longer in need to hunt big prey, dogs evolved with skulls and teeth that were smaller, relative to their size, than a wolf's. Humans chose and reared canids that had a predisposition to assist in guarding and hunting, thus giving rise to the first breeds. The environment played a role, since only dogs that survived environmental conditions could breed. Eventually hybrids were created through crossbreeding, creating greater variation in behavior and form. Since the middle of the nineteenth century, when the first kennel clubs appeared, new breeds were created in a new wave of human-induced selection. Since the beginning of the twentieth century, visual form has been the main factor in the creation of new breeds.

with an "exclusive bloodline," and Dobermans with a "unique genetic blueprint." Breeders aren't writing the genetic traits of their dogs yet, but they are certainly reading and recording them. The American Kennel Club, for example, offers a DNA certification program to settle questions of purebred identification and parentage.

If the creation of dogs has long historical roots, more recent but equally integrated into our daily experience is our use of hybrid organisms. A case in point is the well-known work of botanist and scientist Luther Burbank (1849–1926), who invented many new fruits, plants, and flowers.[11] In 1871, for example, he developed the Burbank potato (also known as the Idaho potato). Because of its low moisture and high starch content, it has excellent baking qualities and is perfect for French fries. Since Burbank, artificial selective breeding of plants and animals has been a standard procedure widely used by farmers, scientists, and amateurs alike. Selective breeding is a long-term technique based on the indirect manipulation of the genetic material of two or more organisms and is responsible for many of the crops we eat and the livestock we raise. Domestic ornamental plants and pets thus invented are already so common that one rarely realizes that a loved animal or a flower offered as a sign of affection is the practical result of concerted scientific effort by humans. Hybrid teas, for example, are the typical roses found at the florist shop—the classic image of the rose. The first hybrid tea was La France, raised by Jean-Baptiste Guillot in

1867. A cherished companion such as the Catalina macaw, with its fiery orange breast and green and blue wings, does not exist in nature. Aviculturists mate blue and gold macaws with scarlet macaws to create this beautiful hybrid animal.[12]

This is not at all surprising, considering that cross-species hybrid creatures have been part of our imaginary for millennia. In Greek mythology, for example, the Chimera (fig. 80) was a fire-breathing creature represented as a composite of a lion, goat, and serpent. Sculptures and paintings of chimeras, from ancient Greece to the Middle Ages and on to modern avant-garde movements, inhabit museums worldwide. Chimeras, however, are no longer imaginary; they are being routinely created in laboratories and are slowly becoming part of the larger genescape. Here I employ the word *chimera* in its cultural, not scientific, sense. Examples include pigs that produce human proteins,[13] plants that produce plastic,[14] and goats with spider genes designed to produce a strong and biodegradable fabric.[15] While in ordinary discourse the word *chimera* refers to any imaginary life form made of disparate parts, in biology *chimera* is a technical term that means an actual organism with cells from two or more distinct genomes. A prime example of a scientific chimera is the "geep," an animal with cells from goat and sheep created by Steen Willadsen and his team.[16] A profound cultural transformation takes place when chimeras leap from legend to life, from representation to reality.

Likewise, there is a clear distinction between breeding and genetic engineering. Breeders manipulate indirectly the natural processes of gene selection and mutation that occur in the wild. Breeders are unable, therefore, to turn genes on or off with precision or to create hybrids with genomic material so distinct as that of a dog and a jellyfish. In this sense, a distinctive trait of transgenic art is that the genetic material is manipulated directly: the foreign DNA is precisely integrated into the host genome. In addition to genetic transfer of existing genes from one species to another, we can also speak of "artist's genes," that is, chimeric genes or new genetic information completely created by the artist through the complementary bases A (adenine) and T (thymine) or C (cytosine) and G (guanine). This means that artists can not only combine genes from different species but write a DNA sequence on their word processors, email it to a commercial synthesis facility, and in less than a week receive a test tube with millions of molecules of DNA with the expected sequence.

Every living organism has genes that can be manipulated, and the recombinant DNA can be passed on to the next generations. The artist literally becomes a genetic programmer who can create life forms by

80. The classic Chimera of Arezzo, the best-known image of the Greek myth. The Chimera of Arezzo is a bronze statue of Etruscan origin (ca. fifth century B.C.), approximately eighty centimeters (thirty-two inches) in height. It was found near Arezzo, in Italy, in 1553. (Courtesy of Archeological Museum, Firenze.)

writing or altering a given sequence. With the creation and procreation of bioluminescent mammals and other creatures in the future,[17] dialogical interspecies communication will change profoundly what we understand as interactive art. These animals are to be loved and nurtured just like any other animal.

The result of transgenic art processes must be healthy creatures capable of development as regular as that of any other creatures from related species.[18] Ethical and responsible interspecies creation will yield the generation of beautiful chimeras and fantastic new living systems, such as plantimals (plants with animal genetic material, or animals with plant genetic material) and animans (animals with human genetic material, or humans with animal genetic material).

As genetic engineering continues to be developed in the safe harbor of scientific rationalism, nourished by global capital, it unfor-

tunately remains partially sheltered from larger social issues, debates on ethics, and local historical contexts. The patenting of new animals created in the lab[19] and of genes of foreign peoples[20] is unacceptable—a situation often aggravated, in the human case, by the lack of consent, equal benefit, or even understanding of the processes of appropriation, patent, and profit on the part of the donor. Since 1980 the U.S. Patent and Trademark Office (PTO) has granted several transgenic animal patents, including patents for transgenic mice and rabbits. The debate over animal patents has broadened to encompass patents on genetically engineered human cell lines and synthetic constructs (e.g., "plasmids") incorporating human genes. The use of genetics in art offers a reflection on these developments from a social and ethical point of view. It foregrounds related relevant issues such as the domestic and social integration of transgenic animals and the arbitrary delineation of the concept of "normalcy" through genetic testing, enhancement, and therapy. It also creates a critical context in which to examine and undermine reductionism and eugenics.

As we try to negotiate social disputes, it is clear that genetic engineering will be an integral part of our existence in the future. It will be possible, for example, to harness the glow of the jellyfish protein for optical data storage devices.[21] Transgenic crops will be a predominant part of the landscape, transgenic organisms will populate the farm, and transgenic animals will become part of our expanded family. For better or worse, vegetables and animals we eat will never be the same. Genetically altered soybeans, potatoes, corn, squash, and cotton have been widely planted and consumed since 1995.[22] Although ecological risks are yet to be fully assessed, the development of "plantibodies," that is, human genes transplanted into corn, soy, tobacco, and other plants to produce acres of pharmaceutical-quality antibodies, promises cheap and abundant much-needed proteins.[23] While in many cases research and marketing strategies place profit above health concerns (the risks of commercialization of unlabeled and potentially sickening transgenic food cannot be ignored),[24] in others biotechnology seems to offer real promises of healing in areas difficult to treat effectively with traditional methods. In the future foreign genetic material will be present in the human body as commonly as mechanical and electronic implants.[25] As the concept of species based on breeding barriers is undone through genetic engineering,[26] the very notion of what it means to be human is at stake. However, this does not constitute an ontological crisis. To be human will mean that the human genome is not a limitation, but our starting point.

## Notes

1. George Gessert, an artist who works with plant hybridization, identified Edward Steichen, well-known for his photographic work, as the first artist to propose and produce genetic art. See George Gessert, "Notes on Genetic Art," *Leonardo* 26, no. 3 (1993): 205. Indeed, in 1949 Steichen wrote, "The science of heredity when applied to plant breeding, which has as its ultimate purpose the aesthetic appeal of beauty, is a creative act." Quoted in Ronald J. Gedrim, "Edward Steichen's 1936 Exhibition of Delphinium Blooms," *History of Photography* 17, no. 4 (1993): 352–63.

2. According to the World Wildlife Federation the top ten most endangered species are: (1) black rhino, (2) giant panda, (3) tiger, (4) beluga sturgeon, (5) goldenseal, (6) alligator snapping turtle, (7) hawksbill turtle, (8) big leaf mahogany, (9) green-cheeked parrot, and (10) mako shark. For additional information on the threat to biodiversity, see C. Hilton-Taylor, comp., *2000 IUCN Red List of Threatened Species* (Gland, Switzerland, and Cambridge: IUCN, 2000); BirdLife International, *Threatened Birds of the World* (Barcelona: Lynx Editions, 2000).

3. For a specific discussion of human-canine interaction, see James Serpell, ed., *The Domestic Dog: Its Evolution, Behaviour, and Interactions with People* (Cambridge and New York: Cambridge University Press, 1996); Lloyd M. Wendt, *Dogs: A Historical Journey: The Human/Dog Connection through the Centuries* (New York: Howell Book House, 1996); Reinhold Bergler, *Man and Dog: The Psychology of a Relationship* (New York: Howell, 1998). See also Kristin Von Kreisler, *The Compassion of Animals* (Rocklin, Calif.: Prima Publishing, 1997). This book is a compilation of informal accounts of the sympathy, kindness, and loyalty of dogs and other animals toward species other than their own.

4. M. Chalfie et al., "Green Fluorescent Protein as a Marker for Gene Expression," *Science* 263 (Feb. 11, 1994): 802–5; S. Inouye and F. I. Tsuji, "Aequorea Green Fluorescent Protein: Expression of the Gene and Fluorescence Characteristics of the Recombinant Protein," *FEBS Letters* 341 (1994): 277–80.

5. W. W. Ward et al., "Spectrophotometric Identity of the Energy-Transfer Chromophores in *Renilla* and *Aequorea* Green Fluorescent Protein," *Photochemistry and Photobiology* 31 (1980): 611–15.

6. Although not common, GFP has been expressed in dog cells. See Sergio C. Oliveira et al., "Biolistic-Mediated Gene Transfer Using the Bovine Herpesvirus-1 Glycoprotein D Is an Effective Delivery System to Induce Neutralizing Antibodies in Its Natural Host," *Journal of Immunological Methods* 245, no. 1 (2000): 109.

7. Randall P. Niedz, Michael R. Sussman, and John S. Satterlee, "Green Fluorescent Protein: An In Vivo Reporter of Plant Gene Expression," *Plant Cell Reports* 14 (1995): 403–6; A. Amsterdam, S. Lin, and N. Hopkins, "The *Aequorea victoria* Green Fluorescent Protein Can Be Used as a Reporter in Live Zebrafish Embryos," *Developmental Biology* 171 (1995): 123–29; J. Pines, "GFP in Mammalian Cells," *Trends in Genetics* 11 (1995): 326–27; C. Holden, "Jellyfish Light Up Mice," *Science* 277 (July 4, 1997): 41; Masahito Ikawa et al., "'Green Mice' and Their Potential Usage in Biological Research," *FEBS Letters* 430 (1998): 83; B. P. Cormack et al., "Yeast-Enhanced Green Fluorescent Protein (yEGFP): A Reporter of Gene Expression in *Candida albicans*," *Microbiology* 143 (1997): 303–11; E. Yeh, K. Gustafson, and G. L. Boulianne, "Green Fluorescent Protein as a Vital Marker and Reporter of Gene Expression in Drosophila," *Proceedings of the National Academy of Sciences of the United States of America* 92 (1995): 7036–40; H. J. Cha et al., "Expression of Green Fluorescent Protein in Insect Larvae and Its Application for

Heterologous Protein Production," *Biotechnology and Bioengineering* 56, no. 3 (1997): 239–47. The larva referred to in the latter is the cabbage looper.

8. Two key obstacles to the creation of *GFP K-9* are gene targeting technology and in vitro fertilization for dogs. These obstacles are on the verge of being overcome. In Sept. 1999, PPL Therapeutics announced the creation of the first higher transgenic mammal by targeted gene manipulation. See Sophia Fox, "European Roundup," *Genetic Engineering News*, Sept. 1, 1999, 54. The dog genome project will further contribute to this work. See S. Thorpe-Vargas, D. Caroline Coile, and J. Cargill, "Variety Spices Up the Canine Gene Pool," *Dog World* 83, no. 5 (1998): 27. At last, in vitro fertilization for dogs will be resolved by the "Missyplicity Project." While there is a significant difference between a cloned dog and a transgenic dog, it is worth mentioning that the "Missyplicity Project" aims at producing the first cloned dog, from a mutt pet called Missy (mixed border collie and husky). In Aug. 1998 a wealthy couple (Mr. and Mrs. John Sperling) donated $2.3 million to Texas A&M University to start the project. The project team is comprised of scientists Mark Westhusin, Duane Kraemer, and Robert Burghardt. For information on the "Missyplicity Project," see <http://www.missyplicity.com>. For a general reference on pre-Columbian hairless dogs, see Amy Fernandez and Kelly Rhae, *Hairless Dogs—The Naked Truth: The Chinese Crested, Xoloitzcuintli and Peruvian Inca Orchid* (Woodinville, Wash.: N.p., 1999); Dee Gannon, *The Rare Breed Handbook* (Hawthorne, N.J.: Golden Boy Press, 1990); Leon F. Whitney, *How to Breed Dogs* (New York: Howell, 1984).

9. Mary Elizabeth Thurston, *The Lost History of the Canine Race: Our 15,000-Year Love Affair with Dogs* (Kansas City: Andrews and McMeel, 1996). See also Frederick Everard Zeuner, *A History of Domesticated Animals* (New York: Harper and Row, 1963); Richard Fiennes and Alice Fiennes, *The Natural History of Dogs* (New York: Bonanza, 1968); Maxwell Riddle, *Dogs through History* (Fairfax, Va.: Denlinger, 1987); Darcy F. Morey, "The Early Evolution of the Domestic Dog," *American Scientist* (July–Aug. 1994): 336–47; Stanley J. Olsen, *Origins of the Domestic Dog* (Tucson: University of Arizona Press, 1985); Jennifer W. Sheldon, *Wild Dogs: The Natural History of the Nondomestic Canidae* (San Diego: Academic Press, 1992); Rosalind Janssen and Jack Janssen, *Egyptian Household Animals* (Buckinghamshire, U.K.: Shire, 1989); D. J. Brewer, *Anubis to Cerberos: Dogs of the Ancient World* (Warminster, U.K.: Aris and Philips, 2002).

10. See Carles Vilà et al., "Multiple and Ancient Origins of the Domestic Dog," *Science* 276 (June 13, 1997): 1687–89. See also J. P. Scott et al., "Man and His Dog," *Science* 278 (Oct. 10, 1997): 205a–9a. In Sept. 1993, wolves and dogs were recognized as the same species in the United States. The American Society of Mammalogists' Mammal Species of the World, adhering to the Code of the International Commission on Zoological Nomenclature, declared that *Canis lupus* is the official species of both dogs and wolves.

11. Luther Burbank, *The Harvest of the Years* (Boston and New York: Houghton Mifflin, 1927); Peter Dreyer, *A Gardener Touched with Genius: The Life of Luther Burbank* (Santa Rosa, Calif.: L. Burbank Home and Gardens, 1993).

12. The common roses of the twentieth century, such as hybrid teas, floribundas and grandifloras, were created by crossing European roses and the Chinas, teas, and Mediterranean types, and many others, during the 1700s and 1800s. See Brent C. Dickerson, *The Old Rose Advisor* (Portland: Timber Press, 1992); J. H. Bennett, *Experiments in Plant Hybridisation* (London: Oliver and Boyd, 1965); Peter Beales, *Roses* (New York: Collins-Harvill [Harper Collins], 1991). On a trip to Sentosa Island, in Singapore, in 1998, I had the opportunity to interact playfully with a Catalina macaw, perched first on my shoulder and then on my forearm. I was able to appreciate its distinct coloration and to observe and appreciate its interaction

with other macaws and humans. A description of the Catalina macaw and other hybrids can be found in Werner Lantermann, *Encyclopedia of Macaws* (Neptune City, N.J.: T.F.H., 1995), 173. See also A. E. Decoteau, *Handbook of Macaws* (Neptune City, N.J.: T.F.H., 1982). Other examples of beautiful birds invented by humans that don't exist anywhere in the wild are the harlequin macaw (a hybrid derived from breeding a blue and gold and a green winged) and the Parisian frilled canary, which has oddly frilled feathers. Examples of new mammals created by humans through crossbreeding include the zorse (zebra and horse), the liger (lion and tiger), zonkey (zebra and donkey), and cama (camel and llama). Crossbreeding also occurs without direct human intervention: in 1985 Hawaii's Sea Life Park reported the birth on their premises of the first "wholfin," a fertile baby from the spontaneous mating of a male false killer whale (*Pseudorcacrassidens*) and a female bottlenose dolphin (*Tursiops truncatus*).

13. E. Cozzi and D. J. G. White, "The Generation of Transgenic Pigs as Potential Organ Donors for Humans," *Nature* 1 (1995): 964–66.

14. Samuel K. Moore, "Natural Synthetics: Genetically Engineered Plants Produce Cotton/Polyester Blends and Nonallergenic Rubber," *Scientific American* (Feb. 1997): 36–37.

15. Phil Cohen, "Spinning Steel: Goats and Spiders Are Working Together to Create a Novel Material," *New Scientist* (Oct. 10, 1998): 11. Another combination of insect and mammal is a mouse with fly genes. In this case, the research has the goal of demonstrating that the biochemical activity utilized in the mouse to mediate brain development has been retained by certain kinds of proteins across the phyla. See Mark C. Hanks et al., "Drosophila Engrailed can Substitute for Mouse Engrailed1 Function in Mid-hindbrain, but Not Limb Development," *Development* 125, no. 22 (1998): 4521–30.

16. C. B. Fehilly, S. M. Willadsen, and E. M. Tucker, "Interspecific Chimaerism between Sheep and Goat," *Nature* 307 (1984): 634–36.

17. G. Brem and M. Müller, "Large Transgenic Mammals," in *Animals with Novel Genes*, ed. N. Maclean (New York: Cambridge University Press, 1994), 179–244; M. Ikawa et al., "Green Fluorescent Protein as a Marker in Transgenic Mice," *Development, Growth, and Differentiation* 37 (1995): 455–59; Elizabeth Pennisi, "Transgenic Lambs from Cloning Lab," *Science* 277 (Aug. 1, 1997): 631.

18. Anthony Dyson and John Harris, eds., *Ethics and Biotechnology* (New York: Routledge, 1994); L. F. M. van Zutphen and M. van Der Meer, eds., *Welfare Aspects of Transgenic Animals* (Berlin and New York: Springer Verlag, 1995).

19. Keith Schneider, "New Animal Forms Will Be Patented," *New York Times*, Apr. 17, 1987; Eliot Marshall, "The Mouse That Prompted a Roar," *Science* 277 (July 4, 1997): 24–25.

20. Adam L. Penenber, "Gene Piracy," *21C-Scanning the Future*, no. 2 (1996): 44–50.

21. Robert M. Dickson et al., "On/Off Blinking and Switching Behaviour of Single Molecules of Green Fluorescent Protein," *Nature* 388 (1997): 355–58.

22. Kathryn S. Brown, "With New Technology, Researchers Engineer a Plant for Every Purpose," *The Scientist* 9 (Oct. 2, 1995): 14–15; Jane Rissler and Margaret Mellon, *The Ecological Risks of Engineered Crops* (Cambridge: MIT Press, 1996).

23. W. Wayt Gibbs, "Plantibodies: Human Antibodies Produced by Field Crops Enter Clinical Trials," *Scientific American* (Nov. 1997): 44.

24. Brian Tokar, "Monsanto: A Checkered History," in "The Monsanto Files," special issue, *The Ecologist* 28 (Sept.–Oct. 1998): 254–61; Andrew Kimbrell, "Why Biotechnology and High-Tech Agriculture Cannot Feed the World," in "The Monsanto Files," special issue, *The Ecologist* 28 (Sept.–Oct. 1998): 294–98.

25. Therapies used by reproductive medicine already result in healthy babies with new genetic material not derived from the parents. One such technique, developed at Saint Barnabas Medical Center in Livingston, New Jersey, takes cytoplasm from a donor egg—complete with mitochondria—and injects it into an egg slated for fertilization. A child born from this process may inherit mitochondrial DNA from both eggs. This genetic modification, which has enabled several infertile women to give birth, is inheritable. See Jacques Cohen et al., "Birth of Infant after Transfer of Anucleate Donor Oocyte Cytoplasm into Recipient Eggs," *Lancet* 350 (July 19, 1997): 186–87. See also Carol A. Brenner et al., "Mitochondrial DNA Heteroplasmy after Human Ooplasmic Transplantation," *Fertility and Sterility* 74, no. 3 (2000): 573. In an article for the *New Scientist* (Oct. 23, 1999) entitled "We Have the Power," Andy Coghlan reported that a Canadian company, Chromos Molecular Systems of Burnaby, British Columbia, had presented preliminary results of experiments with mice given an artificial chromosome. He wrote: "By taking cell samples and exposing them to fluorescent dyes that bind to different parts of the chromosome, Chromos's scientists were able to discover which animals had accepted the chromosome. When the mice carrying the extra chromosome were crossed with normal mice, it was inherited in exactly the same way as the animals' natural chromosomes." This is an indication that human germline gene therapy is becoming a practical possibility. It shows that one day it might be possible, for medical reasons, to add synthetic genes to human embryos that otherwise would develop with serious or fatal congenital problems.

26. Some exemplary cases are the production of rat sperm in the testes of a mouse (which clearly suggests that human sperm could also be produced in the testicles of a rodent), the initial division of a human cell in the egg of a cow, and the alleged creation of an embryonic clone of an adult woman in South Korea. See David E. Clouthier, "Rat Spermatogenesis in Mouse Testis," *Nature* 381 (1996): 418–21; J. M. Robl et al., "Quiescence in Nuclear Transfer," *Science* 281 (Sept. 11, 1998): 1611; BBC Online, "S. Korean Scientists Claim Human Cloning Success" (Dec. 16, 1998), available at <http://www.news.bbc.co.uk>.

## 13. Genesis

The *Genesis* project started with a reductio ad absurdum of molecular biology, the creation of an impossible "biblical gene." This synthetic gene and its corresponding interactive installation were meant to prompt viewers to confront the dangers of reducing life to single factors, such as genes. The project continued with the visualization of the equally absurd "biblical protein" and with new works that examine the cultural implications of proteins as fetish objects. A critical stance is manifested throughout the *Genesis* project by following scientifically accurate methods in the real production and visualization of a gene and a protein that I have invented and that have absolutely no function or value in biology. Rather than explicating or illustrating scientific principles, the *Genesis* project complicates and obfuscates the extreme simplification of standard molecular biology descriptions of life processes, reinstating social and historical contextualization at the core of the debate. In its genomic and proteomic manifestations, the *Genesis* project continues to reveal new readings and possibilities.

### Phase 1

*Genesis* (1998–99) is a transgenic artwork that explores the intricate relationship among biology, belief systems, information technology, dialogical interaction, ethics, and the Internet. The key element of the work is an "artist's gene," that is, a synthetic gene that I invented and that does not exist in nature (fig. 81). This gene was created by translating a sentence from the biblical book of Genesis[1] into Morse code and converting the Morse code into DNA base pairs according to a conversion principle especially developed for this work. The sentence reads: "Let man have dominion over the fish of the sea, and over the fowl of the air, and over every living thing that moves upon the earth."

Originally appeared in *Ars Electronica '99–Life Science*, ed. Gerfried Stocker and Christine Schopf (Vienna and New York: Springer, 1999).

Let man have dominion over the fish of the sea and over the fowl of the air and over every living thing that moves upon the earth

## Morse to DNA conversion principle

DASH (-) = T     A = WORD SPACE

DOT (.) = C      G = LETTER SPACE

```
CTCCGCGTATTGCTGTCACCCCGCTGCCCTGCATCCGTTTGTTGCCGTCGCCGTTTGTCA
TTTGCCCTGCGCTCATGCCCCGCACCTCGCCGCCCGCCCCATTTCCTCATGCCCCGCACC
CGCGCTACTGTCGTCCATTTGCCCTGCGCTCATGCCCCGCACCTCGTTTGCTTGCTCCAT
TTGCCTCATGCCCCGCACTGCCGCTCACTGTCGTCCATTTGCCCTGCGCTCACGCCCTGC
GCTCGTCTTACTCCGCCGCCCTGCCGTCGTTCATGCCCCGCCGTCGTTCATGCCCCGCTG
TATTGTTTGCCCTGCGCCCACCTGCTTCGTTTGTCATGCCCCGCACGCTGCTCGTGCCCC
```

81. Eduardo Kac, *Genesis,* diagram of the *Genesis* gene, 1999. The *Genesis* gene was created by first converting the biblical sentence to Morse code. The next step was the conversion of the Morse code into DNA: dashes were represented by the letter *T* (thymine); dots were represented by the letter *C* (cytosin); word spaces were replaced by the letter *A* (adenine); letter spaces were replaced by the letter *G* (guanine).

This sentence was chosen for its implications regarding the dubious notion of (divinely sanctioned) humanity's supremacy over nature. Morse code was chosen partly because, as first employed in radiotelegraphy, it represents the dawn of the information age—the genesis of global communications.[2]

I do not own a Bible, so I copied and pasted the sentence from one of the many editions available on the Internet. I also used a Web site to create the Morse translation. I then applied my own code to translate the Morse sequence into the gene. Next, I emailed the gene to a company specializing in DNA synthesis. Two weeks later, I received a FedEx package with a vial containing millions of copies of the gene. In a private Hamletian moment, I could not help but wonder: "To be, or not to be the meaning of life, that is the question." Could I possibly have in this tube the source of all life? As I contemplated the salty-looking powder accumulated at the bottom of the transparent vial, it became clear that the isolated gene is inert matter and that alone it is destitute of the agency often ascribed to it. In other words, by itself the gene cannot do anything because—to reiterate the verbal metaphor—to be meaningful it needs a context. The context of the gene is the body of an organism, and the context of the organism is its environment. In the case of my *Genesis*, the organisms are bacteria (fig. 82), and their environment is at once their dish, the gallery, and the Internet.

The gallery display enables local as well as remote (Web) participants to monitor the evolution of the work (fig. 83). This display consists of a petri dish with the bacteria, a flexible microvideo camera, a UV light box, and a microscope illuminator. This set is connected to a video projector and two networked computers. One computer works as a Web server (streaming live video and audio) and handles remote requests for UV activation. The other computer is responsible for DNA music synthesis. The original music, which employs the *Genesis* gene, was composed by Peter Gena. The local video projection shows a larger-than-life image of the bacterial division and interaction seen through the microvideo camera. Remote participants on the Web interfere with the process by turning the UV light on (fig. 84). The fluorescent protein in the transgenic bacteria responds to the UV light by emitting visible light (cyan and yellow).[3] The energy impact of the UV light on the bacteria is such that it disrupts the *Genesis* DNA sequence, accelerating the mutation rate. The left and right walls contain large-scale texts applied directly on the wall: the sentence extracted from the book of Genesis (right) and the *Genesis* gene (left). The back wall contains the Morse translation.

In the context of the work, the ability to change the sentence is a symbolic gesture: it means that we do not accept its meaning in the

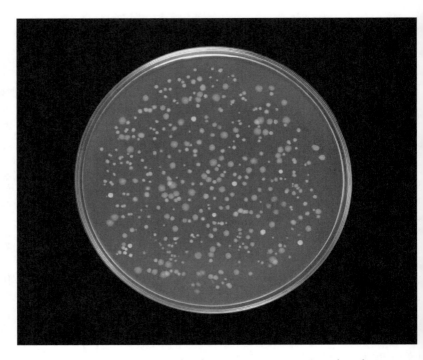

82. Eduardo Kac, *Genesis*, transgenic work on the Internet (detail), 1999. *Genesis* employed two separate kinds of bacteria genetically engineered to glow, emitting either blue or yellow light. The blue bacteria contained the synthetic gene, while the yellow bacteria did not. The mutation rate of the bacteria, as well as their interaction in the petri dish, also contributed to the changes in the biblical sentence.

form we inherited it and that new meanings emerge as we seek to change it. Employing the smallest gesture of the on-line world—the click—participants can modify the genetic makeup of an organism located in a remote gallery. This unique circumstance makes evident, on the one hand, the impending ease with which genetic engineering trickles down into the most ordinary level of experience. On the other, it highlights the paradoxical condition of the nonexpert in the age of biotechnology. To click or not to click is not only an ethical decision but also a symbolic one. If the participant does not click, he allows the Biblical sentence to remain intact, preserving its meaning of dominion. If he clicks, he changes the sentence and its meaning but does not know what new versions might emerge. In either case, the participant faces an ethical dilemma and is implicated in the process.

While it may seem that *Genesis* simply reiterates human dominion over another species, ultimately it reveals that this anthropocentric

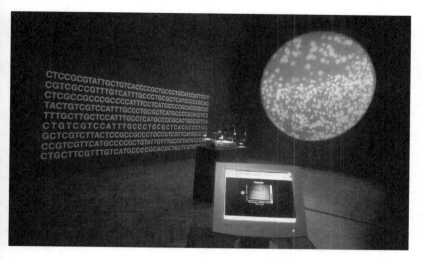

83. Eduardo Kac, *Genesis,* transgenic work on the Internet, 1999. The *Genesis* gene was incorporated into bacteria, which were shown in the gallery. Participants on the Web could turn on an ultraviolet light in the gallery, causing real biological mutations in the bacteria. This changed the biblical sentence in the bacteria. The ability to change the sentence is a symbolic gesture: it means that we do not accept its meaning in the form we inherited it and that new meanings emerge as we seek to change it.

84. Eduardo Kac, *Genesis,* transgenic work on the Internet, 1999. Screen shot of the *Genesis* Web interface. Clicking on the button at the left caused the UV light to turn on in the gallery. The process streamed live, and the illuminated bacteria could be seen in the center window. On the right the participant could control the volume of the streaming *Genesis* music, composed by Peter Gena.

concept has more to do with human perception than with the material relationship that is established in the context of the work. Are we masters of the bacteria that line our stomach, with whom we share our lives in a symbiotic relationship, or are we their minions? Likewise, am I controlling the *Genesis* bacteria, or am I, through an evolutionary process, a vehicle for their will to survive, contributing to the proliferation of bacteria by creating new ones? I call the creation of artwork that produces ethical tension and stimulates reflection and debate "performative ethics." In other words, what is at stake is not the old moral judgment of art but the choreographing of the expressive gesturality of ethics at the service of plastic imagination.

In the nineteenth century the comparison made by Champollion based on the three languages of the Rosetta Stone (Greek, demotic script, hieroglyphs) was the key to understanding the past. Today the triple system of *Genesis* (natural language, genetics, binary logic) is the key to understanding the future. *Genesis* explores the notion that biological processes are now writerly and programmable, as well as capable of storing and processing data in ways not unlike digital computers. Further investigating this notion, at the end of the first showing of *Genesis*, at Ars Electronica '99, the altered biblical sentence was decoded and read back in plain English, offering insights into the process of transgenic interbacterial communication. The mutated sentence read: "LET AAN HAVE DOMINION OVER THE FISH OF THE SEA AND OVER THE FOWL OF THE AIR AND OVER EVERY LIVING THING THAT IOVES UA EON THE EARTH." The boundaries between carbon-based life and digital data are becoming as fragile as a cell membrane.

### Phase 2

While the first phase of *Genesis* focused on the creation and mutation of a synthetic gene through Web participation, the second phase focused on the protein produced by the synthetic gene: the *Genesis* protein.[4]

Protein production is a fundamental aspect of life. Multiple research centers around the world focus their initiatives on sequencing, organizing, and analyzing the genomes of both simple and complex organisms, from bacteria to human beings. Parallel to genomics (the study of genes and their function) we find proteomics (the study of proteins and their function). Proteomics, the dominant research agenda in molecular biology in the postgenomic world, focuses on the visualization of the three-dimensional structure of proteins produced by sequenced genes. It is also concerned with the study of the structure and functionality of these proteins, among many other important aspects, such as similarity among proteins found in different organisms. The second

phase of *Genesis* critically investigates the logic, the methods, and the symbolism of proteomics, as well as its potential as a domain of art making.

With the goal of producing a tangible rendition of the nanostructure of the *Genesis* protein, I produced a digital visualization of the *Genesis* protein's three-dimensional structure.[5] This three-dimensional dataset was used to produce both digital and physical versions of the protein. The digital version is a fully navigable Web object rendered both in VRML (Virtual Reality Modeling Language) and PDB (Protein Data Bank) formats, to enable up-close inspection of its complex volumetric structure. The physical rendition is a small solid object produced via rapid prototyping, to convey in tangible form the fragility of this molecular object.[6]

Quite clearly, genetic engineering will continue to have profound consequences in art as well as in the social, medical, political, and economic spheres of life. I am interested in creating artworks that reflect on the multiple social implications of genetics, from unacceptable abuse to its hopeful promises, from the notion of "code" to the question of translation, from the synthesis of genes to the process of mutation, from the metaphors employed by biotechnology to the fetishization of genes and proteins, from simple reductive narratives to complex views that account for environmental influences. The urgent task is to unpack the implicit meanings of the biotech revolution and, through art making, contribute to the creation of alternative views.

## Phase 3

Bridging the nanoscale of the *Genesis* gene and protein with a more approachable human scale, the third phase focused on giving tangible expression to important aspects of the genomic and proteomic developments of *Genesis*. The project encompasses the production of artworks that capture and further elaborate key ideas manifested in the first and second phases of *Genesis*. Five sets of works have been produced: *Encryption Stones, Transcription Jewels, Fossil Folds, The Book of Mutations,* and *In Our Own Image.*

*Encryption Stones* (fig. 85) is a set of two 20-by-30-inch (50-by-75-centimeter) Indian black granite tablets that allude to the Rosetta Stone in material and visual structure. Both *Encryption Stones* are cut and rock-pitched by hand. The original Rosetta Stone is a slab of black basalt dating from 196 B.C. It measures 39.3 by 27.5 by 11.8 inches (1 meter high by 70 centimeters wide by 30 centimeters deep). Its inscription (a royal decree praising Egypt's king Ptolemy V) was written on the stone three times: in hieroglyphic, demotic, and Greek.

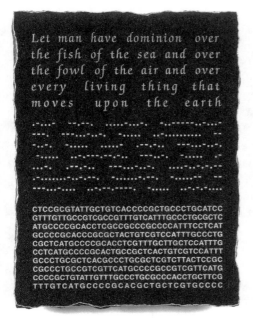 

85. Eduardo Kac, *Encryption Stones,* laser-etched granite (diptych), 20 × 30 in (50 × 75 cm) each, 2001. The triadic configuration of the *Encryption Stones* critically reveals the intersemiotic operations that lie at the heart of our current understanding of life processes. (Collection of Richard Langdale.)

Napoleon's troops discovered it in 1799 near the seaside town of Rosetta in lower Egypt. Jean François Champollion, a French Egyptologist, was able to compare the three languages and decipher Egyptian hieroglyphics, thus enabling our understanding of the past. Since then, almost everything that remains of the Egyptians' ancient writings has been translated by new generations of Egyptologists. The stone resides in the British Museum, in London. The triple code of the *Encryption Stones* sets in indelible form the symbolic and pragmatic association among biology, human language, and communication media, as embodied by the texts, Morse translations, and genetic sequences laser-etched on granite. One *Encryption Stone* has the original biblical passage (top), the Morse version (middle), and the sequence of nucleotides of the *Genesis* gene (bottom). The other *Encryption Stone* has the mutated *Genesis* gene at the top, the mutated Morse translation in the middle, and the resulting altered biblical passage at the bottom. The triadic configuration of the *Encryption Stones* critically exposes the intersemiotic operations that lie at the heart of the contemporary understanding of life processes.

*Transcription Jewels* (fig. 86) is a sculpture encased in a custom-made round wooden box. The word *transcription* is the term employed in biology to name the process during which the genetic information is "transcribed" from DNA into RNA. One "jewel" is a two-inch (five-centimeter) genie bottle in clear glass with gold ornaments and sixty-five milligrams of purified *Genesis* DNA inside. "Purified DNA" means that countless copies of the DNA have been isolated from the bacteria in which they were produced and accumulated and filtrated in a vial.[7] The gene is seen here out of the context of the body, its meaning intentionally reduced to a formal entity to reveal that without acknowledgment of the vital roles played by organism and environment, the "priceless" gene can become "worthless." The other "jewel" is an equally small gold cast of the three-dimensional structure of the *Genesis* protein. By displaying the emblematic elements of the biotech revolution (the gene and the protein) as coveted valuables, *Transcription Jewels* makes an ironic commentary on the process of commodification of the most minute aspects of life. Both the purified gene in *Transcription Jewels* and its protein are not derived from a natural organism but rather were created specifically for the artwork *Genesis*. Instead of a "genie" inside the bottle one finds the new panacea, the gene. No wishes of immortality, beauty, or intelligence are granted by the inert and isolated gene sealed inside the miniature bottle. As a result, the irony gains a critical and humorous twist by the fact that the "precious commodity" is devoid of any real, practical application in biology.

*Fossil Folds* (fig. 87) is a sculpture series based on my "artist's protein," created in *Genesis* and discussed earlier. With *Fossil Folds* I seek to visually entangle protein folding and fossilized images. The word *folds* in the title also alludes to the Deleuzian notion (after Leibniz) of the fold, that is, the mode of unity of disjunctive figures.[8] Fossils are remnants of organisms preserved by mineralization in sedimentary rock. The sequence of protein images set in stone creates a semantic tension between the ephemeral dynamism of life and its immortal visual preservation. This productive ambiguity further resonates with the title, where the idea of what is pliable and dynamic (fold) is combined with the reference to what is immobilized and preserved (fossil), as if the fossil represented the folding and enfolding of both the living and the rock in time.

*Fossil Folds* aims at the investigation of the biological and artistic implications of protein production. In taking this step, I wish to reflect on (and contribute to) artistic possibilities in the postgenomic paradigm, that is, in the realm of proteomics. By using the same material first employed in the *Encryption Stones* (black granite), I create conti-

86. Eduardo Kac, *Transcription Jewels,* glass, purified *Genesis* DNA, gold, wood, dimensions variable, 2001. This work is comprised of actual *Genesis* DNA (inside the genie bottle) and a gold cast of the *Genesis* protein. By displaying the emblematic elements of the biotech revolution (the gene and the protein) as coveted valuables, this work makes an ironic commentary on the process of commodification of the most minute aspects of life.

nuity between the two works, thus linking the *Genesis* gene and its protein. The protein is represented with its twists and turns, helices, sheets, and other three-dimensional features. Each stone reveals a quasi-ideographic form that is evocative of calligraphic gestures, suggesting the emergence of new linguistic forms. Each carved piece in the series evokes a runic inscription, a system of protowriting that exposes the conflation of tropes of life and script in molecular biology. These pro-

87. Eduardo Kac, *Fossil Fold #12* (from the *Fossil Folds* series), carved granite, 13 × 9 in (33 × 23 cm), 2001. Each piece in the series evokes a runic inscription, a system of protowriting that critically exposes the conflation of tropes of life and script in molecular biology.

teic petroglyphs, or "proteoglyphs," are devoid of specific meaning and do not contribute to explaining anything, scientific or otherwise. *Fossil Folds* serves as a reminder that as old biological metaphors such as "code" are repeated, they become "fossilized," losing contact with the creative (i.e., metaphorical) context in which they emerged. In time, as they cease to be playful tropes, these metaphors become conceptual tools, rhetorical instruments that lead to operational procedures through which certain kinds of knowledge are built. An integral part of scientific discourse, metaphors become a key agent in the production of scientific "truth."[9]

*The Book of Mutations* is a portfolio comprised of five pages, each a distinct giclée print on archival watercolor paper. The first "page" is a photograph showing a round image against a black background. This circular form is a petri dish containing the blue and yellow *Genesis* bacteria glowing under ultraviolet light. The fifth and last "page" is the negative image of the first, showing a lighter round image against a black background. These two images evoke the switching between white light and ultraviolet light that takes place in the *Genesis* installation, which is responsible for the bacterial mutation. The remaining three "pages" show mutations of the original biblical sentence em-

ployed in *Genesis*, displayed in spiral form against a black background. The color palette of these three prints matches the hues in the photographs. The second print shows the text with a color palette that matches the fluorescence characteristic of the blue and yellow *Genesis* bacteria. The third print reveals a combination of the previous palette with the lighter palette of the last image. The fourth print in the set presents the verbal mutation exclusively with the light colors of the last image. The color constraint gives both visual and semantic unity to *The Book of Mutations* and further evokes the passage from white light to ultraviolet light (and vice versa). The book can be read manually, or its pages can be displayed sequentially on a wall. Both modes clearly manifest the direct connection between, on the one hand, the bacterial mutation promoted on-line in the *Genesis* installation and, on the other hand, the multiple transformations of the biblical passage in the body of *Genesis* bacteria.

*In Our Own Image* is a pair of digital video sculptures that present, respectively, moving images of *Genesis* bacteria and the *Genesis* three-dimensional protein. Each work has a crystal ball (with diameter of six inches, or 15.2 centimeters) through which a distorted image can be seen in uninterrupted motion. One work shows dynamic patterns of bacterial colonies at speeds impossible to perceive with the naked eye. The other shows a three-dimensional protein whirling in space, decontextualized from the body of the unicellular organism in which it is produced. This work displaces the specular reference of the title with the metaphor of "seeing the future" through a crystal ball. The distortions and the restless movement of bacteria and protein suggest that even the most precise descent into the molecular strata of life is elusive and rife with uncontrollable unpredictability.

### The Genesis Exhibition

All pieces described and discussed earlier, including the Net installation with live bacteria, were presented together in my solo exhibition Genesis, realized at the Julia Friedman Gallery, in Chicago, between May 4 and June 2, 2001. The multiple mutations experienced biologically by the bacteria and graphically by the images, texts, and systems that compose the exhibition reveal that the alleged supremacy of the so-called master molecule must be questioned. The *Genesis* project makes evident that "life" is no longer, purely and simply, a biochemical phenomenon. Instead, it states that we must consider life as a complex system at the crossroads between belief systems, economic principles, legal parameters, political directives, scientific laws, and cultural constructs.

## Notes

1. I selected the King James English version (KJV), instead of the Hebrew original text, as a means of highlighting the multiple mutations of the Old Testament and its interpretations and also to illustrate the ideological implications of an alleged "authoritative" translation. King James tried to establish a final text by commissioning several scholars (a total of forty-seven worked on the project) to produce this translation, meant to be univocal. Instead, this collaborative effort represents the result of several "voices" at work simultaneously. Most of the Old Testament books were written in Hebrew, while parts of the books of Daniel and Ezra were written in Aramaic. The King James Bible was translated in 1611 after consultation of previous translations to multiple languages; that is, it is a translation of many translations. In the preface of the authorized version, the translators wrote: "Neither did we think much to consult the Translators or Commentators, Chaldee, Hebrew, Syrian, Greek or Latin, nor the Spanish, French, Italian, or Dutch." Following centuries of oral tradition, the Bible was written over a long time span by many authors. It is unclear exactly when the Bible was written down. However, it is believed that the text was fixed in scrolls during the period from 1400 B.C. to 100 A.D. Since the first versions of the text had no connection between letters, no spaces between words and sentences, no periods or commas, and no chapters, the material encouraged multiple interpretations. Subsequent translations and editions attempted to simplify and organize the text—that is, to arrest its continuous transmutation—only to generate more versions. The division of the Bible into chapters was carried out by Stephen Langton (d. 1227), who later became the Archbishop of Canterbury. Father Santes Pagninus, a Dominican priest, divided the Old Testament chapters into verses in 1528. With the advent of moveable-type printing in 1450, yet newer versions proliferated, all different in their own way, with both deliberate and accidental changes. The biblical passage from KJV employed in my transgenic work *Genesis* is emblematic, as it speaks of dominion. King James is the founding monarch of the United States. Under his reign, the first successful colonies were established. In his own words, King James sought to propagate "Christian religion to such people as yet live in darkness." The colonizers brought his authorized translation. The genesis of the New World was built upon dominion "over every living thing that moves upon the earth." See Kenneth L. Barker, ed., *The NIV: The Making of a Contemporary Translation* (Grand Rapids, Mich.: Zondervan, 1986); Eugene H. Glassman, *The Translation Debate* (Downers Grove, Ill.: InterVarsity Press, 1981); D. A. Carson, *The King James Version Debate* (Grand Rapids, Mich.: Baker, 1979).

2. I employed Morse code not out of a technical need but as a symbolic gesture meant both to expose the continuity of ideology and technology and to reveal important aspects of the rhetorical strategies of molecular biology. Samuel Morse embraced the radical Protestant movement of the 1830s known as nativism. The nativist platform was racist, anti-immigrant, anti-Catholic, and anti-Semitic. All his life Morse hated and feared American Catholics, supported denying citizenship to the foreign-born, and wrote pamphlets against the abolishment of slavery. In my work *Genesis*, the translation of the KJV Genesis passage into Morse code represents the continuity from fierce British colonialism to the bigotry of nativist ideology. The industrialization of North America, in tandem with technological hegemony, was based on the gargantuan profits amassed from the slave trade in the eighteenth century. In 1844 Morse sent the first telegraphic message, from Baltimore to Washington, D.C.: "What hath God wrought!" The translation from KJV/Morse to a gene is meant to reveal the continuity between imperialist ideology

and the reductionistic view of genetics, both focused on suppressing the complexity of historic, political, economic, and environmental forces that make up social life. See Samuel Irenaeus Prime, *Life of Samuel F. B. Morse* (New York: Appleton, 1875); Jeffrey L. Kieve, *The Electric Telegraph: A Social and Economic History* (Newton Abbot, U.K.: David and Charles, 1973); Paul J. Staiti, *Samuel F. B. Morse* (Cambridge and New York: Cambridge University Press, 1989). In addition, the Morse code is a central metaphor in molecular biology. In his influential essay "What Is Life?" (1943) physicist Erwin Schrödinger promoted an atomistic view of biology and predicted key characteristics of genetic material more than a decade before the structure of DNA was understood. He wrote: "It has often been asked how this tiny speck of material, the nucleus of the fertilized egg, could contain an elaborate codescript involving all the future development of the organism. . . . For illustration, think of the Morse code. The two different signs of dot and dash in well-ordered groups of not more than four allow of thirty different specifications." The metaphor of the "code-script" proposed by Schrödinger took center stage in molecular biology and became an epistemological instrument in this field. This begs the question, which I seek to ask with *Genesis*, of how meaning is constructed in science. How do we go from the metaphor of "genes as code" to the "fact" that "genes are code"? Is it by the progressive erasure of the initial conditions of enunciation of a metaphor? See Erwin Schrödinger, *What Is Life? The Physical Aspect of the Living Cell with Mind and Matter and Autobiographical Sketches* (Cambridge: Cambridge University Press, 1992), 61; Richard Doyle, *On Beyond Living: Rhetorical Transformations of the Life Sciences* (Stanford: Stanford University Press, 1997), 25–38.

3. The first time I presented the *Genesis* installation, in 1999, I created bacteria with ECFP (enhanced cyan fluorescent protein) and EYFP (enhanced yellow fluorescent protein). The ECFP bacteria contained the synthetic gene, while the EYFP bacteria did not. These fluorescent bacteria emit cyan and yellow light when exposed to UV radiation (302 nm). As they make contact with each other, bacterial communication takes place and we start to see color changes. As they grow in number, mutations naturally occur in the plasmids. Along the mutation process, the precise information originally encoded in the ECFP bacteria is altered. The mutation of the synthetic gene occurs as a result of three factors: (1) the natural bacterial multiplication process; (2) bacterial dialogical interaction; (3) human-activated UV radiation. For subsequent versions, since *Genesis* traveled to approximately twenty-five venues worldwide in five years, I created exclusively green fluorescent bacteria.

4. In actuality, genes do not "produce" proteins. As Richard Lewontin clearly explains: "A DNA sequence does not specify protein, but only the amino acid sequence. The protein is one of a number of minimum free-energy foldings of the same amino acid chain, and the cellular milieu together with the translation process influences which of these foldings occurs." See R. C. Lewontin, "In the Beginning Was the Word," *Science* 291 (Feb. 16, 2001): 1264.

5. First, the amino-acid chain unique to the *Genesis* DNA sequence was mapped onto it. Then, I researched protein fold homology using the Protein Data Bank, operated by the Research Collaboratory for Structural Bioinformatics (RCSB). Protein visualization was carried out with the assistance of Charles Kazilek and Laura Eggink, BioImaging Laboratory, Arizona State University, Tempe.

6. Rapid prototyping was developed with the assistance of Dan Collins and James Stewart, Prism Lab, Arizona State University, Tempe.

7. DNA synthesis, assembly, amplification, and purification were carried out with the assistance of Scott Bingham, associate research scientist, Arizona State University, Tempe. Six liters of bacteria were grown, and 130 milligrams of DNA were produced.

8. Gilles Deleuze, *The Fold: Leibniz and the Baroque,* trans. Tom Conley (Minneapolis: University of Minnesota Press, 1993).

9. For a critique of the notion of "code" and related issues, see Evelyn Fox Keller, *Refiguring Life: Metaphors of Twentieth-Century Biology* (New York: Columbia University Press, 1995); Richard C. Lewontin, *Biology as Ideology: The Doctrine of DNA* (Concord, Ont.: Anansi, 1991).

# 14. GFP Bunny

My transgenic artwork *GFP Bunny* comprises the creation of a green fluorescent rabbit (fig. 88), the public dialogue generated by the project, and the social integration of the rabbit. GFP stands for green fluorescent protein. *GFP Bunny* was realized in 2000 and first introduced to the public at large in Avignon, France. Transgenic art, I propose elsewhere,[1] is a new art form based on the use of genetic engineering to create unique living beings. This must be done with great care; with acknowledgment of the complex issues thus raised; and, above all, with a commitment to respect, nurture, and love the life thus created.

### Welcome, Alba

I will never forget the moment when I first held her in my arms (fig. 89), in Jouy-en-Josas, France, on April 29, 2000. My apprehensive anticipation was replaced by joy and excitement. Alba—the name given her by my wife, my daughter, and me—was lovable and affectionate and an absolute delight to play with. As I cradled her, she playfully tucked her head between my body and my left arm, finding at last a comfortable position to rest and enjoy my gentle strokes. She immediately awoke in me a strong and urgent sense of responsibility for her well-being.

Alba is undoubtedly a very special animal, but I want to be clear that her formal and genetic uniqueness is but one component of the *GFP Bunny* artwork. The *GFP Bunny* project is a complex social event that starts with the creation of a chimerical animal that does not exist in nature (i.e., "chimerical" in the sense of a cultural tradition of imaginary animals, not in the scientific connotation of an organism in which there is a mixture of cells in the body); it also includes at its core: (1) ongoing

---

Originally appeared in *Eduardo Kac: Telepresence, Biotelematics, and Transgenic Art*, ed. Peter T. Dobrila and Aleksandra Kostic (Maribor, Slovenia: Kibla, 2000).

88. Eduardo Kac, *GFP Bunny*, transgenic work, 2000. Alba, the fluorescent bunny. (Photograph by Chrystelle Fontaine.)

89. Eduardo Kac, *GFP Bunny*, transgenic work, 2000. Eduardo Kac and Alba. (Photograph by Chrystelle Fontaine.)

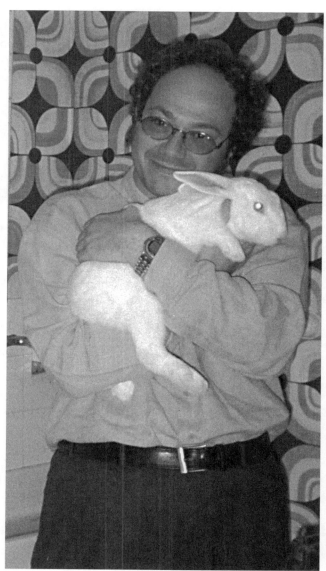

dialogue between professionals of several disciplines (art, science, philosophy, law, communications, literature, social sciences) and the public on the cultural and ethical implications of genetic engineering; (2) contestation of the alleged supremacy of DNA in life creation in favor of a more complex understanding of the intertwined relationship among genetics, organism, and environment; (3) extension of the concepts of biodiversity and evolution to incorporate precise work at the genomic level; (4) interspecies communication between humans and a transgenic mammal; (5) integration and presentation of *GFP Bunny* in a social and interactive context; (6) examination of the notions of normalcy, heterogeneity, purity, hybridity, and otherness; (7) consideration of a nonsemiotic notion of communication as the sharing of genetic material across traditional species barriers; (8) public respect and appreciation for the emotional and cognitive life of transgenic animals; (9) expansion of practical and conceptual boundaries of art making to incorporate life invention.

## Glow in the Family

Alba, the green fluorescent bunny, is an albino rabbit. This means that, since she has no skin pigment, under ordinary environmental conditions she is completely white with pink eyes. Alba is not green all the time. She only glows when illuminated with the correct light. When (and only when) illuminated with blue light (maximum excitation at 488 nm), she glows with a bright green light (maximum emission at 509 nm). It is imperative to use a special yellow filter to see the glow. She was created with EGFP, an enhanced version (i.e., a synthetic mutation) of the original wild-type green fluorescent gene found in the jellyfish *Aequorea victoria* (fig. 90). EGFP gives about two orders of magnitude greater fluorescence in mammalian cells (including human cells) than the original jellyfish gene.[2]

The first phase of the *GFP Bunny* project was completed in February 2000 with the birth of Alba in Jouy-en-Josas, France. This was accomplished with the invaluable assistance of zoosystemician Louis Bec[3] and scientists Louis-Marie Houdebine and Patrick Prunet.[4] Alba's name was chosen by consensus among my wife Ruth, my daughter Miriam, and myself. The second phase is the ongoing debate, which started with the first public announcement of Alba's birth, in the context of the Planet Work conference, in San Francisco, on May 14, 2000. The third phase will take place when the bunny comes home to Chicago, becoming part of my family and living with us from this point on.

90. Eduardo Kac, *GFP Bunny*, transgenic work, 2000. Shown above is the jellyfish *Aequorea victoria*, from which the fluorescent gene was sequenced and cloned. (Courtesy of David Wrobel.)

## From Domestication to Selective Breeding

The human-rabbit association can be traced back to the biblical era, as exemplified by passages in the books of Leviticus (Lev. 11:5) and Deuteronomy (Deut. 14:7), which make reference to *saphan*, the Hebrew word for rabbit. Phoenician seafarers discovered rabbits on the Iberian Peninsula around 1100 B.C. and, thinking that these were hyraxes (also called rock dassies), called the land "i-shepan-im" (land of the hyraxes). Since the Iberian Peninsula is north of Africa, relative geographic position suggests that another Punic derivation comes from *sphan*, "north." Bunnies were also part of Egyptian culture (fig. 91). As the Romans adapted "i-shepan-im" to Latin, the word Hispania was created—one of the etymological origins of Spain. In his Book III the Roman geographer Strabo (ca. 64 B.C.–A.D. 21) called Spain "the land of rabbits." Later on, the Roman emperor Servius Sulpicius Galba

91. The Egyptian bunny. Scene from the unlocated tomb-chapel of the scribe Nebamun at Thebes. Eighteenth Dynasty, ca. 1400 B.C. © Copyright The British Museum.

(5 B.C.–A.D. 69), whose reign was short-lived (68–69 A.D.), issued a coin on which Spain is represented with a rabbit at her feet. A similar coin was issued by the Roman emperor Publius Aelius Hadrianus (Hadrian), who reigned from 117 to 138 A.D. Although semidomestication started in the Roman period, in this initial phase rabbits were kept in large walled pens and were allowed to breed freely. For the Aztecs the rabbit had particular significance (fig. 92). Tochtli, or rabbit, was the eighth day sign of the Tonalpohualli, the Aztec sacred calendar. The rabbit is the Aztec calendar sign for the date of the earth's creation.

Humans started to play a direct role in the evolution of the rabbit from the sixth to the tenth century A.D., when monks in southern France domesticated and bred rabbits under more restricted conditions. The rabbit should not be confused with the hare, which is similar in appearance but in fact belongs to a different species. Studies on the molecular biology of hares and rabbits suggest they diverged and developed separate evolutionary histories approximately twenty million years ago.[5] Originally from the region comprised by southwestern

92. Aztec rabbit. Shown on the back of the Coronation Stone of Moctezuma II. Tochtli, or rabbit, was the eighth day sign of the Tonalpohualli, the Aztec sacred calendar. The rabbit is the Aztec calendar sign for the date of the earth's creation. Mexico, Tenochtilan, Aztec Culture, Coronation Stone of Moctezuma II ("Stone of the Five Suns"), c. 1503, Basalt, 55.9 × 66 × 22.9 cm, Major Acquisitions Fund, 1990.11 bottom view photo © The Art Institute of Chicago. All Rights Reserved.

Europe and North Africa, the European rabbit (*Oryctolagus cuniculus*) is the ancestor of all domestic rabbit breeds. Since the sixth century, because of its sociable nature, the rabbit increasingly has become integrated into human families as a domestic companion. However, this is not true in all countries. While in the United States rabbits are

among the most popular house animals, in France they are virtually absent from family life. In any case, it was human-induced selective breeding that created the morphological diversity found in rabbits everywhere. The first records describing a variety of fur colors and sizes distinct from wild breeds date from the sixteenth century. While new rabbit species are still being discovered in the wild, as exemplified by the striped rabbit found in Sumatra in 1999, it was not until the eighteenth century that selective breeding resulted in the Angora rabbit, which has a uniquely thick and beautiful wool coat.[6] The process of domestication carried out since the sixth century, coupled with ever-increasing worldwide migration and trade, resulted in many new breeds and in the introduction of rabbits into new environments different from their place of origin. While there are well over one hundred known breeds of rabbit around the world, "recognized" pedigree breeds vary from one country to another. For example, the American Rabbit Breeders Association (ARBA) "recognizes" forty-five breeds in the United States, with more under development.

In addition to selective breeding, naturally occurring genetic variations also contributed to morphological diversity. The albino rabbit, for example, is a natural (recessive) mutation that in the wild has minimal chances of survival (due to lack of proper pigmentation for camouflage and keen vision to spot prey). However, because it has been bred by humans, it can be found widely in healthy populations. The human preservation of albino animals is also connected to ancient cultural traditions: almost every Native American tribe believed that albino animals had particular spiritual significance and had strict rules to protect them.[7]

### From Breeding to Transgenic Art

*GFP Bunny* is a transgenic artwork and not a breeding project. The differences between the two include the principles that guide the work, the procedures employed, and the main objectives. Traditionally, animal breeding has been a multigenerational selection process that has sought to create pure breeds with standard form and structure, often to serve a specific performative function. As it moved from rural milieus to urban environments, breeding deemphasized selection for behavioral attributes but continued to be driven by a notion of aesthetics anchored on visual traits and morphological principles. Transgenic art, by contrast, offers a concept of aesthetics that emphasizes the social rather than the formal aspects of life and biodiversity, that challenges notions of genetic purity, that incorporates precise work at the

genomic level, and that reveals the fluidity of the concept of species in an ever-increasing transgenic social context.

As a transgenic artist, I am interested not in the creation of genetic objects but in the invention of transgenic social subjects. In other words, what is important is the completely integrated process of creating the bunny; bringing her to society at large; and providing her with a loving, caring, and nurturing environment in which she can grow safely and healthily. This integrated process is important because it places genetic engineering in a social context in which the relationship between the private and the public spheres is negotiated. In other words, biotechnology, the private realm of family life, and the social domain of public opinion are discussed in relation to one another. Transgenic art is not about the crafting of genetic objets d'art, either inert or imbued with vitality. Such an approach would suggest a conflation of the operational sphere of life sciences with a traditional aesthetics that privileges formal concerns, material stability, and hermeneutical isolation. Integrating the lessons of dialogical philosophy[8] and cognitive ethology,[9] transgenic art must promote awareness of and respect for the spiritual (mental) life of the transgenic animal. The word *aesthetics* in the context of transgenic art must be understood to mean that creation, socialization, and domestic integration are a single process. The question is not to make the bunny meet specific requirements or whims but to enjoy her company as an individual (all bunnies are different), appreciated for her own intrinsic virtues, in dialogical interaction.

One very important aspect of *GFP Bunny* is that Alba, like any other rabbit, is sociable and in need of interaction through communication signals, voice, and physical contact. As I see it, there is no reason to believe that the interactive art of the future will look and feel like anything we knew in the twentieth century. *GFP Bunny* shows an alternative path and makes clear that a profound concept of interaction is anchored in the notion of personal responsibility (as both care and possibility of response). *GFP Bunny* gives continuation to my focus on the creation, in art, of what Martin Buber called dialogical relationship,[10] what Mikhail Bakhtin called the dialogic sphere of existence,[11] what Emile Benveniste called intersubjectivity,[12] and what Humberto Maturana calls consensual domains:[13] shared spheres of perception, cognition, and agency in which two or more sentient beings (human or otherwise) can negotiate their experience dialogically. The work is also informed by Emmanuel Levinas's philosophy of alterity,[14] which states that our proximity to the other demands a response and that the interpersonal contact with others is the unique relation of ethical responsi-

bility. I create my works to accept and incorporate the reactions and decisions made by the participants. This is what I call the human-plant-bird-mammal-robot-insect-bacteria interface.

In order to be practicable, this aesthetic platform—which reconciles forms of social intervention with semantic openness and systemic complexity—must acknowledge that every situation, in art as in life, has its own specific parameters and limitations. So the question is not how to eliminate circumscription altogether (an impossibility) but how to keep it indeterminate enough so that what human and nonhuman participants think, perceive, and do when they experience the work matters in a significant way. My answer is to make a concerted effort to remain truly open to the participant's choices and behaviors, to give up a substantial portion of control over the experience of the work, to accept the experience as-it-happens as a transformative field of possibilities, to learn from it, to grow with it, to be transformed along the way. Alba is a participant in the *GFP Bunny* transgenic artwork; so is anyone who comes in contact with her and anyone who gives any consideration to the project. A complex set of relationships among family life, social difference, scientific procedure, interspecies communication, public discussion, ethics, media interpretation, and art context is at work.

Throughout the twentieth century art progressively moved away from pictorial representation, object crafting, and visual contemplation. Artists searching for new directions that could more directly respond to social transformations gave emphasis to process, concept, action, interaction, new media, environments, and critical discourse. Transgenic art acknowledges these changes and at the same time offers a radical departure from them, placing the question of actual creation of life at the center of the debate. Undoubtedly, transgenic art also develops in a larger context of profound shifts in other fields. Throughout the twentieth century physics acknowledged uncertainty and relativity, anthropology shattered ethnocentricity, philosophy denounced truth, literary criticism broke away from hermeneutics, astronomy discovered new planets, biology found "extremophile" microbes living in conditions previously believed not capable of supporting life, molecular biology made cloning a reality.

Transgenic art acknowledges the human role in rabbit evolution as a natural element, as a chapter in the natural history of both humans and rabbits, for domestication is always a bidirectional experience. As humans domesticate rabbits, so do rabbits domesticate their humans. Moving beyond the metaphor of the artwork as a living organism into a complex embodiment of the trope, transgenic art does not attempt to moderate, undermine, or arbitrate the public discussion. It seeks to contribute a new perspective that offers ambiguity and subtlety where

we usually only find affirmative ("in favor") and negative ("against") polarity. *GFP Bunny* highlights the fact that transgenic animals are regular creatures that are as much a part of social life as any other life form and thus are deserving of as much love and care as any other animal.[15]

In developing the *GFP Bunny* project I have paid close attention and given careful consideration to any potential harm that might be caused. I decided to proceed with the project because it became clear that it was safe.[16] There were no surprises throughout the process: the genetic sequence responsible for the production of the green fluorescent protein was integrated into the genome through zygote microinjection.[17] The pregnancy was carried to term successfully. *GFP Bunny* does not propose any new form of genetic experimentation, which is the same as saying: the technologies of microinjection and green fluorescent protein are established well-known tools in the field of molecular biology. Green fluorescent protein has already been successfully expressed in many host organisms, including mammals.[18] There are no mutagenic effects resulting from transgene integration into the host genome. Put another way, green fluorescent protein is harmless to the rabbit. It is also important to point out that the *GFP Bunny* project breaks no social rule: humans have played a direct role in the evolution of rabbits for at least fourteen hundred years.

### Alternatives to Alterity

As we negotiate our relationship with our lagomorph companion,[19] it is necessary to think about rabbit agency without anthropomorphizing it. Relationships are not tangible, but they form a fertile field of investigation in art, pushing interactivity into a literal domain of intersubjectivity. Everything exists in relationship to everything else. Nothing exists in isolation. By focusing my work on the interconnection between biological, technological, and hybrid entities I draw attention to this simple but fundamental fact. To speak of interconnection or intersubjectivity is to acknowledge the social dimension of consciousness. Therefore, the concept of intersubjectivity must take into account the complexity of animal minds. In this context, and particularly in regard to *GFP Bunny*, one must be open to understanding the rabbit mind, and more specifically to Alba's unique spirit as an individual. It is a common misconception that a rabbit is less intelligent than, for example, a dog, because, among other peculiarities, it seems difficult for a bunny to find food right in front of her face. The cause of this ordinary phenomenon becomes clear when we consider that the rabbit's visual system has eyes placed high and to the sides of the skull, allowing the rabbit to see nearly 360 degrees. As a result, the rabbit has a small blind spot of about 10

degrees directly in front of her nose and below her chin.[20] Although rabbits do not see images as sharply as we do, they are able to recognize individual humans through a combination of voice, body movements, and scent as cues, provided that humans interact with their rabbits regularly and don't change their overall configuration in dramatic ways (such as wearing a costume that alters the human form or using a strong perfume). Understanding how the rabbit sees the world is certainly not enough to appreciate its consciousness, but it allows us to gain insights about its behavior, which leads us to adapt our own to make life more comfortable and pleasant for everyone.

Alba is a healthy and gentle mammal. Contrary to popular notions of the alleged monstrosity of genetically engineered organisms, her body shape and coloration are exactly of the same kind we ordinarily find in albino rabbits. For those that are unaware that Alba is a glowing bunny, it is impossible to notice anything unusual about her. Therefore Alba undermines any ascription of alterity predicated on morphology and behavioral traits. It is precisely this productive ambiguity that sets her apart: being at once same and different. As is the case in most cultures, our relationship with animals is profoundly revealing of ourselves. Our daily coexistence and interaction with members of other species remind us of our uniqueness as humans. At the same time, they allow us to tap into dimensions of the human spirit that are often suppressed in daily life—such as communication without language—that reveal how close we really are to nonhumans. The more animals become part of our domestic life, the further we move breeding away from functionality and animal labor. Our relationship with other animals shifts as historical conditions are transformed by political pressures, scientific discoveries, technological development, economic opportunities, artistic invention, and philosophical insights. As we transform our understanding of human physical boundaries by introducing new genes into developed human organisms, our communion with animals in our environment also changes. Molecular biology has demonstrated that the human genome is not particularly important, special, or different. The human genome is made of the same basic elements as other known life forms and can be seen as part of a larger genomic continuum rich in variation and diversity.

Western philosophers, from Aristotle[21] to Descartes,[22] from Locke[23] to Leibniz,[24] from Kant[25] to Nietzsche[26] and Buber,[27] have approached the enigma of animality in a multitude of ways, evolving in time and elucidating along the way their views of humanity. While Descartes and Kant possessed a more condescending view of the spiritual life of animals (which can also be said of Aristotle), Locke, Leibniz, Nietsche, and Buber are—in different degrees—more tolerant toward our eu-

karyotic others.[28] Our ability to generate life through the direct method of genetic engineering prompts a reevaluation of the cultural objectification and the personal subjectification of animals, and in so doing it renews our investigation of the limits and potentialities of what we call humanity. I do not believe that genetic engineering eliminates the mystery of what life is; to the contrary, it reawakens in us a sense of wonder toward the living. We will only think that biotechnology eliminates the mystery of life if we privilege it in detriment to other views of life (as opposed to seeing biotechnology as one among other contributions to the larger debate) and if we accept the reductionist view (not shared by many biologists) that life is purely and simply a matter of genetics. Transgenic art is a firm rejection of this view and a reminder that communication and interaction between sentient and nonsentient actants lie at the core of what we call life. Rather than accepting the move from the complexity of life processes to genetics, transgenic art gives emphasis to the social existence of organisms and thus highlights the evolutionary continuum of physiological and behavioral characteristics between the species. The mystery and beauty of life are as great as ever when we realize our close biological kinship with other species and when we understand that from a limited set of genetic bases life has evolved on Earth with organisms as diverse as bacteria, plants, insects, fish, reptiles, birds, and mammals.

## Transgenesis, Art, and Society

The success of human genetic therapy suggests the benefits of altering the human genome to heal or to improve the living conditions of fellow humans.[29] In this sense, the introduction of foreign genetic material in the human genome can be seen not only as welcome but as desirable. Developments in molecular biology, such as the earlier example, are at times used to raise the specter of eugenics and biological warfare, and with it the fear of banalization and abuse of genetic engineering. This fear is legitimate, historically grounded, and must be addressed. Contributing to the problem, companies often employ empty rhetorical strategies to persuade the public, thus failing to engage in a serious debate that acknowledges both the problems and benefits of the technology.[30] There are indeed serious threats, such as the possible loss of privacy regarding one's own genetic information, and unacceptable practices already under way, such as biopiracy (the appropriation and patenting of genetic material from its owners without explicit permission).

As we consider these problems, we cannot ignore the fact that a complete ban on all forms of genetic research would prevent the de-

velopment of much-needed cures for the many devastating diseases that ravage human- and nonhumankind. The problem is even more complex. Should such therapies be developed successfully, what sectors of society will have access to them? Clearly, the question of genetics is not purely and simply a scientific matter, but one that is directly connected to political and economic directives. Precisely for this reason, the fear raised by both real and potential abuse of this technology must be channeled productively by society. Rather than embracing a blind rejection of the technology, which is undoubtedly already a part of the new biopolitics,[31] citizens of open societies must make an effort to study the multiple views on the subject, learn about the historical background surrounding the issues, understand the vocabulary and the main ongoing research efforts, develop alternative views based on their own ideas, debate the issue, and arrive at their own conclusions in an effort to generate mutual understanding. Inasmuch as this seems a daunting task, drastic consequences may result from hype, sheer opposition, or indifference.

This is where art can also be of great social value. Since the domain of art is symbolic even when intervening directly in a given context,[32] art can contribute to reveal the cultural implications of the revolution under way and offer different ways of thinking about and with biotechnology. Transgenic art is a mode of genetic inscription that is at once inside and outside the operational realm of molecular biology, negotiating the terrain between science and culture. Transgenic art can help science to recognize the role of relational and communicational issues in the development of organisms. It can help culture by unmasking the popular belief that DNA is the "master molecule" through an emphasis on the whole organism and the environment (the context). And finally, transgenic art can contribute to the field of aesthetics by opening up the new symbolic and pragmatic dimension of art as the literal creation of and responsibility for life.

### Notes

1. Eduardo Kac, "Transgenic Art," *Leonardo Electronic Almanac* 6, no. 11 (1998).

2. After green fluorescent protein was first isolated from *Aequorea victoria* and used as a new reporter system (see Martin Chalfie et al., "Green Fluorescent Protein as a Marker for Gene Expression," *Science* 263 [Feb. 11, 1994]: 802–5), it was modified in the laboratory to increase fluorescence. See R. Heim, A. B. Cubitt, and R. Y. Tsien, "Improved Green Fluorescence," *Nature* 373 (1995): 663–64; R. Heim and R. Y. Tsien, "Engineering Green Fluorescent Protein for Improved Brightness, Longer Wavelengths and Fluorescence Resonance Energy Transfer," *Current Biology* 6 (1996): 178–82. Further work altered the green fluorescent protein gene to conform to the favored codons of highly expressed human proteins and thus al-

lowed improved expression in mammalian cells. See J. Haas, E. C. Park, and B. Seed, "Codon Usage Limitation in the Expression of HIV-1 Envelope Glycoprotein," *Current Biology* 6 (1996): 315–24. For a comprehensive overview of green fluorescent protein as a genetic marker, see Martin Chalfie and Steven Kain, *Green Fluorescent Protein: Properties, Applications, and Protocols* (New York: Wiley-Liss, 1998). Since its first introduction in molecular biology, GFP has been expressed in many organisms, including bacteria, yeast, slime mold, many plants, fruit flies, zebra fish, many mammalian cells, and even viruses. Moreover, many organelles, including the nucleus, mitochondria, plasma membrane, and cytoskeleton, have been marked with GFP.

3. Artist, curator, and cultural promoter Louis Bec coined the term *zoosystémicien* (zoosystemician) to define his artistic practice and his sphere of interest, that is, the digital modeling of living systems. Formerly Inspecteur à la création artistique chargé des Nouvelles Technologies, Ministère de la Culture (Coordinator of Art and Technology for the French Ministry of Culture), Louis Bec was the director of the festival Avignon Numérique (Digital Avignon), celebrated in Avignon, France, from Apr. 1999 to Nov. 2000, on the occasion of Avignon's status as European cultural capital of the year 2000.

4. Louis-Marie Houdebine and Patrick Prunet are scientists who work at the Institut National de la Recherche Agronomique-INRA (National Institute of Agronomic Research), France. Louis-Marie Houdebine is the director of research of the Biology of Development and Biotechnology Unit, INRA, Jouy-en-Josas Center, France. See also C. Viglietta, M. Massoud, and L. M. Houdebine, "The Generation of Transgenic Rabbits," in *Transgenic Animals—Generation and Use*, ed. L. M. Houdebine (Amsterdam: Harwood Academic Publishers, 1997), 11–13. Patrick Prunet is a researcher in the Group in Physiology of Stress and Adaptation, INRA, Campus de Beaulieu, Rennes, France.

5. For an account of the history of domestication, see Zeuner, *A History of Domesticated Animals;* Juliet Clutton-Brock, *Domesticated Animals from Early Times* (London: British Museum, 1981); Roger A. Caras, *A Perfect Harmony: The Intertwining Lives of Animals and Humans throughout History* (New York: Simon and Schuster, 1996); Achilles Gautier, *La domestication: Et l'homme créa ses animaux* (Paris: Editions Errance, 1990); Daniel Helmer, *La domestication des animaux par les hommes préhistoriques* (Paris: Masson, 1992); and Carl O. Sawer, *Agricultural Origins and Dispersals: The Domestication of Animals and Foodstuffs* (Cambridge: MIT Press, 1970). For specific references on the domestication of rabbits, see F. Biadi and A. Le Gall, *Le lapin de garenne* (Paris: Hatier, 1993); G. Bianciotto, *Bestiaires du Moyen Âge* (Paris: Stock, 1980); J. J. Brochier, *Anthologie du lapin* (Paris: Hatier, 1987); "Le lapin, aspects historiques, culturels et sociaux," *Ethnozootechnie*, no. 27 (1980). For a discussion of rabbit evolution from the perspective of molecular biology, see C. Su and M Nei, "Fifty-Million-Year-Old Polymorphism at an Immunoglobulin Variable Region Gene Locus in the Rabbit Evolutionary Lineage," *Proceedings of the National Academy of Sciences of the United States of America* 96 (1999): 9710–15; and K. M. Halanych and T. J. Robinson, "Multiple Substitutions Affect the Phylogenetic Utility of Cytochrome b and 12S rDNA Data: Examining a Rapid Radiation in Leporid (Lagomorpha) Evolution," *Journal of Molecular Evolution* 48 (1999): 369–79.

6. Thebault R. G. Rochambeaus, "Angora Rabbit: Breeding and Genetics," *Productions Animales* 2, no. 2 (1989): 145–54. Regarding the discovery of new rabbit species, see K. Alison et al., "Striped Rabbits in Southeast Asia," *Nature* 400 (1999): 726.

7. Detailed information about the spiritual values of individual tribes can be found in Sam D. Gill, *Dictionary of Native American Mythology* (New York: Ox-

ford University Press, 1994). See also Arlene B. Hirschfelder, *Encyclopedia of Native American Religions: An Introduction* (New York: Facts on File, 2000); Richard Erdoes and Alfonso Ortiz, eds., *American Indian Myths and Legends* (New York: Pantheon Books, 1985). A case that well illustrates the sacred qualities of albino animals for Native American tribes was the birth of Miracle, the white buffalo calf. Miracle was born on Dave Heider's farm, in Janesville, Wisconsin, on Aug. 20, 1994. The announcement of Miracle's birth prompted the American Bison Association to say that the last documented white buffalo died in 1959. Miracle is held sacred by buffalo-hunting Plains Indians, including the Lakota, the Oneida, the Cherokee, and the Cheyenne. Soon after her birth, Joseph Chasing Horse, traditional leader of the Lakota nation, visited the site of Miracle's birth and conducted a pipe ceremony there, while telling the story of White Buffalo Calf Woman, a legendary figure who brought the first pipe to the Lakota people. Following suit, more than twenty thousand people came to see Miracle, and the gate to the Heider's pasture and the trees next to it soon became covered with offerings: feathers, necklaces, and pieces of colorful cloth. News of the calf spread quickly through the Native American community because its birth fulfilled a two-thousand-year-old prophecy of northern Plains Indians. Joseph Chasing Horse explained in a newspaper interview that two thousand years ago a young woman who first appeared in the shape of a white buffalo gave the Lakota's ancestors a sacred pipe and sacred ceremonies and made them guardians of the Black Hills. Before leaving, she also prophesied that one day she would return to purify the world, bringing back spiritual balance and harmony; the birth of a white buffalo calf would be a sign that her return was at hand. Owen Mike, head of the Ho-Chunk (Winnebago) buffalo clan, said in the same article that his people have a slightly different interpretation of the white calf's significance. He added, however, that the Ho-Chunk version of the prophecy also stresses the return of harmony, both in nature and among all peoples. "It's more of a blessing from the Great Spirit," Mike explained. "It's a sign. This white buffalo is showing us that everything is going to be okay." See Tom Laskin, "Miracle," *Isthmus* (Nov. 25–Dec. 1, 1994).

In note 12 of chapter 5 of *The Voyage of the Beagle,* Charles Darwin highlights both the rarity and the beauty of albino animals. Commenting on what distinguishes "the cock bird from the hen," he observes, "A Gaucho assured me that he had once seen a snow-white or Albino variety, and that it was a most beautiful bird."

8. In the twentieth century, dialogical philosophy found renewed impetus with Martin Buber, who published in 1923 the book *I and Thou,* in which he stated that humankind is capable of two kinds of relationship: I-Thou (reciprocity) and I-It (objectification). In I-Thou relations one fully engages in the encounter with the other and carries on a real dialogue. In I-It relations "It" becomes an object of control. The "I" in both cases is not the same, for in the first case there is a nonhierarchical meeting while in the second case there is detachment. See Buber, *I and Thou.* Martin Buber's dialogical philosophy of relation, which is very close to phenomenology and existentialism, also influenced Mikhail Bakhtin's philosophy of language. Bakhtin stated in countless writings that ordinary instances of monological experience—in culture, politics, and society—suppress the dialogical reality of existence.

9. Cognitive ethology can be defined as "the evolutionary and comparative study of nonhuman animal thought processes, consciousness, beliefs, or rationality, and is an area in which research is informed by different types of investigations and explanations." See Marc Bekoff, "Cognitive Ethology and the Explanation of Nonhuman Animal Behavior," in *Comparative Approaches to Cognitive Science,* ed. J. A. Meyer and H. L. Roitblat (Cambridge: MIT Press, 1995), 119–50. A pio-

neer of ethology, the Estonian zoologist Jakob von Uexküll (1864–1944) devoted himself to the problem of how living beings subjectively perceive their environment and how this perception determines their behavior. In 1909 he wrote "Umwelt und Innenwelt der Tiere," introducing the German word *umwelt* (roughly translated, "environment") to refer to the subjective world of an organism. The book has been excerpted in *Foundations of Comparative Ethology*, ed. G. Burghardt (New York: Van Nostrand Reinhold, 1985). Since Uexküll emphasized the fact that signs and meanings are of the utmost importance in all aspects of biological processes (at the level of the cell or the organism), he also anticipated the concerns of cognitive ethology and biosemiotics (the study of signs, of communication, and of information in living organisms). See Jacob von Uexküll, *Mondes animaux et monde humain: Suivi de théorie de la signification* (Paris: Denoël, 1984). Further contributing to the study of the subjective world of other animals, Donald Griffin first demonstrated that bats navigate the world using biosonar, a process he called "echolocation." See Donald Griffin, *Listening in the Dark: The Acoustic Orientation of Bats and Men* (Ithaca and London: Cornell University Press, 1986). First published in 1958. Griffin has since contributed to cognitive ethology with many books, most notably *The Question of Animal Awareness: Evolutionary Continuity of Mental Experience* (New York: The Rockefeller University Press, 1976); *Animal Thinking* (Cambridge: Harvard University Press, 1984); and *Animal Minds* (Chicago: University of Chicago Press, 1992). In recognition of Griffin's pioneering work, which exhibited the problems of behaviorist and cognitive thinking that fails to acknowledge conscious awareness in mammals and thinking in small animals, several researchers pushed forward the research agenda of cognitive ethology. See Carolyn A. Ristau, ed., *Cognitive Ethology: The Minds of Other Animals: Essays in Honor of Donald R. Griffin* (Hillsdale, N.J.: Erlbaum, 1991). In his book *Kinds of Minds,* Daniel Clement Dennett makes a general attempt to explain consciousness irrespective of species. He takes the "intentional stance," that is, the strategy of interpreting the behavior of something (a living or nonliving thing) as if it were a rational agent whose actions are determined by its beliefs and desires. He examines the "intentionality" of a molecule that replicates itself, that of a dog that marks territory, and that of a human who wishes to do something in particular. In the end, for Dennett it is our ability to use language that forms the particular mind humans have. Dennett believes that language is a way to unravel the representations in our mind and extract units of them. Without language, an animal may have exactly the same representation, but it doesn't have access to any unit of it. See *Kinds of Minds: Toward an Understanding of Consciousness* (New York: Basic Books, 1996). For an examination of the rapport between philosophical theories of mind and empirical studies of animal cognition, see C. Allen and M. Bekoff, *Species of Mind: The Philosophy and Biology of Cognitive Ethology* (Cambridge: MIT Press, 1997). Focused studies on the intelligence of nonprimate species have also contributed to demonstrate the unique mental abilities of creatures such as marine mammals, birds, and ants. See R. J. Schusterman, J. A. Thomas, and F. G. Wood, eds., *Dolphin Cognition and Behavior: A Comparative Approach* (Hillsdale, N.J.: Erlbaum, 1986); A. F. Skutch, *The Minds of Birds* (College Station: Texas A&M University Press, 1996); Irene Maxine Pepperberg, *The Alex Studies: Cognitive and Communicative Abilities of Grey Parrots* (Cambridge and London: Harvard University Press, 2000). For the question of communication in ants, see Deborah Gordon, "Wittgenstein and Ant-Watching," *Biology and Philosophy* 7 (1992): 13–25. Gordon points out that "the way that scientists see animals' behavior occurs . . . [in] a system embedded in the social practices of a certain time and place" (23). Gordon's field studies of interactions between neighboring colonies have shown that ants learn to recognize not only their own nest-mates but also ants from neighboring, unrelated colonies. Her

field studies have led to further research concerning communication networks within ant colonies. For a more exhaustive examination of the problem, see Deborah Gordon, *Ants at Work: How an Insect Society Is Organized* (New York: Free Press, 1999). The key contribution of Gordon's book is to undo the popular perception that ant colonies run according to rigid rules and to show (based on her fieldwork with harvester ants in Arizona) that an ant society can be sophisticated and change its collective behavior as circumstances require. Finding inspiration in Charles Darwin's book *The Expression of Emotions in Man and Animals* (New York: D. Appleton and Company, 1872), Jeffrey M. Masson and Susan McCarthy make a convincing case for animal emotion. See *When Elephants Weep: The Emotional Lives of Animals* (New York: Bantam Doubleday Dell, 1995). On the minds of nonhuman primates, see D. L. Cheney and R. M. Seyfarth, *How Monkeys See the World: Inside the Mind of Another Species* (Chicago: University of Chicago Press, 1990); S. Montgomery, *Walking with the Great Apes: Jane Goodall, Dian Fossey, and Birutè Galdikas* (New York: SUNY Press, 1991); S. Savage-Rumbaugh and R. Lewin, *Kanzi: The Ape at the Brink of the Human Mind* (New York: Wiley, 1994); A. E. Russon, K. A. Bard, and S. T. Parker, eds., *Reaching into Thought: The Minds of the Great Apes* (Cambridge: Cambridge University Press, 1996); F. M. de Waal, *Bonobos: The Forgotten Ape* (Berkeley: University of California Press, 1997).

10. Buber, *I and Thou*, 124. According to Michael Theunissen, "Buber sought to outline an 'ontology of the between' in which individual consciousness can only be understood within the context of our relationships with others, not independent of them." See *The Other: Studies in the Social Ontology of Husserl, Heidegger, Sarte, and Buber*, trans. Christopher Macann. (Cambridge: MIT Press, 1984), 271–72.

11. Mikhail Mikhailovich Bakhtin, *Problems of Dostoevsky's Poetics*, trans. Caryl Emerson (Minneapolis: University of Minnesota Press, 1984), 270. For Bakhtin, dialogic relationships "are an almost universal phenomenon, permeating all human speech and all relationships and manifestations of human life—in general, everything that has meaning and significance" (40).

12. On the formation of "ego" or subjectivity through language, and the notion that it is only through language that we are conscious (i.e., are "subject" at all), see Emile Benveniste, "Subjectivity in Language," in *Problems in General Linguistics*, trans. Mary Elizabeth Meek (1966; repr., Coral Gables: University of Miami Press, 1971), 223–30. Echoing Buber, Benveniste's position is that when a person says "I" (i.e., when an individual occupies a subject position in discourse), he or she takes his or her place as a member of the intersubjective community of persons. Thus, in being a subject/person, he or she is not simply an object/thing.

Benveniste was certainly not the only to consider the intersubjective nature of human experience. For Maurice Merleau-Ponty, for example, our not-sameness to each other is not a flaw but the very condition of communication: "the body of the other—as bearer of symbolic behaviors and of the behavior of true reality—tears itself away from being one of my phenomena, offers me the task of a true communication, and confers on my objects the new dimension of intersubjective being." For Merleau-Ponty it is in the ambiguity of intersubjectivity that our perception "wakes up." See Maurice Merleau-Ponty, *The Primacy of Perception and Other Essays on Phenomenological Psychology, the Philosophy of Art, History and Politics*, ed. James M. Edie (Evanston: Northwestern University Press, 1964), 17–18. For a critical analysis of Merleau-Ponty's position on intersubjectivity, see Robert M. Friedman, "Merleau-Ponty's Theory of Intersubjectivity," *Philosophy Today* 19 (Fall 1975): 228–42. Jürgen Habermas also gave the concept of intersubjectivity a central place in his work. Giving continuation to one of the projects of the Frankfurt School (the critique of the notion that valid human knowledge is restricted to empirically testable propositions arrived at by means of systematic inquiry pro-

fessed to be objective and devoid of particular interests), Habermas finds in intersubjectivity a means of opposing theories that base truth and meaning on individual consciousness. For him, intersubjectivity is a communication situation in which "the speaker and hearer, through illocutionary acts, bring about the interpersonal relationships that will allow them to achieve mutual understanding." See Jürgen Habermas, "Some Distinctions in Universal Pragmatics," *Theory and Society* 3, no. 2 (1976): 157. Habermas further explained his view of intersubjective communication: "When a hearer accepts a speech act, an agreement comes about between at least two acting and speaking subjects. However this does not rest only on the intersubjective recognition of a single, thematically stressed validity claim. Rather, an agreement of this sort is achieved simultaneously at three levels. . . . It belongs to the communicative intent of the speaker (a) that he perform a speech act that is right in respect to the given normative context, so that between him and the hearer an intersubjective relation will come about which is recognized as legitimate; (b) that he make a true statement (or correct existential presuppositions), so that the hearer will accept and share the knowledge of the speaker; and (c) that he express truthfully his beliefs, intentions, feelings, desires, and the like, so that the hearer will give credence to what is said." See *The Theory of Communicative Action*, vol. 1, *Reason and the Rationalization of Society* (Boston: Beacon Press, 1984), 307–8.

13. From the perspective of his unique and systematic branch of theoretical biology, Maturana explains the notion of consensual domain with great clarity: "When two or more organisms interact recursively as structurally plastic systems, each becoming a medium for the realization of the autopoiesis of the other, the result is mutual ontogenic structural coupling. From the point of view of the observer, it is apparent that the operational effectiveness that the various modes of conduct of the structurally coupled organisms have for the realization of their autopoiesis under their reciprocal interactions is established during the history of their interactions and through their interactions. Furthermore, for an observer, the domain of interactions specified through such ontogenic structural coupling appears as a network of sequences of mutually triggering interlocked conducts that is indistinguishable from what he or she would call a consensual domain. In fact, the various conducts or behaviors involved are both arbitrary and contextual. The behaviors are arbitrary because they can have any form as long as they operate as triggering perturbations in the interactions; they are contextual because their participation in the interlocked interactions of the domain is defined only with respect to the interactions that constitute the domain. Accordingly, I shall call the domain of interlocked conducts that results from ontogenic reciprocal structural coupling between structurally plastic organisms a consensual domain." See Humberto R. Maturana, "Biology of Language: The Epistemology of Reality," in *Psychology and Biology of Language and Thought*, ed. G. Miller and E. Lenneberg (New York: Academic Press, 1978), 47. For an earlier discussion of "consensual domains," see Maturana, "The Organization of the Living: A Theory of the Living Organization," *The International Journal of Man-Machine Studies* 7 (1975): 313–32.

Still, in "Biology of Language," Maturana explains the term *autopoiesis*: "There is a class of dynamic systems that are realized, as unities, as networks of productions (and disintegrations) of components that: (a) recursively participate through their interactions in the realization of the network of productions (and disintegrations) of components that produce them; and (b) by realizing its boundaries, constitute this network of productions (and disintegrations) of components as a unity in the space they specify and in which they exist. Francisco Varela and I called such systems autopoietic systems, and autopoietic organization their organization. An autopoietic system that exists in physical space is a living system (or, more correctly, the physical space is the space that the components of living systems specify and in

which they exist)" (36). See also Humberto R. Maturana and F. G. Varela, *Autopoiesis and Cognition: The Realization of the Living* (Dordrecht, Boston, and London: Reidel, 1980). This book was originally published in Chile as *De maquinas y seres vivos* (Santiago de Chile: Editorial Universitaria, 1972).

14. Emmanuel Levinas wrote, "Proximity, difference which is non-indifference, is responsibility." See *Otherwise Than Being; or, Beyond Essence*, trans. Alphonso Lingis (Boston: Martinus Nijhoff Publishers, 1981), 139. Partially influenced by the dialogical philosophy of Martin Buber, Levinas sought to go beyond the ethically neutral tradition of ontology through an analysis of the "face-to-face" relation with the Other. For Levinas, the Other cannot be known as such. Instead, the Other arises in relation to others, in a relationship of ethical responsibility. For Levinas, this ethical responsibility must be regarded as prior to ontology. For his insights on Buber's work, see "Martin Buber and the Theory of Knowledge," in *The Philosophy of Martin Buber*, ed. P. Schilpp (La Salle, Ill.: Open Court, 1967), 133–50.

15. On the question of the welfare of transgenic animals, see C. J. Moore and T. B. Mepham, "Transgenesis and Animal Welfare," *Alternatives to Laboratory Animals* 23 (1995):380–97; and L. F. M. van Zutphen and M. van der Meer, eds., *Welfare Aspects of Transgenic Animals* (New York: Springer, 1997).

16. By this I mean that the process was expected to be (and in fact was) as common as any other rabbit pregnancy and birth. This is due to the fact that transgenic technology has been successfully and regularly employed in the creation of mice since 1980 and in rabbits since 1985. See J. W. Gordon et al., "Genetic Transformation of Mouse Embryos by Microinjection of Purified DNA," *Proceedings of the National Academy of Sciences of the United States of America* 77 (1980): 7380–84; J. W. Gordon and F. Ruddle, "Integration and Stable Germ Line Transmission of Genes Injected into Mouse Pronuclei," *Science* 214 (Dec. 11, 1981): 1244–46; R. E. Hammer et al., "Production of Transgenic Rabbits, Sheep and Pigs by Microinjection," *Nature* 315 (June 20–26, 1985): 680–83; James M. Robl and Jan K. Heideman, "Production of Transgenic Rats and Rabbits," in *Transgenic Animal Technology: A Laboratory Handbook*, ed. Carl A. Pinkert (San Diego: Academic Press, 1994). For additional information on expression of GFP in rabbits, see T. Y. Kang et al., "Cloning of Transgenic Rabbit Embryos Expressing Green Fluorescent Protein (GFP) Gene by Nuclear Transplantation," *Theriogenology* 53, no. 1 (2000): 222.

17. The zygote is the cell formed by the union of two gametes. A gamete is a reproductive cell, especially a mature sperm or egg capable of fusing with a gamete of the opposite sex to produce the fertilized egg. Direct microinjection of DNA into the male pronucleus of a rabbit zygote has been the method most extensively used in the production of transgenic rabbits. As the foreign DNA integrates into the rabbit chromosomal DNA at the one-cell stage, the transgenic animal has the new DNA in every cell. For detailed discussion of the methods and applications of microinjection technology, see J. C. Lacal, R. Perona, and J. Feramisco, *Microinjection* (New York: Springer, 1999).

18. See note 2, this chapter.

19. A lagomorph is one of the various gnawing mammals in the order Lagomorpha, including rabbits, hares, and pikas.

20. Dana M. Krempels, "What Do Rabbits See?" *House Rabbit Society: Orange County Chapter Newsletter* 5 (Summer 1996): 1. For a more comprehensive examination of vision in rabbits and other animals, see R. H. Smythe, *Vision in the Animal World* (New York: St. Martin's Press, 1975).

21. In part 1 of book 9 of his *History of Animals*, written ca. 350 B.C., Aristotle recognized the complexity of animal emotional states: "Of the animals that are comparatively obscure and short-lived the characters or dispositions are not so obvious to recognition as are those of animals that are longer-lived. These latter ani-

mals appear to have a natural capacity corresponding to each of the passions: to cunning or simplicity, courage or timidity, to good temper or to bad, and to other similar dispositions of mind." See Aristotle, *History of Animals,* books 7–10 (Cambridge and London: Harvard University Press, 1991). Although in the first chapter of the *Metaphysics* Aristotle attributes forms of reason and intelligence to animals, in another book (*Politics*) he claims that humans are the only animal capable of logos (book 7, part 13): "Animals lead for the most part a life of nature, although in lesser particulars some are influenced by habit as well. Man has rational principle, in addition, and man only." Also in the *Politics,* he compares animals to slaves (book 1, part 5): "the use made of slaves and of tame animals is not very different; for both with their bodies minister to the needs of life." See *The Works of Aristotle* (London: Oxford University Press, 1966).

22. In his 1637 "Discourse on the Method," Descartes insists on an absolute separation between human and animal. For him, consciousness and language create the boundary of being between humankind and animals. Descartes states that "beasts have less reason than men" and that in fact "they have no reason at all." See Rene Descartes, "Discourse on the Method," in *Descartes: Selected Philosophical Writings,* trans. John Cottingham, Robert Stoothoff, and Dugald Murdoch. (Cambridge: Cambridge University Press, 1988), 45. For Descartes, since animals do not have a recognizable language they lack reason and as a result are in his view like automata, capable of mimicking speech but not truly able to engage in discourse that enables and supports consciousness. The byproduct of this view is the ascription of animality to the domain of the unconscious. This maneuver did not escape the attention of semiotician Charles Sanders Peirce, who criticized Descartes: "Descartes was of the opinion that animals were unconscious automata. He might as well have thought that all men but himself were unconscious." See "Minute Logic," in *Peirce on Signs: Writings on Semiotic by Charles Sanders Peirce,* ed. James Hoopes. (Chapel Hill: University of North Carolina Press, 1991), 234.

23. In *An Essay Concerning Human Understanding* (book 2, chapter 11), John Locke wrote: "If it may be doubted whether beasts compound and enlarge their ideas that way to any degree; this, I think, may be positive in that the power of abstracting is not at all in them; and that the having of general ideas is that which puts a perfect distinction betwixt man and brutes, and is an excellency which the faculties of brutes do by no means attain to. For it is evident we observe no footsteps in them of making use of general signs for universal ideas; from which we have reason to imagine that they have not the faculty of abstracting, or making general ideas, since they have no use of words, or any other general signs." Even though Locke denied animals the faculty of abstract thought, he still did not agree with Descartes in considering animals automata. Still, in the same chapter, Locke wrote, "if they [animals] have any ideas at all, and are not bare machines, (as some would have them,) we cannot deny them to have some reason." See *An Essay Concerning Human Understanding* (New York: Dover, 1959), 208. In his partial rejection of the Cartesian theory of knowledge John Locke proposed two sources of ideas: sensation and reflection. By means of the difference between ideas of sensation and ideas of reflection, Locke distinguished man from animals: animals had certain sensory ideas and a degree of reason but no general ideas (i.e., abstraction ability) and as a result no language for their manifestation. For Locke, abstraction is firmly beyond the capacity of any animal, and it is precisely abstract thought that plays a fundamental role in forming the ideas of mixed modes, on which morality depends.

24. For Gottfried Leibniz, animals did not have self-consciousness and the power to recognize eternal truths, which for him were characteristics of the souls of men. He wrote: "I am also inclined to believe that there are souls in the lower animals because it pertains to the perfection of things that when all those things are

present which are adapted to a soul, the souls also should be understood to be present.... But no one should think that it can with equal justice be inferred that there must also be minds in the lower animals; for it must be known that the order of things will not allow all souls to be free from the vicissitudes of matter, nor will justice permit some minds to be abandoned to agitation. So it was sufficient that souls should be given to the lower animals, especially as their bodies are not made for reasoning, but destined to various functions—the silkworm to weave, the bee to make honey, and the others to the other functions by which the universe is distinguished." See "A Specimen of Discoveries about Marvellous Secrets," in *Philosophical Writings* (London and Melbourne: Dent, 1984), 84.

25. In *The Metaphysics of Morals (Metaphysical First Principles of the Doctrine of Virtue)*, Kant states that we as human beings are distinguished from other animals by our capacity to set ends for ourselves, which is only possible for a rational being. See *The Metaphysics of Morals* (Cambridge: Cambridge University Press, 1991), 381, 384–85, 392. For Kant the moral faculty of humans was directly connected to the fundamental property of reason. He did not find in nature the origin of morality and thus denied animals membership in the (moral) kingdom of ends. For Kant, the sense of moral duty is inherent in humans (but not in animals): "animals are not self conscious and are there merely as a means to an end. That end is man." He continued, "our duties towards animals are merely indirect duties towards humanity." In other words, Kant believed one should not harm animals because in doing so one indirectly would damage humanity (one might see another human as less human and become prone to other kinds of cruelty). See "Duties to Animals," in *Animal Rights and Human Obligations,* ed. T. Regan and P. Singer (Englewood Cliffs, N.J.: Prentice-Hall, 1976), 122. See also I. Kant, "Duties to Animals and Spirits," in *Lectures in Ethics,* ed. L. Infield (New York: Harper and Row, 1963), 239–41.

26. In his seminal essay "On Truth and Lies in a Nonmoral Sense" (1873), Friedrich Nietzsche (who once stopped a man from beating his horse) wrote: "As a 'rational' being, [a person] now places his behavior under the control of abstractions. He will no longer tolerate being carried away by sudden impressions, by intuitions. First he universalizes all these impressions into less colorful, cooler concepts, so that he can entrust the guidance of his life and conduct to them. Everything which distinguishes man from the animals depends upon this ability to volatilize perceptual metaphors in a schema, and thus to dissolve an image into a concept." See "On Truth and Lies in a Nonmoral Sense," in *Philosophy and Truth,* ed. Daniel Breazeale (New York: Humanity, 1999), 84. In this essay, Nietzsche states that what we call "truth" is only "a mobile army of metaphors, metonyms, and anthropomorphisms." For him arbitrariness prevails within human experience: what one ordinarily calls "truth" is nothing but the invention of fixed conventions for practical purposes, particularly those of security and consistency.

27. Buber expounds on the I-Thou relationship between human and nonhuman animals: "Man once 'tamed' animals, and he is still capable of this singular achievement. He draws animals into his atmosphere and moves them to accept him, the stranger, in an elemental way, and to respond to him. He wins from them an often astonishing active response to his approach, to his addressing them, and moreover a response which in general is stronger and directer in proportion as his attitude is a genuine saying of Thou. Animals, like children, are not seldom able to see through any hypocritical tenderness. But even outside the sphere of taming a similar contact between men and animals sometimes takes place—with men who have in the depths of their being a potential partnership with animals, not predominantly persons of 'animal' nature, but rather those whose very nature is spiritual." See *I and Thou,* 125.

28. For a comprehensive examination of the approaches to animality within the Western tradition, and for a philosophical contribution toward a more respectful understanding of nonhuman animals, see Elisabeth Fontenay, *Le silence des betes* (Paris: Fayard, 1998).

29. On Sept. 14, 1990, researchers at the U.S. National Institutes of Health performed the first (approved) gene therapy procedure on four-year-old Ashanti De-Silva. Born with a disease called severe combined immune deficiency (SCID), she lacked a healthy immune system and was vulnerable to every passing germ. In Ashanti's gene therapy procedure, doctors grew her own white blood cells in the lab, inserted the missing gene into the cells, and then reintroduced the genetically modified blood cells back into her bloodstream. The therapy strengthened Ashanti's immune system to the point that she became able to live a regular life, but the procedure was not a permanent cure. The process must be repeated every few months. See Ira H. Carmen, "Debates, Divisions, and Decisions: Recombinant DNA Advisory Committee (RAC) Authorization of the First Human Gene Transfer Experiments," *American Journal of Human Genetics* 50, no. 2 (1992): 245–60; T. Friedmann, "A Brief History of Gene Therapy," *Nature Genetics* 2, no. 2 (1992): 93–98.

30. A case in point is the notorious example of Monsanto's claim that it seeks to feed the world and the rebuke from twenty-four African delegates to the Food and Agriculture Organization (FAO) negotiations on the International Undertaking for Plant Genetic Resources, June 1998. See Kenny Bruno, "Monsanto's Failing PR Strategy," in "The Monsanto Files," special issue, *The Ecologist* 28 (Sept.–Oct. 1998): 291.

31. See Michel Foucault, "The Birth of Biopolitics," in *Ethics: The Essential Works*, vol. 1, ed. P. Rabinow (London: Penguin, 1997), 73–79. In his essay on biopolitics at the end of *History of Sexuality*, vol. 1, Foucault argues in reference to the eighteenth century: "For the first time in history, no doubt, biological existence was reflected in political existence; the fact of living was no longer an inaccessible substrate that only emerged from time to time, amid the randomness of death and its fatality; part of it passed into knowledge's field of control and power's sphere of intervention." See *History of Sexuality* (New York: Random House, 1981), 1: 142.

32. Here I use the word *symbolic* in the sense that the artwork is not just an entity to be regarded for its intrinsic and unique properties or just a pragmatic way of accomplishing a goal, but also (and always) a means of producing a world of understanding. My use of the word is partially motivated by Erwin Panofsky's application of Ernst Cassirer's *Philosophy of Symbolic Forms* (3 vols., 1923–29). See Erwin Panofsky, *Perspective as Symbolic Form* (New York: Zone Books, 1991). Panofsky says that perspective is "one of those 'symbolic forms' in which 'spiritual meaning' is attached to a concrete, material sign and intrinsically given to this sign" (40–41).

## 15. The Eighth Day

*The Eighth Day* is a transgenic artwork that investigates the new ecology of fluorescent creatures that is evolving worldwide. I developed this work at the Institute for Studies in the Arts, Arizona State University, Tempe, where it was exhibited in 2001.[1] While fluorescent creatures exist in isolation in laboratories, seen collectively they form the nucleus of a new synthetic bioluminescent system. The piece brings together living transgenic life forms and a biological robot (biobot) in an environment housed under a clear four-foot-diameter Plexiglas dome (fig. 93), thus making visible what it would be like if these creatures would in fact coexist in the world at large.

### Transgenic Ecologies

As the viewer walks into the gallery, she first sees a blue-glowing semisphere against a dark background. This semisphere is the four-foot dome, aglow with its internal blue light. She also hears the recurring sounds of water washing ashore. This evokes the image of the earth as seen from space. The water sounds both function as a metaphor for life on Earth (reinforced by the spherical blue image) and resonate with the video of moving water projected on the floor. In order to see *The Eighth Day* the viewer is invited to "walk on water."

*The Eighth Day* presents an expansion of biodiversity beyond wild-type life forms. As a self-contained artificial ecological system (fig. 94) it resonates with the words in the title, which add one day to the period of creation of the world as narrated in the Judeo-Christian Scriptures. All of the transgenic creatures in *The Eighth Day* are created through the cloning of a gene that codes for the production of green fluorescent protein. As a result, all creatures express the gene through bioluminescence, and their glow is clearly seen by all gallery viewers. The trans-

Originally appeared in *The Eighth Day*, exhibition catalog (Institute for Studies in the Arts, Arizona State University, Tempe, 2001).

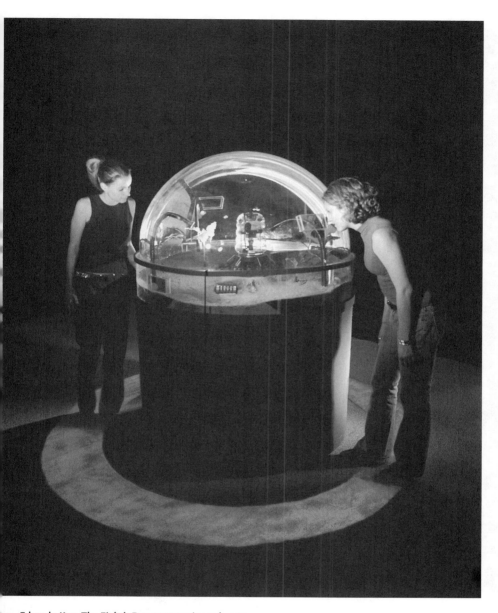

93. Eduardo Kac, *The Eighth Day*, transgenic work, 2001. *The Eighth Day* is a transgenic artwork that investigates the new ecology of fluorescent creatures that is evolving worldwide. As they walk in, participants hear the sound of water washing ashore and see a transgenic environment housed under a clear Plexiglas dome. Moving water is projected on the floor. Viewers must "walk on water" to experience *The Eighth Day*.

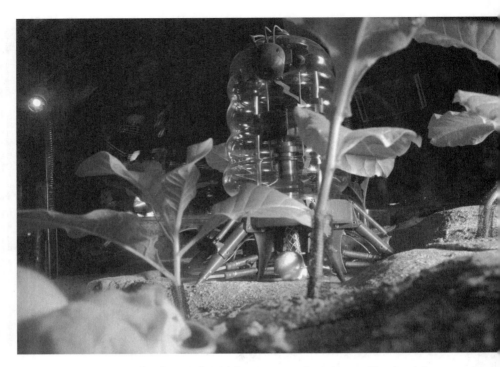

94. Eduardo Kac, *The Eighth Day*, transgenic work, 2001. The piece brings together living transgenic life forms and a biological robot (biobot), thus making visible what it would be like if these creatures would in fact coexist in the world at large.

genic creatures in *The Eighth Day* are GFP plants, GFP amoebae (fig. 95), GFP fish (fig. 96), and GFP mice (fig. 97).[2]

While one might think that *The Eighth Day* is purely speculative (about a hypothetical future), a closer examination of contemporary developments reveals that science fiction has turned science fact. With *The Eighth Day* I draw attention to the fact that a transgenic ecology is already in place.[3] Transgenic crops are cross-pollinated by insects that fly from one place to another. Transgenic animals are found on farms worldwide. Transgenic fish and flowers are being developed for the ornamental global market. Transgenic fruits-as-vaccine are being developed in several countries. New varieties of animals and vegetables are being developed, such as pigs with spinach genes, grapevines with silkworm genes, and potatoes with genes of bees and moths.[4] We do not grasp the complexity of this cultural transformation when driving by a cornfield, when putting on a cotton shirt, or when drinking a glass of soy milk.

*The Eighth Day* dramatizes this condition by bringing together beings originally developed in isolation in laboratories, now selected and

95. Eduardo Kac, *The Eighth Day*, transgenic work, 2001. The transgenic amoebae glow green when illuminated with blue light.

96. Eduardo Kac, *The Eighth Day*, transgenic work, 2001. The transgenic fish glow green when illuminated with blue light.

97. Eduardo Kac, *The Eighth Day*, transgenic work, 2001. The transgenic mice glow green when illuminated with blue light.

bred specifically for *The Eighth Day*. Selective breeding and mutation are two key evolutionary forces. *The Eighth Day* literally touches on the question of transgenic evolution.

## Transgenic Biorobotics

A biobot is a robot with an active biological element within its body that is responsible for aspects of its behavior. The biobot created for *The Eighth Day* has a colony of GFP amoebae[5] that function as its cerebellum (fig. 98). When amoebae divide or move in a particular direction the biobot exhibits dynamic behavior inside the enclosed environment.

The body of the biobot functions as a bioreactor, nourishing and culturing the amoebal colony. The biobot has a biomorphic form, and the amoebal cerebellum is visible through the transparent bioreactor. The amoebae form a network within the bioreactor, ceasing individual behavior and functioning as a single larger multicellular organism in response to environmental stimuli. Together with an internal sensing unit and a computer, this amoebal network constitutes the nervous system of the biobot. The internal sensing unit is responsible for tracking amoebae movement, and the computer issues commands to the biobot legs in response to such movement. The biobot has six legs. When the amoebae move in the direction of a given leg, that leg contracts, causing the biobot to lean forward. Often one leg contracts while another stretches back to its original position, creating a more complex sequence of movements. Ascending and descending or leaning and stretching motion becomes a visual sign of amoebal activity.

The biobot also functions as the avatar of Web participants inside the environment. Independent of the movement of the biobot, Web participants are able to control its eye with a pan-tilt actuator. The autonomous ascending and descending or leaning and stretching motion provides Web participants with a new perspective on the environment. The overall perceivable behavior of the biobot is a combination of activity that takes place in the microscopic network of the amoebae and in the macroscopic human network. Humans and amoebae "meet" in the body of the biobot and affect each other's experience and behavior, producing through their coupling an ephemeral "consensual domain."[6]

## The View from Within

In the gallery, visitors are able to see the terrarium with transgenic creatures both from inside and outside the dome. As they stand outside the

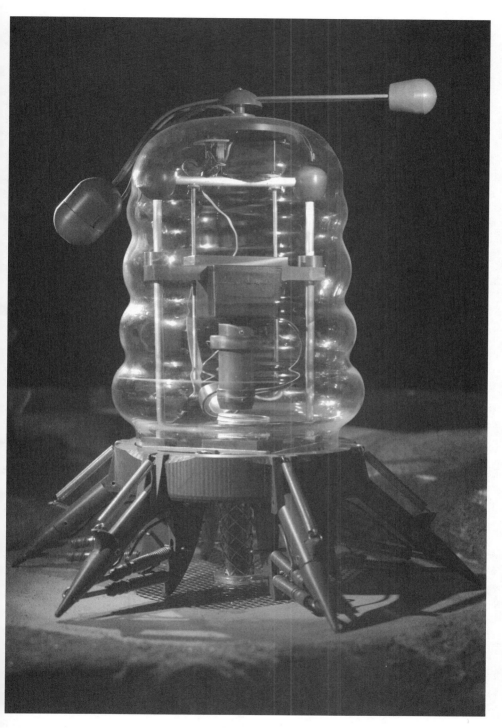
98. Eduardo Kac, *The Eighth Day,* transgenic work, 2001. Biobot close-up.

dome looking in, someone on-line sees the space from the perspective of the biobot looking out, perceiving the transgenic environment (fig. 99), the faces or bodies of local viewers. An on-line computer in the gallery also gives local visitors an exact sense of what the experience is like remotely on the Internet.

Local viewers may temporarily believe that their gaze is the only human gaze contemplating the organisms in the dome. However, once they navigate the Web interface they realize that remote viewers can also experience the environment from a bird's-eye point of view, looking down through a camera mounted above the dome. They can pan, tilt, and zoom, seeing humans, mice, plants, fish, and the biobot up close. Thus, from the point of view of the on-line participant, local viewers become part of the ecology of living creatures featured in the work, as if enclosed in a websphere (fig. 100).

By enabling participants to experience the environment inside the dome from the point of view of the biobot, *The Eighth Day* creates a context in which participants can reflect on the meaning of a transgenic ecology from a first-person perspective.

## The Transgenic Human Condition

The tangible and symbolic coexistence of the human and the transgenic shows that humans and other species are evolving in new ways. It dramatizes the urgent need to develop new models with which to understand this change and calls for the interrogation of difference, taking into account clones, transgenics, and chimeras.

The Human Genome Project (HGP) has made it clear that all humans have in their genome sequences that came from viruses,[7] acquired through a long evolutionary history. This shows that we have in our bodies DNA from organisms other than human. Ultimately, this means that we too are transgenic. Before deciding that all transgenics are "monstrous," humans must look inside and come to terms with their own "monstrosity," that is, with their own transgenic condition.

The common perception that transgenics are not "natural" is incorrect. It is important to understand that the process of moving genes from one species to another is part of wild life (without human participation). The best example is the bacterium called "agrobacterium," which enters the root of a plant and communicates its genes to it. Agrobacterium has the ability to transfer DNA into plant cells and integrate the DNA into the plant chromosome.[8]

*The Eighth Day* suggests that romantic notions of what is "natural" have to be questioned and that the human role in the evolutionary history of other species (and vice versa) has to be acknowledged, while at

99. Eduardo Kac, *The Eighth Day*, transgenic work, 2001. Web interface from inside.

100. Eduardo Kac, *The Eighth Day*, transgenic work, 2001. Web interface from above.

the same time respectfully and humbly marveling at this amazing phenomenon we call "life."

### Notes

1. *The Eighth Day* team: Richard Loveless, Dan Collins, Sheilah Britton, Jeffery (Alan) Rawls, Jean Wilson-Rawls, Barbara Eschbach, Julia Friedman, Isa Gordon, Charles Kazilek, Ozzie Kidane, George Pawl, Kelly Phillips, David Lorig, Frances Salas, and James Stewart. Additional thanks to Andras Nagy, Samuel Lunenfeld Research Institute, Toronto; Richard Firtel, University of California, San Diego; and Chi-Bin Chien, University of Utah, Salt Lake City.

2. It is important to point out that all organisms were in excellent health and had all of their needs taken care of on a daily basis, before, during, and after the exhibition.

3. This is true primarily in the United States, since many crops in the United States (e.g., corn, cotton, canola, and soy) are transgenic, but also increasingly in

other parts of the world, most notably Argentina, Canada, and China. In fact, the American Association for Health Freedom indicated in 2001 that more than 60 percent of processed food in the United States contains genetically engineered ingredients, including baking mixes, soft drinks, cereals, soups, cooking oils, salad dressings, juices, canned foods, crackers, snacks, and baby food. This figure was reinforced by a survey by the International Food Information Council.

4. The new pigs were created in Japan by a team coordinated by Norio Murata, a professor at the National Institute for Basic Biology. See "Scientists Insert Spinach Gene into Pigs to Cut Fat," *Mainichi Shimbun,* Jan. 24, 2002. The grapes with genes found in the silkworm larvae were developed to resist Pierce's disease by a team led by Dennis Gray, a University of Florida professor of developmental biology. On May 15, 2001, the U.S. Patent and Trademark Office issued a joint patent for the technology to the University of Florida and the U.S. Department of Agriculture. The potatoes with genes of bees and moths were developed to fight potato blight fungus, which caused the Great Irish Potato Famine of 1845. See Milan Osusky et al., "Cationic Peptide Expression in Transgenic Potato Confers Broad-Spectrum Resistance to Phytopathogens," *Nature Biotechnology* 17 (Nov. 1, 1999): 45; Trisha Gura, "Engineering Protection for Plants," *Science* 291 (Mar. 16, 2001): 2070.

5. The amoeba (*Dyctiostelium discoideum*) are also known as slime mold.

6. A "consensual domain" does not imply consensus; rather, it signifies consensuality, a coincidence of the sensuous. See note 13, chapter 14.

7. See T. A. Brown, *Genomes* (Oxford: Bios Scientific Publishers, 1999), 138; and David Baltimore, "Our Genome Unveiled," *Nature* 409 (2001): 814–16. In private email correspondence (Jan. 28, 2002), and as a follow-up to our previous conversation on the topic, Dr. Jens Reich, of Division of Genomic Informatics of the Max Delbruck Center in Berlin-Buch, stated: "The explanation for these massive [viral] inserts into our genome (which, incidentally, looks like a garbage bin anyway) is usually that these elements were acquired into germ cells by retrovirus infection and subsequent dispersion over the genome some 10 to 40 millions ago (as we still were early apes)." The HGP also suggests that humans have hundreds of bacterial genes in the genome. See International Human Genome Sequencing Consortium, "Initial Sequencing and Analysis of the Human Genome" *Nature* 409 (Feb. 15, 2001): 860. Of the 223 genes coding for proteins that are also present in bacteria and in vertebrates, 113 cases are believed to be confirmed. See page 903 of the same issue. In the same correspondence mentioned above, Dr. Reich concluded: "It appears that it is not man, but all vertebrates who are transgenic in the sense that they acquired a gene from a microorganism."

8. This natural ability has made a genetically engineered version of the agrobacterium a favorite tool of molecular biology. See L. Herrera-Estrella, "Transfer and Expression of Foreign Genes in Plants" (Ph.D. diss., Gent University, Belgium, 1983); P. J. J. Hooykaas and R. A. Shilperoort, "Agrobacterium and Plant Genetic Engineering," *Plant Molecular Biology* 19 (1992): 15–38.

# 16. Move 36

*Move 36*[1] makes reference to the dramatic move made by the computer called Deep Blue against chess world champion Gary Kasparov in 1997. This competition can be characterized as a match between the greatest chess player who ever lived and the greatest chess player who never lived. The installation sheds light on the limits of the human mind and the increasing capabilities developed by computers and robots, inanimate beings whose actions often acquire a force comparable to subjective human agency.

According to Kasparov, Deep Blue's quintessential moment in game two came at Move 36. Rather than making a move that was expected by viewers and commentators alike—a sound move that would have afforded immediate gratification—it made a move that was subtle and conceptual and, in the long run, better. Kasparov could not believe that a machine had made such a keen move. The game, in his mind, was lost.

The installation presents a chessboard made of earth (dark squares) and white sand (light squares) in the middle of the room. There are no chess pieces on the board. Positioned exactly where Deep Blue made its Move 36 is a plant whose genome incorporates a new gene that I created specifically for this work. The gene uses ASCII (the universal computer code for representing binary numbers as Roman characters, on- and off-line) to translate to the four bases of genetics Descartes's statement: "Cogito ergo sum" (I think therefore I am).

Through genetic modification, the leaves of the plants curl. In the wild these leaves would be flat. The "Cartesian gene" was coupled with a gene that causes this sculptural mutation in the plant, so that the public can see with the naked eye that the "Cartesian gene" is expressed precisely where the curls develop and twist.

The "Cartesian gene" was produced according to a new code I created especially for the work. In 8-bit ASCII, the letter C, for example,

---

Original appeared in *Kac Web* (2002); available at <http://www.ekac.org>.

101. Eduardo Kac, "Move 36," 2002–4, transgenic installation with plant and two digital video loops, dimensions variable (detail).

is 01000011. Thus, the gene is created by the following association between genetic bases and binary digits:

A = 00
C = 01
G = 10
T = 11

The result is the following gene with fifty-two bases:

CAATCATTCACTCAGCCCCACATTCACCCCAGCACT
CATTCCATCCCCCATC

The creation of this gene is a critical and ironic gesture, since Descartes considered the human mind a "ghost in the machine" (for him the body was a "machine"). His rationalist philosophy gave new imputus both to the mind-body split (Cartesian dualism) and to the mathematical foundations of current computer technology.

The presence of this "Cartesian gene" in the plant, rooted precisely where the human lost to the machine, reveals the tenuous border be-

102. Eduardo Kac, "Move 36," 2002–4, transgenic installation with plant and two digital video loops, dimensions variable (partial view).

tween humanity, inanimate objects endowed with lifelike qualities, and living organisms that encode digital information. A single parallel light beam shines delicately over the plant. Silent square video projections on two opposing walls contextualize the work, evoking two chess opponents in absentia. Each video projection is composed of a grid of small squares, resembling a chessboard. Each square shows short animated loops cycling at different intervals, thus creating a complex and carefully choreographed thread of movements. The cognitive engagement of the viewer with the multiple visual possibilities presented on both projected boards subtly emulates the mapping of multiple paths on the board involved in a chess match.

A game for phantasmic players, a philosophical statement uttered by a plant, a sculptural process that explores the poetics of real life and evolution. This installation gives continuity to my ongoing interventions at the boundaries between the living (human, nonhuman animals) and the nonliving (machines, networks). Checkmating traditional notions, "Move 36" reveals nature as an arena for the production of ideological conflict—and the physical sciences as a locus for the creation of science fictions.

Note

1. *Move 36* was commissioned by the Exploratorium, San Francisco, and was made possible by the National Endowment for the Arts with additional funding from the National Science Foundation and Creative Capital Foundation, New York. In 2004 *Move 36* was exhibited as follows: Exploratorium, February 26 to May 31; Gwangju Biennale, Korea, 10 September to 13 November; and XXVI Bienal de São Paulo, Brazil, September 25 to December 19. In the first half of 2005 *Move 36* was exhibited at Centro Cultural Conde Duque, Madrid, January 18 to February 20, 2005 and at Center for Art and New Technologies, Las Palmas de Gran Canaria, Canary Island, Spain (June 23 to July 31, 2005).

# Biographical Note

Eduardo Kac is internationally recognized for his interactive net installations and his bio art. A pioneer of telecommunications art in the pre-Web eighties, Eduardo Kac (pronounced "Katz") emerged in the early nineties with his radical telepresence and biotelematic works. His visionary combination of robotics and networking explores the fluidity of subject positions in the postdigital world. His work deals with issues that range from the mythopoetics of on-line experience (*Uirapuru*) to the cultural impact of biotechnology (*Genesis*); from the changing condition of memory in the digital age (*Time Capsule*) to distributed collective agency (*Teleporting an Unknown State*); from the problematic notion of the exotic (*Rara Avis*) to the creation of life and evolution (*GFP Bunny*).

At the dawn of the twenty-first century Kac shocked the world with his "transgenic art"—first with a groundbreaking net installation entitled *Genesis* (1999), which included an "artist's gene" he invented, and then with his fluorescent rabbit called Alba (2000). He followed up with *The Eighth Day* (2001), an ecology of transgenic fluorescent organisms that included a biological robot, and *Move 36* (2002–4), an impossible match on a chessboard of sand and soil with a new plant of his own creation. From his first on-line works in 1985 to his convergence of the digital and the biological, Kac has always investigated the philosophical and political dimensions of communication processes. Equally concerned with the aesthetic and the social aspects of verbal and nonverbal interaction, in his work Kac examines linguistic systems, dialogic exchanges, and interspecies communication. Kac's pieces, which often link virtual and physical spaces, propose alternative ways of understanding the role of communication phenomena in creating shared realities.

Kac merges multiple media and biological processes to create hybrids from the conventional operations of existing communications systems. Kac first employed telerobotics in 1986, motivated by a desire to convert electronic space from a medium of representation to a

medium for remote agency. He creates pieces in which actions carried out by Internet participants have direct physical manifestation in a remote gallery space. Often relying on the indefinite suspension of closure and the intervention of the participant, his work encourages dialogical interaction and confronts complex issues concerning identity, agency, responsibility, and the very possibility of communication.

Kac's work has been exhibited internationally at venues such as Exit Art and Ronald Feldman Fine Arts, New York; Maison Européenne de la Photographie, Paris; OK Contemporary Art Center, Linz, Austria; InterCommunication Center (ICC), Tokyo; Museu de Arte Contemporânea, São Paulo; Museo de Arte Moderno de México, Mexico City; Fundación Telefónica, Madrid; Henry Art Gallery, Seattle; Le Lieu Unique, Nantes, France; and Seoul Museum of Art, Korea. Kac's work has been showcased in biennials such as First Yokohama Triennial, Japan; Bienal de São Paulo, Brazil; and Gwanju Biennale, Korea. His work is part of several private collections as well as public collections such as the Museum of Modern Art, New York; MIT Museum, Cambridge; and the Museum of Modern Art, Rio de Janeiro, among others.

The recipient of many awards, Kac lectures and publishes worldwide. His work is documented on the Web in eight languages: <http://www.ekac.org>. Eduardo Kac is represented by Julia Friedman Gallery, New York; Laura Marsiaj Arte Contemporânea, Rio de Janeiro; and Galerie J. Rabouan Moussion, Paris.

# Index

Abe, Shuya, 170, 172–73, 175
Adrian, Robert, 41–42, 54n13, 60
*Aequorea victoria*, 218, 225–28, 237, 266, 276n2. *See also* green fluorescent protein (GFP)
aesthetics, 4, 50, 95, 271
agrobacterium, 292, 294n8
Alba, 264–66, 271–73. *See also* GFP Bunny
albino animals, 266–70, 274, 278n7
algorithms, 100
*Alice Sat Here* (Sobell & Hartzell), 183–84
*AlienSpace* (Novak), 73–74
*Altamira* (Ramiro), 43–44
alterity, 271–75
American Rabbit Breeders Association (ARBA), 270
American Standard Code for Information Interchange (ASCII), 66, 71, 295
Anastasi, Bill, 172
*Animation Presse* (Forest), 116–18
Apollinaire, Guillaume, 138
*A-positive* (Bennett & Kac), 218, 225–28
Aristotle, 274–75, 282n21
Ars Electronica, 41, 74–75, 79, 98–101, 160, 254
art, 20, 61, 111–14, 151–52; and biology, 218; and bodies, 227; and dialogism, 103–4; material vs. immaterial, 60, 156–57; participatory, 109–10, 161, 271; and society, 77, 275–76. *See also* robotic art; transgenic art
*Art-Accès* (Orlan), 66
Art by Telephone (exhibit), 24–28, 29

"Arte de los medios de communicación, Un" (Costa, Escari, & Jacoby), 35–36
art events, 3–4, 7
artificial life, 98–100
artists, 6, 50, 60, 192
artist's gene, 249–54
artist's protein, 257
Art Reseaux, 41, 46–50
Ascott, Roy, 7, 36, 38–41, 51
Asimov, Isaac, 168
avatars, 73, 94–96, 209
Avery, Jean-Christophe, 60
*A-Volve* (Sommerer & Mignonneau), 98–100
Aztecs, 83–84, 268–69

Baader, Johannes, 28
*Babel* (Ferraz), 69
bacteria, 251–54, 262n3, 292, 294n8
Baird, John Logie, 21
Bakhtin, Mikhail, 110, 112–13, 121nn5, 7, 122n21; and dialogism, 106–7, 120n1, 271, 280n10
Barthes, Roland, 38
Bartlett, Bill, 53n5
batbot, 202–5, 212n10
bats, 202–5, 213n11, 279n9
*Battle of Rhythms* (Marinetti & Masnata), 52
Baudrillard, Jean, 16, 53n6, 55n28, 139–43
Bauhaus, 17, 21, 97–98
Baxter, Iain, 25–27, 115
Baxter, Ingrid, 115
Bear, Liza, 53n5, 60, 118–20
Bec, Louis, 266, 277n3
Bell, Alexander Graham, 32–34

Bennett, Ed, 142; and *A-positive*, 225; and *Ornitorrinco*, 129, 131–32, 147, 151, 158; and *Ornitorrinco in the Sahara*, 200–201; and *Ornitorrinco, the Webot . . . and Back*, 195–97. See also Kac, Eduardo; telerobotics
Benveniste, Emile, 271, 280n12
*Berlin, Symphony of a Great City* (Ruttmann), 8–9
Berlin Radio, 12
Bible, the, 261n1
biblical gene, 249–54
Bienal de São Paulo, 116, 118
bio art, xi, 237
biocybernetics, 170
biodiversity, 237, 245n2, 266, 270, 286
bioimplants, 228
biological warfare, 275
biology, 100, 217, 227, 274, 281n13; and Morse code, 261n2
biometrics, 227, 232
biopiracy, 275
biopolitics, 276, 285n31
biorobotics, 218, 225–28, 286, 290–91. See also robotic art; telerobotics
biosemiotics, 218
biotechnology, 217, 236, 271, 276
biotelematics, 218, 221–25, 232. See also telematics
*Blade Runner* (Scott), 169
Bleus, Guy, 32
Blumenkranz-Onimus, Noëmi, 13
bodies, 78–79, 92–96, 233, 296; and telepresence, 193, 198–201, 227
*Bodies© INCorporated* (Vesna), 94–96
*Book of Mutations, The* (Kac), 255–56, 259–60
botany, 178
*Bourse de l'Imaginaire, La* (Forest), 66–67
*Bowling Alley* (Cheang), 81
Brecht, Bertolt, 9–12, 108, 120
Brecht, George, 23–24
breeding, 237–42, 247n12, 274; and rabbits, 267–70; and transgenic art, 270–71
Breland, Bruce, 7, 41, 53n3
Breton, André, 108
Broeckmann, Andreas, 71–73
Brooks, John, 33

Bruscky, Paulo, 30–32, 63
Bryson, Norman, 149
Buber, Martin, 106, 112–13, 121nn4, 5, 278n8; and dialogism, 271; and human vs. animal, 274–75, 284n27
*Buck Rogers in the Twenty-fifth Century A.D.* (Nowlan), 138
bunnies. See *GFP Bunny*; rabbits
Burbank, Luther, 241
Burgy, Don, 38
Burnham, Jack, 89
Byars, James Lee, 25, 28–29

Calkins, Richard, 138
Canal 21 (television station), 229
Capek, Karel, 168
Cartesian gene, 295
Carvalho, Flávio de, 60, 62, 233
Cavalcanti, Alberto, 8
Cavellini, Guglielmo, 64–65
censorship, 16
Champollion, Jean François, 256
Cheang, Shu Lea, 80–81
*Children and Communication* (Whitman), 116
chimeras, 73–74, 242–43, 264
*Chimerium* (Hoberman & Fisher), 73–74
China, 140, 145–46
*City Portraits* (O'Rourke), 46, 48
city symphonies, 8–9
Clark, Lygia, 104
Clert, Iris, 30, 64
cloning, 217–18, 246n8, 286
communication, 3–8, 51, 103–20, 182; and Art by Telephone, 24–28; and biosemiotics, 218; and dialogism, 108–14, 120; and electronic art, 114–20; and *GFP Bunny*, 266; interactivity, 104–6, 280n12; interspecies, 202–5, 219–21, 237, 243, 274, 279n9; and mass media, 139–42; and Moholy-Nagy, 20; and monologism, 106–8; "post-symbolic," 8, 54n14; and radio, 11–12; satellite, 140; and space, 151–52, 219–21; speed of, 52n1; and telematics, 103; and telepresence, 127, 139–42, 161–62, 192–93
community, 70, 76, 191
computers, 88–89, 127, 175, 219
Computer Technique Group, 88

# Index

conceptualism, 4, 25, 27
Concrete Music, 9, 14
conformity, 60–61
*Connect* (Prado), 46–47, 50
consciousness, 106, 148, 273, 279n9, 283n22
consensualism, 281n13, 290
*Construction of a Silence, The* (Marinetti & Masnata), 52
constructivism, 16–24, 98
Cooper, Gene, 78–79
Cosic, Vuk, 71–73
Costa, Eduardo, 34–36, 37, 57n52
*Crime Wave* (SRL), 178
crossbreeding. *See* breeding
Crotti, Jean, 28, 30
culture, 5–6, 69–70, 160
CU-SeeMe (software), 61, 78
Cutie (Asimov), 168
cybernetics, 137, 178
cyberspace, 136–39, 145, 148, 163, 194
Cyberware, 96
*CYSP I* (Schöffer), 170–71

*Dada Almanac, The* (Huelsenbeck), 16, 28
Dadaism, 16, 28–30, 55n29, 62
"Dada Salon" (Tzara), 28
dance, 43–44, 118–19
D'Annunzio, Gabriele, 28
Darié, Sandú, 109
*Darker Than Night* (Kac), 202–5
databases, 94–96
Davies, Char, 89–92, 101
Davis, Douglas, 116–17
Dax (Digital Art Exchange), 41, 53n3
*Dax Dakar d'Accord* (Dax), 41
*Deca-Dance* (Stelarc), 179
Deep Blue, 295
dematerialization, 57n52, 156
Denki, Imasen, 179
Depero, Fortunato, 13
Derrida, Jacques, 50, 56n9, 137, 142
Descartes, René, 274–75, 283n22, 295–96
*D/e/u/s* (Kac), 67
Develay, Frédéric, 66
dialogism, 3, 103–20, 127; and biorobotics, 225–28; and collaborative art, 106–8; and electronic art, 114–20, 193–94; and

interactivity, 103–4, 109–12; interspecies, 202–5; and novel, 106–7; and *Ornitorrinco*, 129–35; and politics, 112–14, 116–17; and *Rara Avis*, 84–86, 162–66; and RC Robot, 128–29; and telephone, 23–24, 32–34; and transgenic art, 237, 271; and *Uirapuru*, 203, 206–10
Dialogues exhibit (Kac), 219
Dietz, Steve, 225
digital art, 17–18, 260
Dittborn, Eugenio, 64
DNA, 227, 232, 262n4, 292; and *Genesis*, 249–52, 256–58, 262nn5, 7; and indigenous peoples, 235n16; as "master molecule," 276; and microinjection, 282n17; and Morse code, 262n2; and *Transcription Jewels*, 257; and transgenic art, 241–42, 266
dogs, 237–42, 246nn8, 10
domestication, 267–70, 272. *See also* breeding
Donasci, Otávio, 41, 43, 45–46, 128
*Drama of Distance* (Marinetti & Masnata), 52
Duchamp, Marcel, 4, 24, 28, 30, 62
Duchamp, Suzanne, 28, 30
Dudesek, Karel, 76–77

Eastwood, Tom, 208
ecology, 191. *See also* Net ecology
Egypt, 240, 256, 268
Egyptian fruit bats, 202–5, 212nn7, 10. *See also* bats
*Eighth Day, The* (Kac), 286–94; and biorobotics, 290–91; and evolution, 292–93; and transgenic ecologies, 286–90
electronic art, 104–5, 106–8, 114–20, 136
*Electronic Garden #2* (Seawright), 177
*Electronic Peristyle* (Seawright), 176
*Elektrische Fernsehen und das Telehor, Das* (Mihály), 21
empathy, 112. *See also* telempathy
*Encryption Stones* (Kac), 255–56, 258
endangered species, 237, 245n1
environment, 78–79, 100, 133–34, 137, 155
Enzensberger, H. M., 6, 53n4
*Éphémère* (Davies), 92

*Epizoo* (Roca), 92–94
Ernst, Max, 150
Escari, Raúl, 35–36
*Essay Concerning Human Understanding* (Kac & Nakamura), 218, 219–21
*Essay Concerning Human Understanding* (Locke), 283n23
ethology, 271, 278–79n9
eugenics, 244, 275
events, 3–4, 7
event scores, 23–24
Evoluon, 175
evolution, 100, 266, 273, 292–93, 297
exoskeleton, 92–93
exoticism, 162
"Experiment in Autobiography" (Wells), 33
Experiments in Art and Technology (E.A.T.) (Kluver & Rauschenberg), 116
extremophile, 100
"Eye and Mind" (Merleau-Ponty), 148

facsimile service, 20
Fadon, Carlos, 41, 43, 45, 53n3
Fascism, 12
*Fashion Fiction I* (Costa), 35, 37
Ferguson, Gerald, 115
Ferraz, Flávio, 67, 69
fiber optics, 34
film, 8–9, 59
*First Catastrophe of the Twenty-First Century, The* (Paik), 172
"First Public Display of Television" (Baird), 21
*First Work of Media Art* (Costa, Escari, & Jacoby), 35–36
Fisher, Scott, 73–74
Flusser, Vilèm, 113
Fluxus, 23–24, 64, 117
flying fish, 207–8
Fontana, Lucio, 21–22
Food and Agriculture Organization (FAO), 285n30
*Forbidden Planet* (Wilcox), 169
Forest, Fred, 7, 54n12, 66–67, 80–81, 116–18
Foresta, Don, 41
*Fossil Folds* (Kac), 255–58, 259
*Fractal Flesh* (Stelarc), 81–82
*Frankenstein* (Shelley), 168
Friedman, Ken, 117–18

*From Casablanca . . . Electronic Media* (Forest), 81
Fura dels Baus, La, 180
"Future Eve" (Villiers de l'Isle-Adam), 168
Futurism, 12–14, 52, 62
*Futurismo* (periodical), 12–13

Gablik, Suzi, 112
Galatea, 168
Galba, Servius Sulpicius, 267–68
geep (chimera), 242
Gena, Peter, 251
genes, 249–54, 262n4. *See also* DNA; genetic engineering
*Genesis* project (Kac), 249–63; gene creation, 249–54; *Genesis* protein, 254–55; Phase 1, 249–54; Phase 2, 254–55; Phase 3, 255–60; proteomic development, 255–60
gene therapy, 275–76, 285n29
genetic engineering, 217–18, 234n1, 236, 247n15; and animality, 275; and crops, 241, 287–88, 293n3; and *Eighth Day*, 249–54, 286; ethics of, 237, 243–44, 252, 266; and fertility, 248n25; and *GFP Bunny*, 270, 274; and transgenic art, 241–44
genomes, 254
German avant-garde, 9–12
*GFP Bunny* (Kac), 264–85; and Alba, 264–66, 271–74; and alterity, 273–75; and human-rabbit association, 267–70
*GFP K-9* (Kac), 237–38, 246n8
Gibson, William, 81, 137
Gidney, Eric, 7, 53n5
Gilardi, Piero, 104–5
global exchange, 7–8
Goebbels, Joseph, 9
Goering, Hermann, 10
Goldberg, Ken, 78, 97–98, 100–101, 182–83
Golem, 168
Gómez-Peña, Guillermo, 83–84
*Grande Milano tradizionale e futurista, La* (Marinetti), 13–14
Greenberg, Clement, 110
green fluorescent protein (GFP), 264, 273, 276n2; *Aequorea victoria*, 218, 225–28, 237, 266, 276n2; EGFP (enhanced variety), 266; and *Eighth Day*, 286–90

Grosz, George, 28
Grundmann, Heidi, 79–80
Guillot, Jean-Baptiste, 241
Gulf War (1991–92), 140, 146
Gunkel, Pat, 138
*Gyros* (Moholy-Nagy), 109

Habermas, Jürgen, 280–81n12
*Hands Writing* (Stelarc), 179
hares, 268. *See also* rabbits
Hartzell, Emily, 182–83
Heckert, Matthew, 178
Heemskerk, Joan, 71–72
Heinlein, Robert, 138, 141, 168
*Helpless Robot* (White), 176
Hoberman, Perry, 73–74
Höch, Hannah, 9
Hopper, Robert, 33–34, 57n50
*Horizontal Radio* (Stocker & Grundmann), 79–80
Houdebine, Louis-Maire, 266, 277n4
Houseman, John, 14
*House Plants* (Seawright), 177–78
Huelsenbeck, Richard, 16, 28
Human Genome Project (HGP), 292, 294n7
humanity, 274–75
human-machine interface, 94, 114–15, 189, 202, 227, 233
human vs. animal, 14–15, 21–26, 274–75, 279nn9–12
Huot, Robert, 25, 28
Husserl, Edmund, 113
hybridization, 76–81, 130, 155, 161; and breeding, 241–42; and genetics, 218, 245n1; and robotics, 169, 225
hybrid roses, 241–42, 246n12
hypermedia, 51, 61
hyperreality, 16, 55n28, 141
hyperspace, 5

"I Am a Man" (Jacoby), 35, 58n57
*I and Thou* (Buber), 121n4, 278n8, 284n27
Ihnatowicz, Edward, 170, 172, 174–75, 184
individualism, 111–14
*Infest* (Le François), 47
information highway, 197
*In One Year and Out the Other* (Friedman), 117–18
*In Our Own Image* (Kac), 255–56, 260

interactive art, 51, 88–101, 103, 140, 172; and artificial life, 98–100; and avatars, 94–96; and radio, 11–12; and telepresence, 97–98, 136; and transgenics, 243; and virtual reality, 89–94. *See also Ornitorrinco* works
Interactive Brain-Wave Visual Analyzer (IBVA), 219
Internet, 65, 75, 141, 160, 191; chat rooms, 61, 94–95; and dialogism, 106–8, 120; and DNA, 232; and *Eighth Day*, 292; email, 61; and *Genesis*, 251, 253; and Goldberg, 97; and hybridization, 76–81; and MBone, 81–86; and Net art, 69–72, 74–76; and *Ornitorrinco*, 157–61; and radio, 79–80; and *Rara Avis*, 84–86, 162–66; as social space, 59, 70; and telematics, 221–22, 224; and *Uirapuru*, 210; and videotext, 66–69; and virtual reality, 73–75. *See also* World Wide Web
intersubjectivity, 273, 280–81n12
in vitro fertilization (IVF), 237, 246n8
*IO* (Kac), 74
I. P. Sharp (time-sharing system), 38, 41
*Is Anyone There?* (Wilson), 47, 49
Italian Futurists, 12–14, 52, 62

Jacoby, Roberto, 34, 35–36, 38, 57n52
Jakobson, Roman, 52–53n2, 104
Jenkins, Francis, 21
*Joan, l'Hombre de Carne* (Roca & Jorda), 180–81
jodi.org (Heemskerk & Paesmans), 71–72
Johnson, Ray, 62–63, 65
Jorda, Sergi, 180–81
journalism, 145–46

Kac, Eduardo, 53n3, 66–68, 74–75, 127–35, 142; and Alba, 264–66; and *A-positive*, 225–28; and *GFP K-9*, 237–38; and *Ornitorrinco*, 129–35, 157–61, 195–98, 200–202; and *Rara Avis*, 84–86, 162–66; and RC Robot, 128–29; and *Teleporting an Unknown State*, 218, 221–25; and *Telepresence Garment*, 198–201; and *Time Capsule*, 228–33; and *Uirapuru*, 203, 206–10; and virtual reality, 146–47;

Kac, Eduardo (*continued*)
See also *Eighth Day*; *Genesis* project; *GFP Bunny*; *Move 36*; titles of other individual works
Kanayama, Akira, 170
Kant, Immanuel, 274–75, 284n25
Kaprow, Allan, 60
Kasparov, Gary, 295
Kato, Ichiro, 179
Kawara, On, 30
kinetic art, 109, 170, 176–78
Klein, Yves, 62
Kluver, Billy, 116
Koch, Howard, 14
Kohmura, Masao, 88
Korn, Arthur, 20
Kosice, Gyula, 109–10
Kosuth, Joseph, 25, 26–27, 150
Kriesche, Richard, 80–81, 83
Krotoszynski, Laly, 43

Laañ, Diyi, 109
Lacy, Suzanne, 104, 121n3
Lang, Fritz, 169
language, 32–34, 106–8, 147, 274; and autopoiesis, 281n13; and Benveniste, 280n12; computer, 71–72; and Descartes, 283n22; and humans, 279n9; and Rosetta Stone, 254–55
Lanier, Jaron, 8, 54n14, 137, 152n3
Le François, Christophe, 46–47
Leibniz, Gottfried Wilhelm von, 274–75, 283n24
Lerner, Nathan, 97–98
Levinas, Emmanuel, 271, 282n14
life, 98–100, 257, 272; eternal, 233; and transgenic art, 270, 275, 293
*Light on the Net* (Fujihata), 81
*Light Painting* (Moholy-Nagy), 109
*Light-Space Modulator* (Moholy-Nagy), 20
Limbless Suit (Kac), 200–201
Lindbergh, Charles, 9–12
*Lindberghflug, Der* (Brecht), 9–11, 108
Locke, John, 274–75
Lovink, Geert, 160
Lucas, George, 169
Lütjens, Ole, 77

macaws, 162, 242, 246–47n12
Macintosh computer, 89, 219

macowl, 162–65
Madi movement, 109–10
mail art, 62–65, 127
*Manifesto della radio* (Marinetti & Masnata), 12–13
Marck, Jan van der, 24, 26
Marcus, Aaron, 116–17
Marinetti, Filippo, 12–14, 52, 55n25
Mars, exploration of, 187–90
Marshall, Jules, 77
Martin, Frédéric, 66
Mascha, Michael, 78
Masnata, Pino, 12–13, 14, 52
*Matéria Prima* (television show), 45
Maturana, Humberto, 271, 281n13
MBone. *See* Multicast Backbone
McLuhan, Marshall, 33–34, 57n51, 141
media, 3, 6, 35, 136–37, 168; and alienation, 195, 212n3; and Baudrillard, 53n6; and censorship, 53n4; and dialogism, 103, 107; mass media, 4, 16, 137, 161, 211n2; and McLuhan, 57n51; mediascape, 77, 82, 104, 194, 232; and *Ornitorrinco*, 157, 161; and telepresence, 139–42, 155–56, 161. *See also* film; radio; television; theater
"Media Art, A" (Costa, Escari, & Jacoby), 35, 57n54
*Mediamatic* (magazine), 77
medicine, 236
Medvedev, Pavel Nikolaevich, 113
memory, 137, 228–30, 232–33
*Ménage* (White), 175
*Mensage* (Jacoby), 35, 38
*Mercury Project* (Goldberg & Mascha), 78, 97
*Mercury Theater on the Air, The* (radio show), 14–16
Merleau-Ponty, Maurice, 143, 148–49, 280n12
Messiaen, Olivier, 208
*Metaphysics of Morals, The* (Kant), 284n25
*Metropolis* (Lang), 169
Meyrink, Gustav, 168
microchips, 228–31, 233
Mignonneau, Laurent, 98–101
Mihály, Dénes von, 21
military, 145–46
Millet, Isabelle, 46, 48

mind, 148. *See also* consciousness
Minitel, 66–69
Minsky, Marvin, 138
Minujin, Marta, 34–35
Miracle (white buffalo), 278n7
Mirapaul, Matt, 75
Miró, Joan, 150
mnemotechnics, 228
Moholy-Nagy, Laszlo, 16–25, 97–98, 109, 114; and SSTV, 20–22; and telephone pictures, 16–20, 23–25
Moholy-Nagy, Lucia, 18–19
Moholy-Nagy, Sibyl, 18–19, 109
Moles, Abraham A., 145
monologism, 104, 107–8, 121n1. *See also* dialogism
moon, exploration of, 149–52
Moorman, Charlotte, 172
Morse code, 249–51, 256, 261n2. *See also Genesis* project
Mosaic (Web browser), 59
*Mountain Bike with Force Feedback for Indoor Exercise* (VR system), 146–47
*Move 36* (Kac), 295–97, 298n1
movement, 148–49. *See also* vision
Movie-Drome (VanDerBeek), 25
Mulheres series (Zangirolami), 69–70
Multicast Backbone (MBone), 61, 82–86, 87n39, 163
multicasting, 81–86
multilogism, 107–8
music, 9, 14
mutation, 251, 260, 270
mythology, 168, 242–43

*Naftazteca, El: Cyber TV for 2000 a.d.* (Gómez-Peña), 83–84
Nakamura, Ikuo, 219–21
NASA (National Aeronautics and Space Administration), 145, 148, 187–88
*Natureza Morta ao Vivo* (Fadon), 43, 45
Nazism (National Socialism), 9, 12, 112, 113
Net art, 69–72, 74–76
Net ecology, 191–94, 203, 206–10, 221–25
N. E. Thing Company (NETCO), 25, 27, 115, 123n28
netlife, 156–57, 161n1
Nettime discussion list, 75

*Network III* (Seawright), 176
networking, 42–46, 104, 127, 163; and Art Reseaux, 46–50; and Ascott, 36, 38–41, 51; and digital art, 32, 66–69; and mail art, 62–65; and MBone, 82–85
*Neuromancer* (Gibson), 81, 137
Neves, Nelson das, 67, 69
New York Correspondence School, 62
Nietzsche, Friedrich, 274–75, 284n26
Nixon, Richard, 116
Novak, Marcos, 73–74
novels, dialogism and, 106–7
Nowlan, Philip Francis, 138

on-line message boards, 5
*Opus I, II, III, IV* (Ruttmann), 8
Orlan (artist), 66
Ornitorrinco, 129–35, 194–98, 211n2
*Ornitorrinco (Experience I)* (Kac), 130
*Ornitorrinco in Copacabana* (Bennett & Kac), 130, 132
*Ornitorrinco in Eden* (Bennet & Kac), 78–79, 157–61
*Ornitorrinco in the Sahara* (Bennett & Kac), 200–202
*Ornitorrinco on the Moon* (Bennett & Kac), 149–52
*Ornitorrinco, the Webot, Travels . . . from Turkey to Peru and Back* (Bennett & Kac), 195–98
O'Rourke, Karen, 7, 46, 47–49
*Osmose* (Davies), 89–92
Osthoff, Simone, 200, 202

Padin, Clemente, 64
Paesmans, Dirk, 71–72
Paik, Nam June, 60, 114, 184; and *K-456*, 170, 172–73, 175, 185n11
*Painting, Photography, Film* (Moholy-Nagy), 20
"Palace" (chat room), 94–95
parolibero (words-in-freedom), 13
participant, 5, 11, 136, 161, 172. *See also* interactive art
patenting, 244
*Pathfinder* (robot), 187–90
Pauline, Mark, 178
Peirce, Charles Sanders, 218, 283n22
Penny, Simon, 184
perception, logistics of, 143, 148–49
performative ethics, 254
*Petit Mal* (Penny), 184

phlebot, 225
phonocentrism, 33, 56–57n49
photogram, 97–98
photosynthesis, 222, 224
Phototelegraphic Apparatus (Mihály), 21
phototelegraphy, 20–21
*Piazza Virtuale* (Ponton), 76–77
pigs, 242, 294n4
pingbirds, 207, 210, 213n14
*Plaisir du texte, Le* (Barthes), 38
plants, 178, 234n8, 242; and *Eighth Day*, 287–88; and genetic engineering, 218, 222, 241, 293n3; hybrid roses, 241–42, 246n12; and *Move 36*, 297
plasticity, 236
*Plissure du Texte, La* (Ascott), 38, 40
Plunkett, Edward, 62
"Poésie Futuriste Italiene, La" (Blumenkranz-Onimus), 13
poetry, 12–14, 25, 52, 62, 74
Poincaré, Jules Henri, 114
Ponton European Media Art Lab, 76
Popper, Frank, 38
postage stamps, 62, 64–65
postal system, 61, 127
potatoes, hybrid, 241
Prado, Gilbertto, 41, 46, 50
"Precession of Simulacra" (Baudrillard), 141
*Primera obra de un arte de los medios de communicación* (Costa, Jacoby, & Escari), 35–36
process, 3, 8
protein, 254–55, 257, 262n4. See also DNA
Protein Data Bank (PDB), 255
proteoglyphs, 259
proteomics, 254–55, 257
Prunet, Patrick, 266, 277n4

Quin, Arden, 109

rabbits, 266–70, 274; breeding of, 267–70. See also *GFP Bunny*
*Rabot* (Pauline), 178
radio, 8–16, 33, 79–80, 108; and Futurism, 12–14, 52; and theater, 9–12; and Welles, 14–16
"Radiomovies" (Jenkins), 21
Ramiro, Mario, 41, 43–44

*Rara Avis* (Kac), 84–86, 162–66
Rauschenberg, Robert, 30, 116
RC Robot (Kac), 128–29
*Reabracadabra* (Kac), 66–68
real space and time, 136, 142–46, 153n22, 188–89; and telepresence, 156, 161
*Recaos* (Kac), 67
reductionism, 244, 275
*Refresh* (Web site), 71–73
relativity, 104, 113, 189, 273
remote agency, 161–66. See also telepresence
Renaissance perspective, 148
*Rendez-vous du dimanche 6 fevrier 1916* (Duchamp), 62
Riefenstahl, Leni, 9
"Rien que les heures" (Cavalcanti), 8
RNA, 257. See also DNA
Robbe-Grillet, Alain, 28–29
*Robocybernétique* (television program), 170
robotic art, 168–86, 186n21; emergence of, 175–78; genesis of, 170–75; and telecommunication, 181–85; and theater, 178–81
robotics, 127, 168–69, 227–28. See also telerobotics
*Robot K-456* (Abe & Paik), 170, 172–73, 175, 185n11
Roca, Marcel.lí Antúnez, 92–94, 101, 180–81, 186n21
Ronell, Avital, 32–33
roses, hybrid, 241–42, 246n12
Rosetta Stone, 254–55
Roth, Richard, 146
*Roÿi* (Kosice), 109–10
*Running Cola Is Africa* (Kohmura & Tsuchiya), 88
*R.U.R.* (Capek), 168
Russolo, Luigi, 13
Ruttmann, Walter, 8–9

Santiago, Daniel, 30
Saussure, Ferdinand de, 33–34, 57n50, 106
Schöffer, Nicolas, 170–71
science, 148, 155, 192, 217, 243–44
Scott, Ridley, 169
*Searcher* (Seawright), 176–77
Seawright, James, 176–78
*Secret* (Kac), 74
self-historification, 64–65

# Index

*Send/Receive* (Bear, Sharp, & Sonnier), 118–19
*Senster, The* (Ihnatowicz), 170, 172, 174–75
*ShadowServer* (Goldberg), 97–98
Shannon, C. E., 5, 52n1
Shannon, Tom, 170, 172, 174–75, 184
*Shared Dolor* (Gilardi), 104–5
Sharp, Willoughby, 118–20
Shelley, Mary, 168
Sherman, Tom, 41
Shubin, Dmitry, 202
Shulgin, Alexei, 71–73
Siggraph (gallery), 130, 133, 146, 221
"Signature Event Context" (Derrida), 142
simulation, 146–49, 194
*Simultaneidad en simultaneidad* (Minujin), 34
slow-scan television (SSTV), 20–22, 41, 44, 118–19, 127
Sobell, Nina, 182–83
social relations, 6, 163, 167n8, 272
software, 88–89
*Sojourner* (robot), 188–90
Sommerer, Christa, 98–101
sonar, 212–13n10
Sonnier, Keith, 118–20
space travel, 149–50, 187–90
Spatialism, 21–22. *See also* real space and time
speech, 107, 198
speed, 144–45. *See also* real space and time
*Squat* (Shannon), 170, 172, 174–75
Stalin, Joseph, 112
*Star Wars* (Lucas), 169
Stelarc (artist), 80–82, 178–80
stimulation, 146–49
Stocker, Gerfried, 79
Strabo, 267
subjective cartography, 151
surveillance, 145–46, 229
Survival Research Laboratories (SRL), 178–79
Sutherland, Ivan, 89
symbiosis, 225–28

*Talk-Out!* (television show), 116–17
technology, 7, 16, 51, 192, 229; and bodies, 34, 233, 236; and ethics, 217; privatization of, 77–78; and virtual reality, 89, 156. *See also under specific technology*
technomessianism, 142–43
technophobia, 142
telecommunications, 3–8, 51, 78, 140, 182; and Art by Telephone, 24–28; and dialogism, 120; interspecies, 219–21; and Moholy-Nagy, 20; negative use of, 145–46; and telepresence, 127, 161–62, 192–93. *See also* communication
telecopier, 25, 115
*TeleGarden* (Goldberg), 97, 182–83
telegraphy, 28, 51, 62, 182; Telegraph Exchange (telex), 16, 25, 30–32
telematics, 5–6, 34, 76, 103, 108; biotelematics, 218, 221–25, 232; and Goldberg, 97; and interspecies communication, 219–21; and Kriesche, 81
*Telematic Sculpture* (Kriesche), 81, 83
telempathy, 202, 212n6
teleoperation, 194, 235n14
*Telephonbild* (Moholy-Nagy), 18
telephone, 16, 24, 61, 78, 115; and dialogism, 32–34, 116–18; and *Ornitorrinco*, 129–35, 150, 157–61; pictures, 16–20, 23–25, 47; teleconferencing, 5, 81; and *Telepresence Garment*, 200; videophone, 146, 200
*Teleporting an Unknown State* (Kac), 161n1, 218, 221–25
telepresence, 78, 136–39, 153n20; and communication, 120, 139–42; and culture, 192–94; and interactive art, 97–98; and space travel, 187–90; and telerobotics, 148–49, 193–94; and time, 142–46
"Telepresence" (Minsky), 138
"Téléprésence, naissance d'un nouveau milieu d'experience" (Weissberg), 147–48
telepresence art, 127–52, 155–66, 169, 182; as communication model, 139–42; and *Darker Than Night*, 202–5; and dialogism, 191–93; and Goldberg, 97–98; and *Ornitorrinco*, 129–35, 149–52, 157–61, 195–98, 200–202; and *Rara Avis*, 84–86, 162–66; and RC Robot, 128–29; and remote vision, 146–49; and *Telepresence Garment*, 198–201;

telepresence art (*continued*)
and time, 142–46, 151–52; and *Uirapuru*, 203, 206–10; and virtual reality, 137–39
*Telepresence Garment* (Kac), 198–201
telerobotics, 78, 127, 153n20, 169, 213n13; and *Darker Than Night*, 202–5; and *Ornitorrinco*, 157–61, 195–98, 200–202; and *Rara Avis*, 84–86, 162–66; and RC Robot, 128–29; and space travel, 188–90; and telepresence, 139, 148–49, 193–94; and *Telepresence Garment*, 198–201; and *Time Capsule*, 228–33
Teletel, 66–69
television, 21, 76–78, 113–14, 116–17, 140–42; slow-scan (SSTV), 20–22, 41, 44, 118–19, 127; and space travel, 149–50, 187–90; and *Time Capsule*, 229–33
telex, 16, 25, 30–32
*Terminal Art* (Ascott), 36, 38–39
*Tesão* (Kac), 67
theater, 9–12, 14, 43, 178–81
Theremin, Leon, 21
*Third Hand, The* (SRL), 179–80
*Thundervolt* (Cooper), 78–79
Tien an Men Square, 145–46
*Time Capsule* (Kac), 218, 228–33
time zones, 144
Tintoretto, Jacopo Robusti, 149
*Transcription Jewels* (Kac), 255–58
transgenic art, 236–44, 245n1; aesthetics of, 271; and breeding, 270–71; and chimera, 242–43; and dialogism, 237; and dogs, 237–42; and human condition, 292–93; and *Move 36*, 295–99; and society, 275–76. See also *Eighth Day*; *Genesis* project; *GFP Bunny*
transgenic creatures, 282n17, 287–88, 290, 294n4
transgenic crops, 287–88, 293n3
transgenic ecologies, 286–90
transgenics, 243, 246n8, 271, 290–91, 294n7. See also genetic engineering
*TransVSI Number 12* (Baxter), 25, 115
Tsuchiya, Masanori, 88
*Tum Tum Lullaby* (Masnata), 13
Turing, Alan, 47
turkeys, 195–98

Tzara, Tristan, 28, 30

Ubiqua telecommunications lab, 41
Uexküll, Jakob von, 279n9
*Uirapuru* (Kac), 203, 206–10
*Ultimate Contact, The* (Dax), 41
ultraviolet light, 251, 253. See also green fluorescent protein (GFP)
*Unexpected Destruction of Elaborately Engineered Artifacts* (SRL), 178
unidirectionality, 4, 11–12, 82. See also dialogism
UNIX, 210
U.S. Patent and Trademark Office (PTO), 244

Vallee, Jacque, 36
VanDerBeek, Stan, 25–26
van Eyck, Jan, 149
Van Gogh TV, 76–77
Varela, Francisco, 281n13
Verón, Eliseo, 35
Vesna, Victoria, 94–96, 100–101
video art, 21, 43
videoconferencing, 61, 78, 83, 163
videophones, 146, 200
videotext, 66–69, 127
Viewpoint Data Labs, 96
Villa-Lobos, Heitor, 208
Villiers de l'Isle-Adam, Auguste, 168
*Vira e Mexe* (Ferraz), 67
Virilio, Paul, 143–44, 146, 148–49, 153n22
Virtual Embrace, 225
virtual reality, 4–6, 83, 136–39, 145, 153n20, 236; and interactive art, 89–92; and Lanier, 152n3; and sexuality, 96; and telepresence, 155–57; and tourism, 146–47; and virtual creatures, 98–100
Virtual Reality Modeling Language (VRML), 73–75, 94–96, 208, 211, 255
vision, 143–44, 148–49, 182; and *Telepresence Garment*, 198–201
visual arts, 111, 217
Visual Sensitivity Information (V.S.I.), 115

*Waldo* (Heinlein), 138, 141, 168
Walkman (device), 141
*War of the Worlds, The* (Wells), 14

# Index

*Watcher* (Seawright), 176
Watson, Thomas, 33
Weaver, W., 5, 52n1
webot, 197. See also *Ornitorrinco, the Webot*
*Weekend* (Ruttmann), 9
Weissberg, Jean-Louis, 147–48
Welles, Orson, 14–16
Wells, H. G., 14, 33
Werner, Eric, 178
White, Norman, 175–76
Whitman, Robert, 116
Whitney, John, 88
Wiener, Norbert, 137
Wilcox, Fred, 169
Willadsen, Steve, 242
Wilson, Stephen, 47, 49
*Winke Winke* (X-Space), 182
Witt, Josef, 12
Wodiczko, Krzysztof, 60

wolves, 239–40, 246n10
*World in 24 Hours, The* (Adrian), 41–42
World Wide Web, 59, 65, 70–71, 86n1; and *Eighth Day*, 290; and *Genesis*, 251; and *Ornitorrinco*, 195–98; and *Rara Avis*, 84–86, 162–65; and *TeleGarden*, 182–83; and *Teleporting an Unknown State*, 224; and *Time Capsule*, 228–33; and *Uirapuru*, 207–9. See also Internet

xoloitzcuintli (dog), 237, 239
*X on America, An* (Marcus), 116
X-Space (art group), 182

Zangirolami, Rose, 67, 69
zoosemiotics, 218
zygote microinjection, 273, 282n17